PIERRE-AUGUSTE
RENOIR

PIERRE-AUGUSTE
RENOIR

KONECKY&KONECKY

Konecky & Konecky
156 Fifth Avenue
New York, New York 10010

A production of EDITA-Lausanne
Editorial Direction: Michel Ferloni and Dominique Spiess
Translation: Giles Allen

All photographs used in this work belong to EDITA SA, OFFICE
DU LIVRE, and the ROGER-VIOLET AGENCY, Paris.

© 1994 – Edita, Lausanne for all countries in all languages.
All rights reserved.

ISBN: 1-56852-112-X

Printed in France

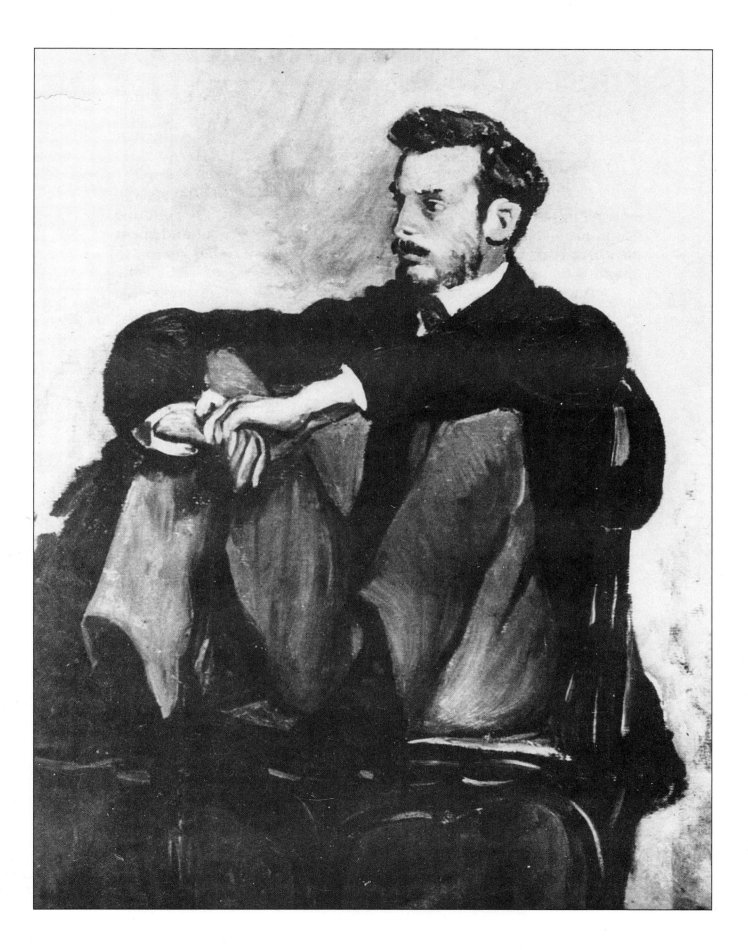

11

FIRST WORKS
1862-1869

Gleyre's studio

For the first part of his life, Renoir worked fast and well. His employers had a high opinion of him, and found him an excellent decorator who would doubtless some day set up a business of his own. But the clever and careful young man had only one dream in life: to become a painter.

After putting some money aside, he decided to take the plunge: he left the studio in 1862 and passed his exams to the art school (Beaux-Arts), obtaining 68th place out of 80, and enrolled in the studio of the painter Charles Gleyre.

He had just turned 21, and for a boy from a modest background who had seemed cut out to be a porcelain painter, this already represented an achievement beyond all reasonable expectations.

But he had finally become a "painter." From that point, Renoir began his own personal artistic search to paint what he wanted to paint, and not what people wanted him to paint.

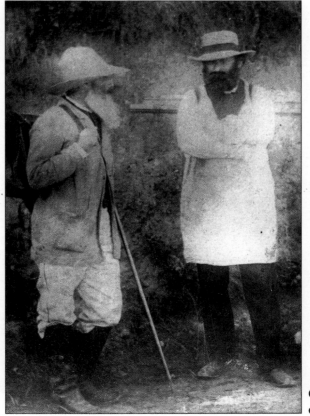

Camille Pissarro
et Paul Cézanne

A new life began, difficult for certain, because he had to eat, to pay for the studio, the courses, the models, but exciting, even thrilling. He and a bunch of friends set out deliberately to challenge academic and pseudo-classical painting in order to express themselves in a revolutionary way, that, a decade or so later, was to be dubbed Impressionism.

In Gleyre's studio, Renoir made the acquaintance of Albert Sisley, Frédéric Bazille and Claude Monet, three friends who stayed together thereafter. Bazille later introduced Renoir to Camille Pissarro, Armand Guillaumin and Paul Cézanne.

What an amazing breeding ground it was! They were all more or less of the same age, those a little better off helped those in the worst financial straits; they shared the same studios, painted the same models, had fun in the same bars and dance halls around Paris, and hammered out among themselves their own new conception of art. They admired Delacroix, Corot, Courbet and Jongkind, and their master was Manet, who was to cause a scandal with his *Déjeuner sur l'herbe* in 1863 and his *Olympia* in 1865.

"You see," said Bazille to his friend Renoir, *"Manet is as important to us as Cimabue and Giotto were to the Italians in the Quattrocento. Because a new Renaissance is on its way. And we've got to be part of it."*

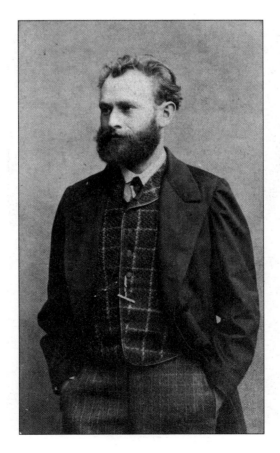

Edouard Manet
1832-1883

The Forest of Fontainebleau

With the arrival of spring, they went off with their rucksacks to paint in the open in the Forest of Fontainebleau, or "in search of motifs," as Cézanne was to call it.

It was there that Renoir one day met Diaz, one of the masters of the School of Barbizon, for whom he felt a true admiration. *"Not badly drawn,"* said Diaz, when he saw Renoir's painting,*"but why on earth do you paint so black?"* Renoir brightened up his palette of colours. Diaz befriended him, gave him advice and even opened an account for him with his paint merchant.

While still in the Forest of Fontainebleau, Renoir often went to his friend the painter Jules Le Coeur who had a house at Marlotte. He painted him in the middle of trees and rocks in a painting in which he experimented using a palette knife, a technique which he quickly dropped.

This is where, too, all the future Impressionists met together in the Cabaret de la mère Anthony, one of the first big paintings Renoir did (195 x 130 cm), in which some of his friends can be recognized. In the foreground is Toto, a poodle with a wooden leg. He is the only character that looks straight at us.

Bertall
Caricature of
la baigneuse au griffon
June, 1870

At the same time, he also met Gustave Courbet, whom he greatly admired and whose two great masterpieces, *Atelier du peintre* and *Enterrement à Ornans*, promoted realism in art.

Renoir, in his early days, had a lot of trouble cutting himself free of Courbet's influence, which can be found particularly in such big paintings as *Diane chasseresse* of 1867 and *La baigneuse au griffon* of 1870.

Lise Tréhot

Renoir could never stay put, and, since his income was extremely modest, he lived either with his parents at Ville-d'Avray or with friends: at Marlotte at Jules Le Coeur's, with Bazille in rue de Visconti in Paris and then at the Batignolles, or alternatively with Sisley.

Sometimes he was hardly even able to paint at all. *"I'm doing almost nothing," he wrote to Bazille, "because I haven't any paints left."* But he never complained, and his bohemian-type existence had some compensations; he made the acquaintance of Lise Tréhot at Jules Le Coeur's in about 1866; she was 18 and became his mistress and his favourite model till 1872, when she married the architect Georges Brière de l'Isle.

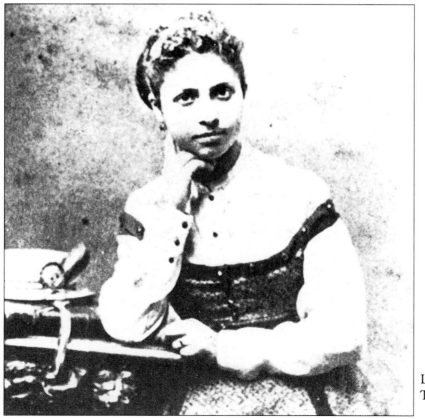

Lise
Tréhot

Caricature of
Lise à l'ombrelle

Lise is found in about 20-odd of Renoir's paintings, some with her name: *Lise cousant* (1866), *Lise à l'ombrelle* (1867), *En été* or *Lise ou la Bohémienne* (1868), *Lise au châle blanc* (1872). Some showed her nude, as, for instance, *Diane chasseresse*, or *La baigneuse au griffon*, that we have already mentioned, others dressed in gorgeous oriental costumes, as in *Odalisque ou une femme d'Alger* (1870). She also posed for *La femme à la mouette* (1868), *La femme à la perruche* (1871) and figured a last time in 1872 among the *Parisiennes habillées en Algériennes*.

Taking part in the Salon

What became of Renoir's work, we might ask, and how were his paintings received?

First we have to step back and place ourselves in the context of the times; for a painter, the only way to become known and

popular - that's to say to sell and to obtain orders - was to participate in the Salon. But the jury was harsh; so were official circles, critics and the public of so-called connoisseurs, those that bought pictures. All these people could only accept as "art" works displaying a certain form of classicism, or rather pseudo-classicism, works conforming both in terms of subject - mostly inspired by religious or mythological scenes - and in style of painting.

Humorous drawing by Cham

The Yerres river at the beginning of the century

The young painters, on the contrary, especially those in what was to be called "Manet's Group," distinguished themselves above all by their subjects, consisting of studied observations of ordinary or "modern" life, totally at loggerheads with the academism then in fashion, and by their way of painting, that sought to render on canvas their visual sensations, and, in particular, their perception of light.

We haven't reached Impressionism yet, but these pioneering attempts were groping in that direction and were going to bear fruit within several years.

For the time being, the only way to make any progress was to be "received" at the official Salon, and for those that had no private fortune, such as Renoir, there was no other choice.

In 1864, Renoir took the risk of sending a first painting *La Esméralda*, inspired by Victor Hugo's novel Notre-Dame de Paris. The painting was accepted, but when he saw it back in his studio after the Salon closed, he found it so awful that he destroyed it!

The following year, he sent the *Portrait de William Sisley*, his friend's father, and *Soirée d'été*, both of which were accepted, and Renoir thought he was launched. But the official circles criticized the jury's indulgence, and the 1866 Salon rejected Renoir, Manet and Cézanne's paintings.

In 1867, *Diane chasseresse* was rejected in its turn.

Finally in 1868, the jury accepted *Lise à l'ombrelle*, a life-size figure in which the subtle interplay between shadow and light represents something new. But despite several favourable comments, the picture was relegated to the "dump in the attic." The picture was, however, talked about, and that was important in itself. Zola wrote: "This Lise...is one of our women, one of our mistresses rather, painted with great truth, and representing a successful attempt at introducing the modern."

Some people started demanding a "Salon des refusés", but the government would not authorize it. It was not until 1874 that the Impressionists-to-be were able to organize their first exhibition, at their own expense.

Flowers and landscapes

Renoir continued to paint, subject to various influences while trying to find his own personal style. Discernible in the works of this period, however, and beside the large paintings that we have already mentioned, we discover other qualities in Renoir that he expressed in smaller paintings.

These are, firstly, splendid landscapes. He was to paint these all his life, with a special liking for riverbanks and the banks of the Seine, which are the settings for some of the masterpieces of his Impressionist

period. He also painted views of Paris, whose movement and liveliness all the Impressionists tried to convey.

It's worth noting that Renoir almost never painted winter landscapes, since he had no more time for anything sad than he did for things ugly or vulgar. *"I have never been able to bear the cold (...) why paint the snow, that sickness of nature?"*

The only painting we know of his is *Patineurs au Bois de Boulogne* dating from 1868, which was more for him an evocation of contemporary Paris life, and *Paysage de neige* which certain experts date to 1875. Renoir was to say of it: *"White doesn't exist in nature. You have to admit that there is a sky above the snow. Your sky is blue. That blue should appear on the snow..."*

He experienced the same pleasure, too, right until the day he died, when he let his brush go and painted admirable bouquets of flowers. *"It rests my brain to paint flowers,"* he said one day. Perhaps his past as a porcelain painter came back in this exercise, that gave him a chance to look for colour combinations that he later applied in his compositions.

We can compare his admirable *Bouquet de fleurs* of 1866, reminiscent of the Dutch masters, or *Fleurs dans un vase* of 1869, with paintings bearing Impressionist influences, such as *Vase de chrysanthèmes* and *Roses mousseuses* of 1890: and, finally, with two paintings of 1901, both called *Fleurs dans un vase*; Renoir, in the last part of his life, showed a liking for roses in which he sought different kinds of harmony in colours. *"I'm looking for variations in flesh colours that I can use for nudes,"* he said.

An exceptional gift

Portraits were also a fertile field of activity. Of course, executing portraits was one way of getting into the wealthy circles that would order pictures from him throughout his life. But portraits also happened to correspond in Renoir's case to an exceptional gift as a portrait painter. They gave him an opportunity to paint some of his masterpieces, both as large paintings with many characters, such as the *Bal du Moulin de la Galette* (1876), or the *Déjeuner des canotiers* (1881), but also as individual portraits of women, and most particularly of children, a speciality where Renoir's art remains unmatched in conveying accuracy, freshness and emotion.

Throughout the different stages of Renoir's artistic evolution, we constantly find landscapes, flowers, women and children, who, under his brush, become a hymn of joy to life and beauty. No other painter has ever been able to transmit the message more convincingly.

Julie Manet and Her Cat

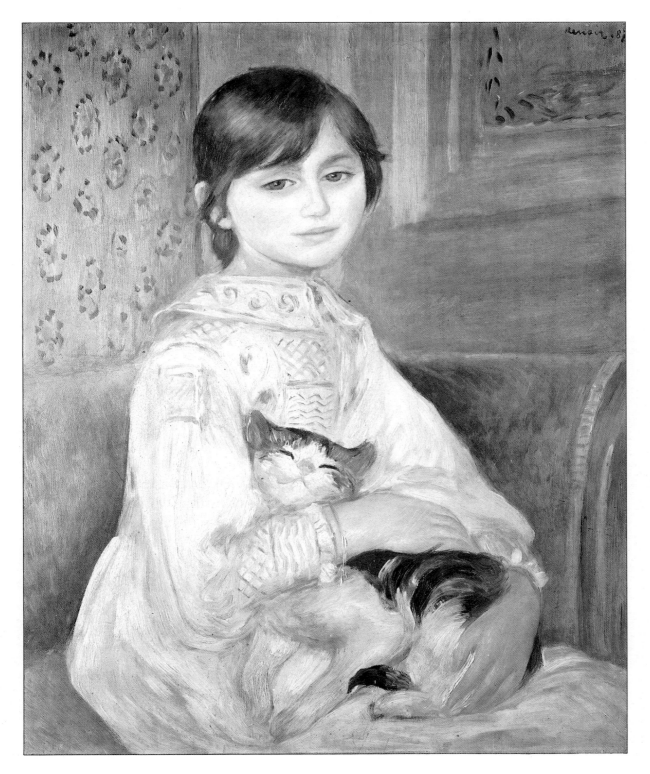

THE IMPRESSIONIST REVOLUTION 1869 - 1881

Manet's Group

Although we cannot confine Renoir to any formulas, schools or tendencies, we do, nevertheless, have to date the major stages in his work in order to make for clarity in this study. We should always remember, however, that he was willing to paint in a classical manner in the middle of the Impressionist period, and to re-adopt Impressionist techniques when doing landscapes in the latter part of his life, long after he had abandoned Impressionism as a style of painting.

Henri Fantin-Latour – *Atelier des Batignolles* – Musée d'Orsay, Paris

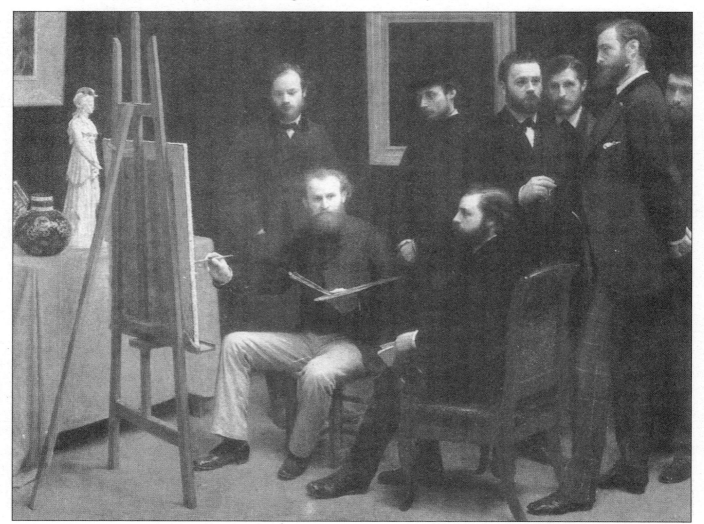

In fact, as we said right in the beginning, Renoir was always authentically himself, painting only what he wanted to paint in the way he wanted, abandoning himself purely to the "exquisite ecstasy of painting."

When did Impressionism begin?

The beginning of the movement is difficult to date, as it varies from painter to painter, and for Renoir, as mentioned, from painting to painting. Two years, however, emerge from the astonishing profusion of masterpieces of this time: 1869 at *La Grenouillère* for Renoir and Monet, and 1874, date of the first Impressionist exhibition.

Frédéric Bazille – *Atelier de Bazille, rue de la Condamine*
Musée d'Orsay, Paris

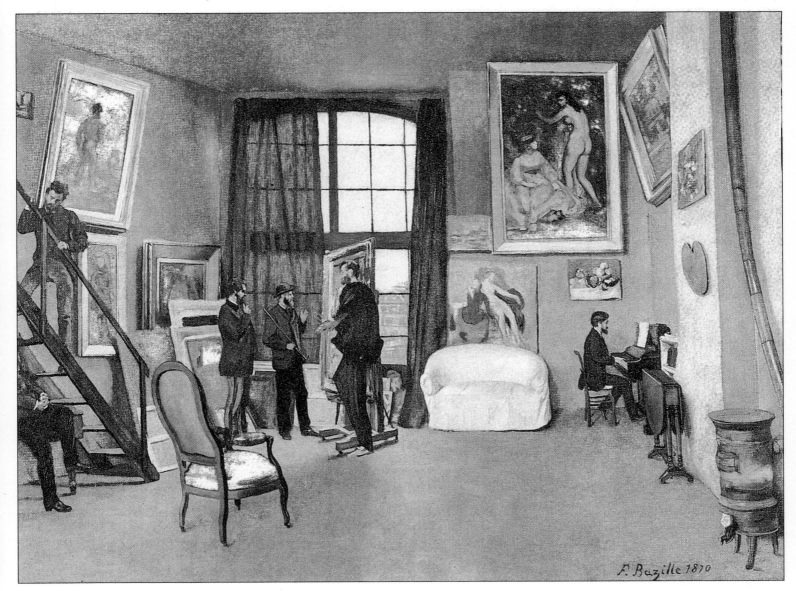

"Manet's Group" would regularly meet together at the café Guerbois, 11, Grande-rue des Batignolles, for interminable good-humoured discussions in which the favourite target was invariably the academism of official circles. They also poked fun at the famous jury of the Salon that obstinately refused to accept this young revolutionary generation whose sole values were truth to life and what was natural. Around Manet, their spiritual master though barely older than themselves, were Degas, Monet, Bazille, Alfred Stevens, Fantin-Latour, Sisley, Pissarro, Cézanne, and naturally, Renoir, as well as writers such as Zola.

Between Chatou and Bougival

One other fashionable rendez-vous was La Grenouillère, near Croissy between Chatou and Bougival, a riverside dance-hall and thermal spa in one, a kind of "Trouville-on-Seine," where a world of people from different social backgrounds came together with the sole aim of having fun, dancing and boating.

Chez Fournaise

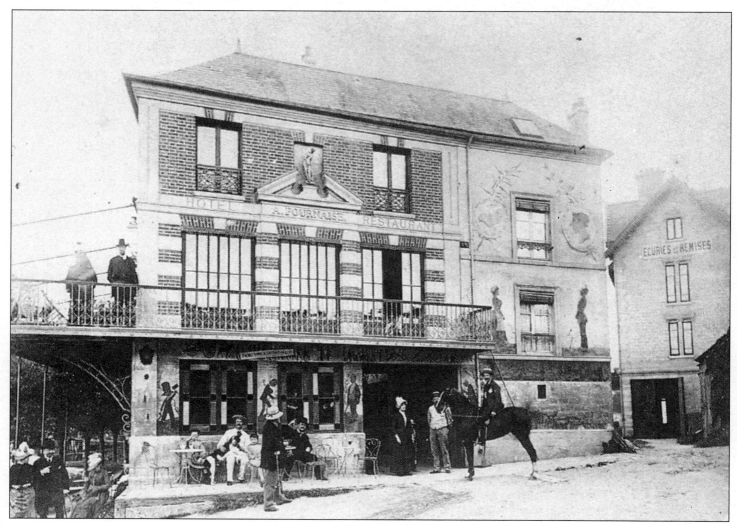

Claude Monet circa 1925

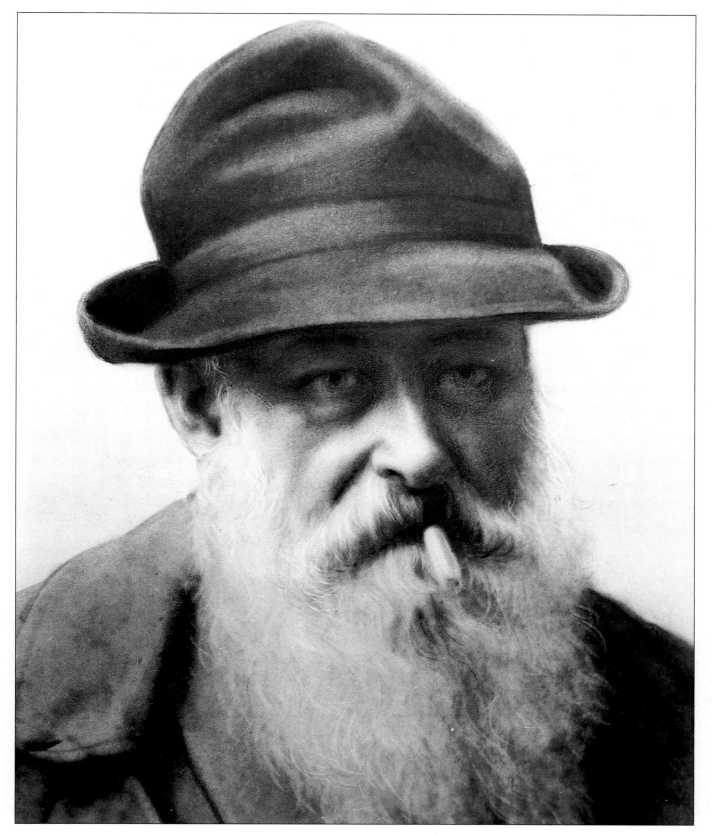

Some naturalist writers like Maupassant often spoke of La Grenouillère in scathing terms as a place "reeking of stupidity, coarseness and lower-class love affairs." Renoir, on the other hand, who had only eyes for beauty and *joie de vivre* in whatever he painted, *said: "In those days, we knew how to have a good time!" and: "I spent all my time at Fournaise's. I could find as many beautiful girls there to paint as I wanted..."*

The two inseparable friends, Monet and Renoir, set up their easels there, painted the same subjects, and then went to Père Fournaise's restaurant, which was to appear in other paintings later.

These were the first masterpieces with an unmistakably Impressionist stamp.

La Grenouillère, of 1869, which exists in many versions under the same title, and was painted by both Renoir and Monet, can be considered the birthplace of Impressionism.

In the painting now in Moscow, Renoir depicted strollers on the riverbank, while, in the one now in Stockholm, the little island that Maupassant called the "Flowerpot," is attached to the bank by two footbridges and to the establishment proper, an old barge with its wooden balcony. This latter version is perhaps the most beautiful: the scene is completely ashimmer, and sun, trees and water mix their reflections with those of the boats and the silhouettes of the people.

Monet and Renoir continued to paint together, but their temperament and their perceptions differed: *Le Pont-Neuf* (1872) seen by Renoir is luminous under a splendid blue sky in which the crowd of passers-by is lively and cheerful, while Monet's is hazy, with a covered sky and passers-by apparently hastening past under their umbrellas.

We find them working on the same subject again in *La mare aux canards* (1873) or at Argenteuil watching the same regattas, the same boaters or the same sailing ship in *La Seine à Argenteuil* (1873). Renoir also painted his friend *Monet peignant dans son jardin à Argenteuil* (1873), and *Portrait de Monet peignant* (1875), his wife, *Madame Monet étendue sur un divan* (1872) in a splendid symphony of blue, and *Madame Claude Monet et son fils* (1874) in the langorous atmosphere of a summer's day.

Another painting, *Femme à ombrelle et enfant* (1873), shows Camille Monet, the painter's wife, deep in tall grass. What wonderful simplicity and charm are conveyed in a few gentle, wavy brushstrokes, where the child's blond head, barely suggested, seems to slip away and the mother's face appears haloed by the pink of the parasol.

Other paintings of the same period such as *Printemps à Chatou*, *Chemin montant dans les hautes herbes* or again *Le pêcheur à la ligne*,

Sentier dans le bois, are perfect examples of Renoir's Impressionist attempts in landscapes literally shimmering with colour and light.

The Impressionists search for their way

People going about everyday life, studies carried out in the open air to capture the changing aspects of nature, visual sensations in which colour is more important than form, the play of light and sun, a very free style without merging tones that leave the individual brushstrokes independent...these are just a few elements in the Impressionist search. They contrast sharply with the Classical painting of dark merging colours, evoking great religious or mythological subjects.

This dual Impressionist revolution - in style of painting and choice of subjects from ordinary life stood in direct contradiction to the dogmas of fashionable academism that glorified Graeco-Roman sculpture as an indisputable model.

And yet - and we come back to this yet again - the Impressionists did not want theoreticians around; they were empiricists, and Renoir, as much as anyone, never wanted to get locked into a system or a method. He was an Impressionist when he wanted to be, and when the subject lent itself to the treatment, but he left the movement in 1881, only returning to it in certain later paintings.

Gallery Durand-Ruel

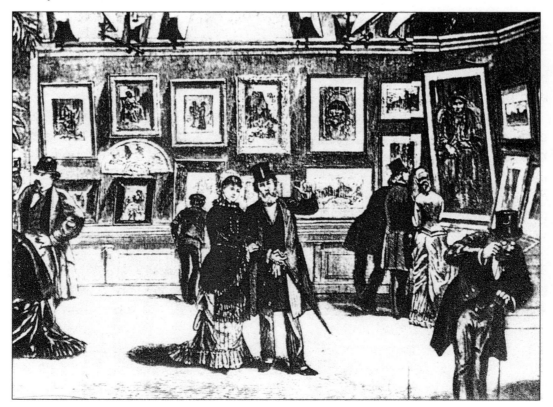

Renoir, in fact, was never going to adhere slavishly to any program, even when successful, and spent his whole life just trying to improve - something only really great painters do.

First admirers

In the meantime, he had to live.
The Impressionists-to-be never managed to make any real impact at the Salon. A few enlightened art-lovers and art dealers did show interest in them. They were able to buy some pictures at laughably low prices, because they were not in demand. Some even went so far as to encourage them, became their friends and followed them throughout their entire careers, building up collections that would one day be worth more than their weight in gold.

One of the first was the international art dealer Paul Durand-Ruel who started to show interest in Monet, Pissarro and Sisley from 1870 on, and from 1873, in Renoir. He organized exhibitions of their works in London.

We could also mention Faure, a baritone at the Paris Opéra, the critic Théodore Duret who was to become the first historian of the Impressionists, Père Martin, Dr. de Bellio, the writer Arsène Houssaye, the excellent painter Caillebotte, who had a private fortune, and a bit later, two people who were going to play an important role in Renoir's life: Victor Chocquet, an official in the Customs Administration, who was to be a stalwart defender of Renoir (there are portraits of his whole

Café de la Nouvelle Athènes

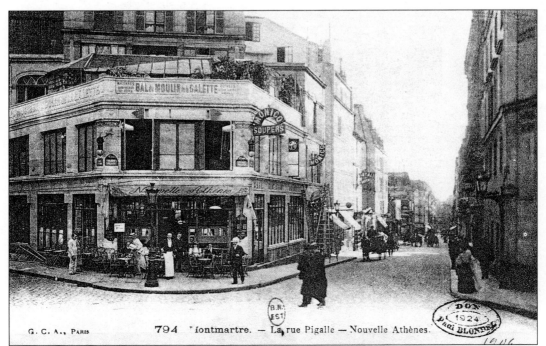

G.C.A., Paris 794 Montmartre. — La rue Pigalle — Nouvelle Athènes.

28

family), and the publisher, Georges Charpentier (the large portrait *Madame Georges Charpentier et ses enfants* was immensely well received at the Salon in 1879).

The Impressionists' first exhibition

Because the critics and the jury of the Salon continued to bar the road to the young ambitious painters of "Manet's Group," who now got together at the café de la Nouvelle Athènes on the corner of rue Pigalle, they decided to form a company to put on a new exhibition to parallel that of the official Salon.
Renoir took part in it, but did not want it to be given a name that would suggest a new school, so it was called Société anonyme coopérative d'artistes peintres, sculpteurs, graveurs (Co-operative, limited company of artists, sculptors and engravers). The site chosen for the exhibition was to be the studios of Nadar the photographer on Boulevard des Capucines at the corner of rue Daunou.

It opened on April 15, 1874. Thirty artists took part, including Astruc, Boudin, Bracquemond, Cézanne, Cals, Degas, Guillaumin, Monet, Berthe Morisot, Pissarro, Renoir, Rouart, and Sisley among others.
Renoir exhibited six paintings, including *La Parisienne* or *La dame en bleu*, and *La loge*, a masterpiece that was to be considered the most representative picture of Impressionism.

Nadar's studio

The Painters by Vogel

Edouard, Renoir's brother, and Nini-Gueule-de-Raie (Nini-fish-face) were the models for *La loge*, also called *L'Avant-scène*. In another painting, probably of the same year, Nini Lopez in brown, again with this curious nick-name, reappears

The hoards of detractors who visited this first Impressionist exhibition did not attack *La loge* directly. Some saw in it the image of women of easy virtue, "their cheeks white, their eyes lit with a gleam of banal passion...attractive, empty, delightful and stupid." Let us not be as severe on Nini, and say simply that she liked being admired.

Rather than the subject, let's look at the painting itself. Renoir, as he was to do especially towards the end of his life, out of horror of emptiness in his paintings, framed his subjects very tightly. Only Nini's face was treated with smoother, closer strokes, the way he did in practically all his portraits, because his talent as a portrait-painter would simply not allow him to deform his model's face.
But around this slightly too demure face that stares out at us - and as though emanating from it - the Impressionist spirit permeates the contours of the cloths and of the flowers and the brilliance of the jewels. The blacks and whites dominate in a subtle play of shadow and light.

La loge was bought for 425 francs by Père Martin, a small trader, originally an artisan saddlemaker, who was thrilled by the whole generation of Impressionists. Durand-Ruel bought it at the end of the century for 7,500 francs and it was purchased in 1925 by the industrialist Samuel Courtauld for a million francs. It is today in the Courtauld Institute Galleries in London.

The first exhibition of the Impressionists attracted a puny 3,500 visitors, as compared to the 400,000 who visited the official Salon. The critics had a field day, and a sarcastic remark in *Le Charivari* on Claude Monet's painting *Impression, soleil levant*, was responsible for giving the painters their name of "Impressionists", that was going to become world-famous: "It's an impression if I'm not totally mistaken ...I am sure, actually, since I am impressed, that there must be some impression in all that..."

Over the next twelve years, in eight exhibitions between 1874 and 1886, Impressionism would about to take the public by storm. For the time being, however, it was a scandal and a financial failure.
The fledgling company was put into liquidation, and on March 24th of the following year a big auction of "Impressionist" paintings was held at the Hôtel Drouot on Renoir's initiative, to try and get back some of the outlay. 73 paintings were exhibited for auction, 20 of them by Renoir; it proved another disaster, with the public hissing, hurling insults and even fighting.

A mass of flesh in decomposition

Renoir continued to paint non-stop, and his talent became more self-assured in the splendid portraits of his backers and sponsors, but also in those of women, for whom Renoir had a particular soft spot. *"I love women,"* he said to his son, *"they never suspect anything. With them, the world becomes a supremely simple place...With them, one feels reassured."*

Among the most beautiful, we could mention *La liseuse* (1874-76), one of his most Impressionist paintings, lit up by a brilliant sun, *La première sortie* (1876) on the same theme as *La loge* , with wonderful effects of shadow and light, and *Torse au soleil* (1875), in which the patches of sun filter through the leaves onto the model's skin in a sensual and joyful interplay.

Torse au soleil was shown along with other of Renoir's paintings at the second exhibition in April 1876 of the group known henceforth as the Impressionists, and delighted Zola, who wrote: "In his work, a range of clear tonalities dominates, with passages between them designed with marvellous harmony. It's like a Rubens lit up by the bright sun of Velasquez. His portrait of a girl pleased me greatly. She is a strange and agreeable figure with her elongated face, her red hair, her barely perceptible smile, reminiscent of some Spanish infanta."
Compare this with what a famous critic of the time wrote in *the Figaro*. "Could somebody try and explain to M. Renoir that the torso of a woman is not a mass of decomposing flesh, with green and purple spots, that describe the state of complete putrefaction of a body..." The other painting

Windmills of Montmartre by Vernier, 1867

exhibited by, among others, Caillebotte, Degas, Monet, Berthe Morisot, Pissarro, and Sisley, encountered the same incomprehension and contempt.

And yet this year 1876 was going to be crucial for Renoir; it was the year in which he finished one of his most famous paintings, the *Bal du Moulin de la Galette*, and that of his meeting with the Charpentier family.

The Bal du Moulin de la Galette

An order for a portrait enabled Renoir to rent, for a hundred francs a month, some rather delapidated premises surrounded by a big flowering garden in rue Cortot on the Butte Montmartre. He was thus just beside the Moulin de la Galette, which he decided to paint and had already sketched.

First he painted *La balançoire*, a marvellous vertical painting in which the blue and violet shadows play on the pale pink dress of the young woman in a garden speckled with patches of sun: "These effects of the sun, which are combined in such a curious fashion, produce exactly the effect of spots of grease on people's clothes," said one caustic critic.
But Zola, in his novel *Une page d'amour* published in 1878, brought Renoir's heroine to life again: "..standing upright on her swing, her arms wide open, holding the ropes. She wore a grey dress with mauve knots. That day, the sun scattered a soft dust through the pale sky. It was like a slothful shower of sunrays falling between the leafless branches."

Entrance to the Moulin de la Galette

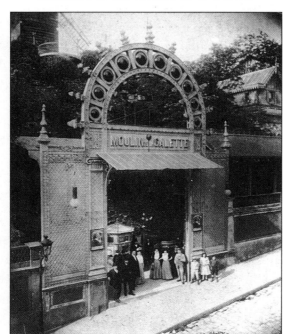

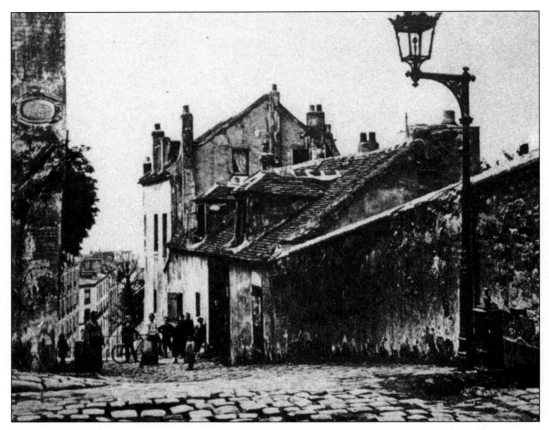

Rue Cortot in Montmartre, 1876

For the *Bal du Moulin de la Galette*, Renoir took a large canvas of 131 x 175 cm to paint on the spot, and brought his friends together there every day. They were painters, a journalist, a civil servant, and models like the young woman in the foreground, Estelle, Jeanne's sister, who posed for *La balançoire*. But they had to pose as different characters. All this little world ate, drank, danced, and had fun as Renoir looked on; he knew in an incomparable way how to convey the atmosphere of a celebration and of the joie de vivre in this popular bar of Montmartre's young people.

One of the first critics favourable to the Impressionists wrote: "The painter has very faithfully rendered the noisy, slightly loose atmosphere of this riverside dance hall, perhaps the last still existing in Paris. People dance in the narrow little garden beside the Mill. A crude light falls from the sky through the chinks in the leaves, casts gold upon fair hair and pink cheeks, sets the young girls' ribbons alight, lights up the whole background of the picture with a joyful flame whose shadows even take on a reflection, and in the middle of which a crowd of dancers contort themselves into the wild postures demanded by a feverish choreography."

Madame Charpentier's Salon

In a completely different social context, that same year Renoir met a young publisher, Georges Charpentier, who had recently bought *Le pêcheur à la ligne*, and who, completely under its spell, wanted to meet its creator.

The Charpentiers entertained in a private Paris mansion where they lived in rue de Grenelle, and Madame Charpentier, a refined and sensitive woman, brought together a varied collection of ladies of the aristocracy, wealthy inhabitants of the Faubourg Saint-Germain, writers, politicians and artists in her drawing-room.
Here Renoir met Gambetta, Jules Ferry, Clémenceau, Zola, Edmond de Goncourt, Flaubert, Théodore de Banville, Barbey d'Aurevilly, Saint-Saëns, Massenet, Reynaldo Hahn, Chabrier and actresses like Jeanne Samary and Yvette Guilbert.

Renoir felt equally at ease in Madame Charpentier's elegant and fashionable receptions as in Montmartre circles. He painted untiringly; at the third Impressionist exhibition in 1877, he put 21 paintings on show, including the *Bal du Moulin de la Galette, La balançoire* and portraits of Madame Charpentier, Madame Daudet and Jeanne Samary.
This latter is fairly exceptional, as it is definitely Impressionist, while generally Renoir used a more unified workmanship for faces in his portraits (see, for instance, Madame Henriot), but perhaps he was so taken by his model's red hair or the sensuality of her face that he dared paint it warm red, orange and scarlet.

"I think he is launched"

As the third Impressionist exhibition in 1877 didn't go better than the previous ones, Renoir, who needed to sell his paintings to have something to live on, decided to return to the official Salon.

"In the whole of Paris," he wrote to Durand-Ruel, *"there are not more than 15 art-lovers capable of appreciating a painter without the Salon..."*
He therefore sent *La tasse de chocolat* to the Salon in 1878, which was accepted; the next year, more importantly, he submitted two major works, the *Portrait de Jeanne Samary* and *Madame Georges Charpentier et ses enfants* to the Salon. The first, that we have just mentioned, was painted in an Impressionist style and was relegated to the "dump" in the attic upstairs, but the second, more "reasonable" in the jury's mind, that had in particular the merit of showing a well-known society figure, was highly praised.

Pissaro would write: "Renoir has made a great splash at the Salon. I think he is launched, thank God, a life of poverty is no fun."

If this portrait seems relatively low-key to us today, it cannot be compared in any way to the fashionable portraits of the time. To begin with, Madame Charpentier and her children are not stilted at all, and are not posing, and the familiar decor is not "arranged." Secondly the Impressionist style is present everywhere in the sumptuous black dress, in the children's hair and in the background surrounding the characters.

Renoir received so many compliments for his "greatest masterpiece" that, exhausted, he was later to say: *Put it into the Louvre, and don't bother me any more with it"* - which is exactly what happened.

Meeting with Aline

In 1880, at his milk merchant's, Renoir met a young milliner, Aline Charigot, who worked not far from his studio. She was 20 and was to pose for him in numerous paintings, become his wife and bear him his three children, Pierre, Jean (the famous film director), and Claude, called Coco.

He often went with Aline on Sunday to La Grenouillère or to the Auberge du Père Fournaise. We can recognize it for the first time in *Les canotiers à Chatou* and in *Madame Renoir au chien*. Two other paintings of this time, La Seine à Asnières, with admirable contrasts between oranges and blues, and *Le déjeuner au bord de la rivière* with its warm relaxed feeling, offer a foretaste of what was to come with one of Renoir's best-known works, which he finished in 1881, *Le déjeuner des canotiers*.

Le déjeuner des canotiers

As always, Renoir called on all his friends to pose.
He had not married Aline yet but was living with her; she figures in the foreground on the left, with her dog. By isolating her from the group, we can create a marvellous portrait, fresh and cheerful, still recognizably Impressionist in style.
On the other hand, the person on the right in the foreground, the painter Caillebotte, is of a drier workmanship, announcing Renoir's next stage, called the "bitter" or "Ingres" period. Behind Aline is Père Fournaise, owner of the restaurant, and, with her elbow on the guardrail, his daughter Alphonsine, who appears in other Renoir paintings. All the other characters shown are friends of Renoir, whose names are not known.

They form an admirable composition, yet one that is very simple, showing a free, happy group of young people: dinner is over, the still

life in the forground shimmers against the whiteness of the tablecloth in a slight haze typical of Renoir's brushstrokes, the light of this sunny afternoon is softened by the awning...

"The boatmen have had lunch under the awning of the restaurant," the critic Théodore Duret wrote. "The painting was made there on the spot, in the open air. The Seine and its banks, beneath a summer sun, confer a bright background. We find traces of that style of painting called Impressionist, common to Renoir and to his painter friends. But we also find particularities that are his and his alone. The women who have just had lunch with the boatmen attract especial attention."

Because of the similarity of subject and composition, and because of the richness of their palettes, *Le déjeuner des canotiers* has often been compared to Veronese's *The Wedding at Cana* (1522) for which Renoir had a particular admiration. He went to look at it again several months before his death in the course of his last visit to the Louvre, transported there in a wheelchair.

Veronese – *The Wedding at Cana* – Musée de Cannes, Paris

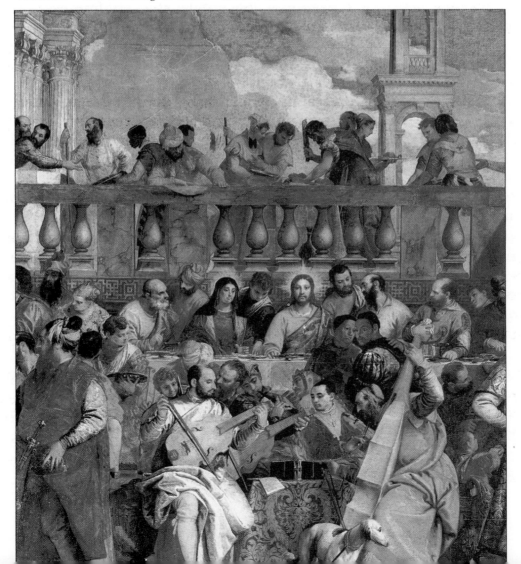

SELF-DOUBTS DURING THE "INGRES" PERIOD - 1881-1889

Le déjeuner des canotiers : the end of one period

In 1881 and 1882, Renoir, who had turned 40, went abroad for the first time to Algeria and Italy.
Memories of Delacroix first drew him to Algeria, which inspired some pictures including *Fête arabe à Alger* and *Femme algérienne*, but he found the light too bright and the women too mysterious. He liked to paint women whose transparent skin did not reject light and did not feel happy painting Algerian women's skin.
During his second stay there, he said that he had discovered white: *"Everything is white, the bournous, the walls, the minarets, the road."*

In Italy, he was seduced by Rome, Naples, and Capri, but, most of all, by Venice, which he evoked in a very subtle, still very Impressionist way in works like *La Place San Marco and Venise, brouillard.*

A man who has seen Raphaels

What, however, captivated Renoir more than anything during his stay in Italy - and it was going to have direct repercussions on his style - were the frescoes at Pompeii, whose sober elegance he admired, and seeing the Raphaels: *the Seated Virgin* in Florence and the frescoes in the museums in Rome were real eye-openers to him.
FHe wrote to Madame Charpentier when speaking of him: *"A man who has seen Raphaels! Great painting,"* and to Durand-Ruel: *"I've been to see the Raphaels in Rome. It was beautiful, and I should have seen it all earlier. It's full of wisdom and knowledge. He never aimed for impossible things like me. But it's beautiful. I prefer Ingres when it comes to oils, but for frescoes, it's admirable in its simplicity and grandeur."*

Ingres and Raphael - the two keys to Renoir's transformation.

After a stay at l'Estaque, where he met Cézanne, and during which time they painted together (*Montagnes à l'Estaque*), Renoir returned to Paris to take part in the seventh Impressionists exhibition in 1882. He had not participated for several years, preferring the Salon, but this time sent 25 paintings, including *Le déjeuner des canotiers.*

The three Dances

A year afterwards, he painted three vertical panels that have become justly famous, on the theme of the dance, setting three contrasting styles of couple against each other: in town, in the country and at Bougival. *La danse à Bougival*, with the characters sketched in the background, the bouquet of violets and the cigarette-end in the foreground, are still related to the Impressionist manner and are reminiscent of the boatmen period. With the other two couples, on the other hand, *La danse à la ville* and *La danse à la campagne*, we can already feel the mark of a more stylized Renoir. His subjects are more carefully drawn, and treated in a drier manner.

The work that was really going to usher in this new period was *Baigneuse* , entitled *Baigneuse blonde* I, that he painted in Capri in 1881, a second version of which he painted in 1882, *Baigneuse blonde II*. It's interesting to note that he slipped a wedding ring onto the finger of his model, Aline Charigot, who had not yet become his wife.

The so-called Ingres period

Renoir moved further and further from Impressionism; he had been enormously marked by Raphael during his stay in Italy, and had always liked Ingres, whose formula was: "Drawing represents integrity in art."

Ingres
Odalisque
Musée de Bonnat, Bayonne

The contours of his figures became precise, he drew his shapes more and more with a rigour that sometimes verges on the dry, which is why we sometimes speak of the "acid", "bitter" or "Ingres" period of Renoir, during an epoch running between 1881 and 1888-89.

At this time, too, he discovered *Il Libro dell'Arte* by Cennino Cennini, a treatise on Florentine painting of the beginning of the 15th century, translated in 1858 by a pupil of Ingres.

As we have, already said, we cannot, and must not, define Renoir's style in any precise fashion. His break with Impressionism was gradual, and he went back to the style occasionally whenever he felt the need to.

But what is certain is that Renoir had self-doubts....

He wrote to Durand-Ruel at the end of 1881: *"I am still research-mad. I am not happy, so I rub it out, and rub it out again. I hope that this mania will come to an end...I am like a child at school. The white page must be neatly written, and so what happens, lo and behold, a blot of ink drops. I'm still at the blot stage - and I'm 40."*

A little later, he said to Vollard: *"Around 1883, something, somehow seemed to break in my work. I had gone as far as I could into Impressionism, and reached the conclusion that I could neither draw nor paint. In fact I had reached a dead-end."*

Manet's death in 1883 affected him as it did all his fellow-painters. He had written to him shortly before :*"You are the happy fighter, with hate for no one, like an ancient Gaul, and I like you for this unfailing cheer, even in the face of injustice."*

Renoir had a feeling that his painting in the open air took on another look once in the studio: *"Outside you are enraptured by the light (...) and then outside you can't see what you are doing."* He considered that he had attached too much importance to luminous effects at the expense of composition, form and the density of things. He wanted to imitate Raphael's frescoes and the works at Pompei by removing the oil from his colours and reining in his palette, so that colour would not dominate but become a means to an end.

Renoir thus modified form, light and colour in the paintings of his so-called "bitter" period.

The easiest way to understand this change is to compare the nudes of various different periods, for instance :*Torse au soleil* of 1875 and the *Baigneuse blonde I* and *Baigneuse blonde II* of 1881 and 1882. While the ways in which the contours of skin in the sun have been rendered are in total contrast, we cannot but help admiring this search for sculptural modelling of a woman's body so

characteristic of Renoir - a search he continued until his dying day.

Another painting, *Les parapluies*, difficult to date (1881-86), is also helpful in understanding Renoir's development, representing, as it does, a transitional work, in which his two styles of painting co-exist. On the left, the woman with the basket is definitely of the new Ingres period with her dry, "purged", carefully drawn silhouette, while the group on the right, especially the two children, bears the hallmark of Impressionism, with its teeming, individually separate strokes of colour. Les parapluies was perhaps painted at two separate times, which would explain this dichotomy.

On the other hand, in the landscapes he came back with from Jersey and Guernesey, which he visited with Aline and some friends in 1883, the Impressionist stamp is again to be felt (*Falaise and Plage de Guernesey*). As always, he idealized whatever he saw: *"Nothing could be prettier than this mixture of men and women on the rocks, we have no trouble imagining ourselves far more in a Watteau landscape than in reality..."*

Wargemont, at the Bérards

Other paintings were typical of this period: *L'après-midi des enfants à Wargemont* of 1884, *La natte* of 1886, and *La bergère, la vache et le brebis* of 1887.

Chateau Wargemont

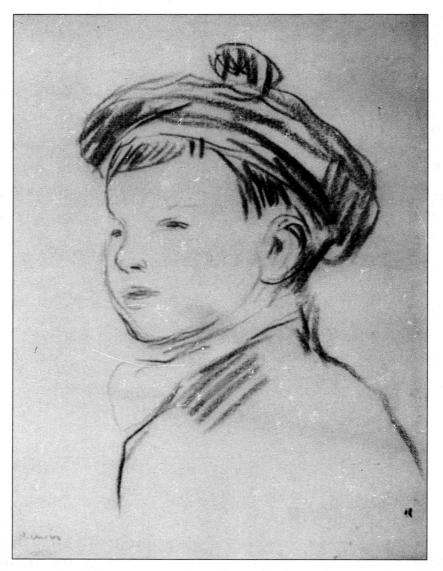

Renoir had become a close friend of Paul Bérard, a diplomat and banker. He had already painted his children and made numerous studies, such as the painting of 1881, entitled *Croquis de têtes*, that shows Bérard's four children: André, Marthe, Marguerite and Lucie. This type of work gave him practice watching children unhindered before executing the final portrait, and Renoir did more and more of this sort, a bit later, using his own sons with the delicacy and exceptional talent that he had for rendering the colours of infants' skins and their grace.

The portrait of 1884 was painted in summer at the Bérards' country house at Wargemont, near Dieppe.

We meet the three daughters again, at a slightly older age, in a monumental composition, very different from the *Croquis*. Everything in this work is bathed in light so that there are no shadows, the tones are raised to the very peak of intensity, and

there are no chiaroscuros. Forms stand out and are outlined, even the dolls faces are stylized, almost hieratic.

How different from *Madame Georges Charpentier* et *ses enfants*, of 1878, in which colour contrasts play between dark and light tones. Here the dominating contrasts are those between colours bathed in the same light.

La natte of 1886, said to show Suzanne Valadon - a painter herself who served as a model for many painters, and mother of Maurice Utrillo - could easily have been by Ingres.

In *La bergère, la vache et le brebis* of 1887, the silhouettes are somehow outlined against a landscape that is itself curiously Impressionist in workmanship. We find the same contrast in *La jeune fille au cygne* (1886), with a flat, stylized face in a swirling harmony of white, yellow and ochre.

The birth of his first son

"I had taken on," said Renoir, *"a big painting of women swimming, that I was to sweat over for three years."*

While the *Grandes Baigneuses*, the major work of a period that came to an end in 1887, gradually took on form, an event in his private life completely changed Renoir's life: the birth of his first son, Pierre, on March 21, 1885.

Paternity threw him into a whole series of studies, drawings and canvases on the theme of maternity. Jean Renoir, his second son, born in 1894, said of his father: *"More crucial than any theory was, in my opinion, Renoir's transition from bachelorhood to the married state (...) The arrival of my brother Pierre must have represented the great revolution in Renoir's life. All the theories of the Nouvelles Athènes (café) were swept away by a simple dimple on the joint of a thigh of a newborn baby."*

A red crayon sketch heightened by chalk of 1886 is one of the most beautiful versions of *Maternité*, and must have served as a preparatory study for the oil paintings of that same year.

Another homage by Renoir to the mother of his son is a painting entitled *Aline Charigot (Mme Renoir)*, in which the young woman comes across to us as simple, smiling and happy in a beautiful harmony of yellow and blue.

Renoir kept this portrait until he died, and in 1916, after Aline's death, had two bronzes made: a *Buste de Madame Renoir*, replica of a painting, and a *Maternité*, inspired by the drawings and paintings of the same title that reminded him of happy days. They are still at the Domaine des Collettes at Cagnes, Renoir's last home.

Les Grandes Baigneuses

Just as Renoir left numerous sketches and drawings for his *Maternité*, he also left admirable studies of nudes that served him as preparatory work for *Les Grandes Baigneuses*.

These innumerable studies go to show Renoir's determination and hard work to arrive at exactly the line required. "It would be interesting," wrote Berthe Morisot, "to show the public all these preparatory drawings for a single canvas, since it generally imagines the Impressionists worked with the greatest of ease." This was one of the numerous reproaches made about "Manet's Group."

And Berthe Morisot, enthusiastic about Renoir's trial attempts, added: "I don't see how one can go further in rendering form. Two drawings of nude women going into the sea delight me as much as Ingres'. Renoir told me that he considers the nude to be one of the indispensable forms of art."

One of the most delightful ones is the crayon heightened by pastel entitled *Nu, étude pour les Grandes Baigneuses*, admirable in its purity.

Renoir hoped with this painting to retrieve the public's favour, since it did not much appreciate his new Ingres style. Even his faithful group, such as the art dealer Durand-Ruel, who had just exhibited the French Impressionists in New York, was disappointed. But Renoir kept confident and continued to work feverishly. *"I am going to topple Raphael,"* he joked, which proves just how much importance he attached to his new picture.

Why did Renoir choose such a subject, one might well ask?

He was undoubtedly inspired by a bas-relief of the end of the seventeenth century by François Giraudon, *Le bain des nymphes*, which is set in the park at Versailles. He wanted, additionally, to pay homage to the Ancients, and he had been marked by Ingres, drawing like him bodies whose silhouettes stand out, as we have seen in other works of that period. The paint is laid on by means of a knife, and smoothened out, without any thickening, using a very reduced palette of colours, thus giving the painting the decorative feel of a warm and sensual fresco.

It is worth noting, too, that when exhibiting his painting, Renoir subtitled it *Essai de peinture décorative*.

Renoir had traveled far from the girls and boatmen of La Grenouillère.

True, the décor and the background treatment still receive the same Impressionist touch, but the people have been somehow dehumanized to become nymphs in the way the Greeks portrayed them, with all the charm of their youth and flesh...a flesh that was going to "blossom" and end in the "ample" women of Renoir's last period.

The reaction of his painter friends - apart from Monet who spoke of the *"magnificent painting of the Baigneuses"* - was on the whole negative. Pissarro, who much admired Renoir's art, wrote: "I can fully understand all the effort expended, and it's an excellent thing not just to stand still, but he is solely taken up with line, figures are outlined against each other without any attempt to create harmony between them, so that the end-result doesn't make sense."

Renoir was not understood, or rather his former style was greatly missed, while his new style was felt as something of a betrayal of the Impressionist cause.

Yet critics like Théodore de Wyzewa said of the *Baigneuses* that they remained "the testimony of those years of research and hesitation. I cannot ever forget the supernatural emotion this painting caused me...that delicious mix of vision and dream." And Proust described the painting as one of Elstir's most beautiful - Elstir was the character for whom Renoir served as model in *A la recherche du temps perdu*.

The Judgment of Paris

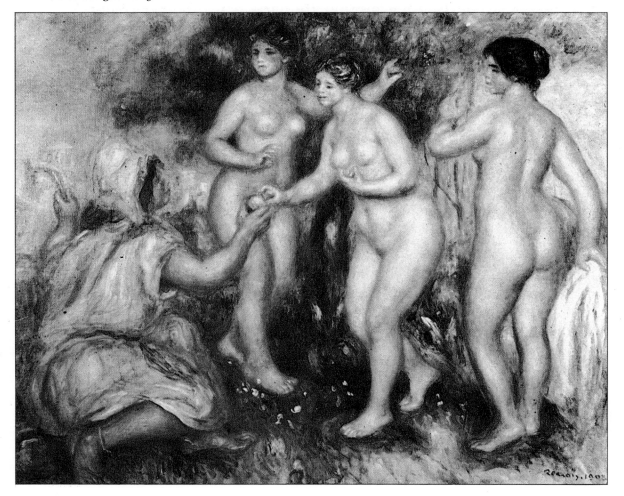

THE BLOSSOMING
OF THE "PEARLY" PERIOD
1889-1900

The Midi

In 1889, after Renoir had had the first attacks of articular rheumatism that were to cause him such suffering and leave him helpless in the last years of his life, he rented a house in Provence, where he joined Cézanne. Side by side, they painted the *Montagne Sainte-Victoire*. Curiously, when depicting nature, Renoir rendered a more Impressionist atmosphere, cheerful, luminous and full of optimism and life.

At the same time, Renoir continued to execute occasional portraits to order, although a number of his patrons had been put off by his new style. *Les filles de Catulle Mendès* (1888) grouped round the piano is considered to be a masterpiece: Renoir had left his linear period behind, but kept the vigor and form of the lines in the faces of his models, while creating around the girls a warm and colourful atmosphere of a somewhat Impressionist inspiration.

Predominanace of light and form

If he moved away from his "bitter" or "Ingres" period around the years 1888-89, Renoir did not, nevertheless, simply return to Impressionism. He continued to search, as he had always done and would do right to the end of his life. He never considered he had "made it" even when he was showered with honours at the end of his life. He worked away relentlessly at his job of painting, but allowed himself more liberty in his workmanship, which became more flexible and fluid.
From his experience as an Impressionist, he kept the fresh and lively tones of his colours and an unrivalled lightness of touch. From his Ingres experience, he drew a passion for form and contour. And at this point, Renoir seemed to have solved the problem of a predominance of light or form when linking the two together.

He was now going to dedicate himself almost solely to the painting of female nudes. These were going to gradually take on even greater consistency; he would compare them to ripe fruit. His other models were going to be children, especially his own sons: Jean, the film director was born in 1894, and the last, Claude in 1901.

The paintings of the early 1890s were often transitional works

Renoir at home in Cagnes-sur-Mer

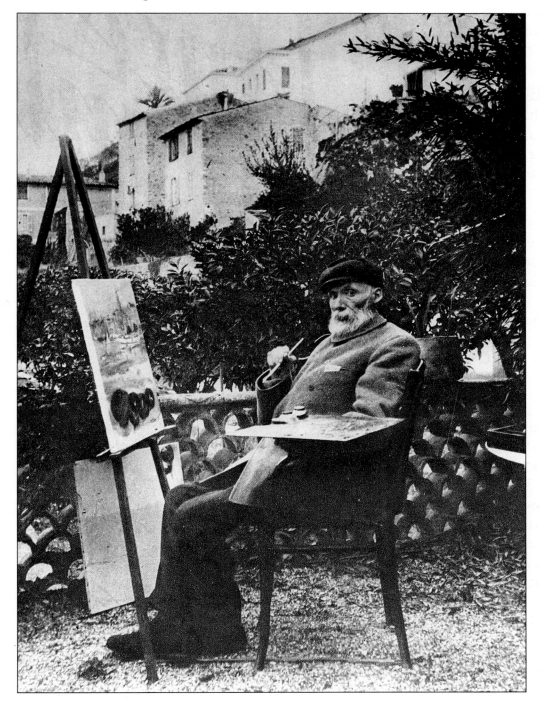

between the dryness that had come before and the full mastery of his later style.

In *Marchand des pommes* (1890), for example, in which Renoir painted his wife with Pierre and his nephew in a lighting that allied shade and sun, the artist did not outline his subjects but modelled and sculpted them with long brushstrokes which "enveloped them in dark or light colours."

In the painting called *Dans la prairie*, or in *La cueillette des fleurs*, both of 1890, both young girls have their hair free that Renoir "ensnares" with long silky brushstrokes just as he emprisons with similar strokes the light dresses or wavy grass in the meadow.

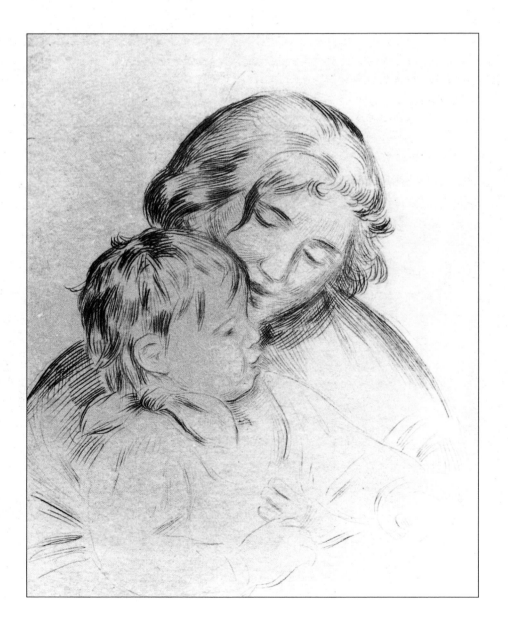

The so-called "pearly" period

This new style of painting became most evident in the way he painted the flesh of his numerous bathers, so that this period is called the "pearly" period of the artist. Renoir worked on refining this technique until about 1900.

We can look at the *Baigneuse assise sur un rocher* (1892), or *Jeune fille attachant ses cheveux* (1892-95), or *Baigneuse aux cheveux longs* (1895), to take just a few examples. Sensual, either gleaming or swathed in a more diffused lighting, these bathers are no longer outlined. Their full forms and hair are given their contours by Renoir's brush, who has them melt imperceptibly into a barely suggested background. All these bathers hover between being modern and being totally atemporal. They are simply young and beautiful; they don't look at us, we cannot even tell whether they are models or nymphs.

At the end of his life he said: *"The simplest subjects are eternal. Whether the nude woman emerges from a rough wave or from her bed, whether she is called Venus or Nini, it doesn't matter. Nothing better will ever be invented."*

What an eternal admirer of women!

A commission from the State

Renoir also chose children and young girls for subjects. He liked to group them in pairs and would paint several treatments of the same theme.

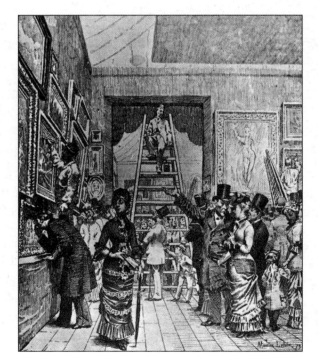

The Salon,
May 11, 1879.

We have already seen *Jeune femme au piano* (1876) at the height of the Impressionist period, and *Les filles de Catulle Mendès* (1888), in which the three young girls pose, since it is a portrait. In *La leçon de piano* (1889), faces are less individualized, because the real subject of the painting is the young girls' concentration on studying their score.

Three years later in 1892, Renoir again took up the theme, framing them more tightly, and undertook a series of pastels and oils entitled *Jeunes filles au piano*.
In this case, in fact, it was a State commission for the Musée du Luxembourg; the poet Mallarmé had organized it. This project caused Renoir a lot of anxiety, which accounts for the multiple variations in existence on this theme.
In 1920, Arsène Alexandre, an art critic and collector, described Renoir's anguish: "I remember the enormous trouble he went to carrying out the official order for a painting that a well-intentioned friend had gone to much trouble to push his way (...) Renoir started his painting five or six times over, it was almost identical each time. Just the idea of a commission was enough to paralyse him, and to send him into a frenzy of self-doubt."

It has often been questioned which version was best; two of them are in Paris, at the Musée d'Orsay and at the Musée de l'Orangerie in the Tuileries Gardens.

Gustave Caillebotte's Collection

In 1894, Gustave Caillebotte died. Caillebotte was an art patron, collector and excellent Impressionist painter - one of his most famous works was *Les raboteurs de parquet* (1875) - he had been Renoir's friend from the beginning. Renoir was named executor of his will.

As executor, Renoir had to fight for three years to get the French State to accept 38 of the 67 paintings of a fabulous collection consisting of Manets, Monets, Pissarros, Sisleys, Cézannes, Degas and Renoirs. This explains how the *Bal du Moulin de la Galette* stayed in France while so many others of Renoir's works and other Impressionist masterpieces found their way abroad. The painter Gérome, famous at the time and a member of the Institut de France, said in an interview: "For the State to have accepted such rubbish implies an advanced state of moral decline..."

In the middle of the arguments this legacy created, Renoir painted the children of Martial Caillebotte, the deceased painter's brother.
Portraits d'enfants (1895) is one of those marvellous paintings that make Renoir so beloved, the type at which he excelled. The work is subtle and delicate, catching the natural, unposed expression of the young children wonderfully, as they are disturbed while reading, and

Caillebotte *Self-Portrait*, 1888

rendering the freshness of their pretty faces.

The little boy on the left, as was the custom of the times, wore his hair long; boys' curly locks were only cut when they were about seven, and they dressed for a long while like girls.

A young peasant girl, Gabrielle

At this period Renoir lived in rue Giraudon, Montmartre, in the Château des Brouillards that housed a motley, eccentric collection of people. In 1894, at the birth of Jean, the Renoir's second son, a young peasant girl from Essoyes came into the picture, a cousin of Madame Renoir called Gabrielle, who was rapidly going to become part of the household and leave her name on many paintings for which Renoir used her as his model: *Gabrielle aux seins nus* (1907), *Gabrielle aux bijoux* (1910),*Gabrielle à la rose* (1911), *Gabrielle en blouse rouge* (1913).
Finally she is often shown with Renoir's children: Gabrielle, Jean et une petite fille (1895). Two other pictures of the same year entitled *Gabrielle et Jean* show her with the future great film director, aged one at the time, in her arms.

She reappears kneeling, and holding on to little Jean, in a big painting at the Barnes Foundation, *La famille Renoir* (1896); here, too, we find Pierre in a sailor's suit, gripping his mother's arm. Renoir continued painting children with the very numerous portraits of Coco, his third son, born on 4 August 1901.

The Chateau des Brouillards in Montmartre where Renoir lived for a time.

The death of Berthe Morisot

Early in 1895, Renoir was in the Midi, working with Cézanne in the open air. It was here that he learned of the death of Berthe Morisot, whom he had greatly admired as a painter; they had been friends for many years.

She came from a rich, bourgeois family; Fantin-Latour and Corot had been her masters, and she had married Manet's brother. She had always fought beside the Impressionists and exhibited her paintings with them from their first exhibition in 1874. Her death was a great shock to Renoir.

It was through her that Renoir had got to know Ambroise Vollard, a young art dealer. As soon as his gallery opened in rue Lafitte, he had immediately bought Renoirs paintings. He, Durand-Ruel and Bernheim-Jeune, were the three main art dealers to whom Renoir sold his works.

Renoir painted a portrait of Vollard in 1908, in which he depicts him as the archetype of an art-lover, holding a Maillol statuette. Many of the large nudes in Renoir's last period were done for Vollard.

It was not until 1910 that he painted a portrait of Durand-Ruel, then aged 80, although he had painted his children Charles et Georges Durand-Ruel in 1882. Paul Durand-Ruel had been interested in the Impressionist group from 1870, and had never ceased to help them and to promote them in France, as well as abroad. But his preference had always been for Renoir; a lifetime's friendship linked the two men.

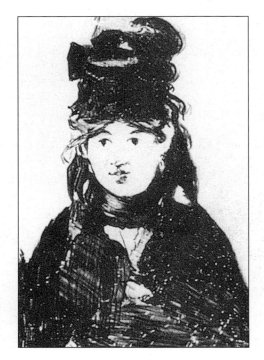

Edouard Manet
Berthe Morisot
Private collection

THE PATRIARCH
IN PARADISE REGAINED
1900-1919

In the plenitude of his art

Renoir had reached the peak of his career and was famous in France and abroad, where numerous sales and exhibitions of Impresssionists were organized. It was at this time, incidentally, that fake Renoirs started to appear.

The autumn Salon in 1904 gave over a whole room to him, and he was soon to become its honorary president. He was made a Chevalier of the Légion d'honneur in 1900, and an officier in 1912. Curiously enough, it was not the Ministry of Arts that awarded him this decoration, but the Ministry of Trade, on the occasion of an industrial exhibition in South America. In academic circles, the Impressionists were still anathema!

Renoir's studio
in Cagnes

No longer in financial need, but suffering greatly and more and more handicapped by his crises of crippling rheumatism, Renoir never, however, stopped working. In fact, he had never been much interested in honours or money; his only real motivation being what he called "the exquisite ecstasy of painting."

He could now afford a house at Essoyes in the département of Aube, his wife's home village, and made frequent stays in the Midi where he decided to spend the winters; he finally was to retire there. He first stayed at Magagnosc and at Le Cannet, before settling into a spacious apartment with his whole family in the Maison de la Poste at Cagnes. Today this house is the town hall.

Henceforth, in full possession of the techniques of his art, despite his suffering, Renoir could spend the last years of his life painting every day what he liked and those that he loved: his family, nature and female nudes. The apotheosis and blossoming of this last period, called "Cagnes" or "classical", might best be thought of as "Mediterranean classicism."

His first great subject: the family

His wife, his three sons and Gabrielle the servant and model, made up the family group around Renoir; we could also add the mass of friends that often came to see him at Les Collettes.

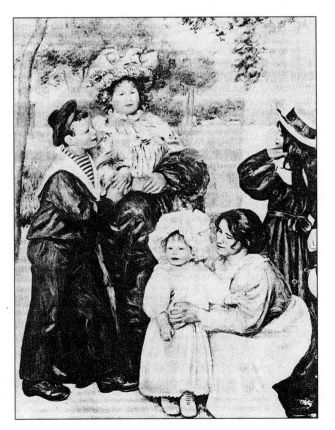

The Artist's Family,
1896

His wife had gotten fatter and grown older. She was no longer the Aline of so many paintings. She had aged and become diabetic, but kept up the house with the same good humour, and looked after her children and Renoir, who became more and more dependent on her.

He did one last a painting of her in 1910, called *Madame Renoir avec Bob*, five years before she died. Renoir kept it beside him to the end. She posed there with her little dog on her knees, staring straight at us with those beautiful melancholy eyes of hers. Here is that same look we saw in *Le déjeuner des canotiers* of 1881 in which she figured in the foreground, playfully amusing herself with a little dog, and again in *Aline Charigot*, her radiant portrait of 1885.

We have already met Gabrielle in the many paintings in which she had appeared since 1894. She didn't leave the Renoir family until 1914, just before marrying the American painter Conrad Slade. We often meet her in the role of nanny to the Renoir children. Renoir also constantly painted and sketched his son Claude, nicknamed Coco; he can be seen in a 1903 pencil drawing, *Claude et Renée*, and in a small oil dating from the same year, *Two heads of Coco*. In a 1905 red chalk sketch he is shown playing with his toy soldiers, *Claude Renoir jouant*, and in 1909 he is dressed in costume, in *Le Clown*, one of the most famous paintings in the Musée de l'Orangerie in Paris.

It must have been a great joy for the nearly helpless Renoir to follow the smile or the games of this marvellous little being with chubby cheeks, still free as the air and bouncing with life, who was his son.

His second big subject: nature at Cagnes

From trips there and stays with Cézanne, Renoir had long been under the charm of the Mediterranean light, and now he could paint it from his window or garden.

La villa de la poste à Cagnes (1903), *Terrasse à Cagnes, Cros-de-Cagnes, Maisons à Cagnes* (1905), *Les vignes à Cagnes* (1908), are evidence of his love for this village and its surroundings. Renoir simplified his palette, and his paintings exploded in oranges, yellows and reds, those intense colours of the Midi. The warm tones already give a hint of the bathers and nudes that were to blossom in the works of the last 10 years of his life.

In 1907, he bought the house at Les Collettes, covering three hectares of old olive trees, orange trees and rose bushes on the edge of a hill. In this paradise, Renoir had a big villa built, where he could receive his friends, with two studios plus one other, entirely glassed in, outside. He often had himself carried in a stretcher-chair outside, and painted there amid the old twisted olive trees. Works from this period include *Le jardin des Collettes*, (1909) and *La ferme des Collettes* (1915), depicting the former house that went with the property.

Renoir in Cannet, 1901

Claude Renoir later recounted that his father had to fight to keep the whole place's character. He wanted neither palm trees, nor flower beds, nor well-mown lawns, and he stopped the gardeners from pulling up the weeds that grew along the paths.

Like Monet, Renoir wanted to be surrounded by the kind of nature that corresponded to his own pictorial vision. Monet had chosen the pond and refined garden at Giverny (in Normandy), Renoir at Les Collettes had preserved an ancient world where olive trees provided a backdrop for nude nymphs that came down from the Olympus for the greater joy of mankind. Giverny and Les Collettes have managed to preserve the presence of the two great Impressionists who dwelt there, and the two have today become museums.

Renoir's health did not improve, nor did his suffering lessen, but he kept his good humour and thought of nothing but painting. "Renoir is in the same sad state," wrote Durand-Ruel, "but he does have an astonishing character. He can neither walk nor even get up out of his chair. He has to be carried everywhere by two people, What agony! And yet, he's still just as happy as before when he can paint." Renoir painted himself in several small-size portraits, as in *Autoportrait au chapeau blanc* (1910), and we have many photos of him in which we can't help being impressed, behind the face contorted by pain, by the depth and nobility of the man they called the patriarch of Les Collettes.

His third great subject: nudes

Ever since he had begun to paint, Renoir had treated women with the same passion. *"My great aim has always been to paint people like beautiful fruit."* But as a conclusion to an evolution expressed through his different "periods", he finally reached in the last years of his life a kind of plenitude and opulence: his "flower-girls" became his "fruit-women." They remind us of the classicism of a Titian or a Rubens, whom he considered, along with Veronese, his great masters. At the same time, his nudes have lost their human characteristics and blossomed out to become sort of eternal mythological archetypes of the sun-drenched girls of the Mediterranean: *"It is as though in this blessed country misfortune can never touch you."*

The colours of his palette were gradually reduced to the warm tones of flesh in a set of reds that use the possibilities of oil paints to the utmost; *"I like an oily, greasy, smooth painting wherever possible,"* he said…"I love stroking the painting, passing my hand over it." And then, too: "As I look at a nude body, there is a myriad of infinitely small nuances. I have to find those that will make the flesh come alive and breathe on my canvas."

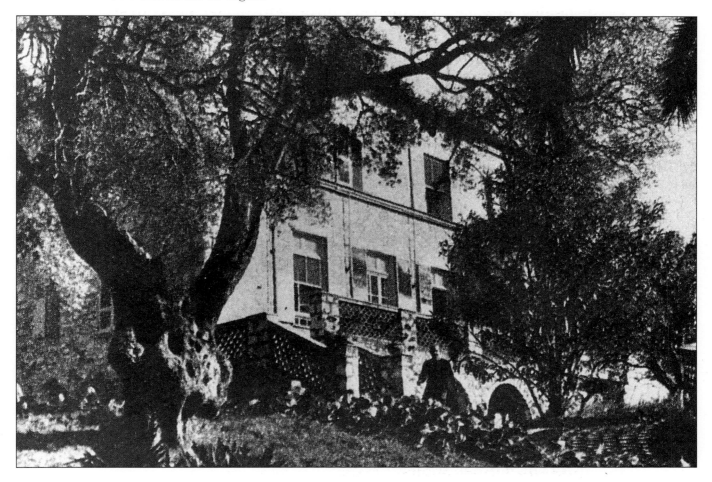

Before talking about one of the last masterpieces, *Les Baigneuses* (c. 1918-19), often considered Renoir's artistic testament, let us look at some of the nudes that, scattered all through this period, lit up the vision of a man often ravaged with pain.

The Baigneuses

There are several versions of a *Baigneuse* in existence (1903 and 1905), nude and seated in the same position with clothes and a hat lying at her feet. Renoir later abandoned all these accessories to concentrate on his model. She fills up virtually the whole painting with her full, buxom form in the *Baigneuse assise s'essuyant la jambe* (1910), reminiscent of a Titian or a Rubens. At this point in time, Renoir went to Munich to admire the Rubens, about which he said: *"Here we have the most radiant plenitude, the most beautiful colour, and all this with very thin paint."*

We find the same textures in his *Baigneuse* of 1913, in which the different tones of flesh are given life and consistency by delicate variations in colours. The plenitude of form is obtained by layers of

very thin paint, such as he had seen in Rubens' paintings.

Occasionally, Renoir elongated his models to make big nudes of them, lying on cushions, or paired them as he did in a very pretty small painting, almost a sketch, called *Femmes nues dans un paysage* of 1910, bathed in Mediterranean light. Sometimes he included companions for these nymphs at the back of the painting, such as in *Ode aux fleurs* (1903-09) or in the *Baigneuse assise* (1914), mid-way between models and groups of bathers.

In the latter, the paint is particularly thin, letting the grain of the canvas appear on occasion; we are even justified in wondering whether Renoir did not rub off his paint or whether the overly thin layer was partially absorbed by the canvas.

Whatever the case, the painting of the different tones of flesh is warm, glistening and luminous, suggesting the models posed outside in the sun, while Renoir himself worked inside, in his glass-walled studio.

In 1928, Albert André evoked the painter's enthusiasm: "Just look at the light on the olive trees (...) it gleams like a diamond (...) it's enough to drive you mad (...) Ah! that nipple, is it hard enough? Is it gentle yet heavy enough? The pretty fold just underneath with that golden tone (...) It's worth getting down on one's knees for. In the last resort, if there hadn't been nipples, I don't think I would ever have painted figures."

In the background of these paintings, as in the background of the famous *Baigneuses* that we will speak of later, the small figures are treated with a great liberty of brushstroke, reminding us a lot of the numerous sketches Renoir made when preparing his big works. This process allowed him leeway in experimenting with his paints to render even better the crimson of the skin of his models without risking ruining a great painting.

It was for this same reason that he continued to paint flowers, especially roses, because of their affinity with the tones of a woman's body. *"It rests my brain,"* he used to say, *"to paint flowers. I don't have to concentrate so intensly as when I am faced by a model. When I paint flowers, I place new tones, I try out new values boldly, unafraid of ruining a canvas. I wouldn't dare to do it with a figure, I'd be too afraid of spoiling the whole thing. And I use the experience I get out of these trials for my paintings."*

If Renoir made numerous portraits of men, in particular of all those that helped him in his early days, and of those that later became his friends, he practically never painted male nudes. When the German industrialist Thurneyssen ordered some pictures after one of Renoir's last trips to Munich in 1910, he painted his son Alxexandre Thurneyssen en jeune pâtre with the same contours as in his feminine nudes, and when he undertook *Le jugement de Pâris*, he finally chose

Renoir's studio in Cagnes, 1917

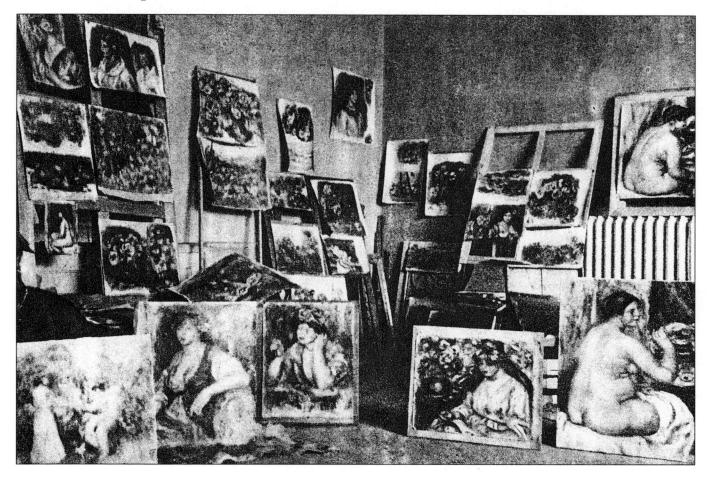

Gabrielle to pose as Paris with a phrygian bonnet. She also appears as the goddess on the right.

There are two versions of this painting, one of 1908 and the other of 1914, in which a little temple appears with a massive Mercury that more or less successfully fills in the empty space Renoir could not bear; he framed his subjects in a tighter and tighter way, the models took up the whole available space. He would add, if he felt like it, a few small figures in the background, and above all he tried to create a continuity between the nudes and the décors.

Ultimate vision of beauty

With the *Baigneuses* of 1918-19, Renoir reached an ultimate vision of eternal beauty.

This was a repetition of his *Grandes Baigneuses* of 1887, which he had worked on for three years. The two paintings are roughly of the same size, the subject is identical, and in the background some small figures are splashing in the water beyond the monumental foreground.

But the two methods of treating the subject are diametrically opposed, characteristic of these two different periods.

In the painting finished in 1887, during his Ingres period, carefree and cheerful girls splashed around beside the water. He gave most importance to the forms, that are almost drawn in, the matter is dry and smooth.

On the other hand, in the *Grandes Baigneuses*, we have majestic, opulent nudes lounging in the grass. The strokes are fluid, the colours, with pinks and oranges predominating, mould the two women and melt into the background. The way Renoir uses his palette is exceptional: the bodies are constructed of gentle, billowy forms, enlivened by warm strokes and touches of light.

"I see a nude body," he would say, *"and there is a myriad of tiny nuances. I have to find those that will make the flesh quiver and come to life."* And: *"I fight with my figures till they are one with the landscape."*

One of these two women is Dédée, Andrée Hessling, whom Jean Renoir was to marry after his father's death. But Renoir didn't want in the last works to represent one face or another, he transcended the individuality of the models; he no longer painted human beings but a new paradise peopled with nymphs and goddesses, descended from Olympus by the painter's magic - and for our greater pleasure - in the light of ancient Greece.

"What admirable beings, these Greeks," said Renoir, *shortly before his death. "Their existence was so happy that they thought that the Gods, to find their paradise and to love, descended down to earth. Yes, earth was the paradise of the Gods. That is what I want to paint."*

Bust of Renoir by Paulin

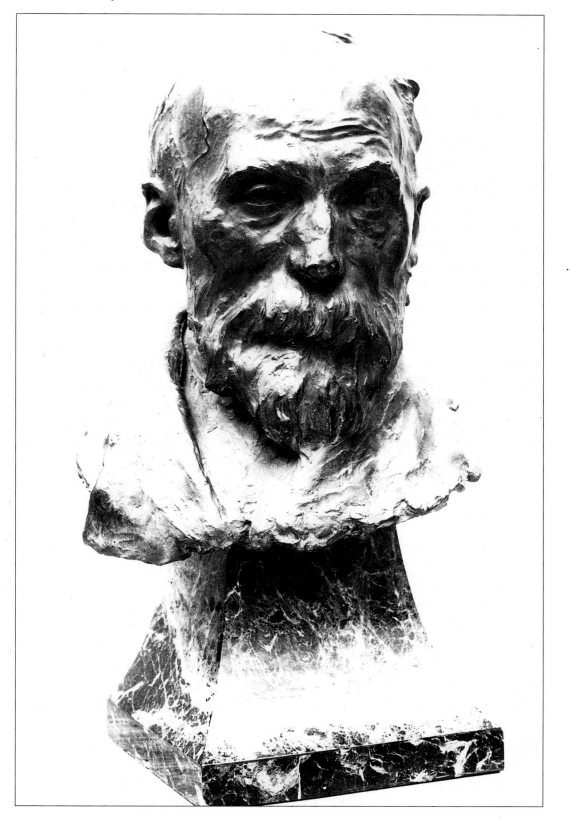

The immortality of bronze

Just as Renoir in his last years had reached in his oil paintings a sort of state of grace in the blossoming of his personal vision, that had become some kind of "paradise of the gods", or rather of the goddesses, he made his first serious experiments at sculpture.

It is perhaps best to consider the conception of volume that he had always tried to convey through all his different "periods" when faced with a choice between form and light. Perhaps his nudes had reached a degree of plasticity that we might call "sculptural," and he wanted to create them in three dimensions. Or was it that, feeling the end near, he wanted to mould in that immortality conferred by bronze some of the passions of his life. This is confirmed by his choice of subjects: goddesses, his wife and children. And curiously, as if to turn his memories into something solid, he took as his models...his own paintings.

But a problem arose, as he lay emprisoned in his wheelchair, his hands deformed and shrivelled by illness: he was unable to mould the materials, and had to call on assistants to do it for him. An Italian, Guino, and a Frenchman, Morel, modelled the clay according to Renoir's instructions, who dictated from his wheelchair what they were to do with the help of a long walking stick: *"It's as though I had a hand at the end of this stick,"* he said. *"To work well, it's not good to be too near. When you have your nose over your clay, how can you possibly see what you are doing?"*

In this way he executed, among other bronzes, *Buste de Claude Renoir* (1908), *Jugement de Pâris* (1914), a copy of the painting, *Maternité* (1916), that may be compared with the red chalk sketch and the oil of 1886, a very beautiful *Buste de Madame Renoir* that we mentioned in connection with *Madame Renoir avec Bob* , and *Venus victrix* (1914), a true masterpiece, a symbol of all the bathers and the victorious Venuses of antiquity.

Aline's death

In the meanwhile, the outside world was in a state of chaos. The First World War had come to shatter the calm of the domain of Les Collettes. Claude was still too young, but the other two sons were called up. Pierre was seriously wounded and Madame Renoir left immediately to be by his bedside. Jean in turn was also seriously wounded twice, and his life was in danger; Madame Renoir once again left immediately for Gérardmer. As soon as she knew that her son was out of danger, she came back to be with her husband, but, worn out by worry and exhaustion, Aline died in June 1915.

Renoir was alone, and turned to painting for consolation.

One of the last big paintings was *Le concert*, where his models

were probably the same as those in *Les Baigneuses*: the dark-haired Madeleine Bruno and the red-haired Dédée.

No empty space - one of the notable characteristics of Renoir's style - the composition fills the entire painting, the roses in the vase echo those of the wallpaper and the hair of the two girls: the patches of gold on the small table and the brilliance of the roses echoes those of the headband and the clothing. The dominant colours are a warm orange and brick red.

Georges Rivière, who came to see Renoir, said: "I found him even thinner, though that seemed at first barely possible. His voice was so weak that at moments you could hardly hear what he said. Although he continued to paint every day, work caused him to suffer more and more, and the sessions were interrupted by frequent rest-breaks. He was well aware of his feebleness, and knew the seriousness of his state; but in general he didn't speak about it."

The Pope of painting

Renoir was promoted commandeur of the Legion of Honour in February 1919.

He learned that the 1878 painting of *Madame Georges Charpentier et ses enfants*, which had played the vital role in the launching of his career, was in the place of honour in the Louvre then exhibiting its recent acquisitions, and he decided to go to Paris to see it in the museum again in May 1919.

He arrived at the museum in his wheelchair, and at first the guards hesitated to let him in, but a curator, hearing who the illustrious visitor was, accompanied him throughout his visit and had him transported through the museum like a "Pope of painting."

Renoir stayed a long while contemplating Veronese's *Wedding at Cana* that had inspired earlier *Le déjeuner des canotiers*. He thoroughly enjoyed his visit and confided to Georges Rivière with a smile: *"Huh! If I had gone to the Louvre in my wheelchair 30 years ago, they wouldn't have been long in throwing me out."*

It was the last joy he had.

Back in Cagnes on 30 November, he was still painting and began a little still life. Then the end came. Two doctors from Nice were at his bedside. One of them, having had some luck woodcock shooting told Renoir about it. Delirious, Renoir demanded his palette to paint it.
Jean and Claude were beside him, Pierre was to arrive the next day.
He died at 2:00 on the morning of Wednesday December 3, 1919, at the age of 78.

RENOIR'S PLACE IN ART

As a painter, belonging to the second half of the nineteenth century that saw the birth of Industrial Revolution and its train of social consequences, Renoir refused to highlight its negative aspects, unlike Manet or Degas in art and Zola or Maupassant in literature.

He witnessed the Franco-Prussian War of 1870 and the Great War, but never drew on these dramas, even though they affected him closely.

Some people have said that he was a painter of the eighteenth century, born a century too late. It is true that he felt the grace of that age from early on, and felt at ease with it all his life, and that his art often expressed the refinement and delicacy of a Boucher or a Fragonard.

Others have seen in him a painter continuing in the line of Delacroix or Courbet. He did admire them, but it was Ingres that most influenced him during his period of self-doubt from 1891 on, and it is with Corot that his landscapes are best compared.

Still others have seen in his paintings of the last twenty years of his life a return to the great classics, Rubens and Titian in particular.

How then does he fit into the Impressionist movement, so important in the history of art? There is no question that, in the company of his friend Monet, he painted some of his best-known masterpieces, and these guarantee his position among the masters of this movement?

In fact, if Renoir was subject to various influences in the course of his life, as with every creator, he never attached himself to a style or to a school. Traditionalist or revolutionary, Impressionist or classical, he was always authentically himself, painting each picture the way he felt it, following his instinct and living solely - but to the full - the moment of painting.

"I love paintings that make me want to want to wander round them when it's a landscape, or to pass my hand over a nipple or along a back, if it is a woman's figure."

He never gave in to facility to attain success. When at last his paintings started to be exhibited and sold throughout the world, he began to have doubts about his art, abandoned triumphant Impressionism, and started out again on a new, even more demanding basis. At the height of this Ingres period and of his "hard manner," he continued looking, and finally in the last years, once again changed his style to the mature blossoming of his Mediterranean mythology.

Renoir in 1917

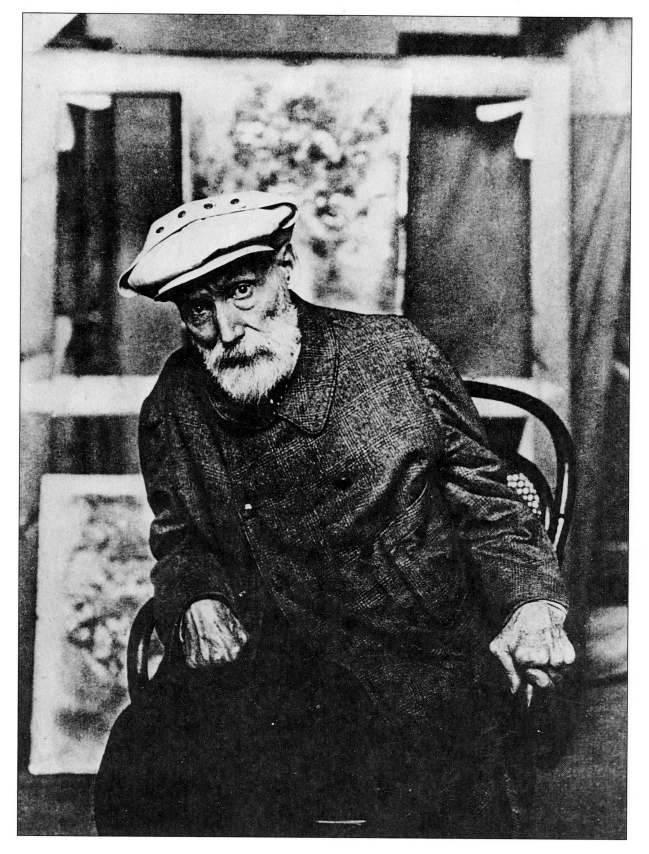

Can we hold it against him - yet some have - not to have influenced the generation to come after him, as Cézanne and Monet did?

And supposing Renoir had been, with his very personal brand of traditionalism, not a precursor but far more an heir to a prestigious past? *"I'm only carrying on,"* he said to us, *"what others have done - and much better - before me."*

This instinctive, natural continuity, this sensual, hedonistic view of the world, served by an exceptional talent as a painter, perhaps explains so many masterpieces.

Let us not therefore try and wrap up Renoir in a formula, because, as he said himself: *"Theories do not make a good painting,"* and later: *"Don't ask me whether painting should be subjective or objective; to tell the truth, I don't care in the least."*

Let us simply not attempt to diminish him with words. They are inadequate to express all the pleasure that Renoir gives us.

What does it matter if his magnificent work has no social message? It is first and foremost a hymn to beauty and to the joy of life, that he was always able to express in a world that was his and his alone, and that cannot be compared to any other.

Renoir was a lover all his life.

A lover of the glimmer of the sun and water at La Grenouillère, of wild, colourful dances at the Moulin de la Galette, of the pearly brilliance of a bouquet of roses or peonies, of paths winding through tall grass in meadows bathed in sunlight, of the gentle softness of childen's faces or the shapely sculptural qualities of womens' bodies.

His human qualities were on a par with his talent.

Modest and simple, even when he became famous, he said:*"Painters always consider themselves extrarordinary people. They imagine that because they put some blue instead of a some black, they are changing the face of the world. As for myself, I have always denied being a revolutionary."*

A relentless worker, he never stopped painting right up to his death; he had always aimed at being a good working painter, which is why he was able to create such a vast and profuse body of painting. He never considered he had "made it" and sought unceasingly the secrets of the great masters. *"The only reward of work,"* he said,*"is the work itself."*

He was as true to himself when he was an apprentice to a porcelain manufacturer as when he was honoured as "the Pope of painting." He was just as at ease with the "girls" in Montmartre as in Madame Charpentier's drawing room. His richness was interior,

and he communicated it through his painting.

An optimist, he only wanted to see the beautiful side of life, and kept this love of life and beauty even when he was in extreme pain from crippling illness. Paralysed in his wheelchair, he painted with the same youthful zeal and with the same joy the most expansive bathers *"like ripe fruit."*

At the end of his life, Renoir said to his son: *"Perhaps I have painted the same three or four paintings all my life!"*

It is true that Renoir's world is a simplified vision of modern society, in particular, the preponderant role that he gave to women. It would in fact be more accurate to speak of "place" rather than role, because we never see his women in action. They are expansive, passive or distant, beautiful objects for us to look at, or for the painter's brush.

The rounded faces of the Venus type such as Aline's or her children's and of most of his models have in a certain way become the signature of his work. Proust said: "Women pass in the street, different from those of former times, because they are Renoirs."

English translation by Giles Allen - The Peney Press

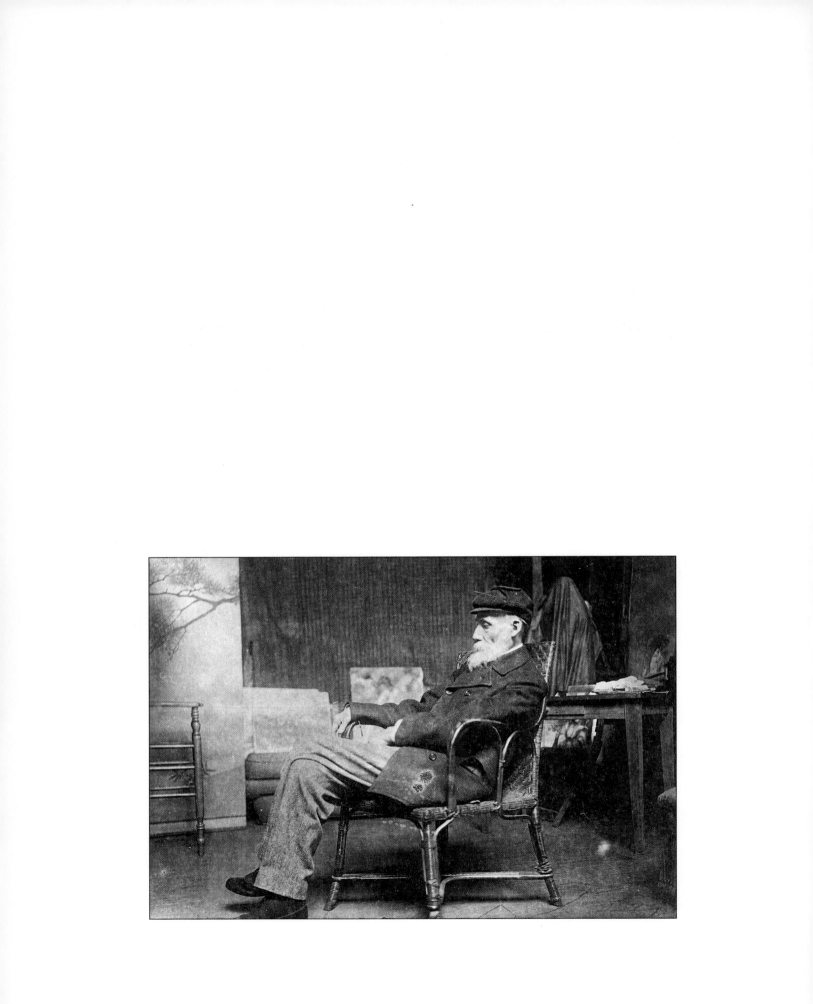

WORKS

Portrait de la mère de Renoir

1860 - oil on canvas - 45 x 38 cm -
Private collection

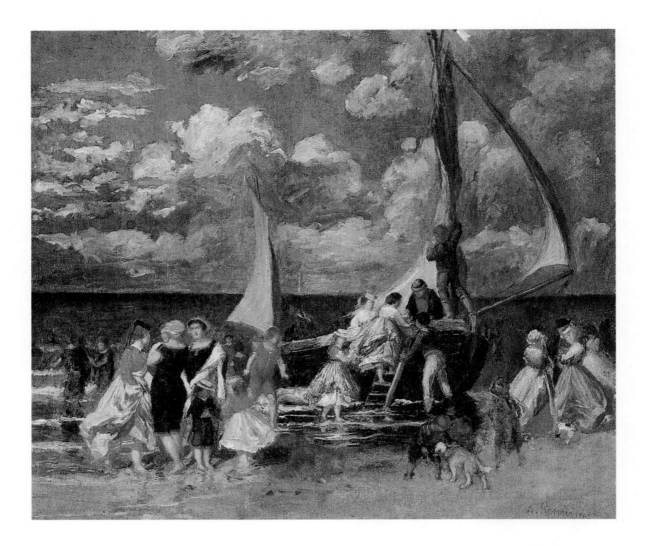

Retour d'une partie de bateau

c. 1862 - oil on canvas - 50.8 x 60.9 cm -
Private collection

Portrait de William Sisley

*1864 - oil on cloth - 81 x 65 cm -
Musée d'Orsay, Paris*

Arums et plantes de serre

1864 - oil on canvas - 130 x 98 cm -
Oskar Reinhart Foundation, Winterthur

Le cabaret de la mère Anthony

1866 - oil on canvas -190 x 130 cm -
Nationalmuseum, Stockholm

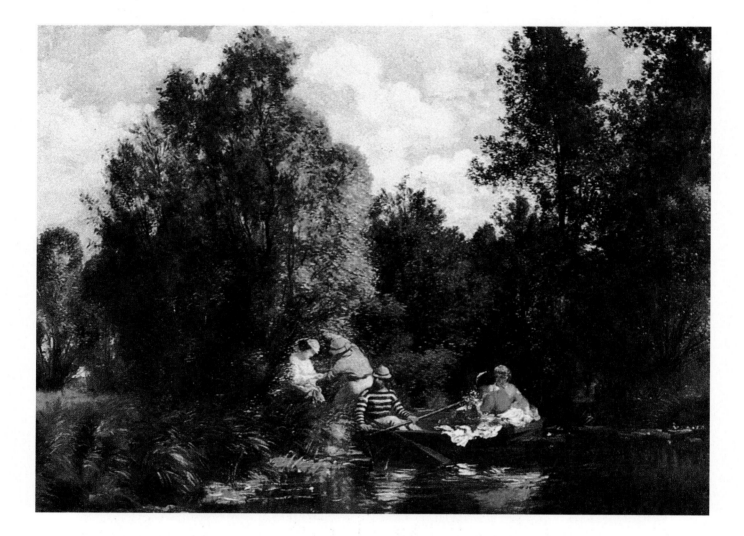

Sortie en canot

1866 - oil on canvas - 67.9 x 90.8 cm -
Private collection

Le bouquet de fleurs

1866 - oil on canvas - 104 x 80.5 cm -
Fogg Art Museum, Cambridge, Massachusetts

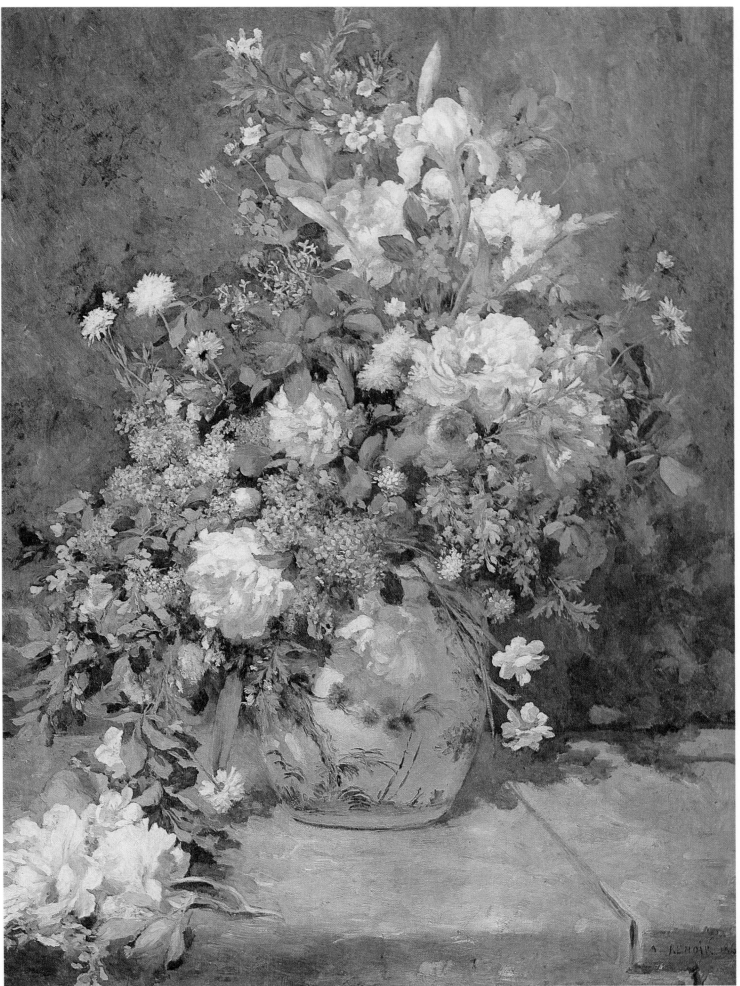

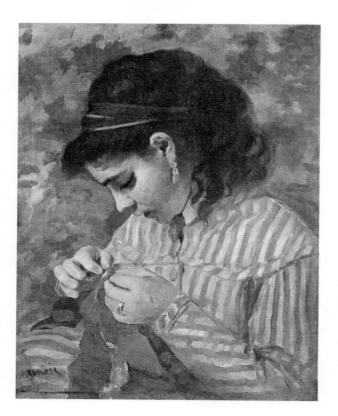

Lise cousant

1866 - oil on canvas - 55 x 45 cm -
Emery Reves Collection

Le baiser volé
1866 - watercolour - 24 x 17.5 cm -
Emery Reves Collection

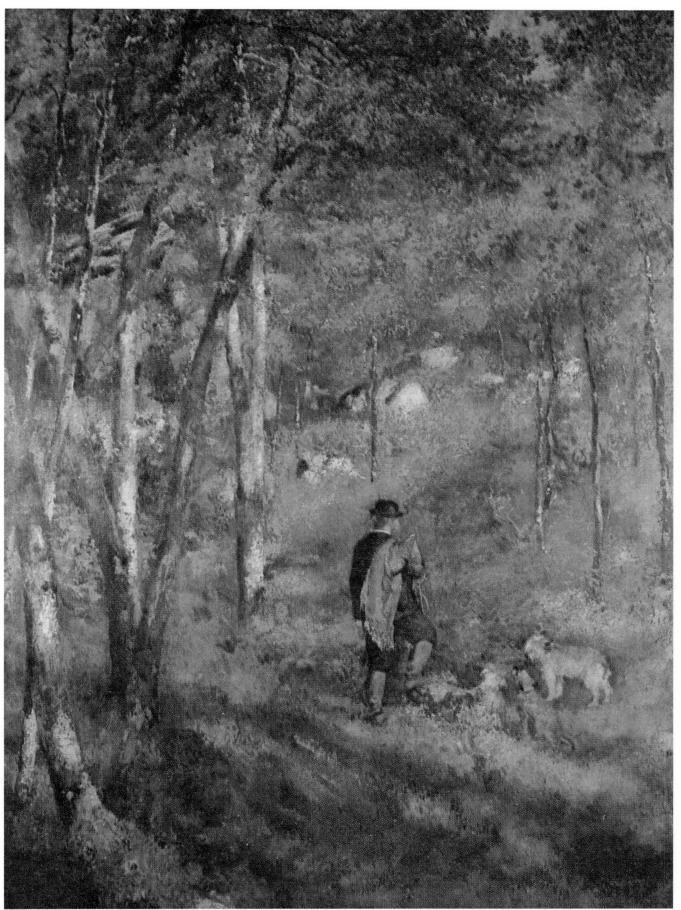

Le peintre Jules Le Coeur dans la forêt
de Fontainebleau F / 14

1866 - oil on canvas - 106 x 80 cm -
Sao Paulo, Museu de Arte

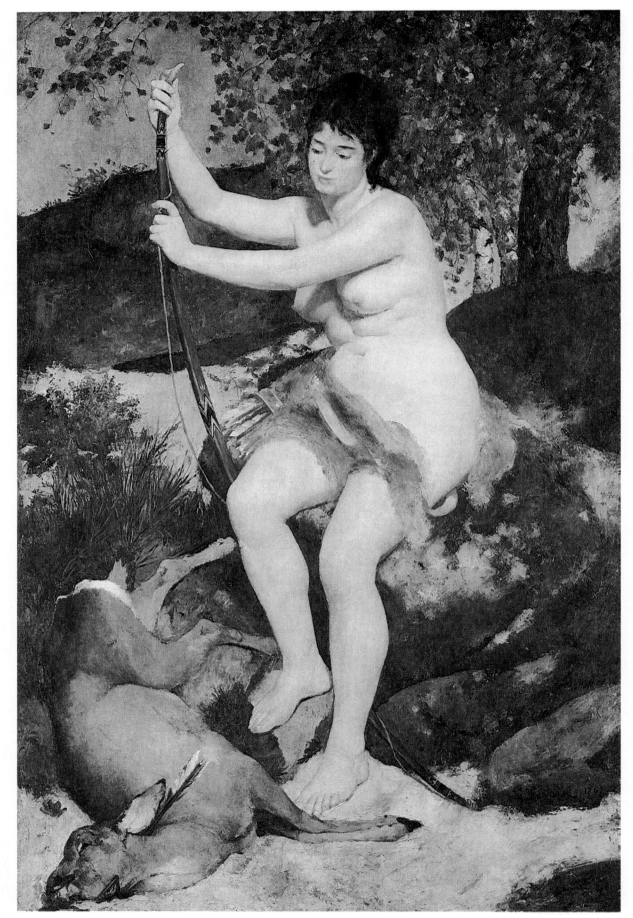

Diane chasseresse

1867 - oil on canvas - 196 x 130 cm -
National Gallery of Art, Washington

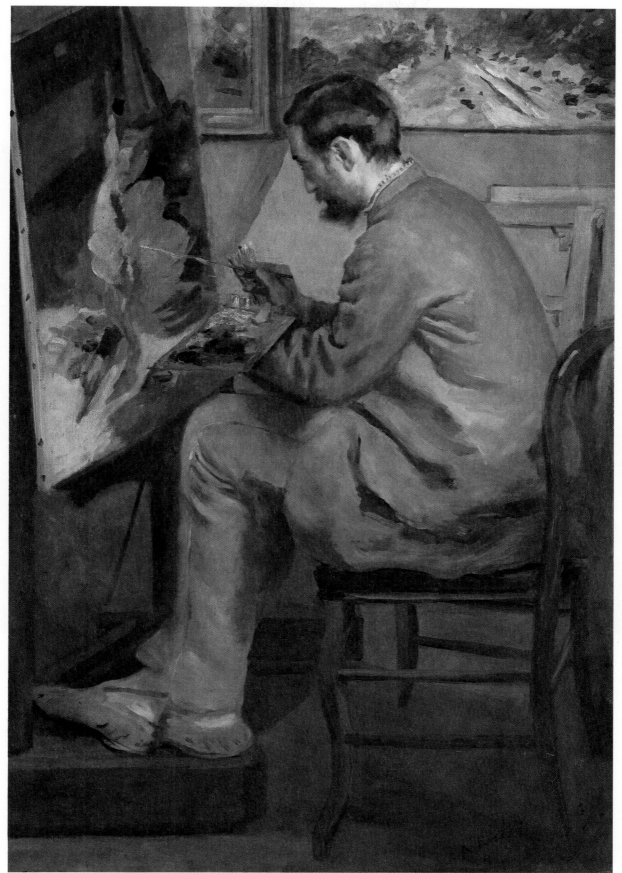

Portrait de Bazille

1867 - oil on canvas - 106 x 74 cm -
Musée d'Orsay, Paris

84

La barque à Chatou

1867 - oil on canvas - 25 x 34 cm
Private collection

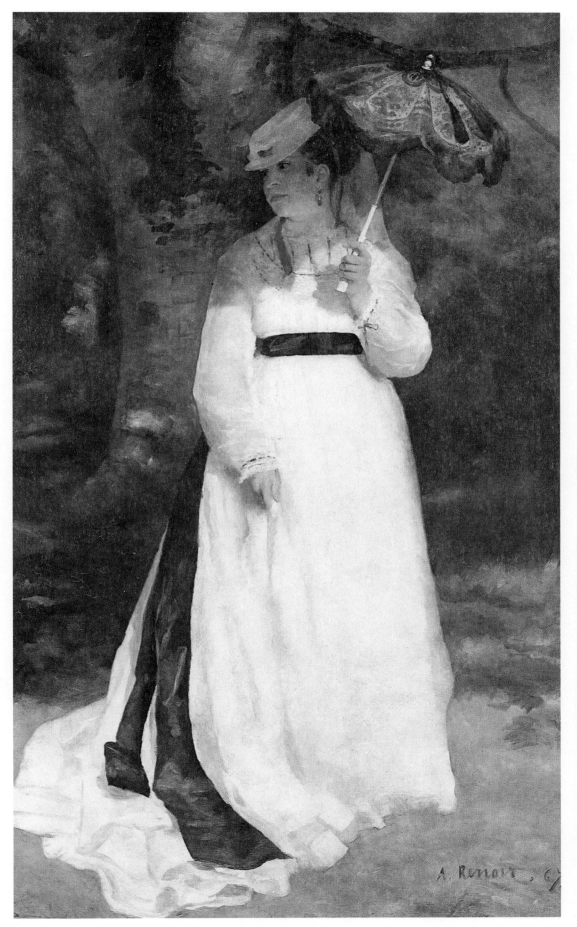

Lise à l'ombrelle

1867 - oil on canvas - 184 x 115 cm -
Folkwang Museum, Essen

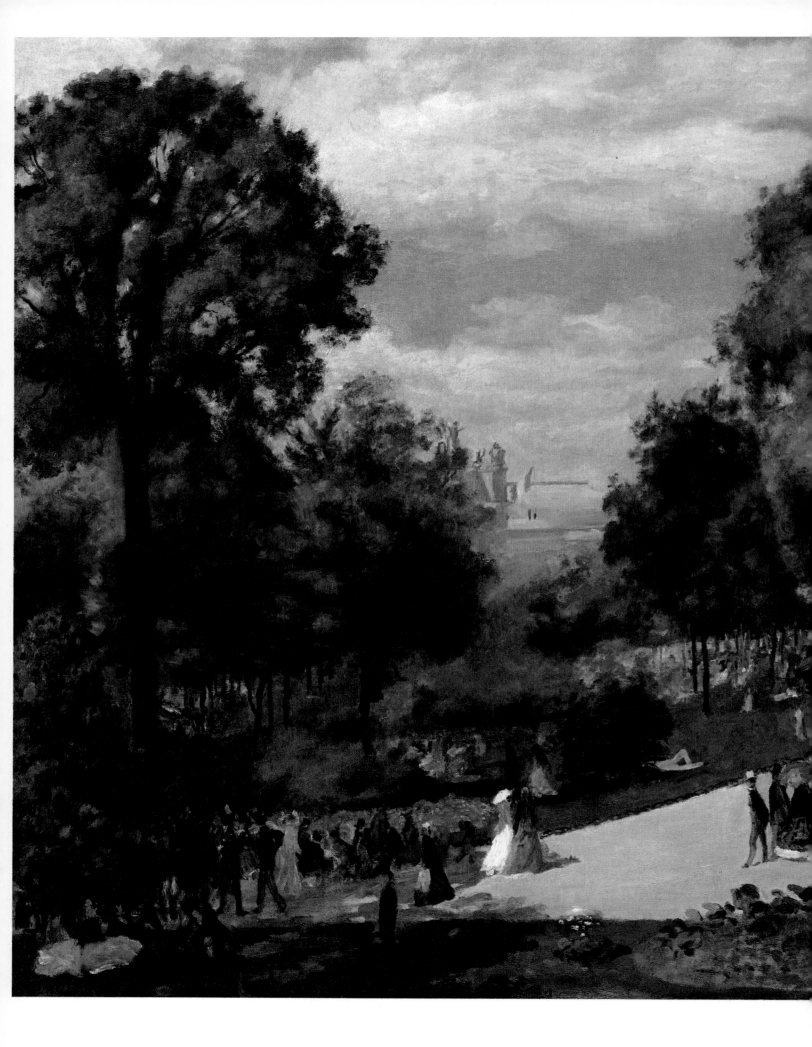

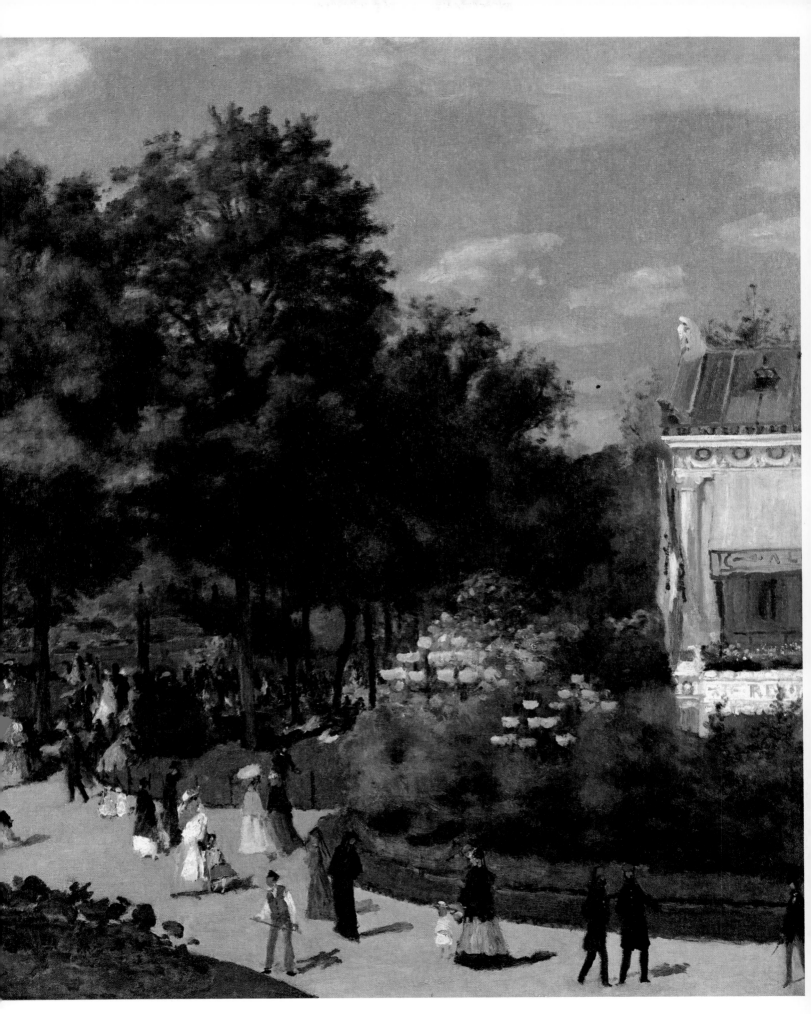

Les Champs-Elysées pendant l'Exposition
universelle de 1867

1867 - oil on canvas - 76.5 x 130 cm -
Private collection

87

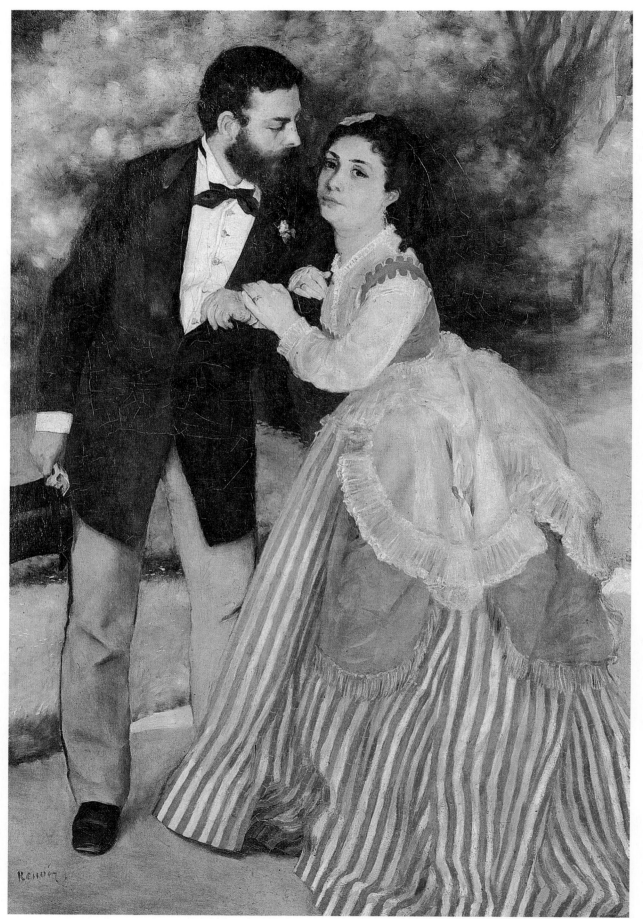

Le couple Sisley

1868 - oil on canvas - 106 x 74 cm -

Wallraf-Richartz Museum, Cologne

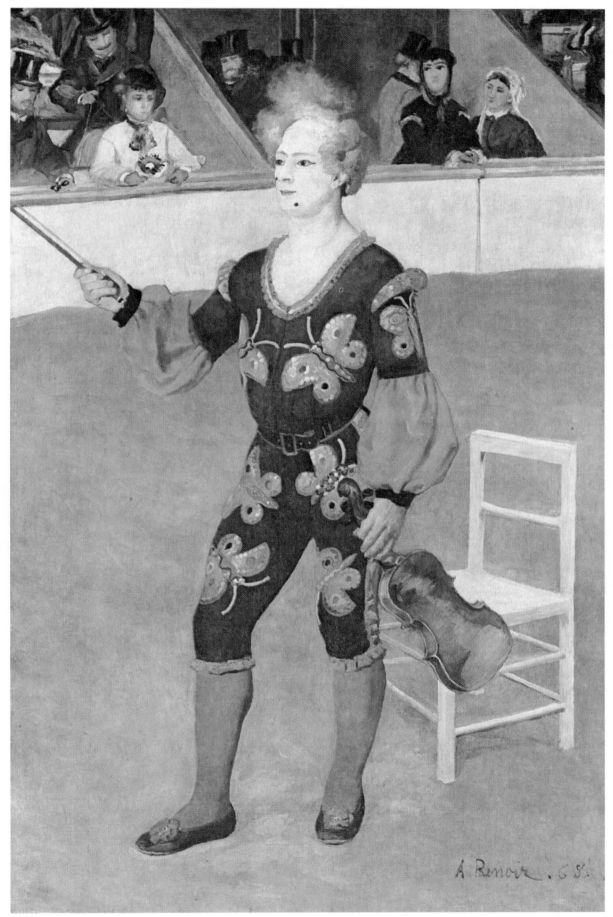

Le clown

*1868 - oil on canvas - 192 x 128 cm -
Rijksmuseum Kröller-Müller, Otterlo*

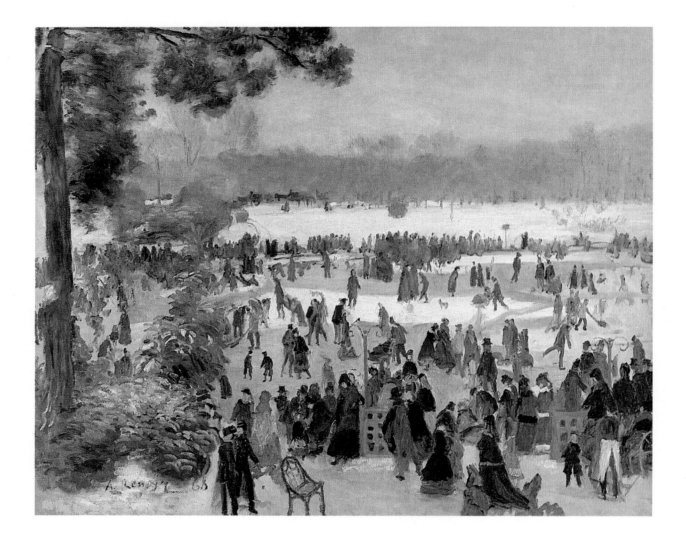

Patineurs au Bois de Boulogne

1868 - oil on canvas - 72 x 90 cm -
Private collection

Le Pont des Arts et l'Institut

c. 1868 - oil on canvas - 62 x 103 cm -
Simon Foundation, Los Angeles

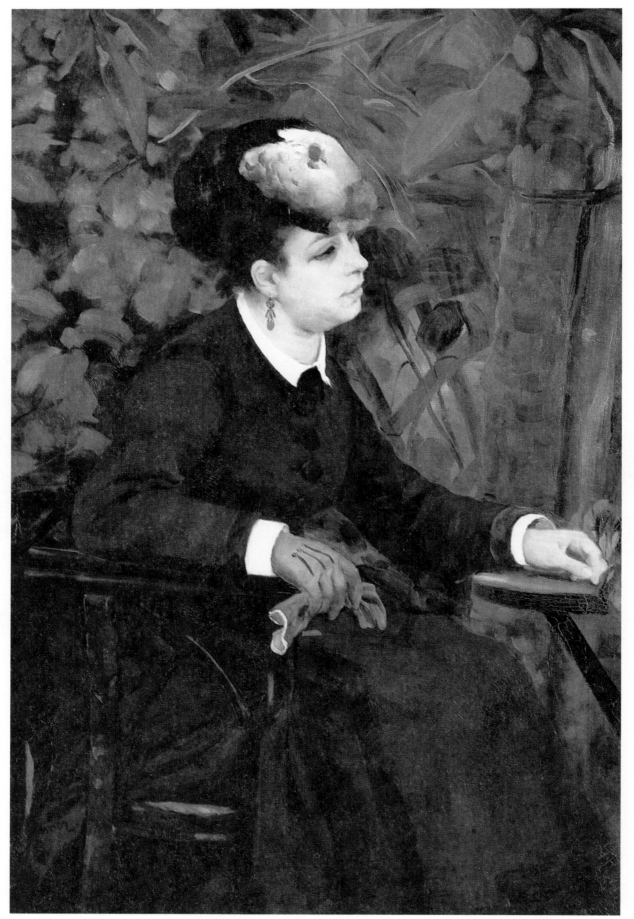

Femme dans un jardin
(also called La femme à la mouette)

c. 1868 - oil on canvas - 106 x 73 cm -
Private collection, held in trust by Kunstmuseum, Basel

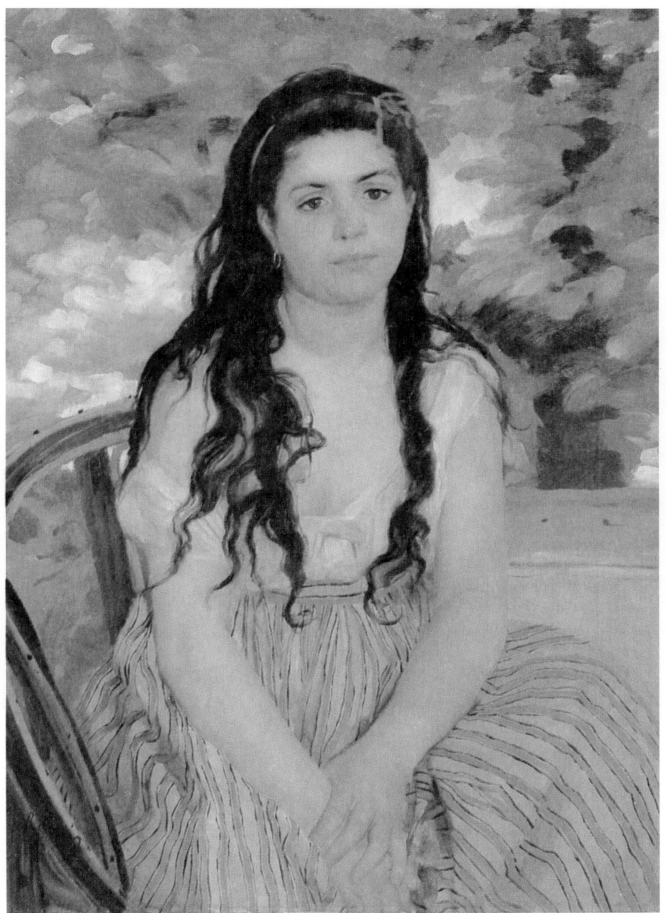

En été (also called Lise ou la bohémienne)

1868 - oil on canvas - 85 x 59 cm -
Nationalgalerie, Berlin

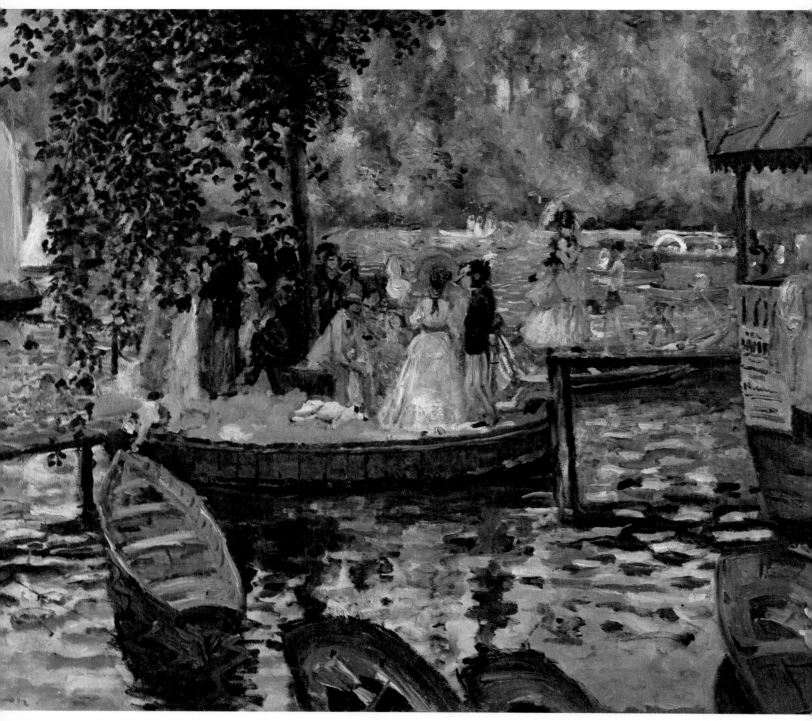

La Grenouillère

*1969 - oil on canvas - 66 x 86 cm -
Nationalmuseum, Stockholm*

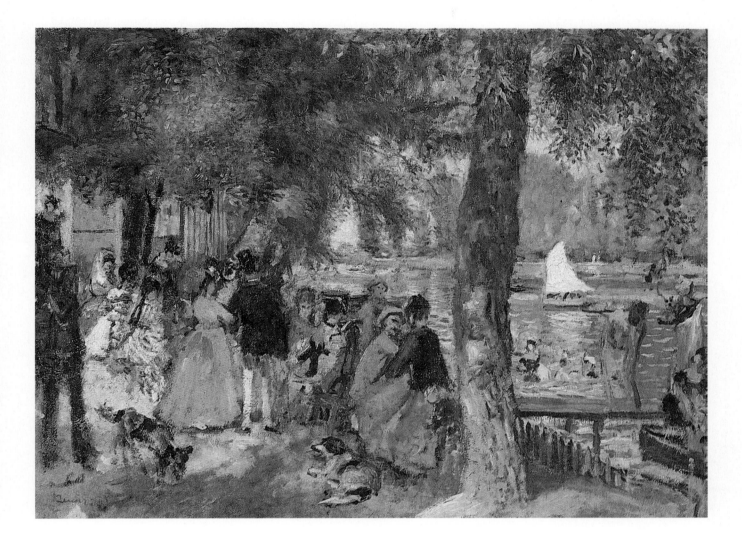

La Grenouillère

1869 - oil on canvas - 58 x 80 cm -
Pushkin Museum, Moscow

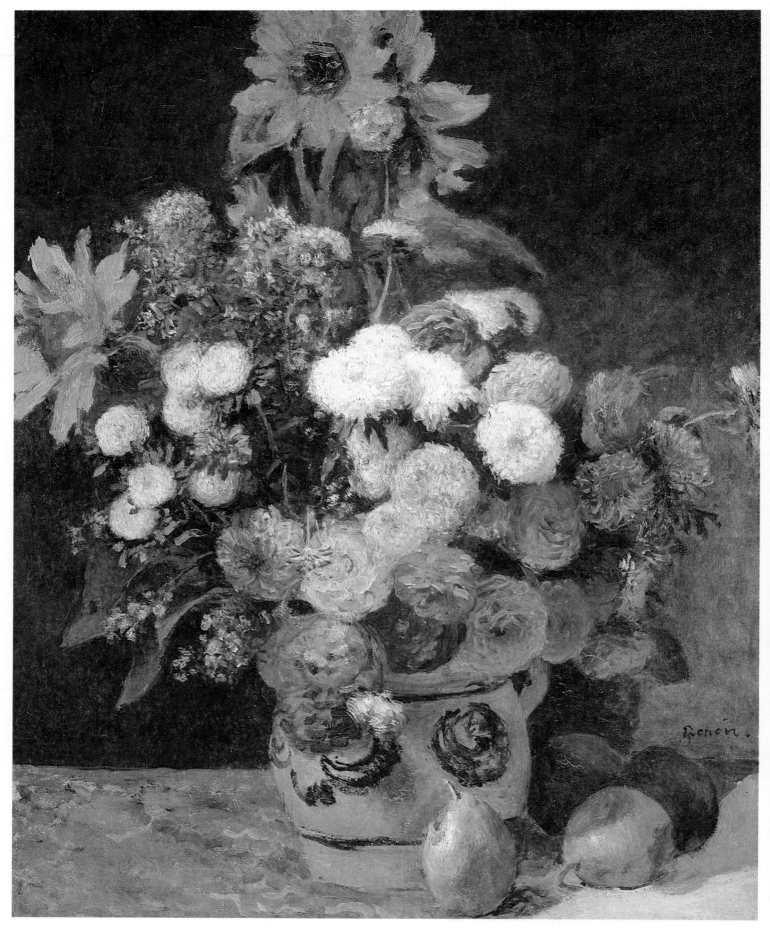

Fleurs dans un vase

c. 1869 - oil on canvas - 65 x 54 cm -
Museum of Fine Arts, Boston

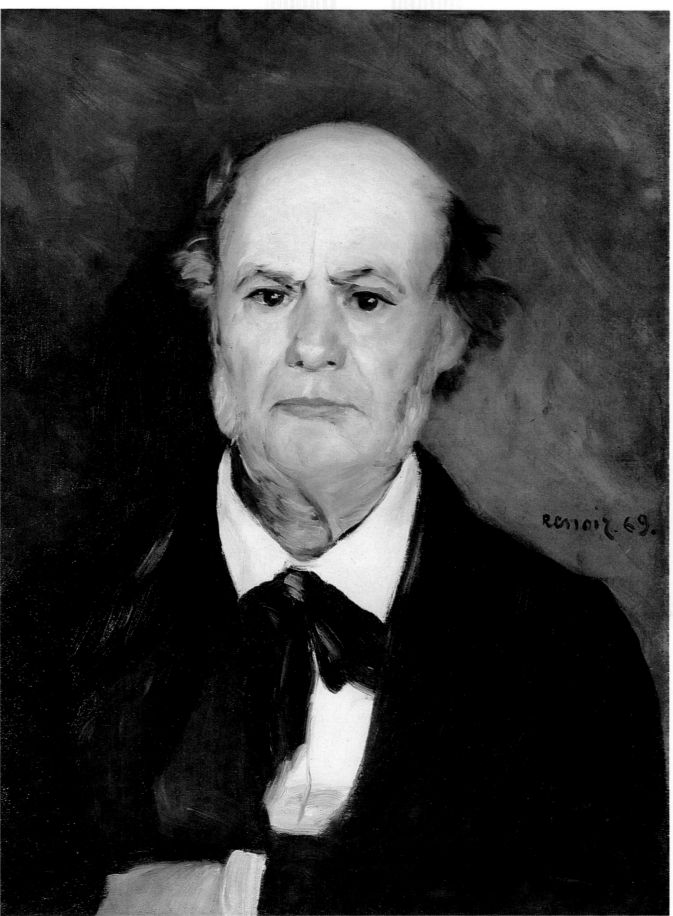

Portrait du père de Renoir

1869 - oil on canvas - 61 x 48 cm -
City Art Museum, St. Louis

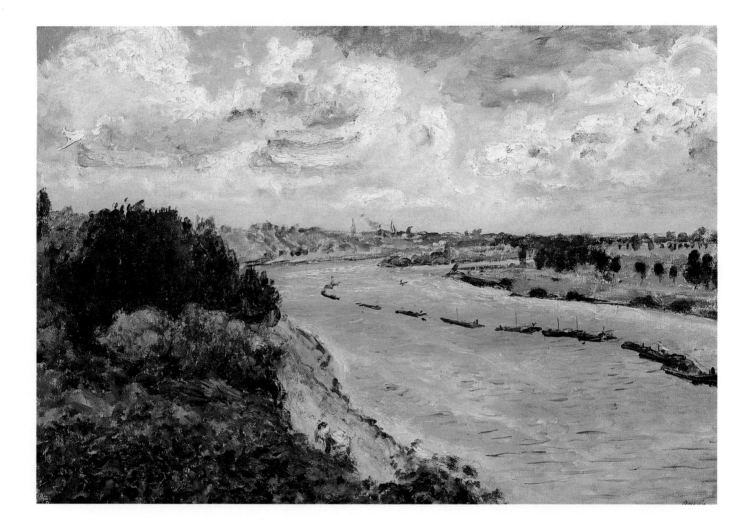

Chalands sur la Seine

1869 - oil on canvas - 46 x 64 cm -
Musée d'Orsay, Paris

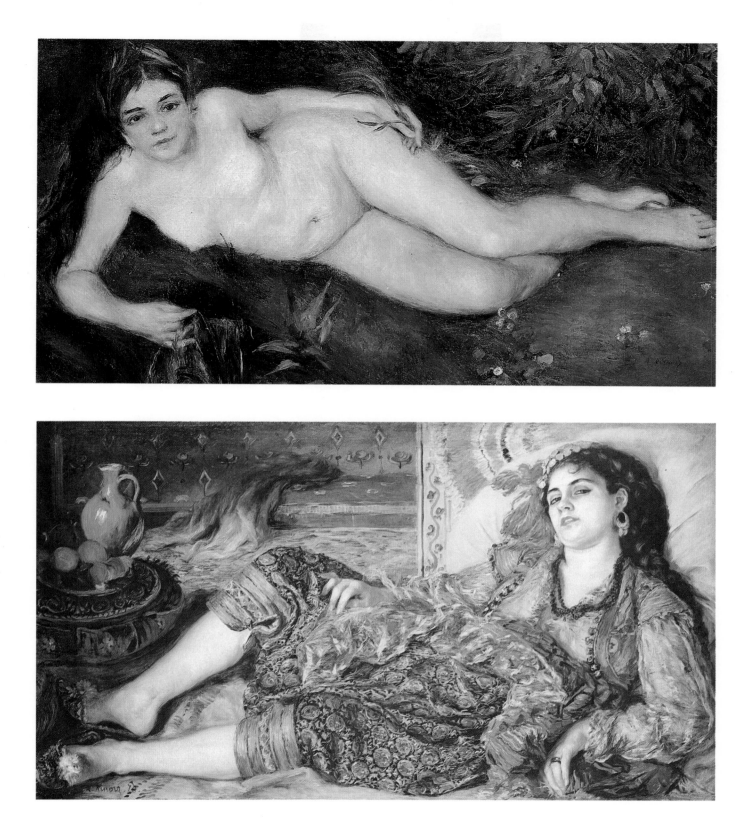

Nymphe à la source

1869 - oil on canvas - 180 x 229 cm -
National Gallery, London

Odalisque ou Une Femme d'Alger

1870 - oil on canvas - 69 x 123 cm -
National Gallery of Art, Chester Dale Collection,
Washington, D.C.

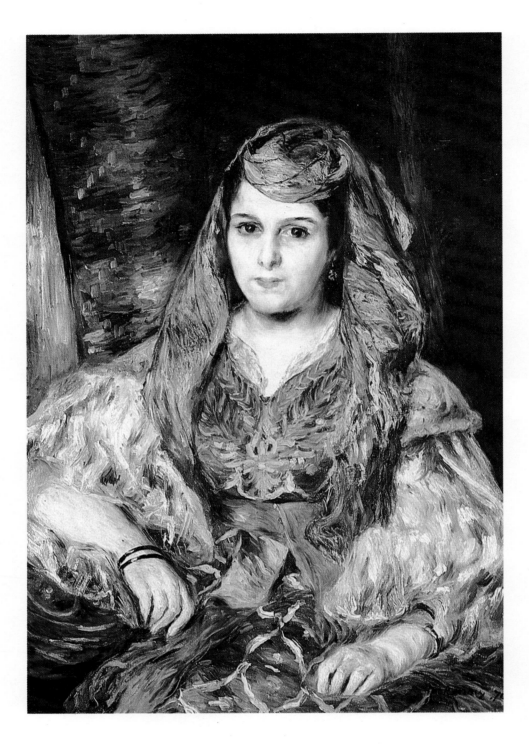

Mme Clémentine Stora en costume algérie
(also called L'Algérienne)

1870 - oil on canvas - 84 x 58 cm -
Fine Arts Museum of San Francisco

La promenade

1870 - oil on canvas - 81 x 65 cm -
The British Rail Pension Fund, London

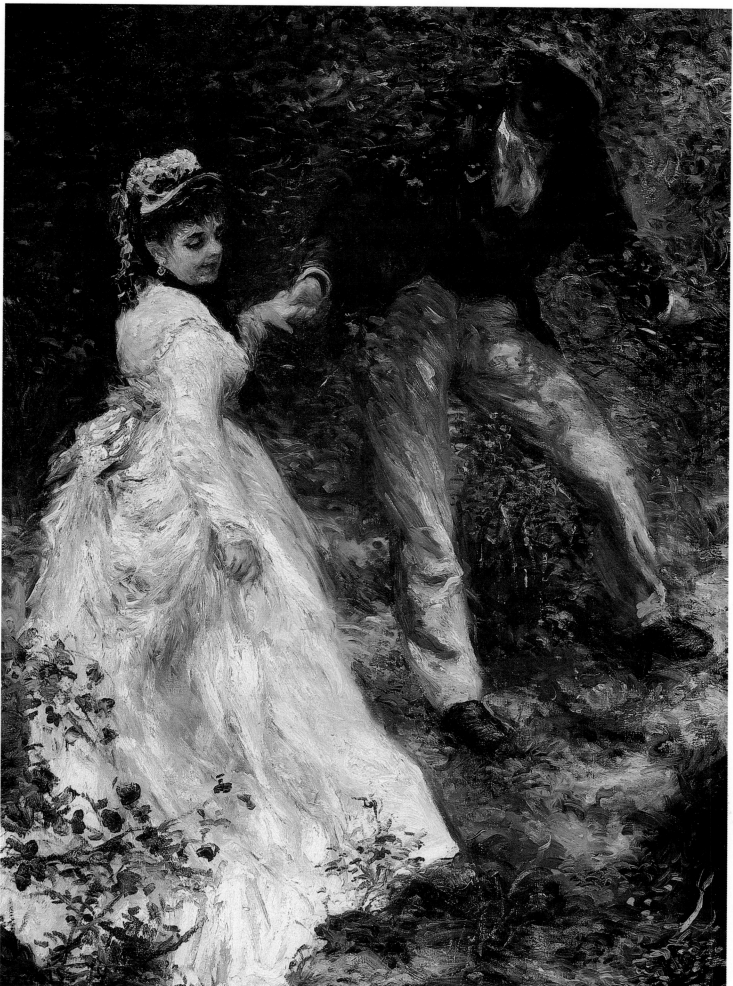

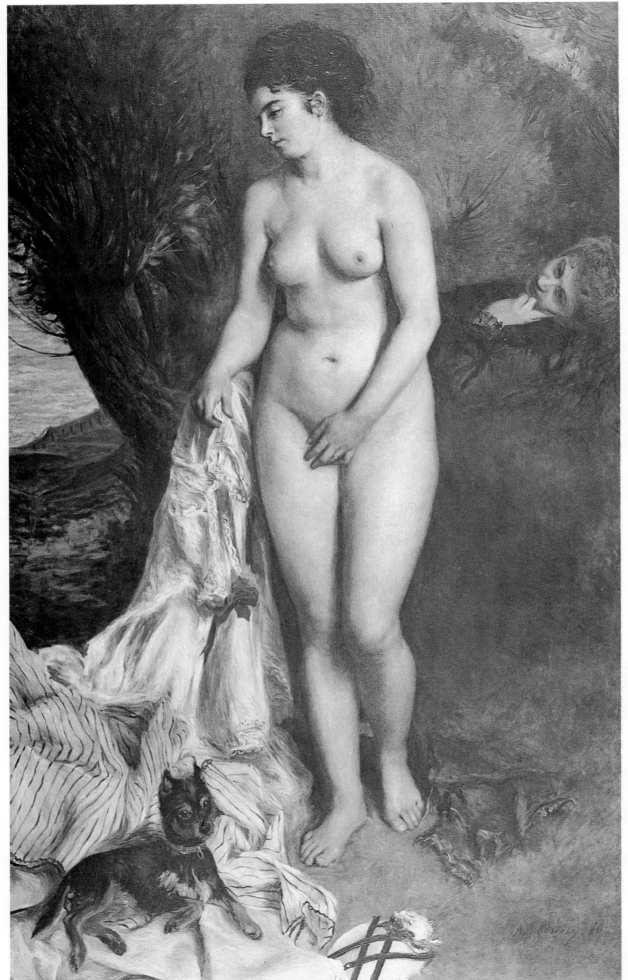

Nature morte au bouquet

1871- oil on canvas - 74 x 59 cm -
Museum of Fine Arts, Houston

La baigneuse au griffon

1870 - oil on canvas - 184 x 115 cm -
Museu de Arte, Sao Paulo

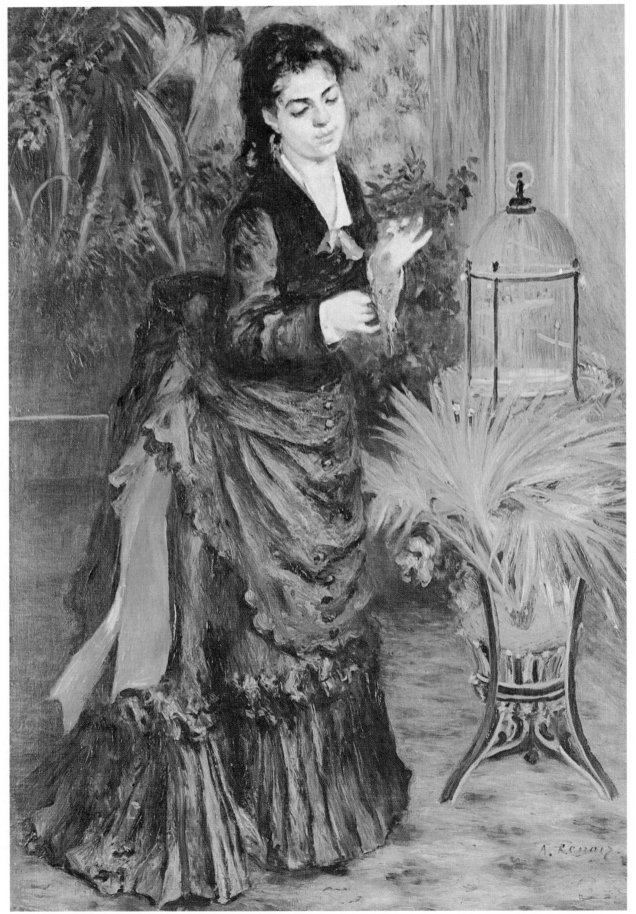

La femme à la perruche

1871 - oil on canvas - 91 x 65 cm -
The Solomon R. Guggenheim Foundation, New York

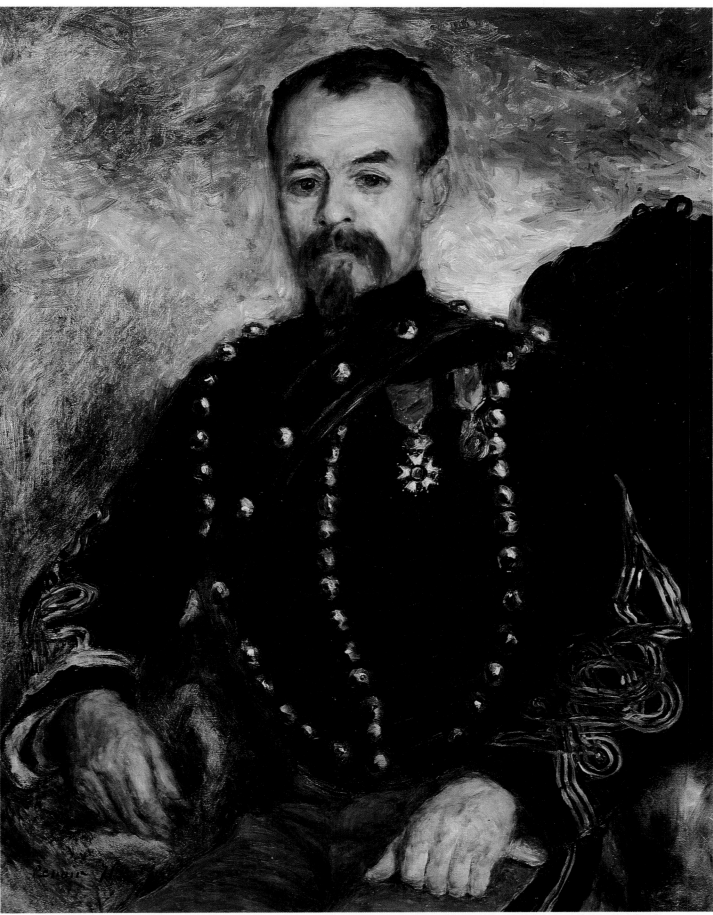

Portrait du Capitaine Darras

1871 - oil on canvas - 81 x 65 cm -
Staatliche Kunstsammlungen Gemäldegalerie, Dresden

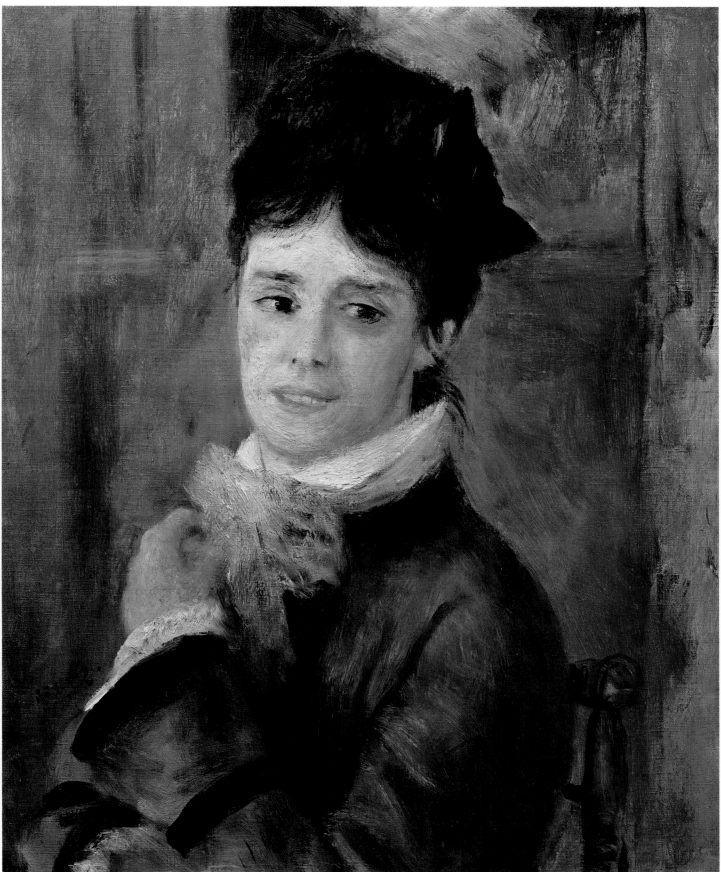

Portrait de Rapha Maître

1871 - oil on canvas - 130 x 83 cm -
Private collection

Portrait de Madame Claude Monet

1872 - oil on canvas - 47 x 37 cm -
Musée Marmottan, Paris

Madame Monet étendue sur un sofa

109 1872 - oil on canvas - 54 x 73 cm -
Calouste Gulbenkian Foundation, Lisbon

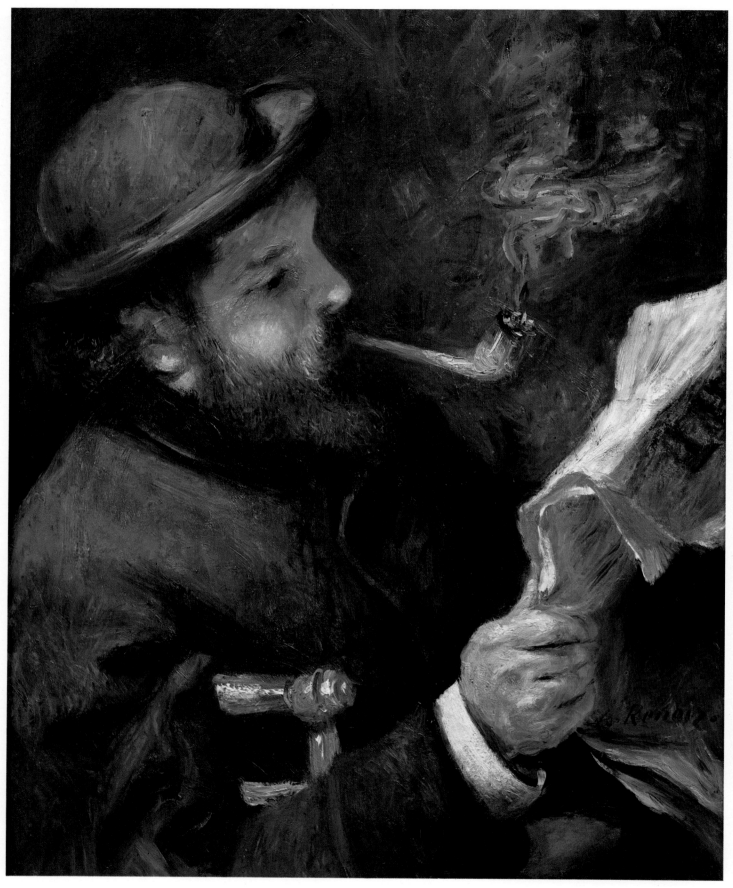

Claude Monet lisant

*1872 - oil on canvas - 61 x 50 cm -
Musée Marmottan, Paris*

Portrait de Claude Monet
1872 - oil on canvas - 61 x 50 cm -
Private collection

Grand vent (also called Le coup de vent)

c. 1872 - oil on canvas - 52 x 82 cm -
Fitzwilliam Museum, Cambridge

Roses dans un vase

c. 1872 - oil on canvas - 66 x 41 cm -
Private collection

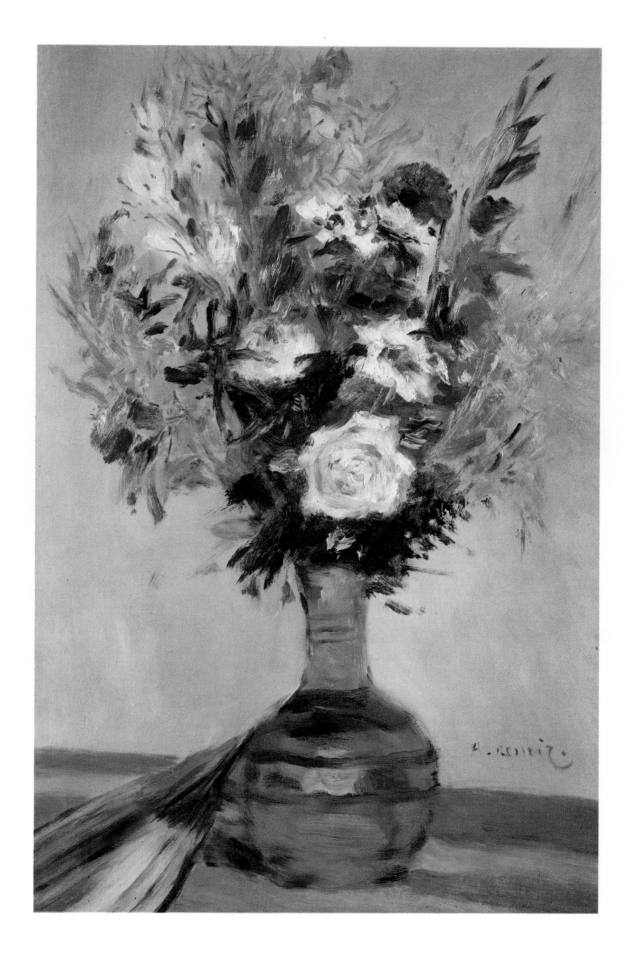

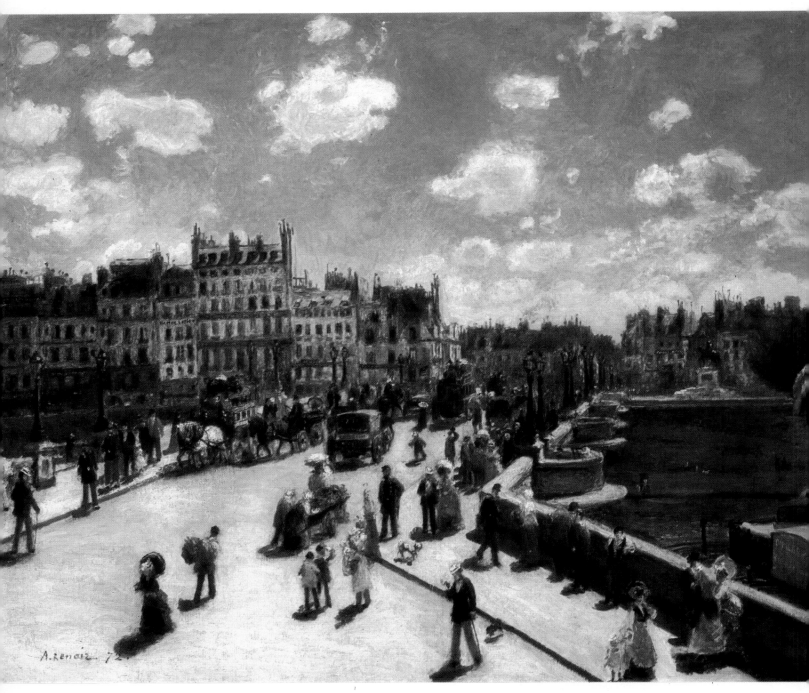

Le Pont-Neuf

*1872 - oil on canvas - 75 x 94 cm -
National Gallery of Art, Alisa Mellon Bruce
Collection, Washington, D.C.*

Parisiennes habillées en Algériennes
or *Le Harem*

1872 - oil on canvas - 156 x 129 cm -
National Museum of Western Art, Tokyo

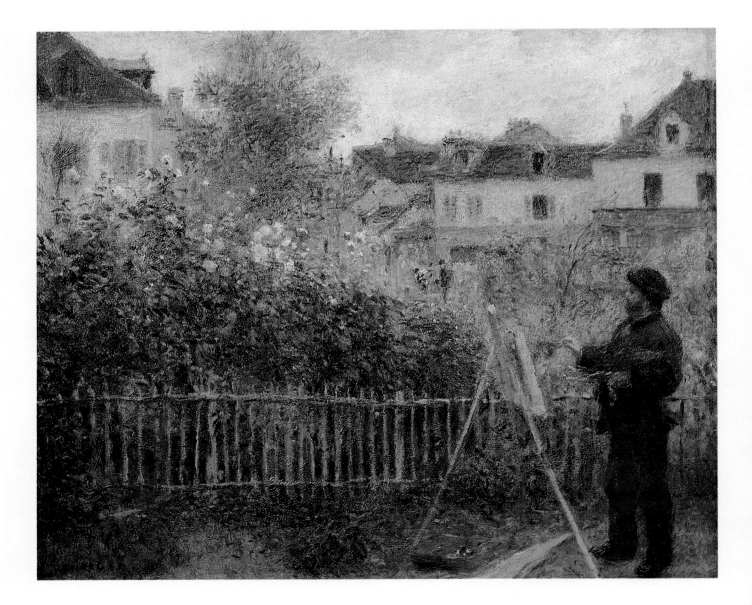

Monet peignant dans son jardin à Argenteuil

1873 - oil on canvas - 50 x 61 cm -
Wadsworth Atheneum, Anne Parrish Titzel legacy, Hartford

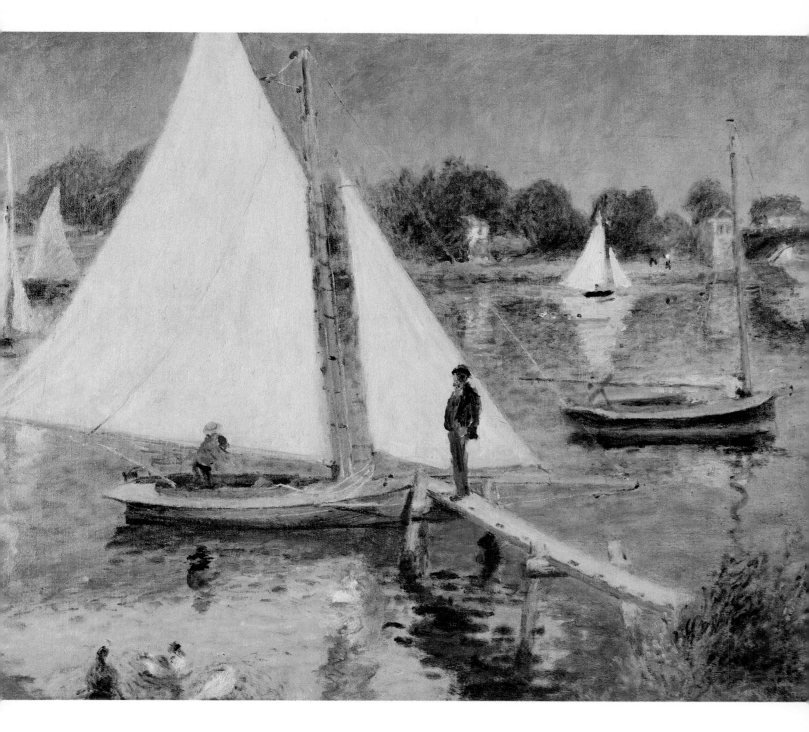

La Seine à Argenteuil

1873 - oil on canvas - 50 x 65 cm -
Portland Art Museum, Winslow B. Ayer legacy, Portland (Oregon)

La prairie or L'abreuvoir

1873 - oil on canvas - 46 x 61 cm -
Private collection

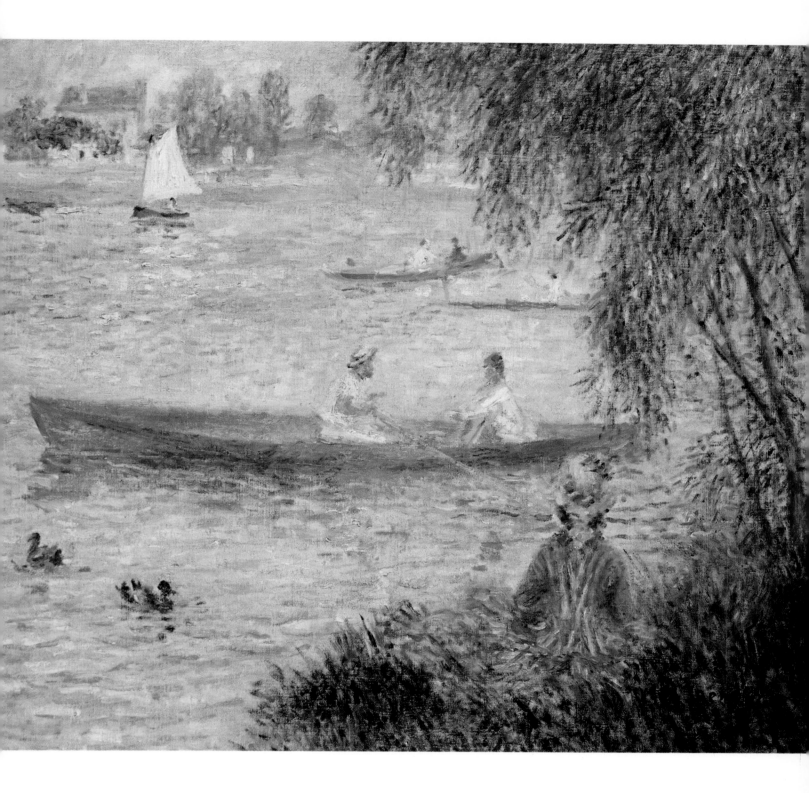

Canotier d'Argenteuil

1873 - oil on canvas - 50 x 61 cm -
Private collection

Femme à l'ombrelle et enfant

c. 1873 - oil on canvas - 46 x 55 cm -
Museum of Fine Arts, John T. Spaulding legacy, Boston

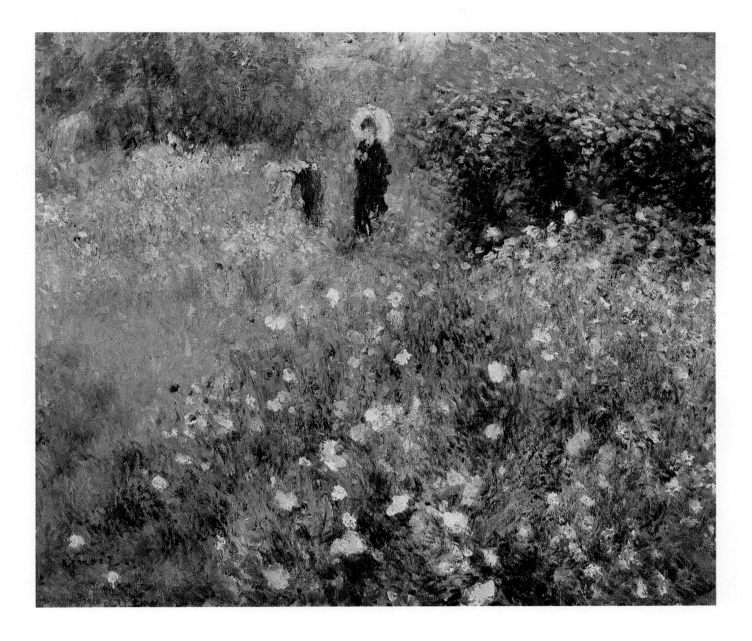

Paysage d'été

c. 1873 - oil on canvas - 54 x 65 cm -
Private collection

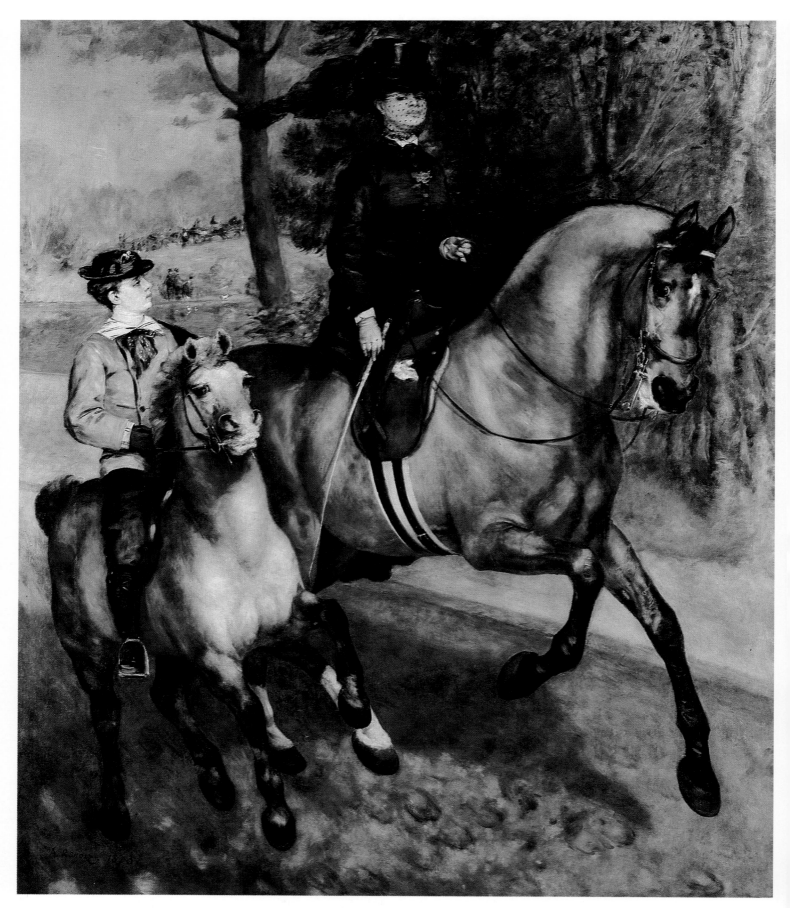

Allée cavalière au Bois de Boulogne
1873 - oil on canvas - 261 x 226 cm -
Kunsthalle, Hamburg

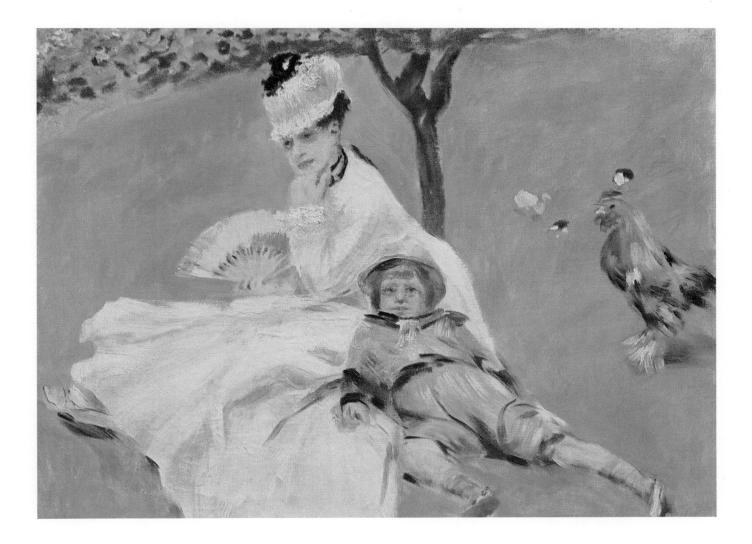

Madame Claude Monet et son fils

*1874 - oil on canvas - 50 x 68 cm -
National Gallery of Art, Alisa Mellon Bruce
Collection, Washington, D.C.*

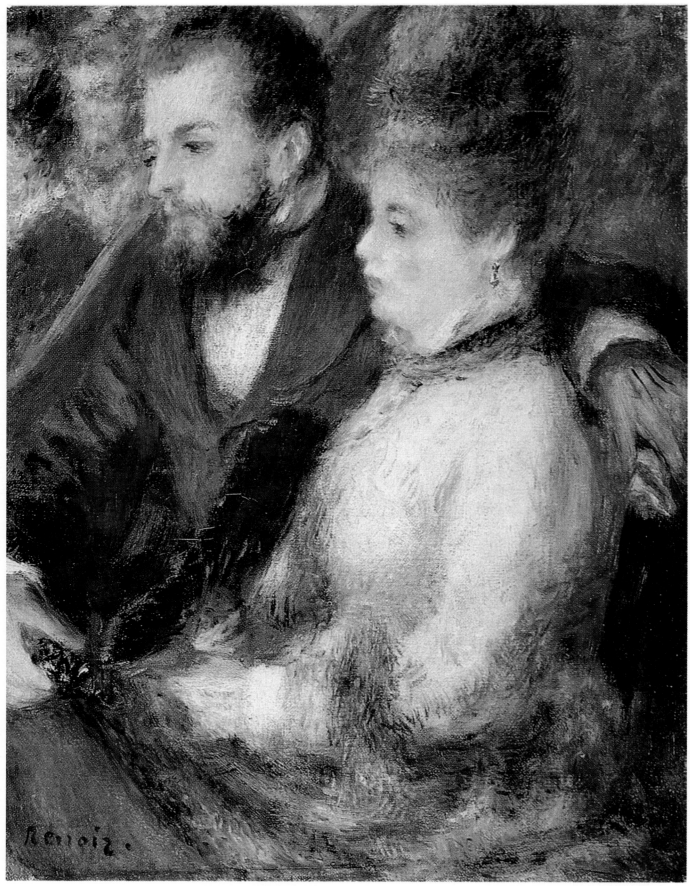

Dans la loge

c. 1874 - oil on canvas - 27 x 22 cm -
Durand-Ruel, Paris

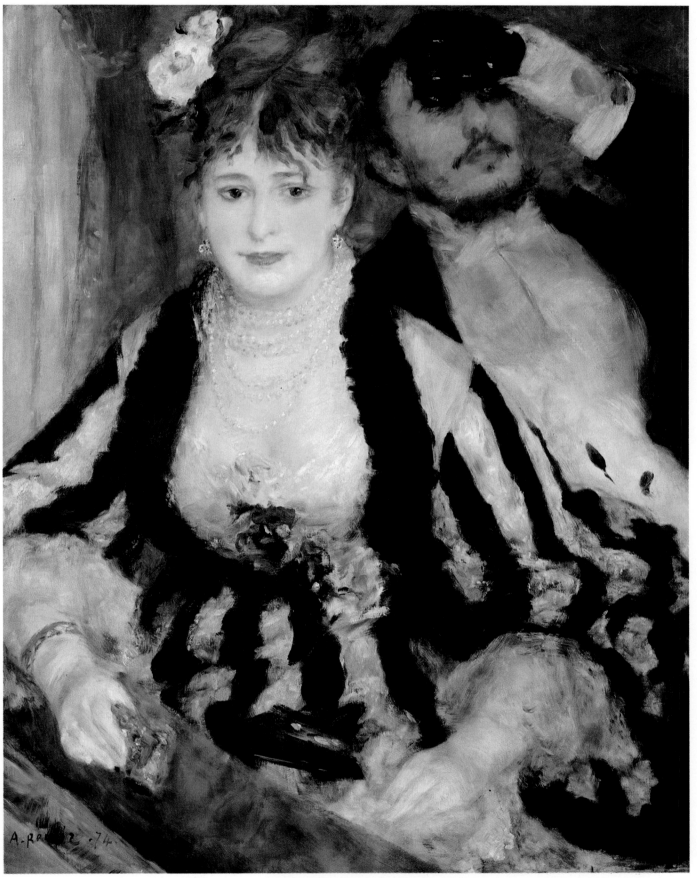

La loge

1874 - oil on canvas - 80 x 63 -
Courtauld Institute Galleries, S. Courtauld
Collection, London

La lecture du rôle

1874 - oil on canvas - 8 x 7 cm -
Musée des Beaux-arts, Rheims

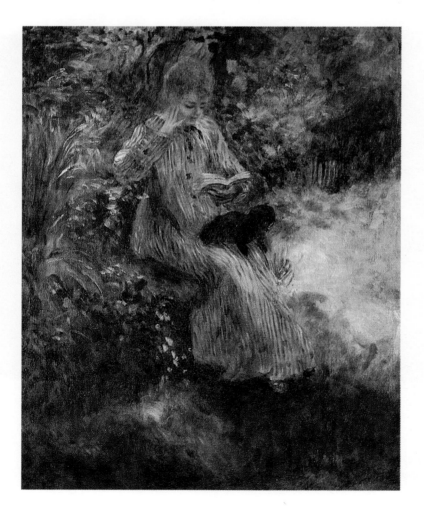

La Parisienne or La Dame en bleu

1874 - oil on canvas - 160 x 106 cm -
National Museum of Wales, Cardiff

Femme au chien noir

1874 - oil on canvas - 61 x 49 cm -
Private collection

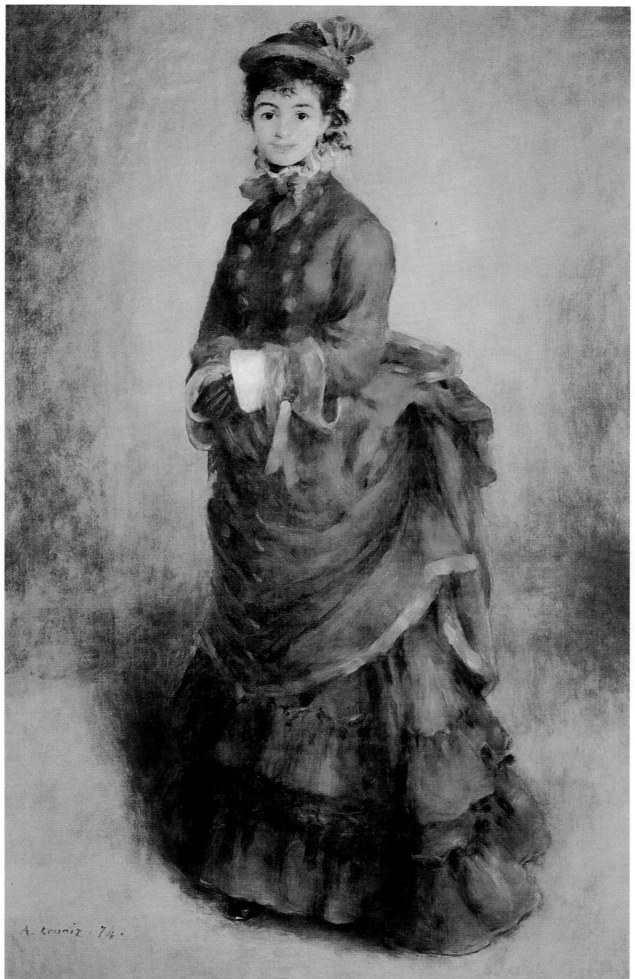

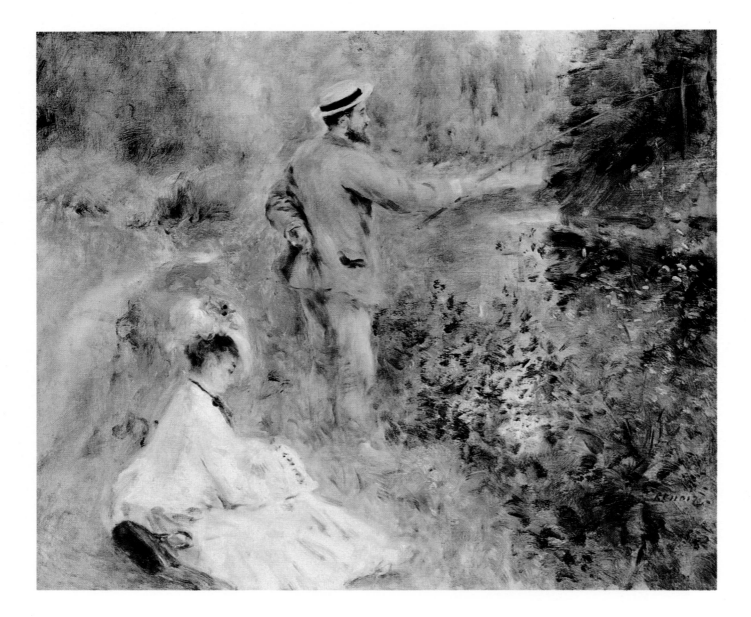

Le pêcheur à la ligne

c. 1874 - oil on canvas - 54 x 65 cm -
Private collection

La danseuse

1874 - oil on canvas - 142 x 94 cm
National Gallery of Art, Widener Collection, Washington, D.C.

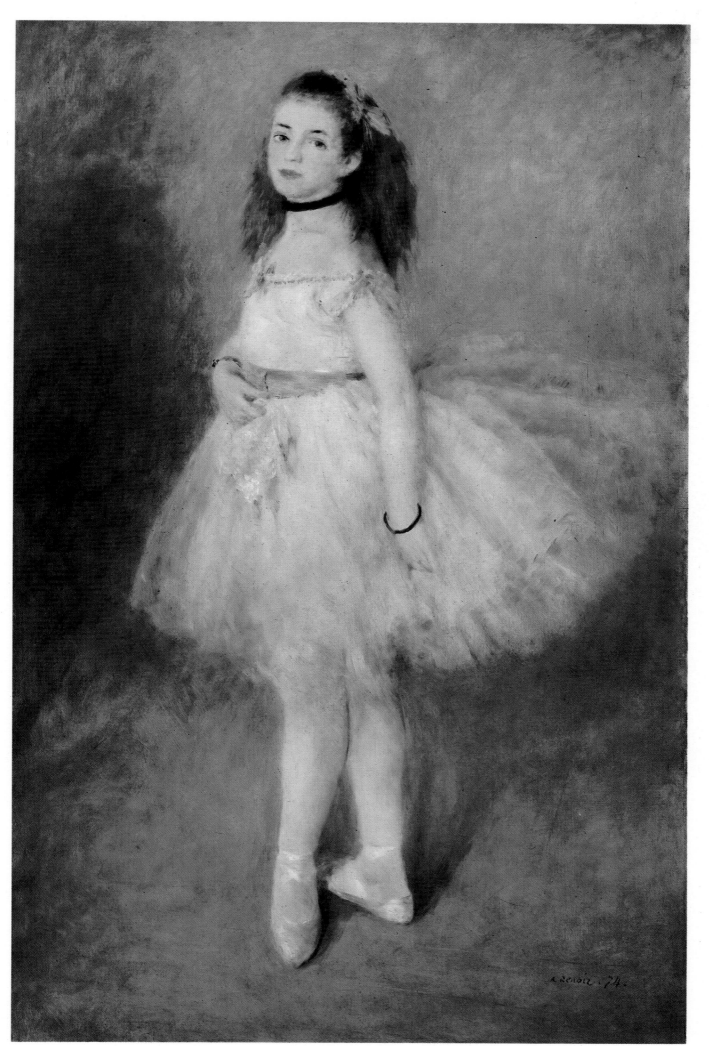

129

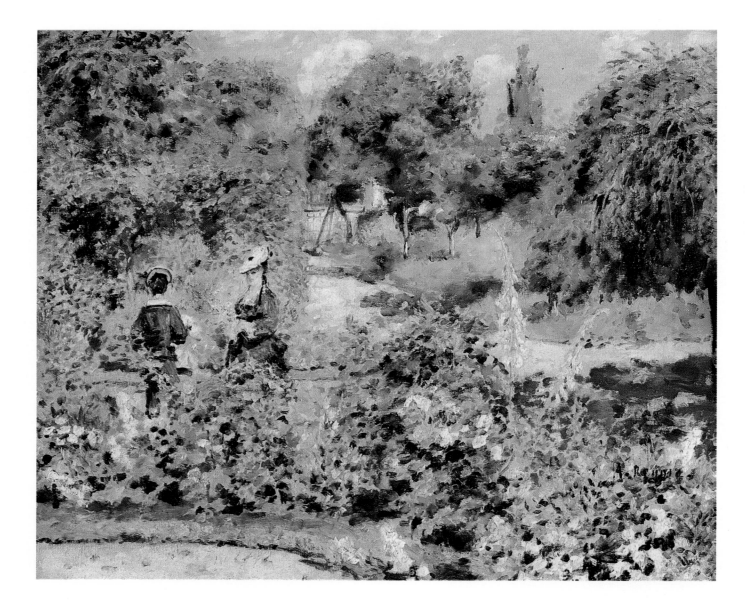

Le jardin à Fontenay

1874 - oil on canvas - 51 x 62 cm -
Oskar Reinhart Collection, Winterthur

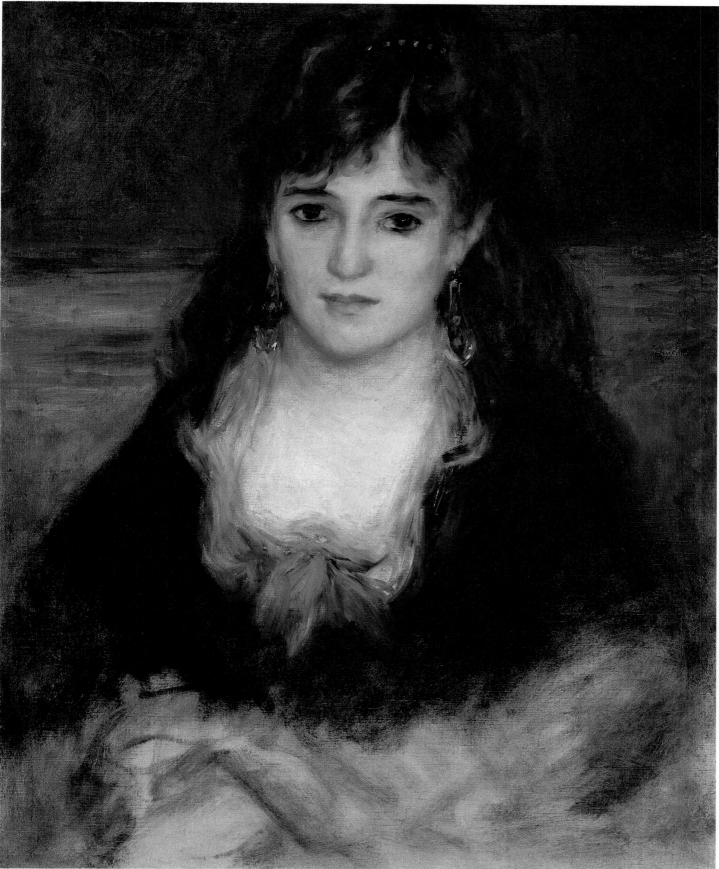

Nini-Gueule-de-Raie

c. 1874 - oil on canvas - 32 x 24 cm -
Private collection

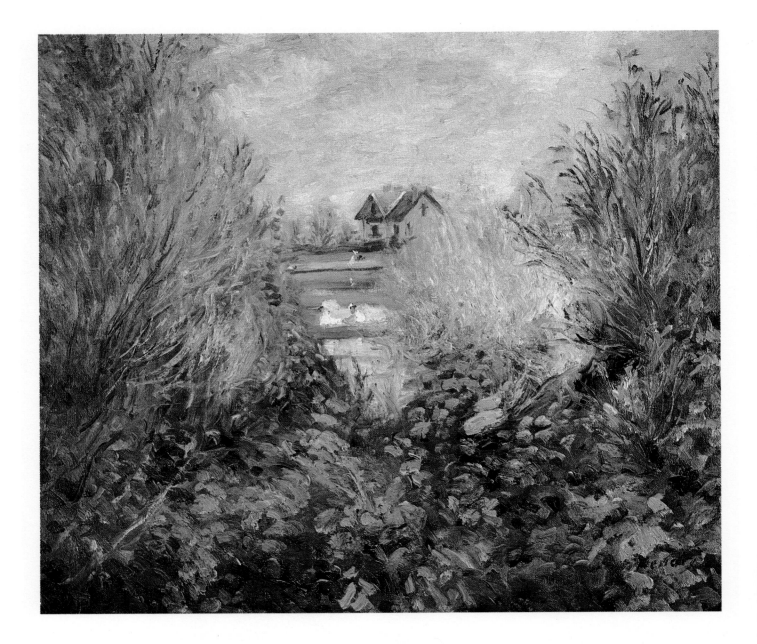

La Seine près d'Argenteuil

c. 1874 - oil on canvas - 47 x 57 cm -
Private collection

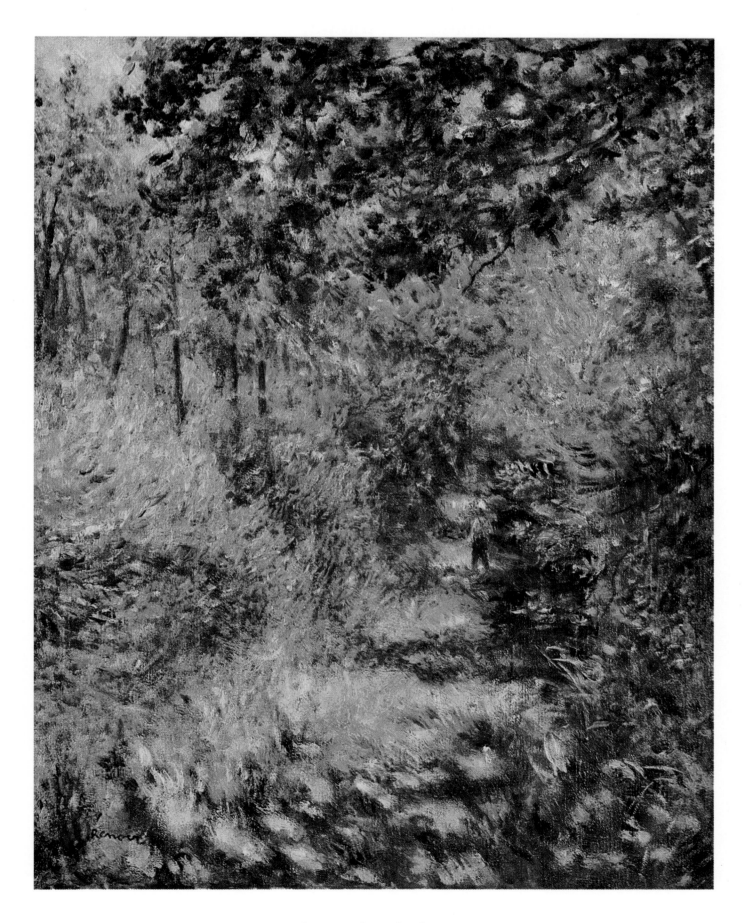

Sentier dans les bois

1874 - oil on canvas - 66 x 55 cm -
Private collection

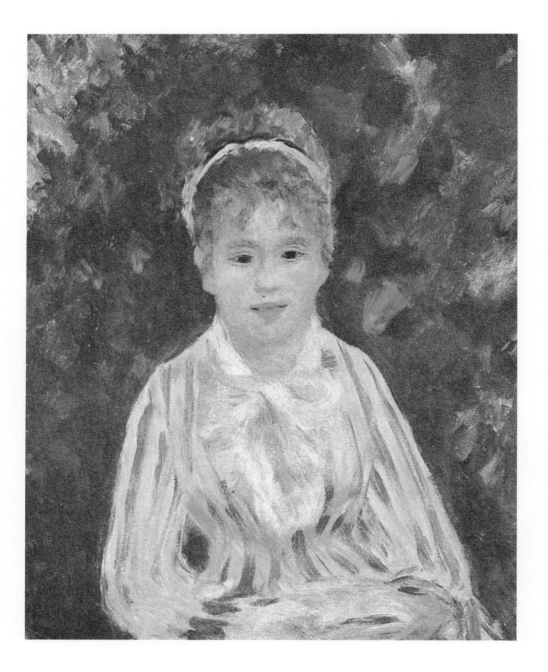

Jeune femme au corsage rayé bleu et rose

1875 - oil on canvas - 61 x 50 cm -

Private collection

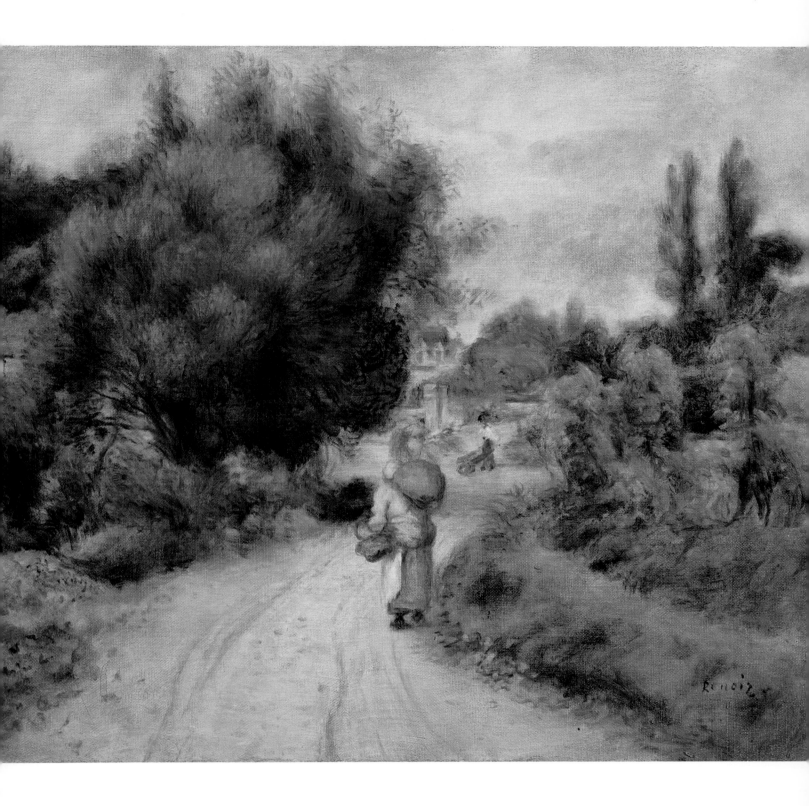

Sur le bord de la rivière

1875 - oil on canvas - 46 x 56 cm -
Private collection

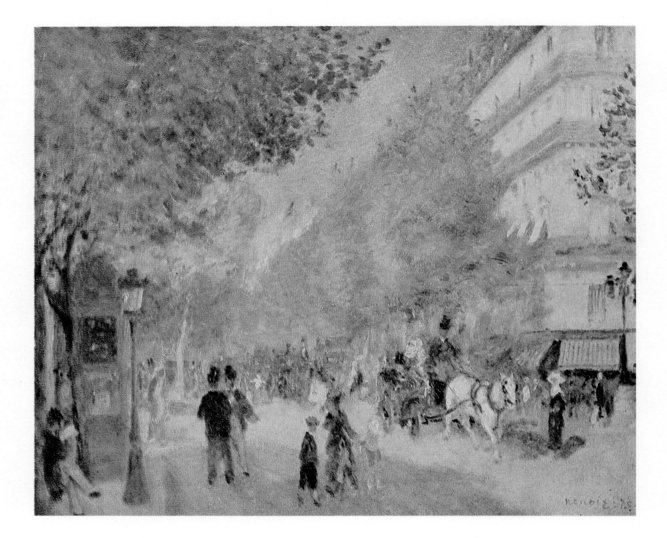

Les Grands Boulevards

1875 - oil on canvas - 50 x 61 cm -
Private collection

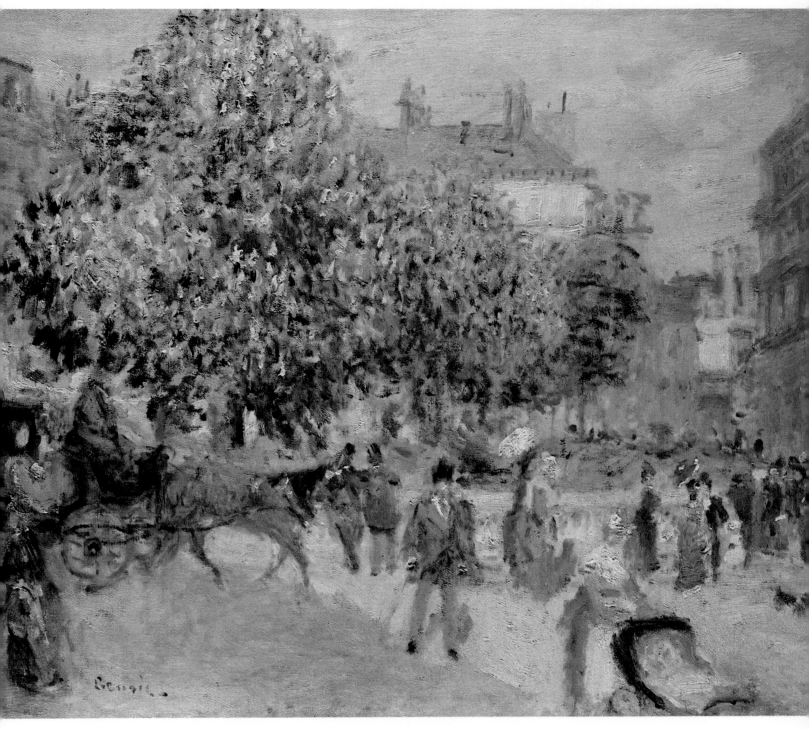

Place de la Trinité

1875 - oil on canvas - 51 x 63 cm -
Private collection

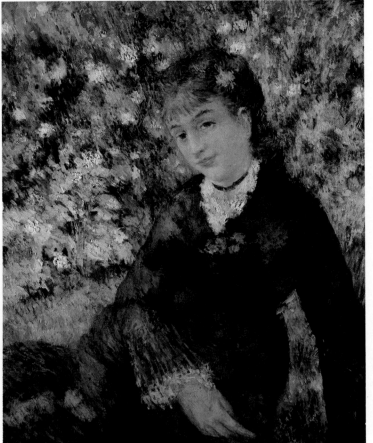

L'été

*1875 - oil on canvas - 65 x 54 cm -
Private collection*

Verger à Louveciennes : le poirier anglais

*1875 - oil on canvas - 65 x 81 cm -
Private collection*

Printemps à Chatou

c. 1872-75 - oil on canvas - 59 x 74 cm -
Private collection

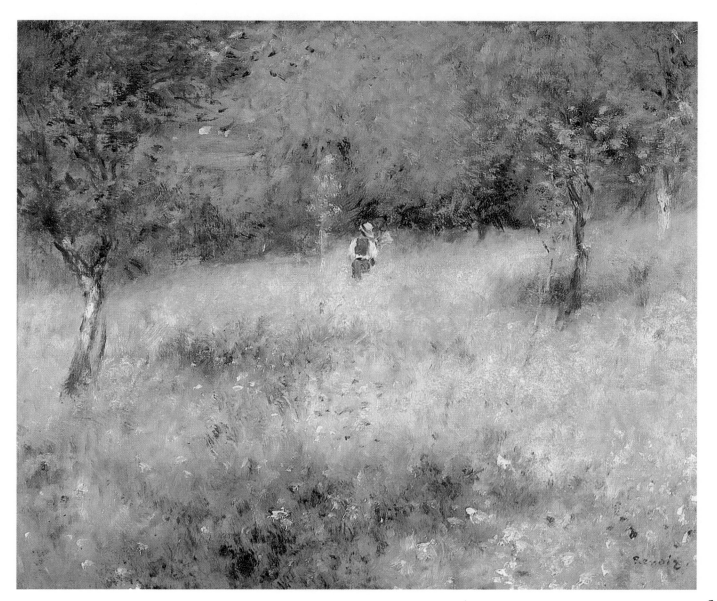

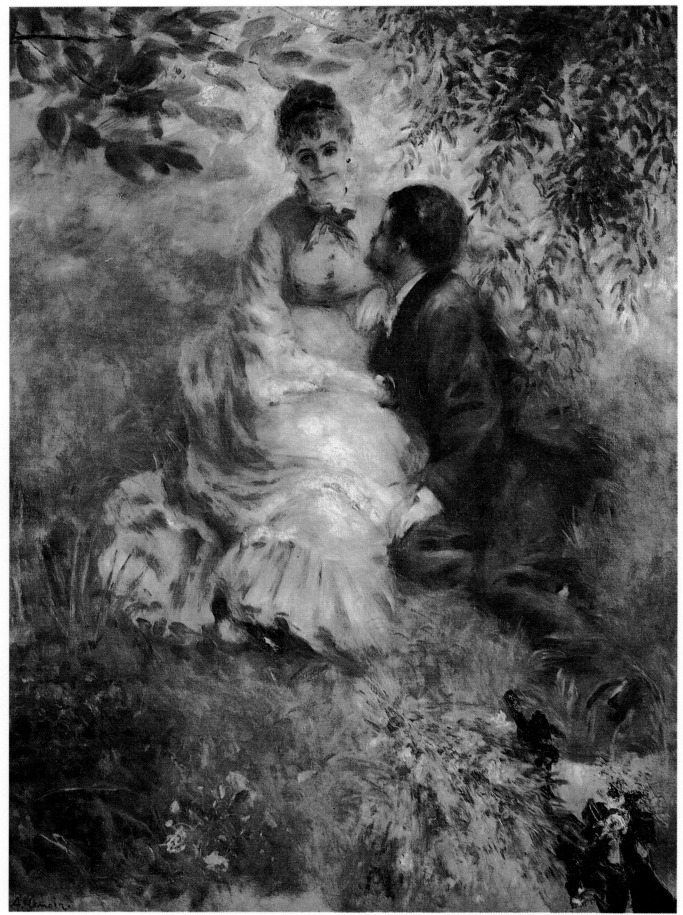

Les amoureux

c. 1875 - oil on canvas - 175 x 130 cm -
Narodni Galerii, Prague

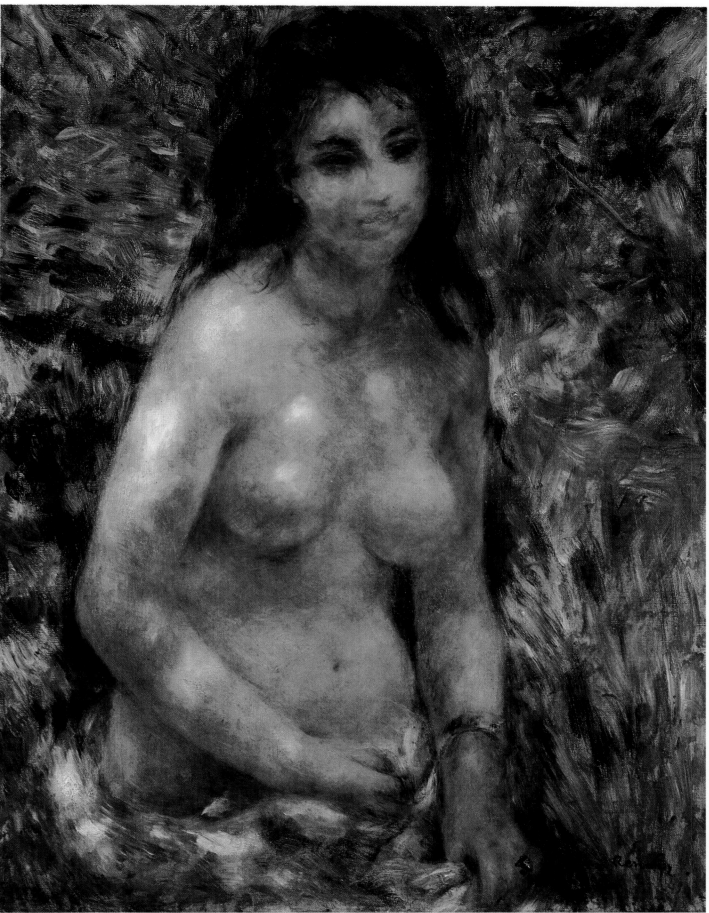

Torse au soleil

1875 - oil on canvas - 81 x 65 cm -
Musée d'Orsay, Paris

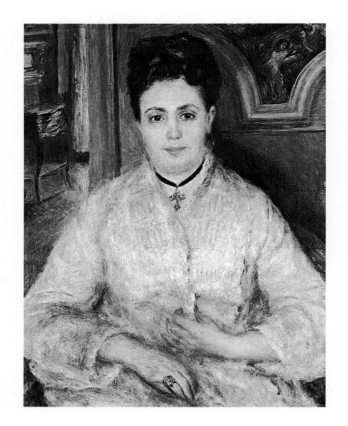

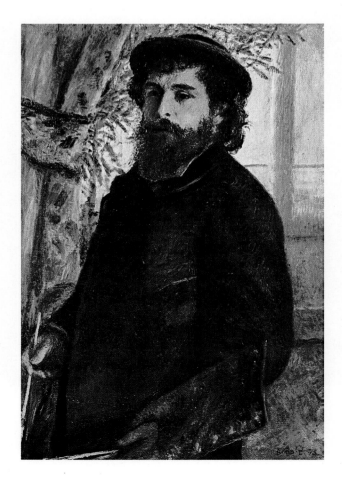

Portrait de Madame Chocquet en blanc

1875 - oil on canvas - 75 x 60 cm -
Staatsgalerie, Stuttgart

Portrait de Monet peignant

1875 - oil on canvas - 85 x 60.5 cm -
Musée d'Orsay, Paris

Paysage de neige

c.1875 - oil on canvas - 51 x 66 cm -
Musée de l'Orangerie, Paris

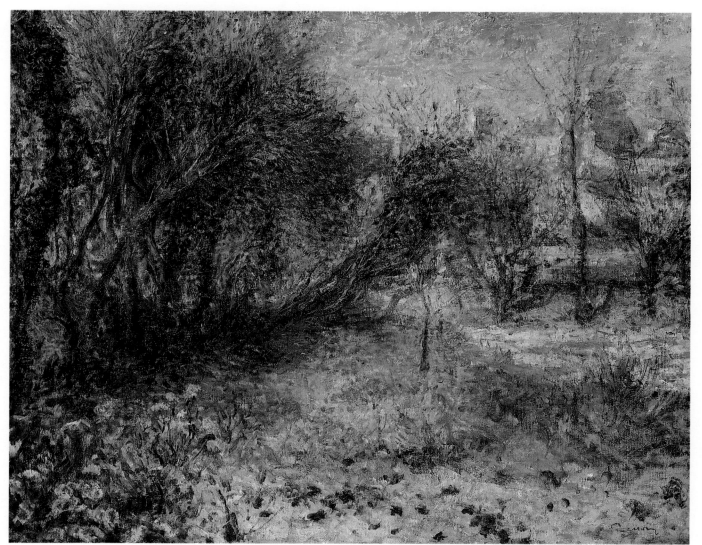

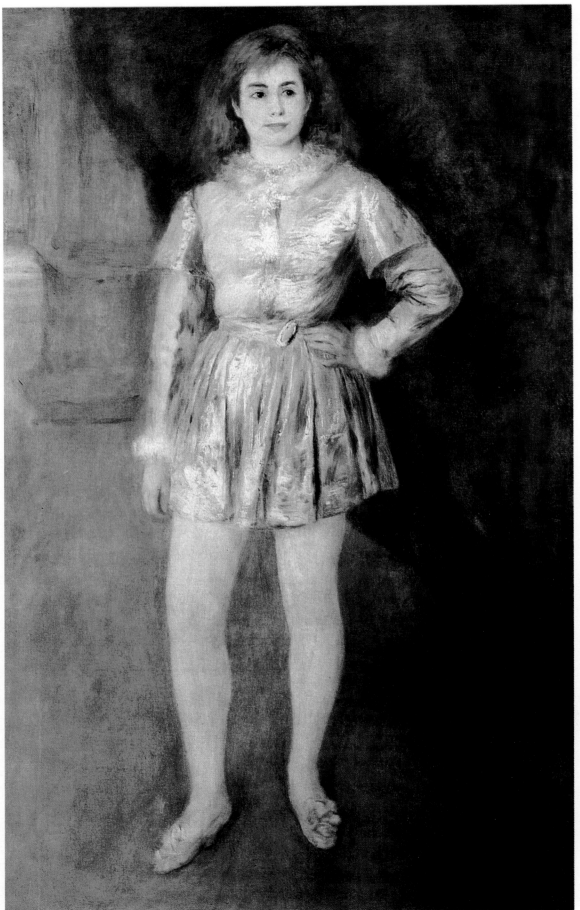

Madame Henriot en travesti

1875 - oil on canvas - 161 x 104 cm -
Gallery of Fine Arts, Columbus

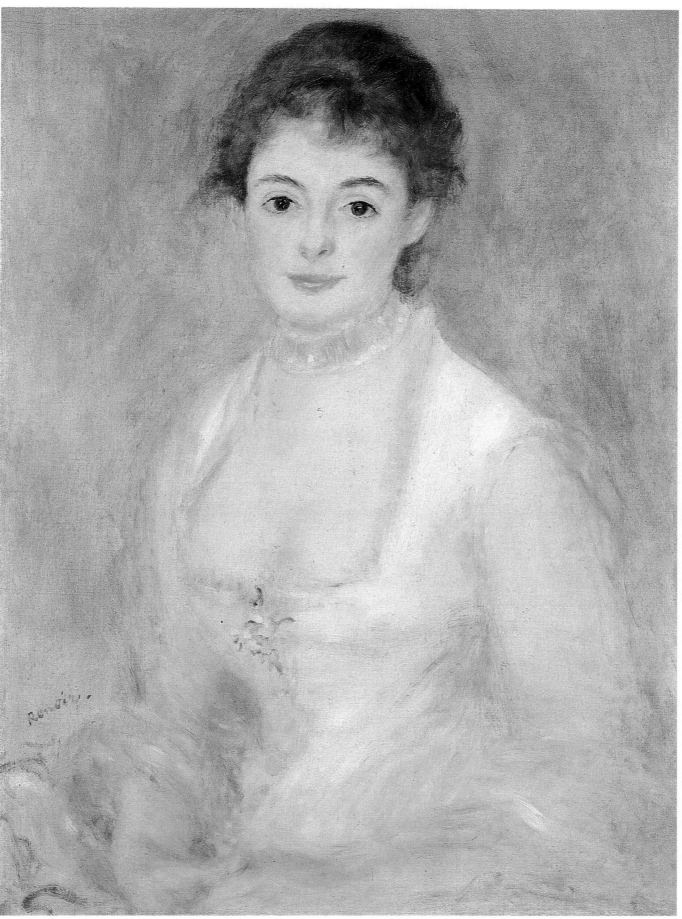

Madame Henriot

1876 - oil on canvas - 70 x 55 cm -
National Gallery of Art, Washington, D.C.

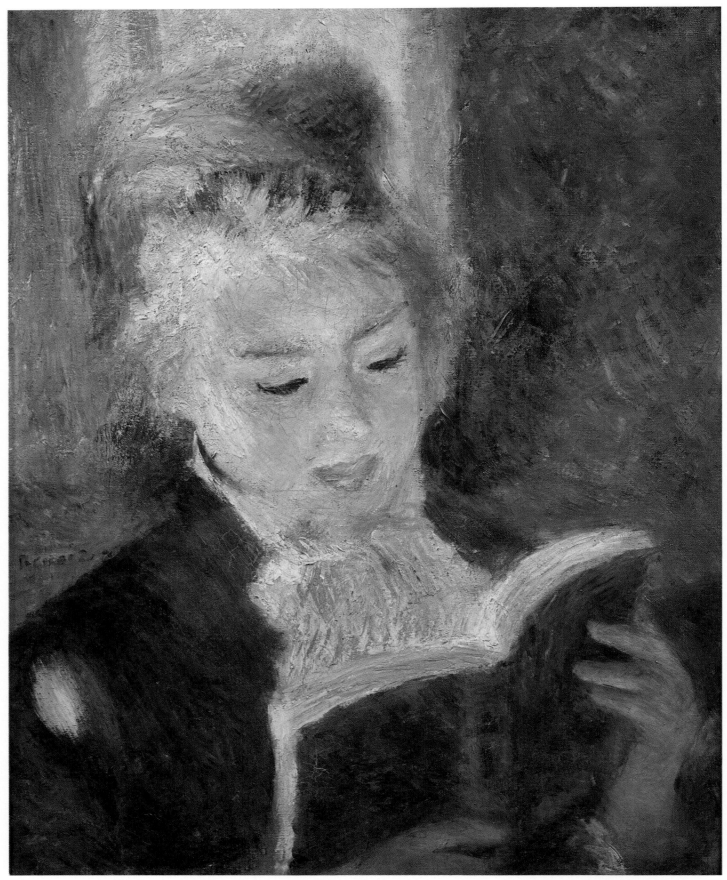

La liseuse

c. 1874-76 - oil on canvas - 46.5 x 38.5 cm -
Musée d'Orsay, Paris

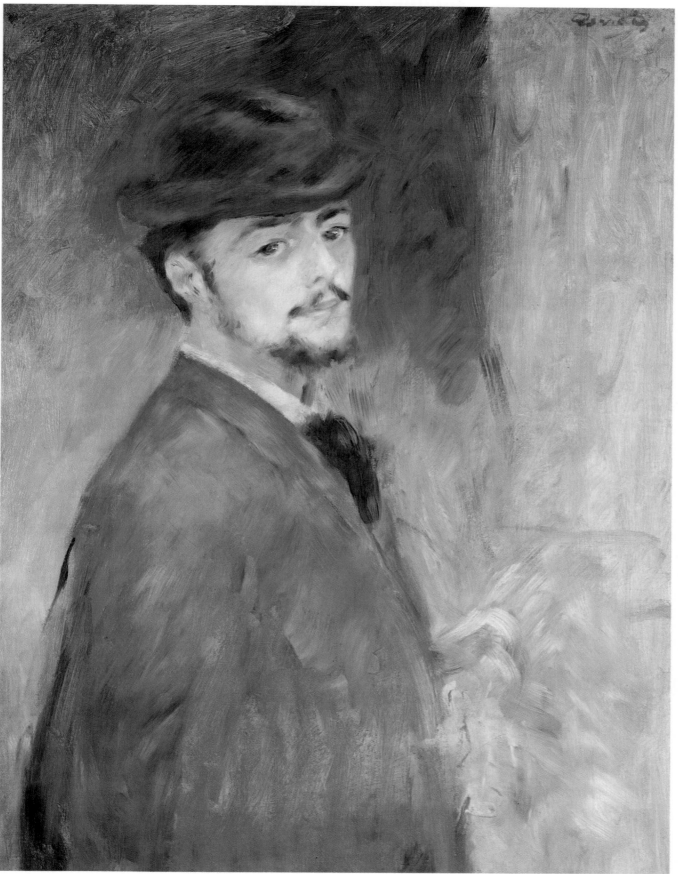

Portrait de Renoir par lui-même

1876 - oil on canvas - 73 x 56 cm -
Courtesy of Harvard Museum, M. Wertheim Collection
The Fogg Art Museum, Cambridge, Massachusetts

148

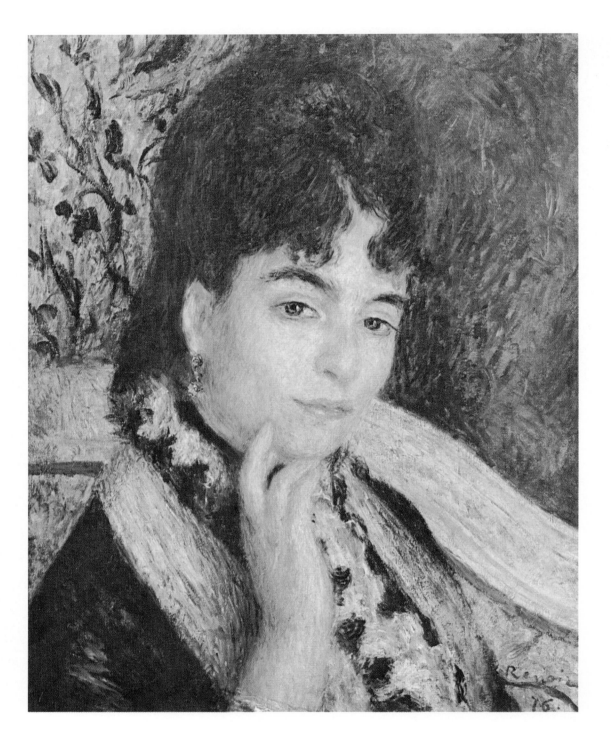

Portrait of Mme Alphonse Daudet

1876 - oil on canvas - 47 x 37 cm -
Musée d'Orsay, Paris

Bord de rivière

c. 1874-76 - oil on canvas - 54.5 x 64.5 cm -
Private collection

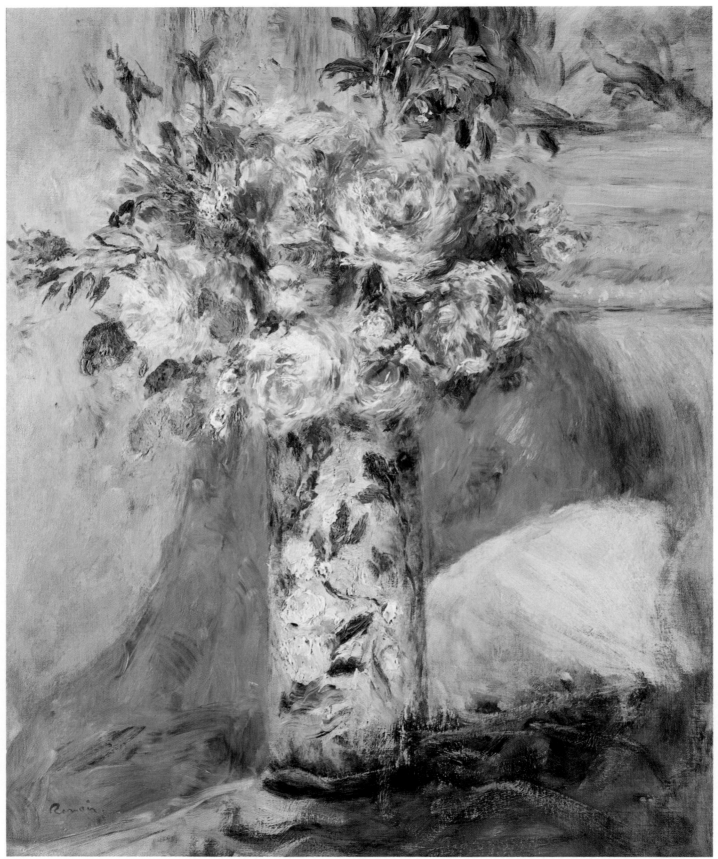

Roses dans un vase

1876 - oil on canvas - 61 x 50 cm -
Private collection

Le jardin de la rue Cortot à Montmartre

1876 - oil on canvas - 151 x 97 cm -
The Carnegie Museum of Art, Pittsburgh

151

Victor Chocquet

1876 - oil on canvas - 46 x 37 cm -
Fogg Art Museum, Cambridge, Massachusetts

Portrait de Monsieur Chocquet

1876 - oil on canvas - 46 x 36 cm -
Oskar Reinhart Collection, Winterthur

Madame Chocquet lisant

1876 - oil on canvas - 65.5 x 55 cm -
Private collection

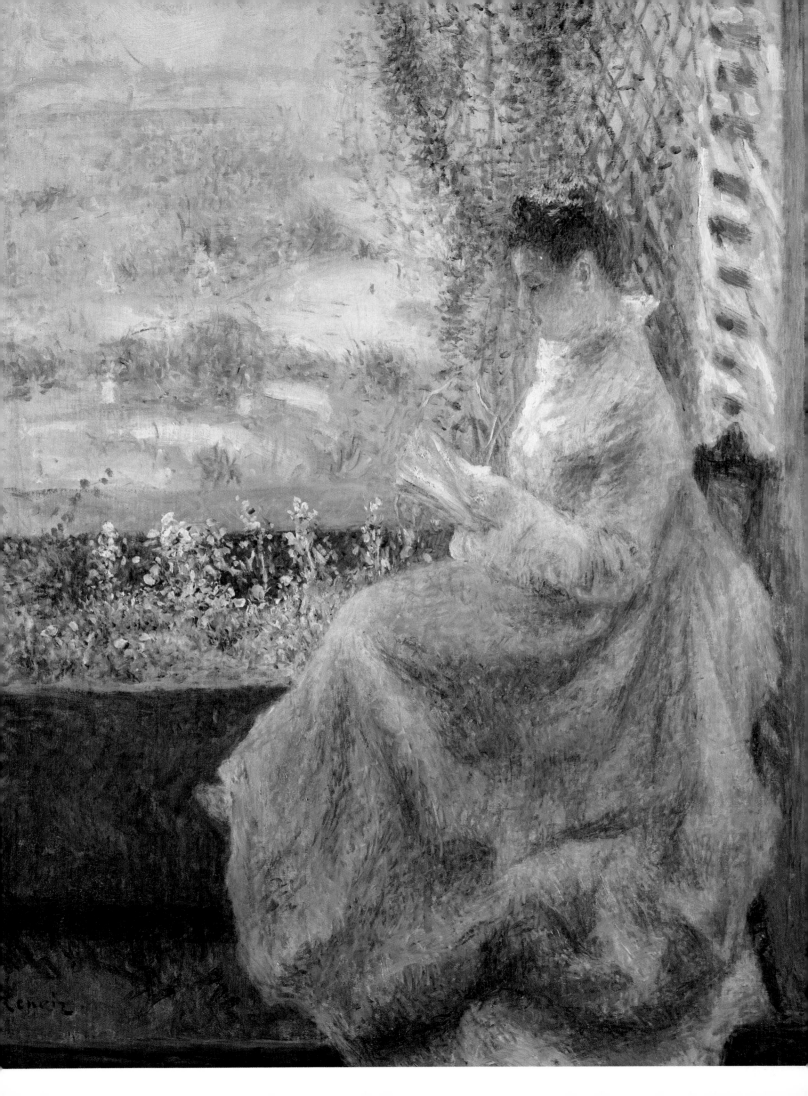

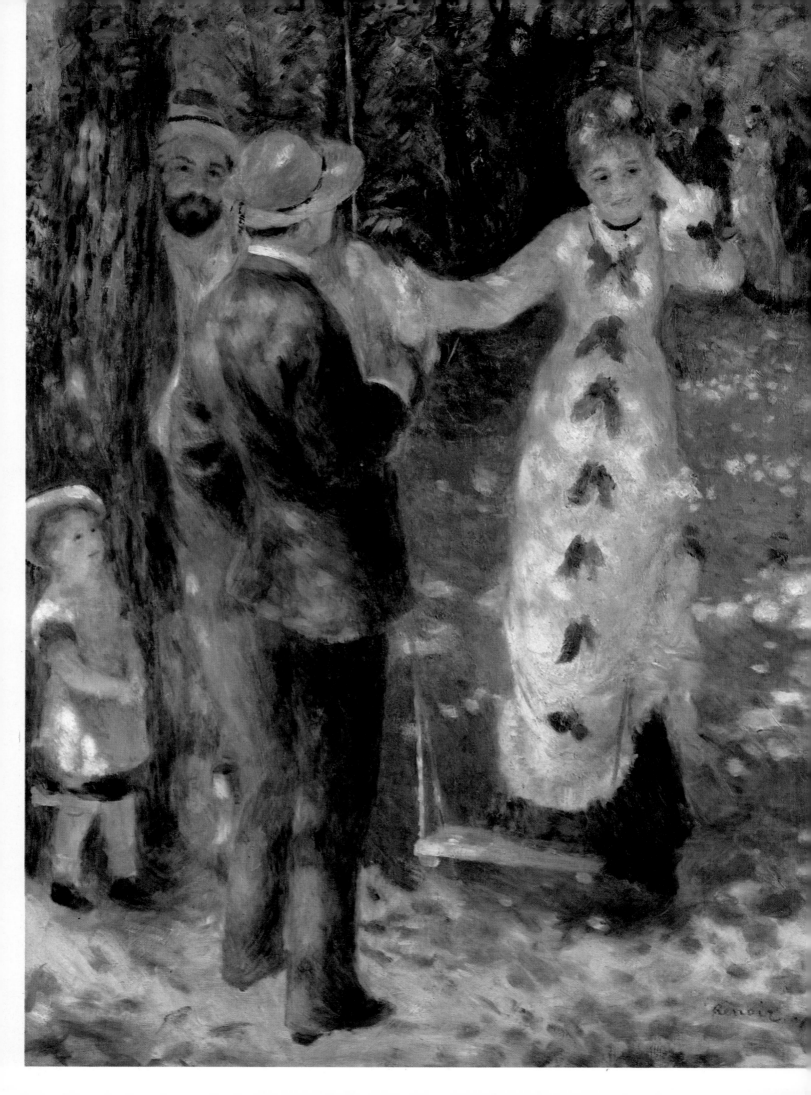

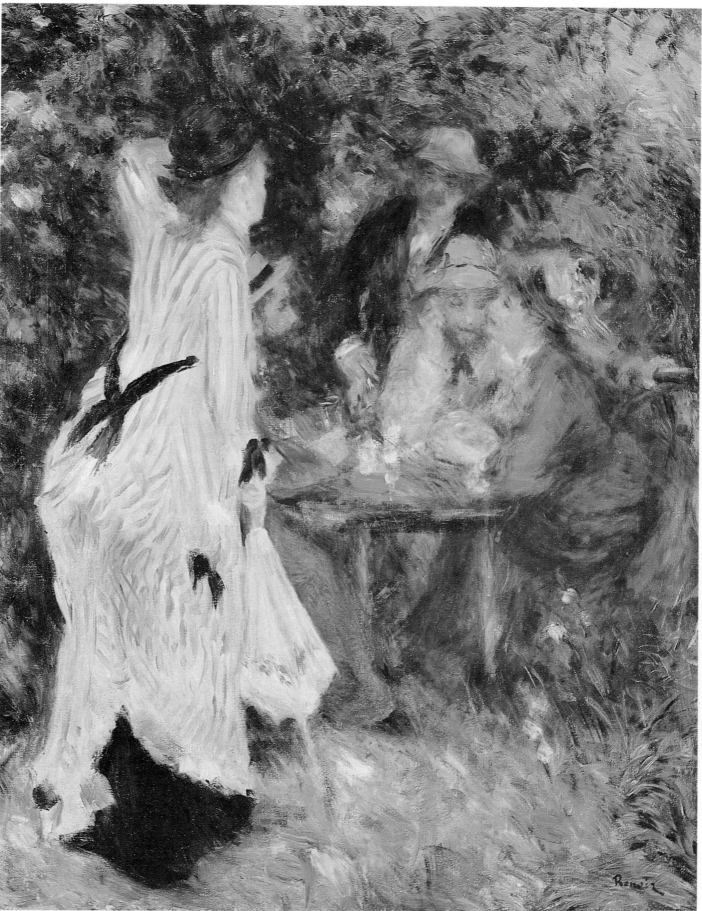

La balançoire

1876 - oil on canvas - 92 x 73 cm -
Musée d'Orsay, Paris

La tonnelle au Moulin de la Galette

c.1876 - oil on canvas - 81 x 65 cm -
Pushkin Museum, Moscow

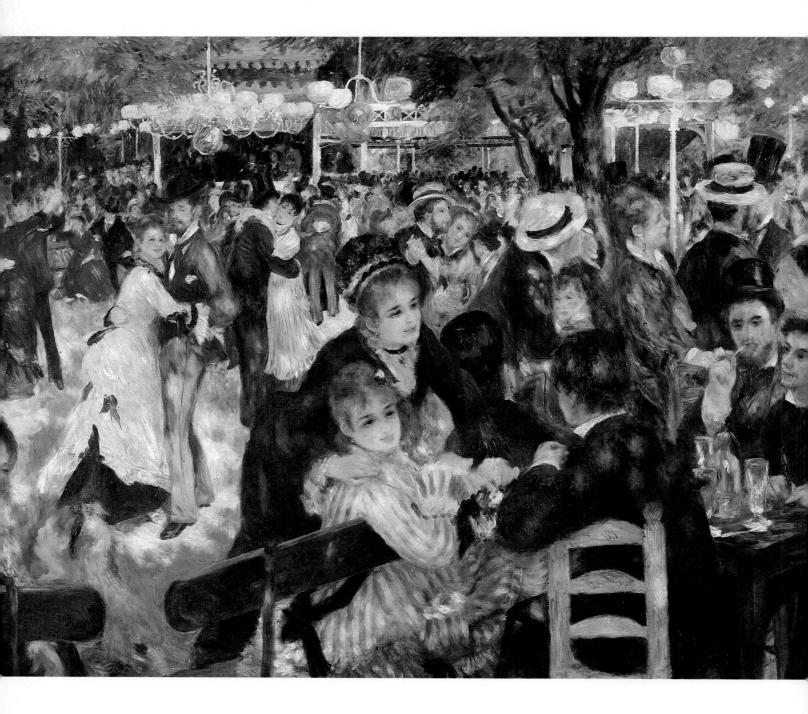

Bal du Moulin de la Galette

1876 - oil on canvas - 131 x 175 cm -
Musée d'Orsay, Paris

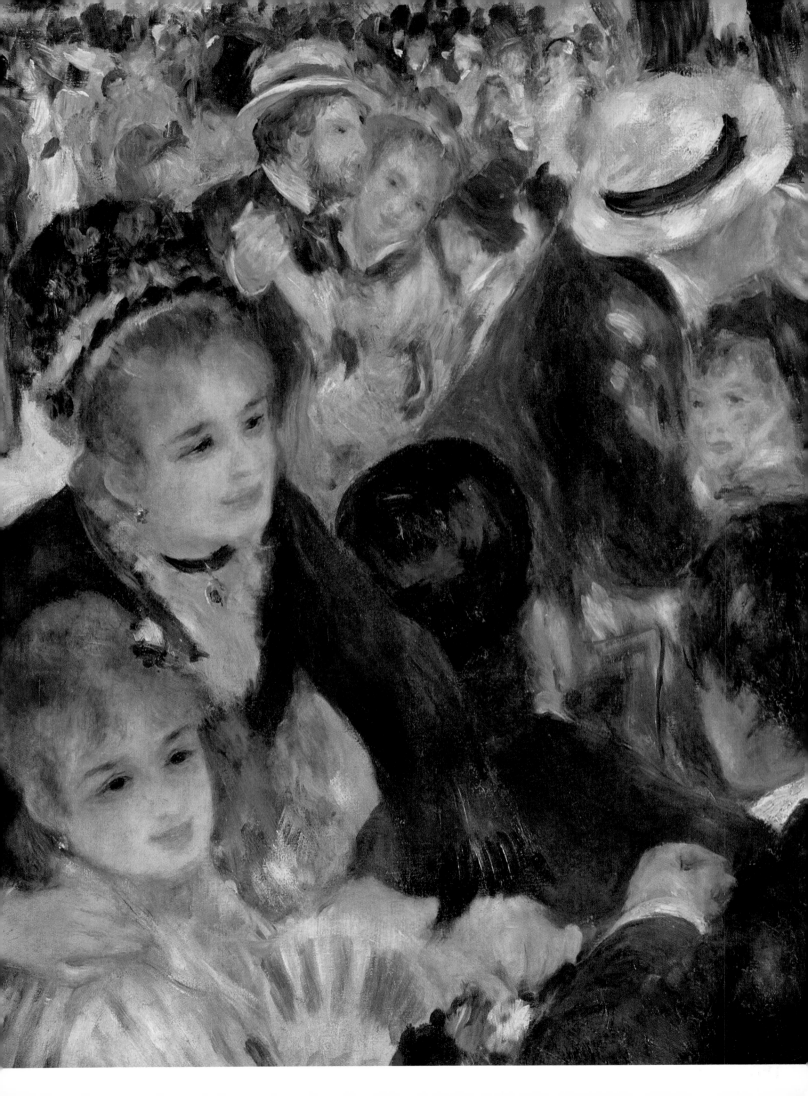

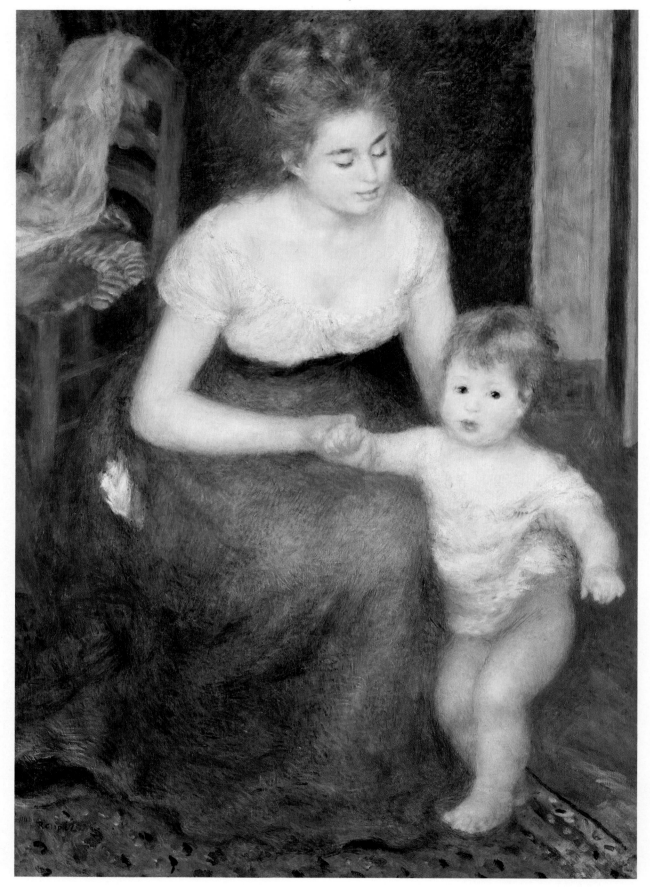

Le premier pas

1876 - oil on canvas - 111 x 80.5 cm -
Private collection

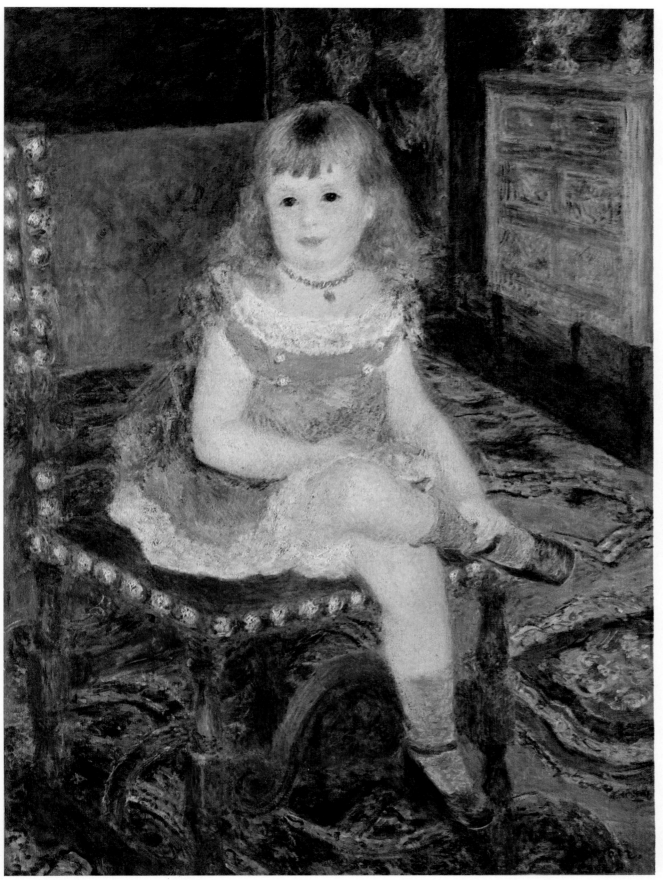

Mademoiselle Georgette Charpentier assise

1876 - oil on canvas - 98x 73 cm -
Private collection

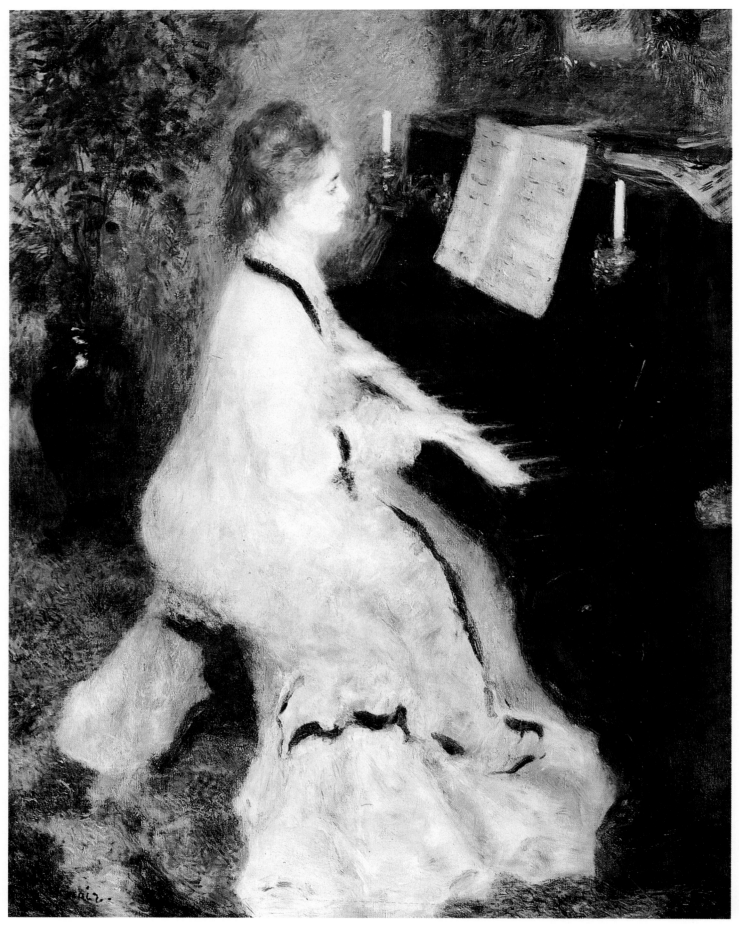

Jeune femme au piano
1876 - oil on canvas - 93 x 74 cm -
Art Institute, Chicago

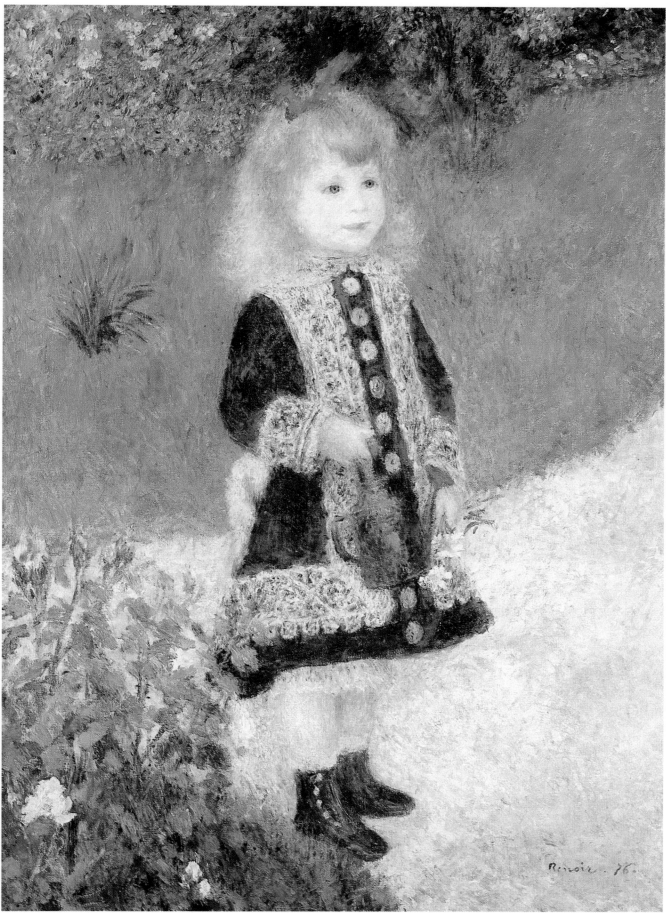

Fillette à l'arrosoir

1876 - oil on canvas - 100 x 73 cm -
National Gallery of Art, Washington, D.C.

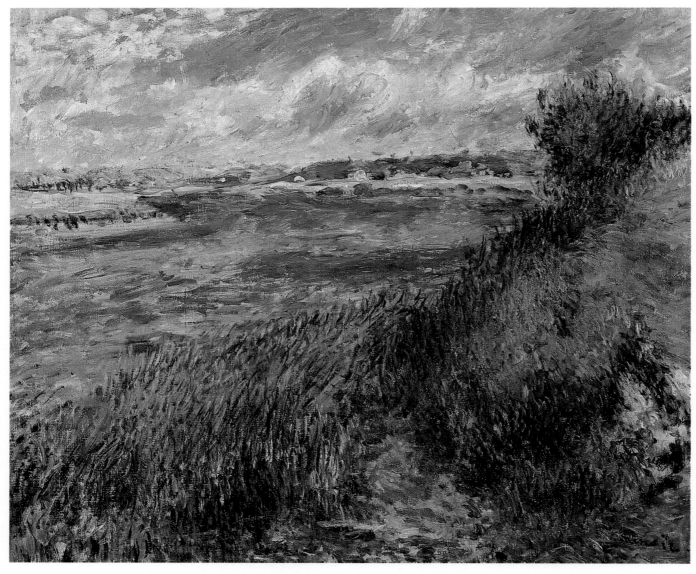

Bords de Seine à Champrosay

1876 - oil on canvas - 55 x 66 cm -
Musée d'Orsay, Paris

La première sortie

1876 - oil on canvas - 65 x 50 cm -
National Gallery, London

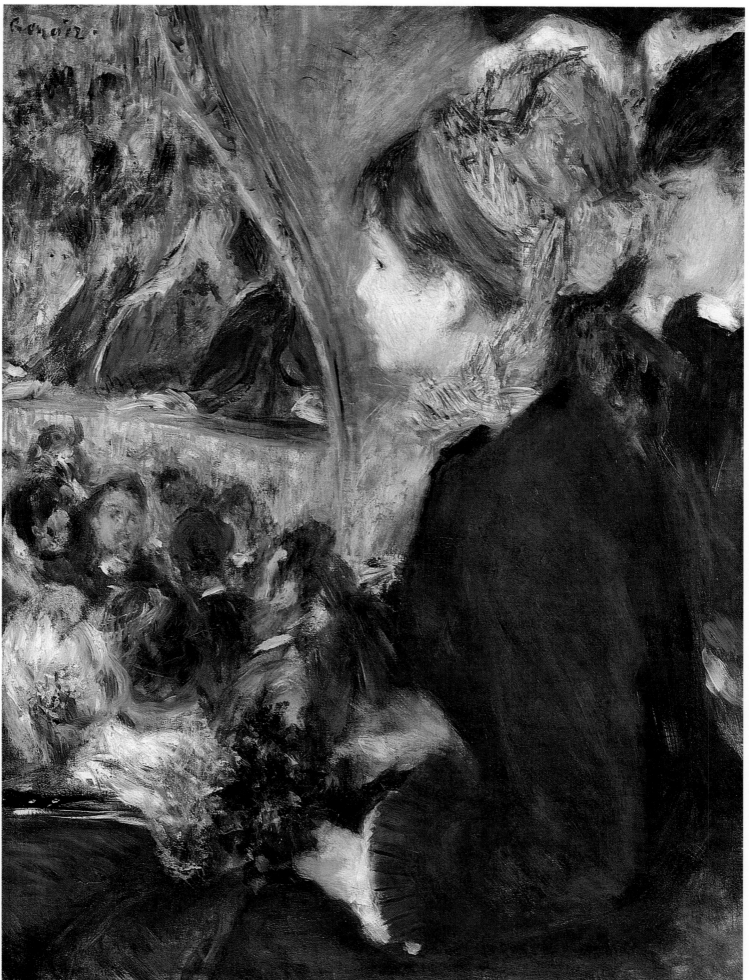

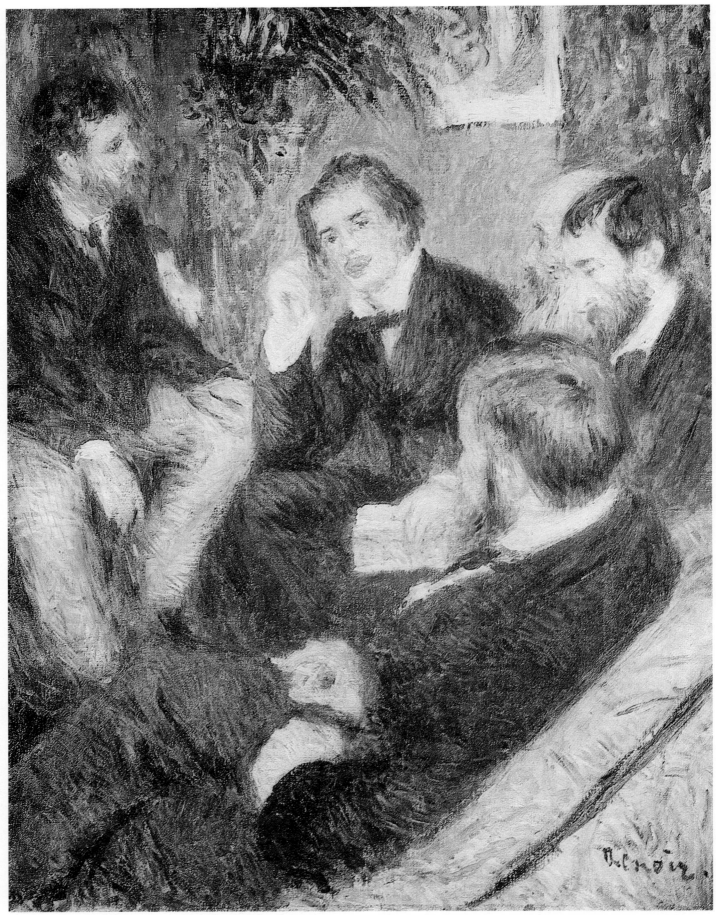

Dans l'atelier de la rue Saint-Georges

1876 - oil on canvas - 46 x 38 cm -
Norton Simon Museum, Pasadena

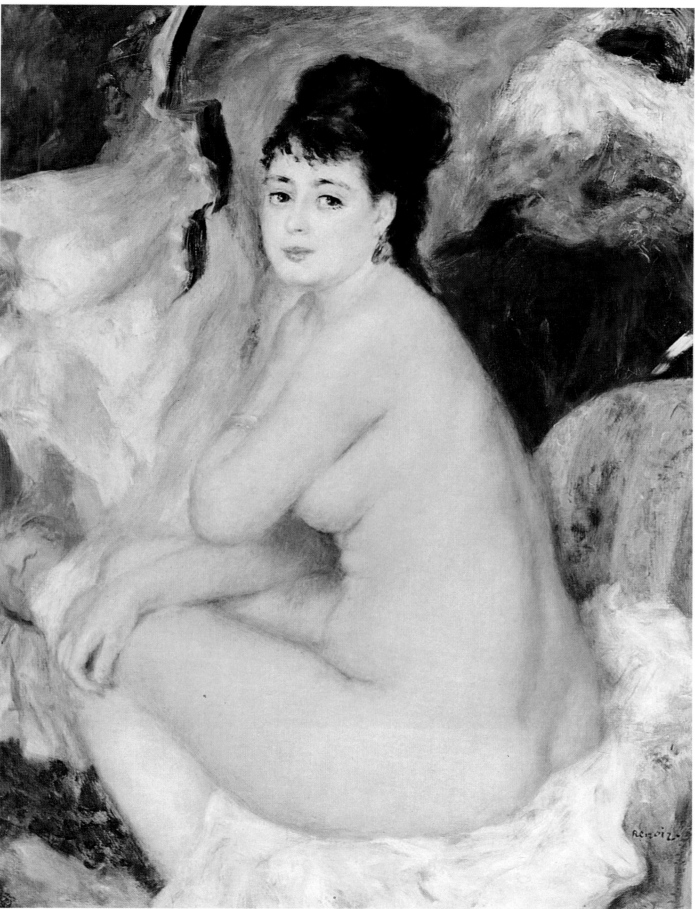

Femme nue or Torse d'Anna

1876 - oil on canvas - 92 x 73 cm -
Pushkin Museum, Moscow

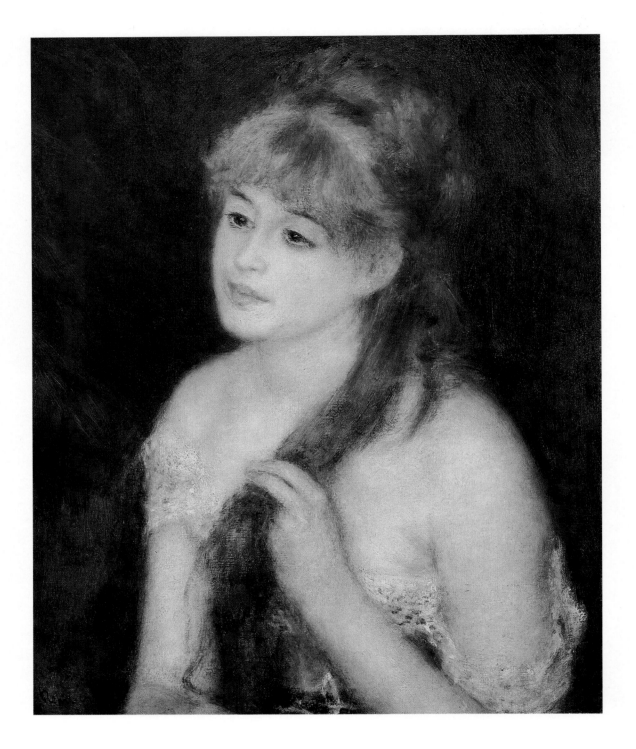

La chevelure or Portrait de Mlle Muller

1876 - oil on canvas - 56 x 46 cm -
National Gallery of Art, Washington, D.C.

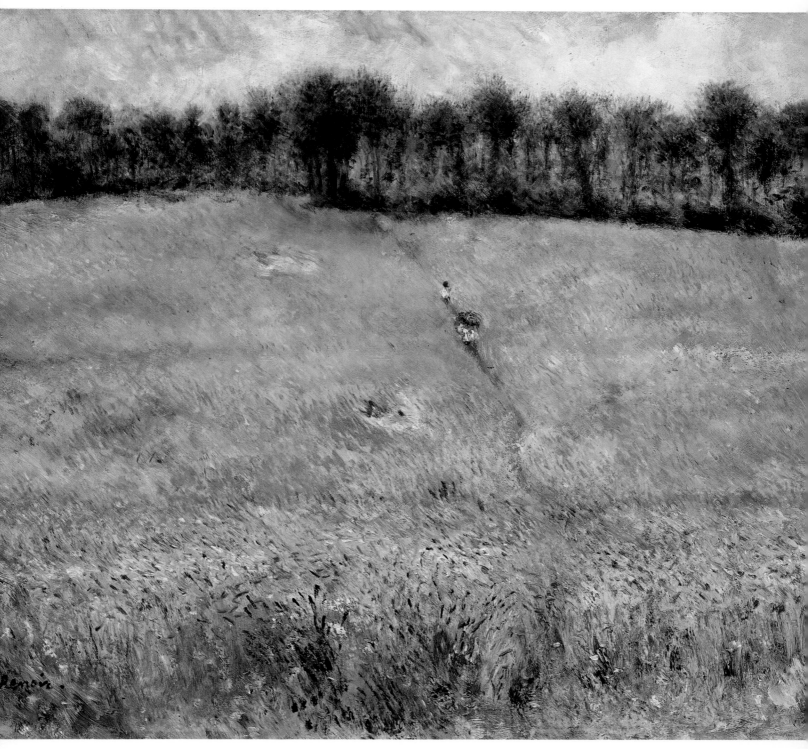

Chemin dans les hautes herbes

c.1876 - oil on canvas - 53.7 x 65 cm -
Private collection

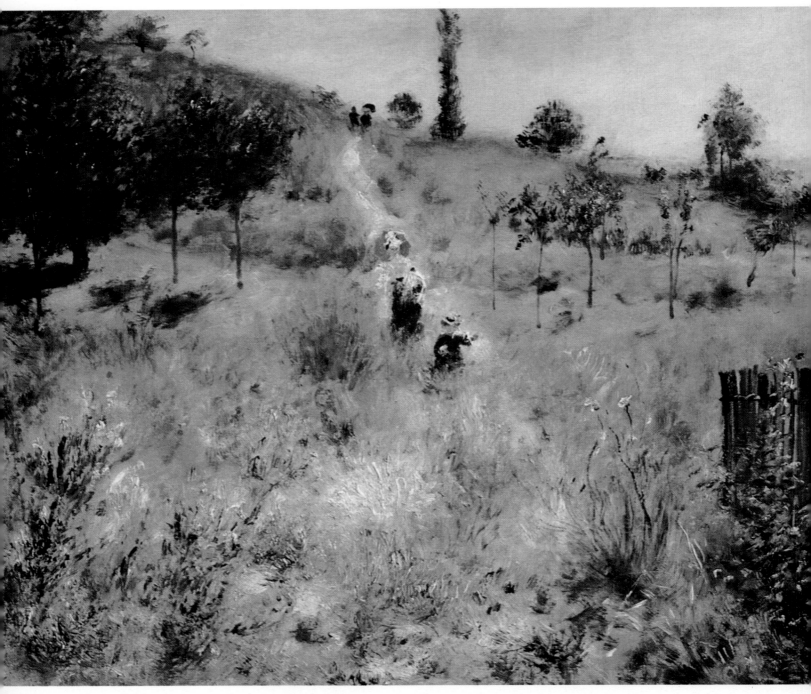

Chemin montant dans les hautes herbes

1876-77 · oil on canvas · 60 x 74 cm ·
Musée d'Orsay, Paris

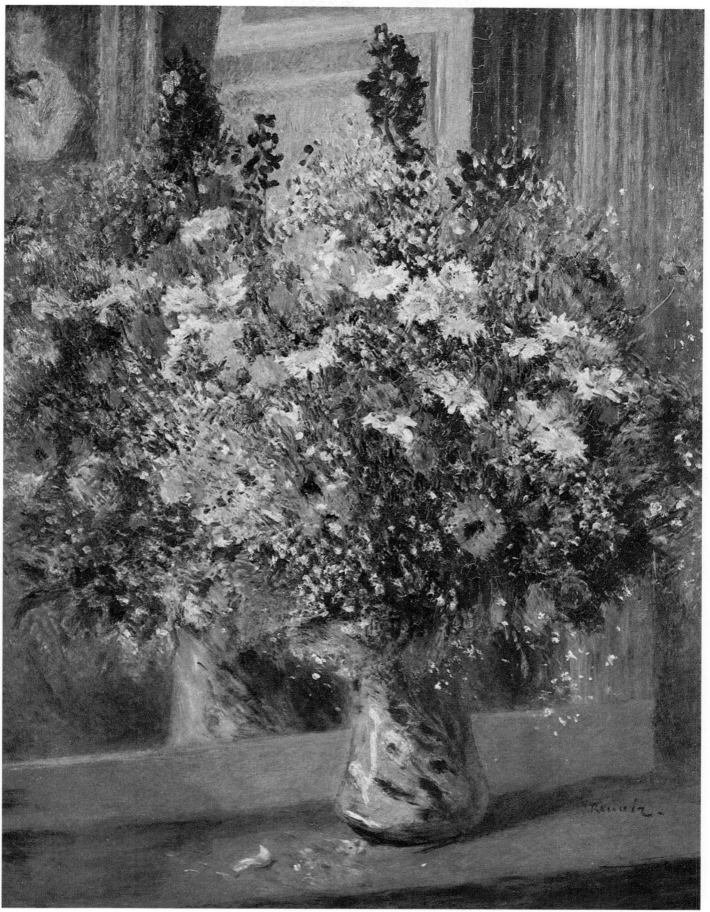

Bouquet devant la glace

1876-77 - oil on canvas - 93 x 72 cm -
Private collection

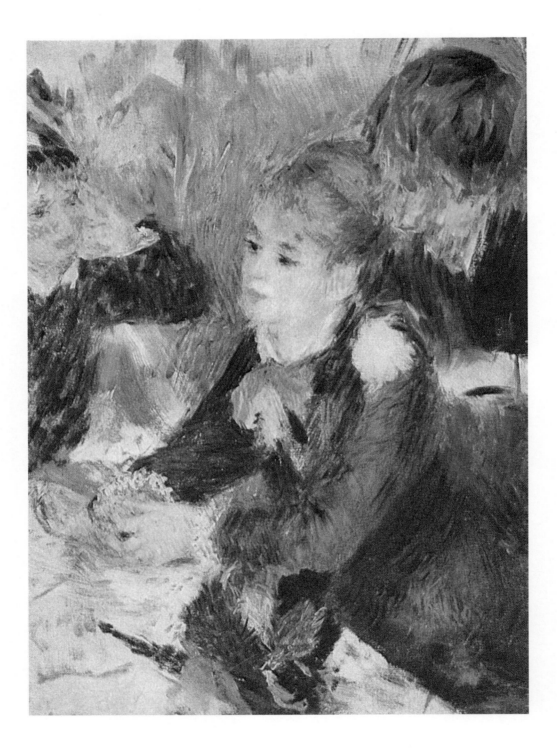

Chez la modiste

c.1876 - oil on canvas - 33 x 23 cm -
Fogg Art Museum, Harvard University, Cambridge, Massachusetts

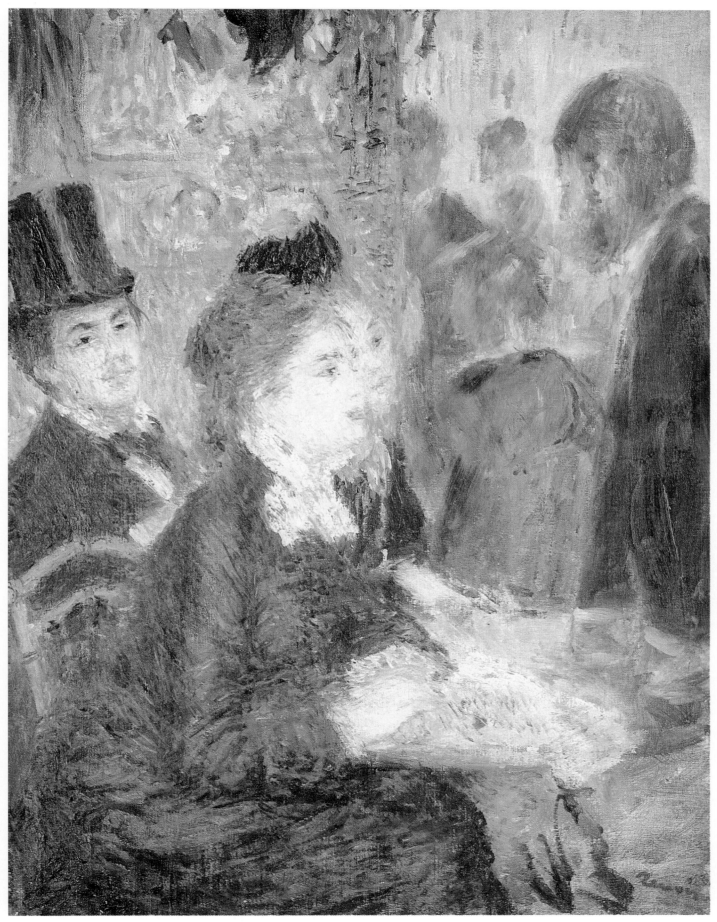

Au café

c.1876-77 - oil on canvas - 35 x 28 cm -
Rijksmuseum Kröller-Müller, Otterlo

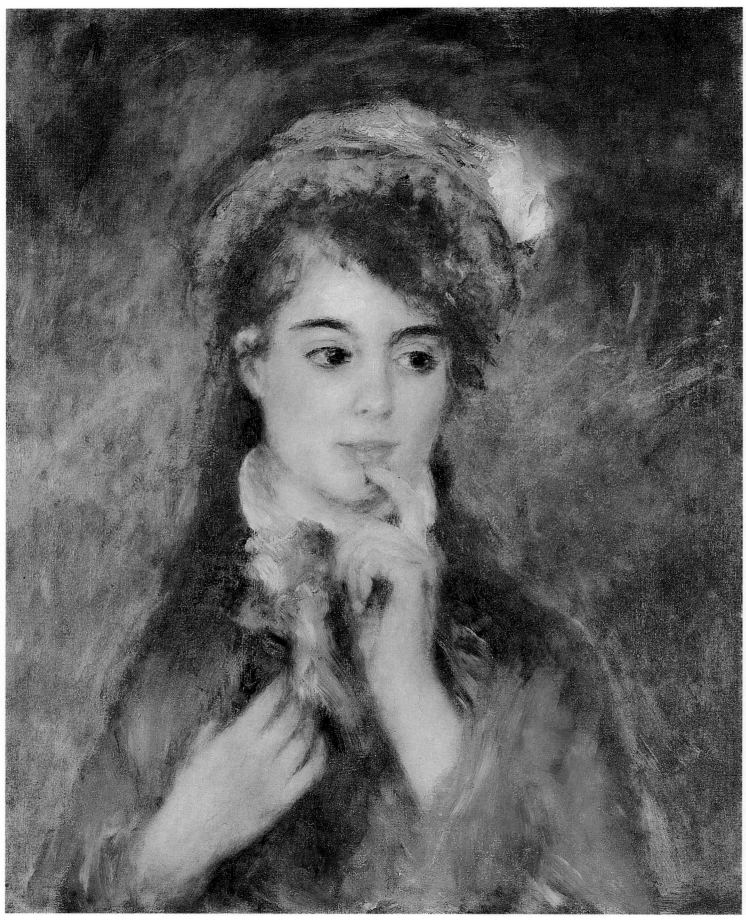

L'ingénue

1877 - oil on canvas - 55 x 46 cm -
Sterling and Francine Clark Art Institute, Williamstown

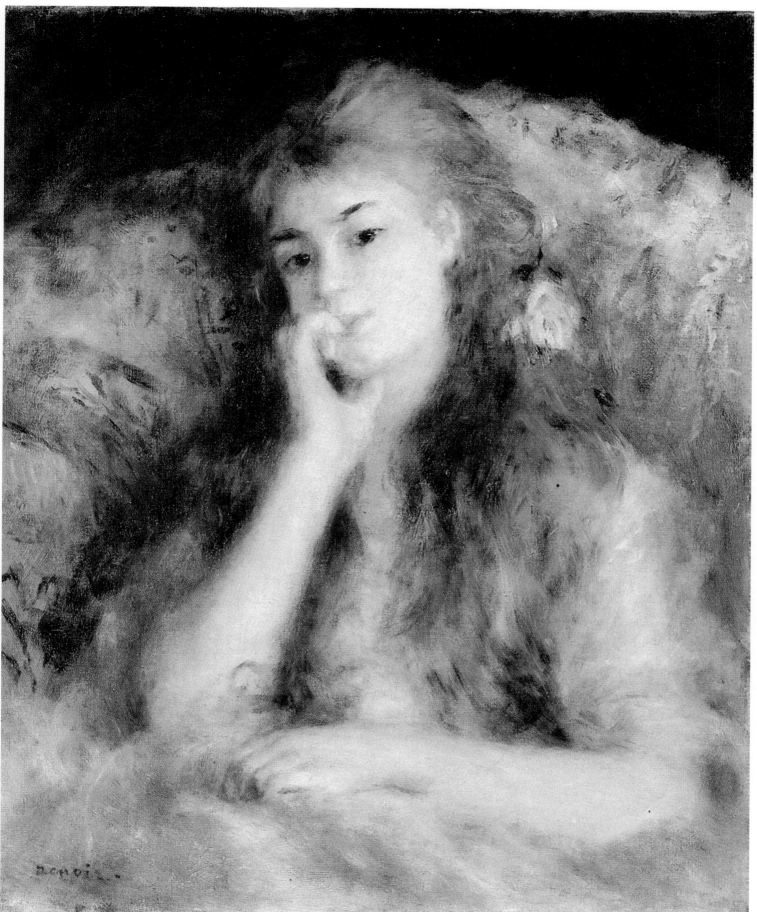

La Pensée

c.1876-77 - oil on canvas - 65 x 55 cm -
London

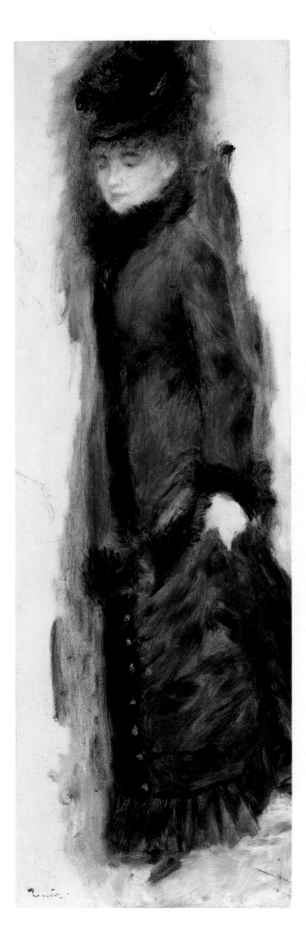

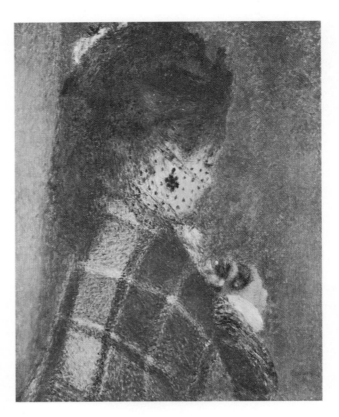

Jeune femme à la voilette

c.1877 - oil on canvas - 61 x 51 cm -
Musée d'Orsay, Paris

Femme relevant sa jupe

1877 - oil on canvas - 68.5 x 22.3 cm -
Private collection

En canot or Jeune fille à la barque
1877 - oil on canvas - 73 x 92 cm -
Private collection

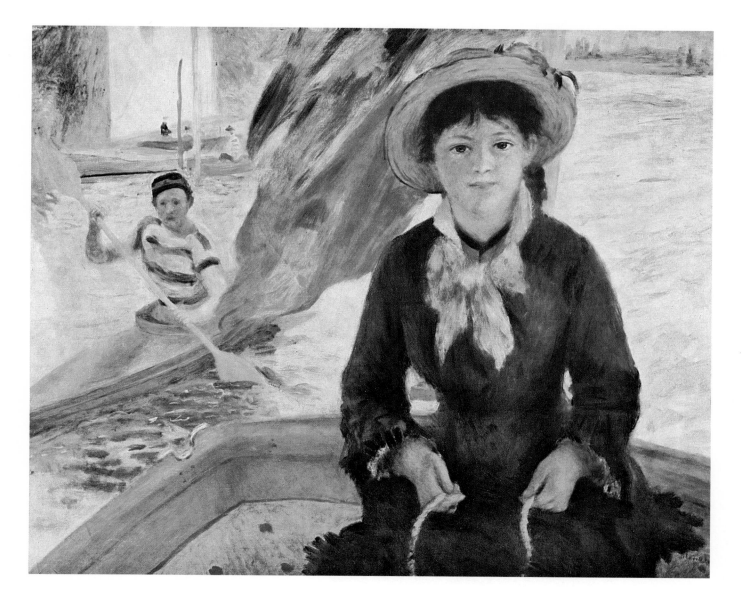

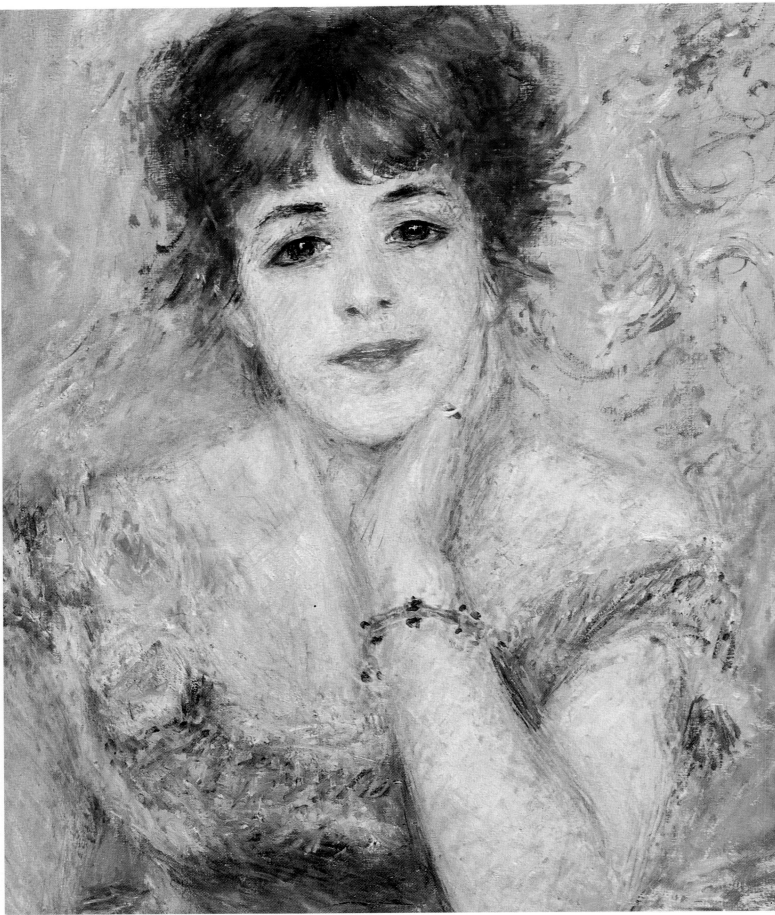

Portrait de Jeanne Samary

1877 - oil on canvas - 56 x 46 cm -
Pushkin Museum, Moscow

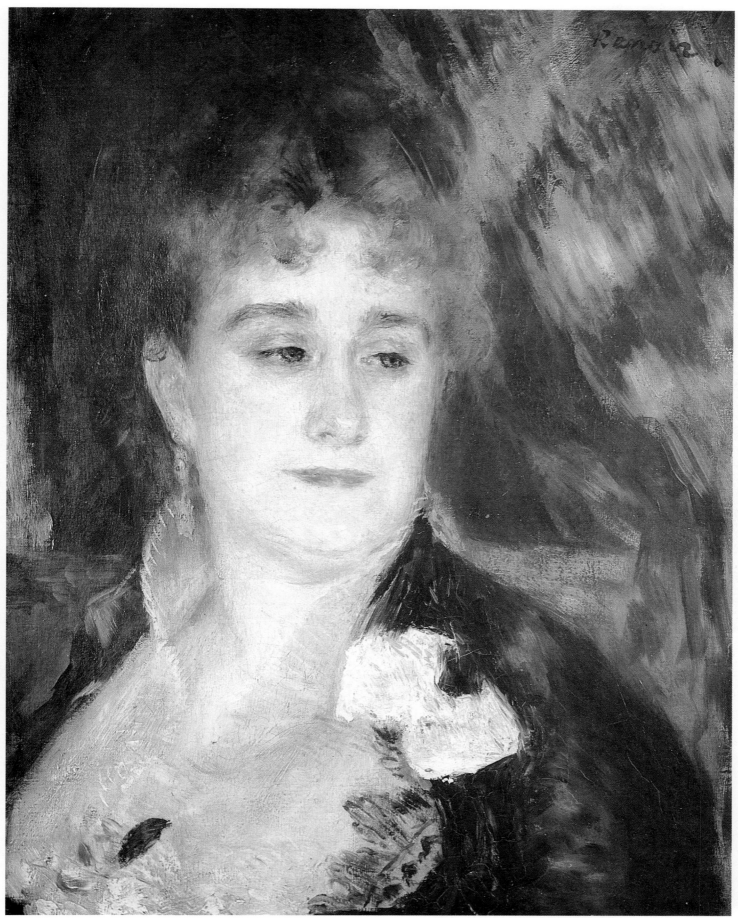

Portrait de Madame Charpentier

1876-77 - oil on canvas - 46 x 38 cm -
Musée d'Orsay, Paris

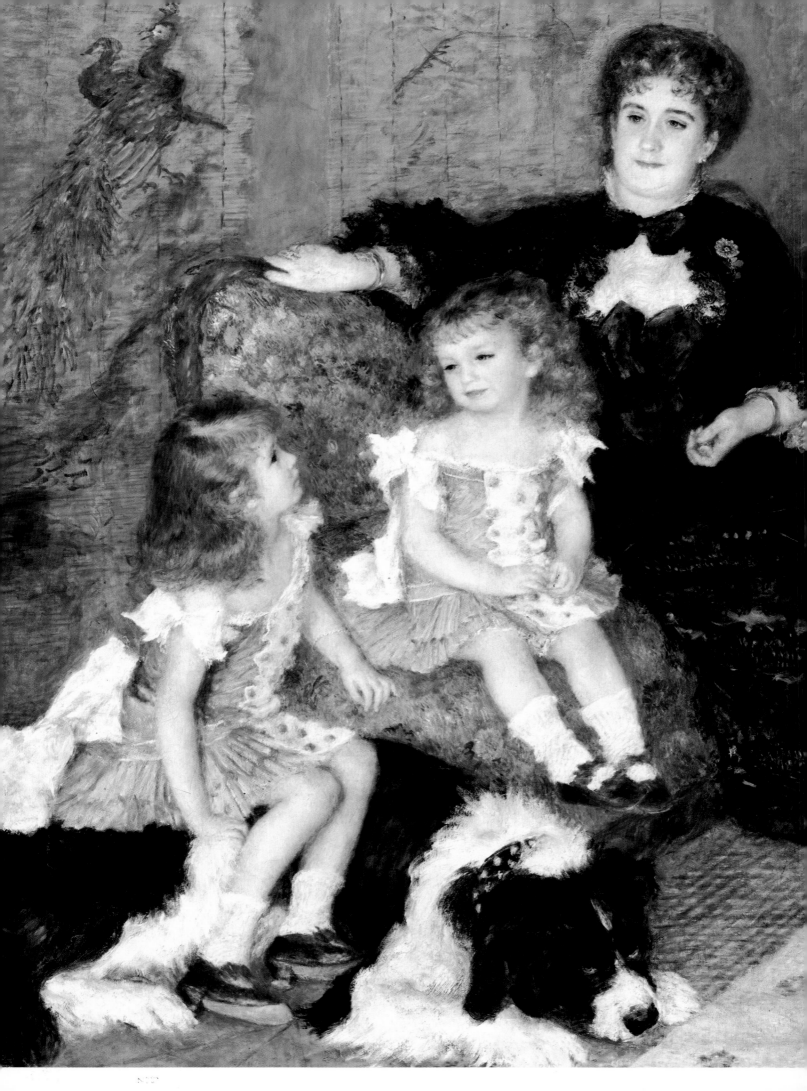

Madame Georges Charpentier
et ses enfants

*1878 - oil on canvas - 154 x 190 cm -
Metropolitan Museum of Art, New York*

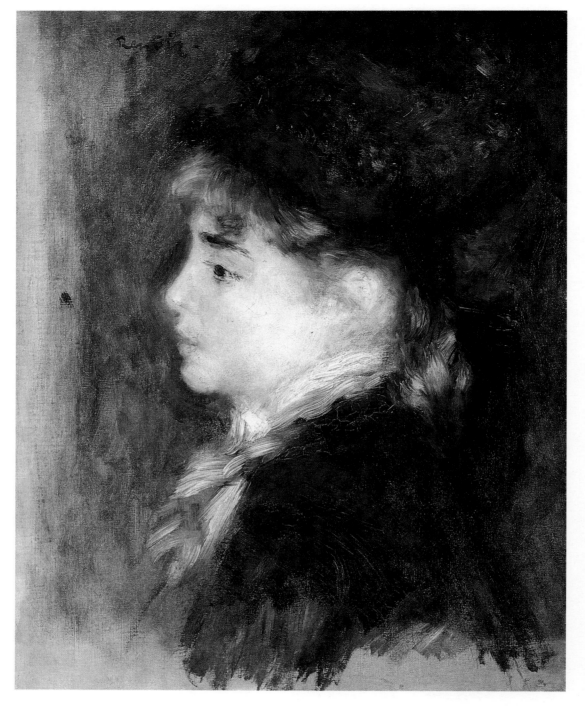

Portrait de Margot

1876-78 - oil on canvas - 46 x 38 cm -
Musée d'Orsay, Paris

Confidence or Les deux inséparables

1878 - oil on canvas - 61 x 50 cm -
Oskar Reinhart Collection, Winterthur

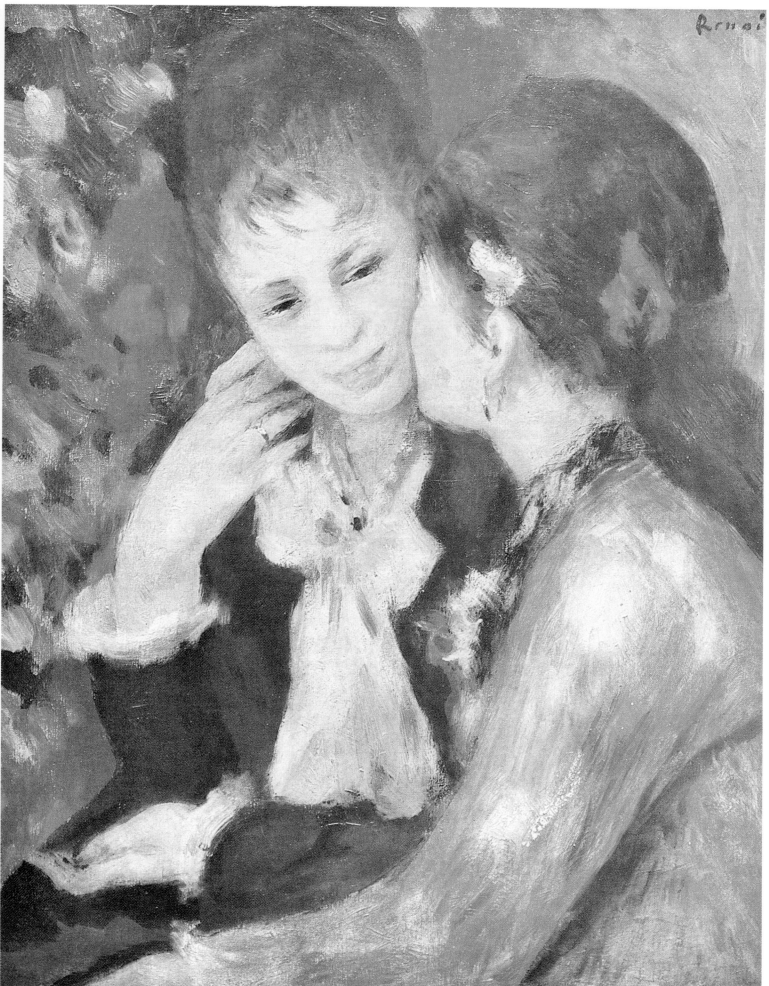

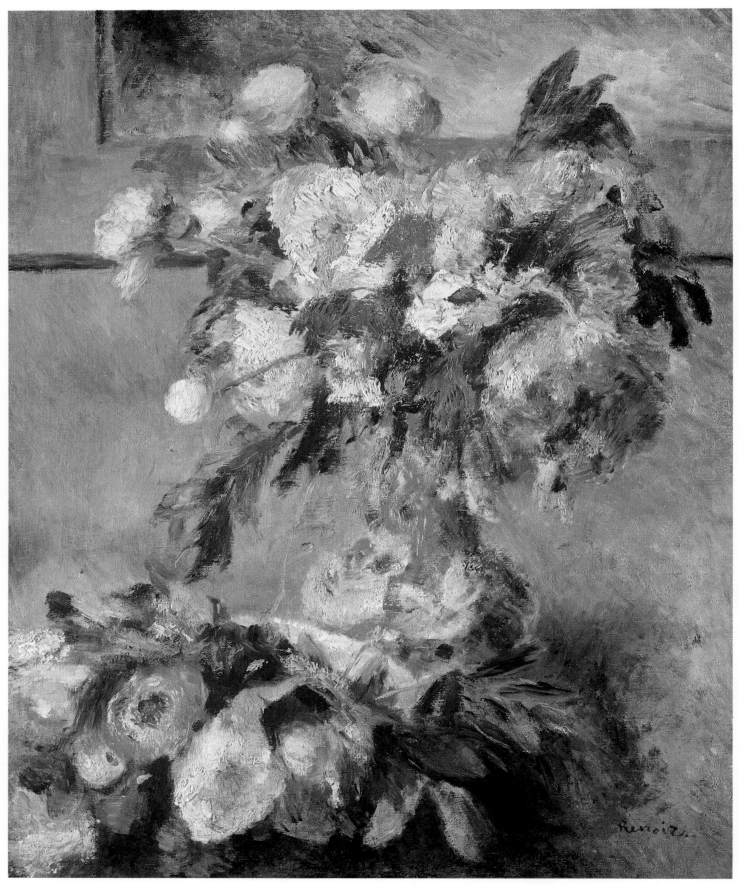

Les pivoines

c.1878 - oil on canvas - 61 x 46 cm -
Private collection

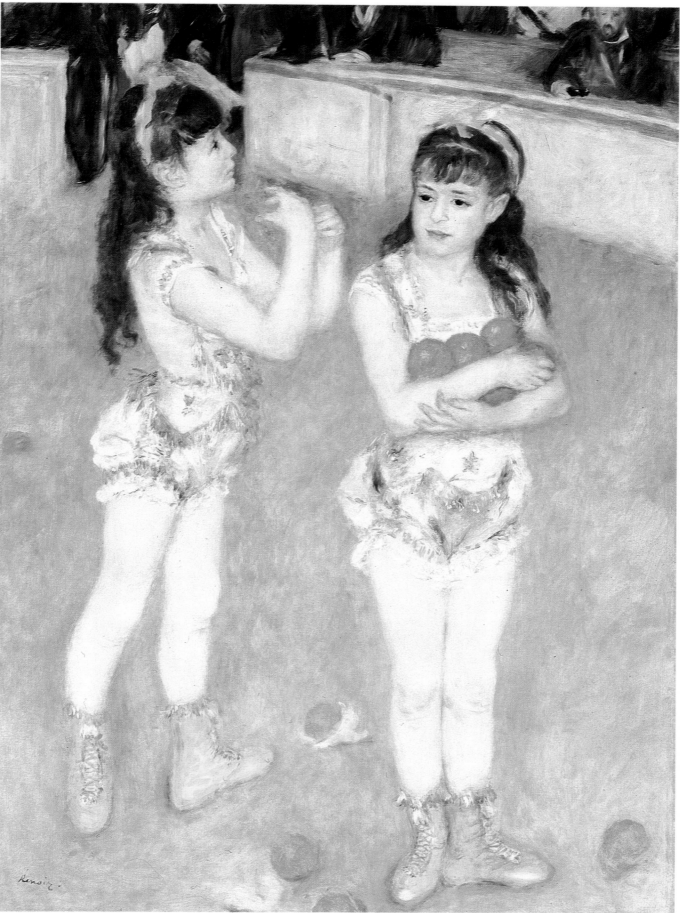

Au cirque Fernando

1879 - oil on canvas - 130 x 98 cm -
Art Institute, Chicago

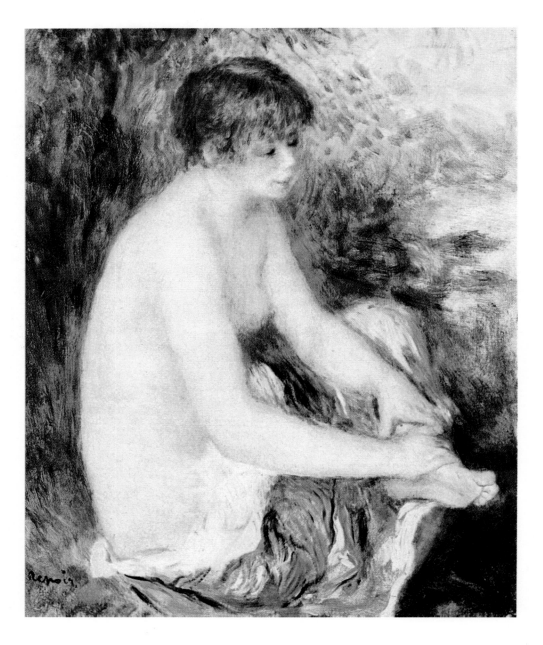

Petit nu bleu

1879 - oil on canvas - 46 x 38 cm -
The Albright-Knox Art Gallery, Buffalo

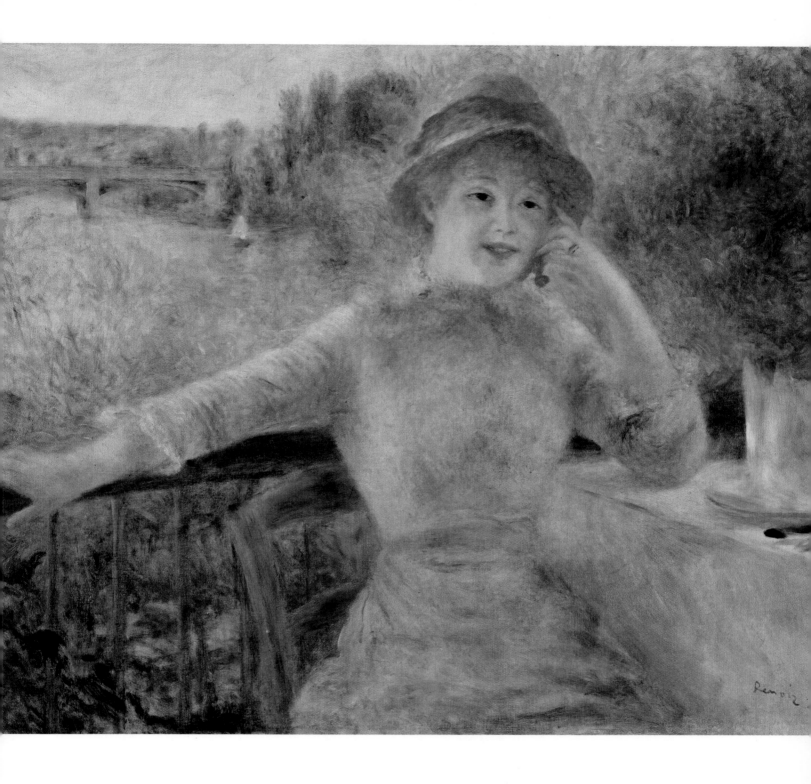

Alphonsine Fournaise dans l'île de Chatou

1879 · oil on canvas · 71 x 92 cm ·
Musée d'Orsay, Paris

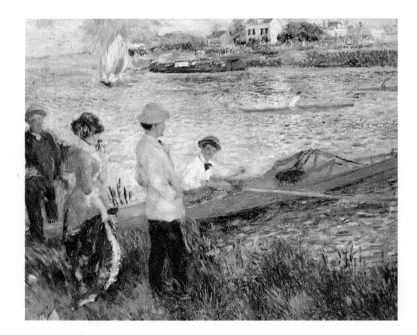

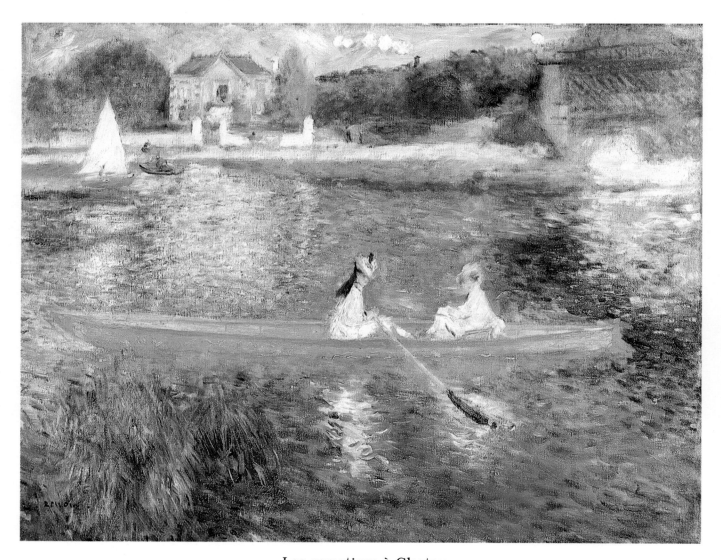

Les canotiers à Chatou

1879 - oil on canvas - 81 x 100 cm -
National Gallery of Art, Washington, D.C.

La Seine à Asnières, also called La yole

1879 - oil on canvas - 71 x 92 cm -
National Gallery, London

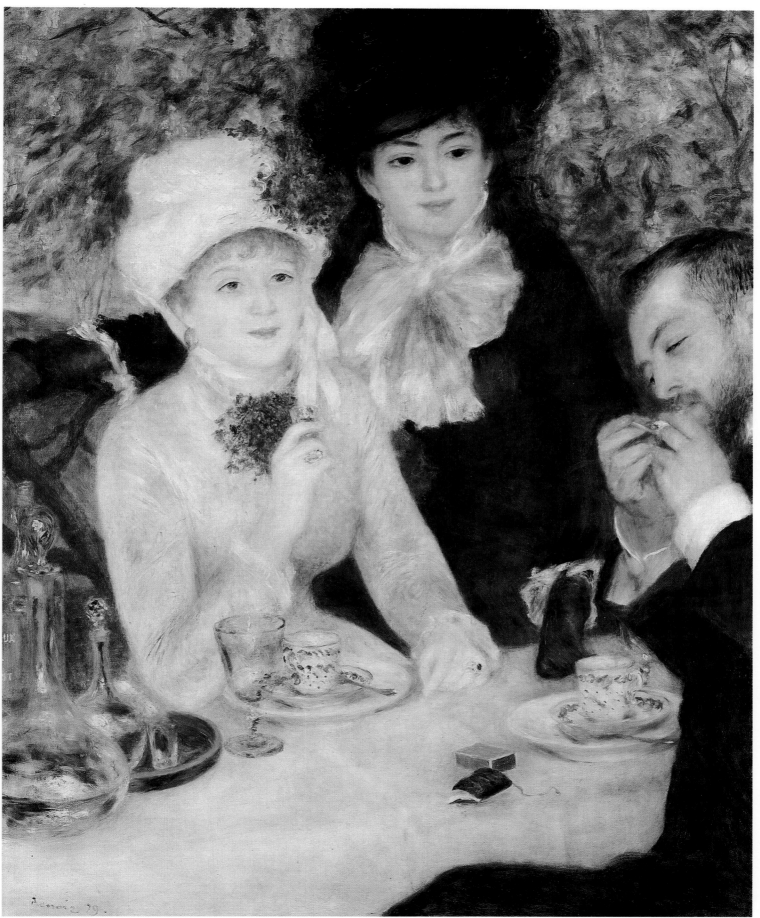

La fin du déjeuner

1879 - oil on canvas - 100 x 82 cm -
Städelsches Kunstinstitut, Frankfurt

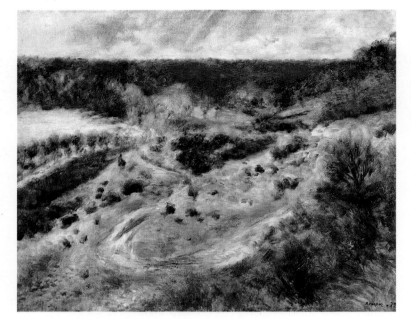

Paysage à Wargement

1879 - oil on canvas - 80 x 100 cm -
The Toledo Museum of Art, Toledo

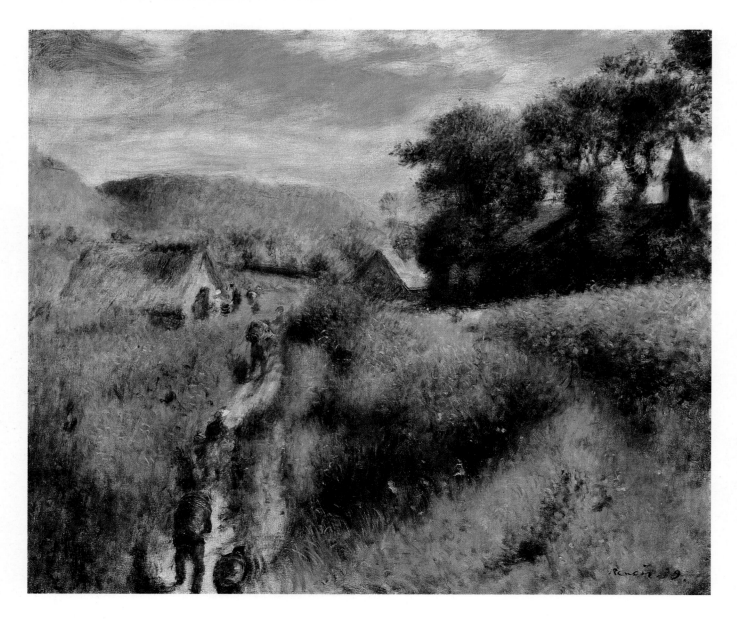

Les vendangeurs

1879 - oil on canvas - 54.2 x 65.4 cm -
National Museum of Art, Washington, D.C.

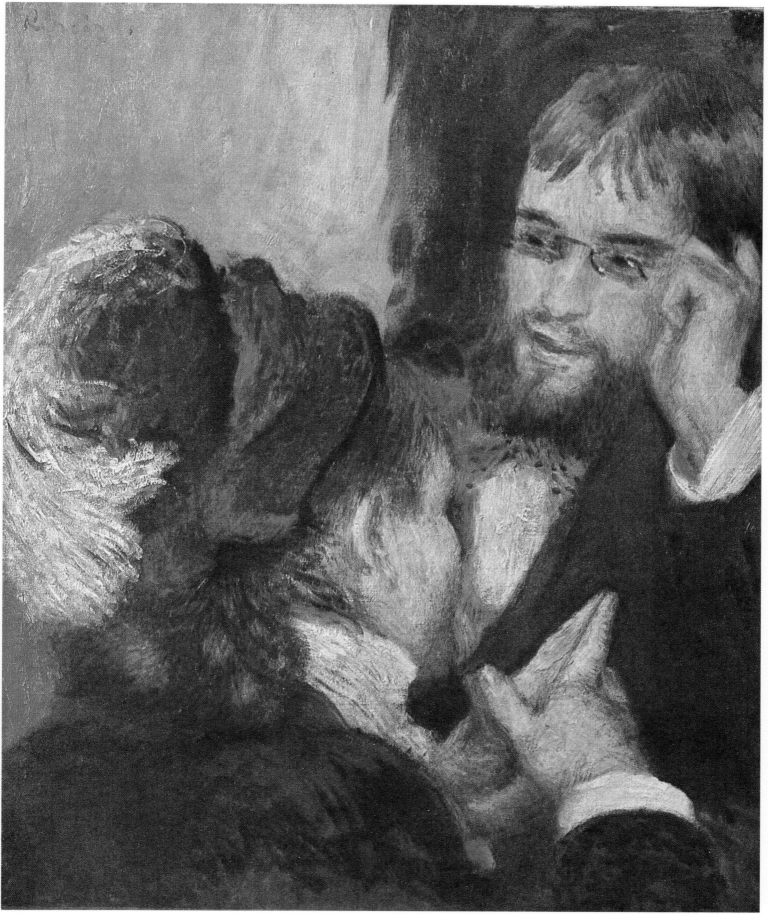

Causerie

1879 - oil on canvas - 45 x 38 cm -
Nationalmuseum, Stockholm

Autoportrait

1879 - oil on canvas - 19 x 14 cm -
Musée d'Orsay, Paris

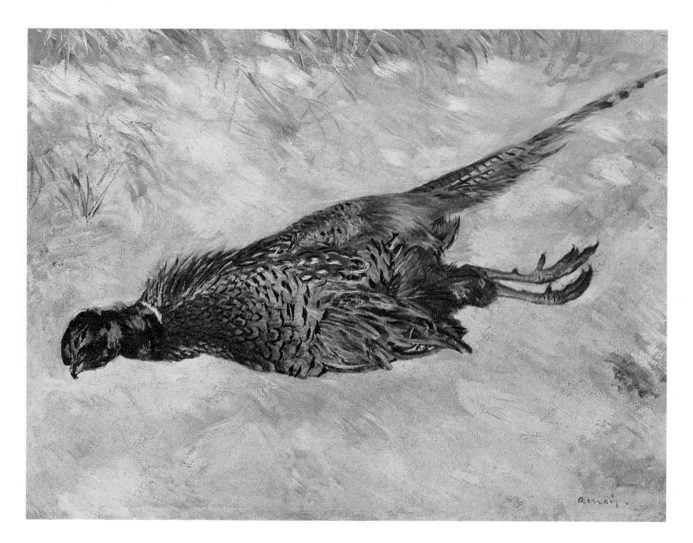

Le faisan sur la neige

1879 - oil on canvas - 46x 64 cm -
Private collection

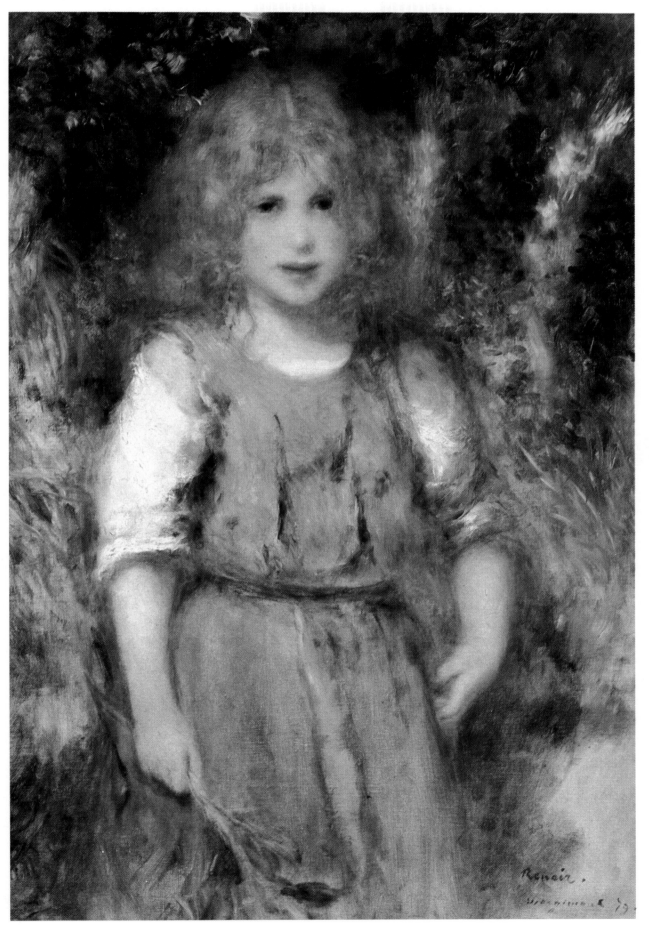

La petite bohémienne

1879 - oil on canvas - 73 x 54 cm -
Private collection

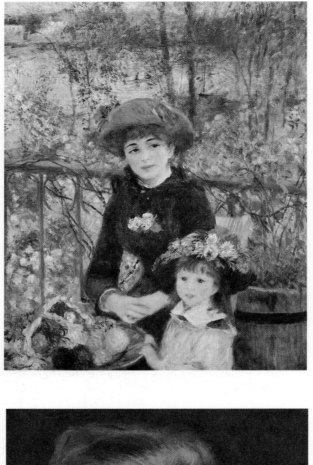

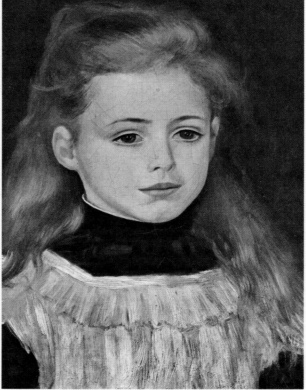

Sur la terrasse

1879 - oil on canvas - 62 x 50 cm -
Art Institute of Chicago

Portrait de Lucie Bérard
(Fillette au tablier blanc)

1879 - oil on canvas - 35 x 27 cm -
Private collection

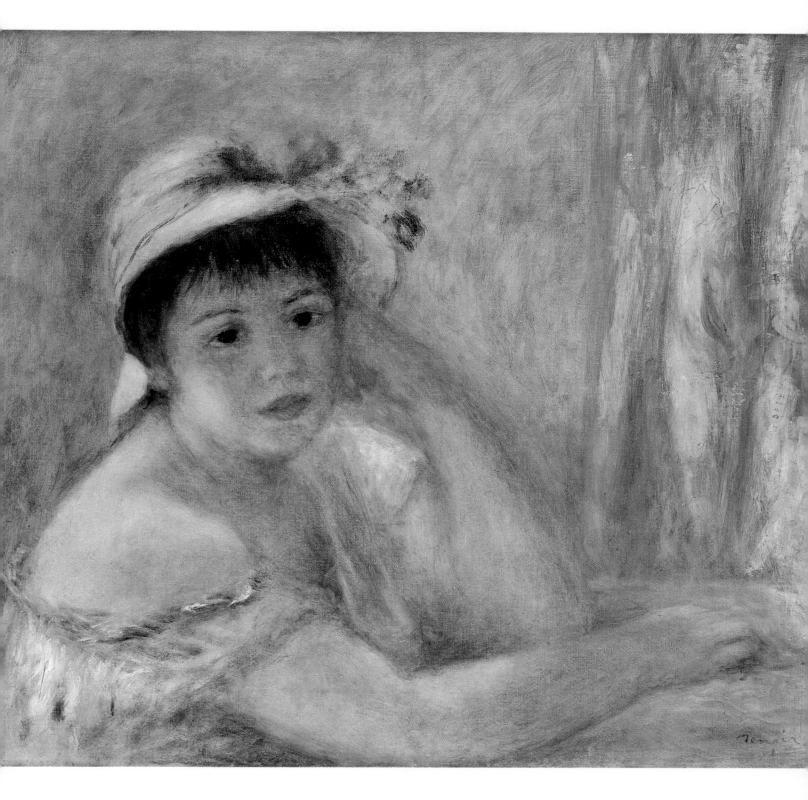

Femme au chapeau de paille
(Mlle Alphonsine Fournaise)

1880 - oil on canvas - 50 x 61 cm -
Private collection

193

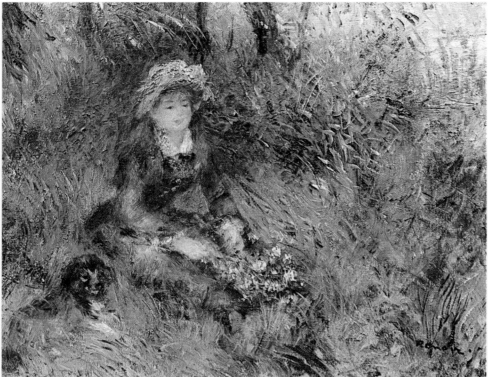

Madame Renoir au chien

*1880 - oil on canvas - 32 x 41 cm -
Private collection*

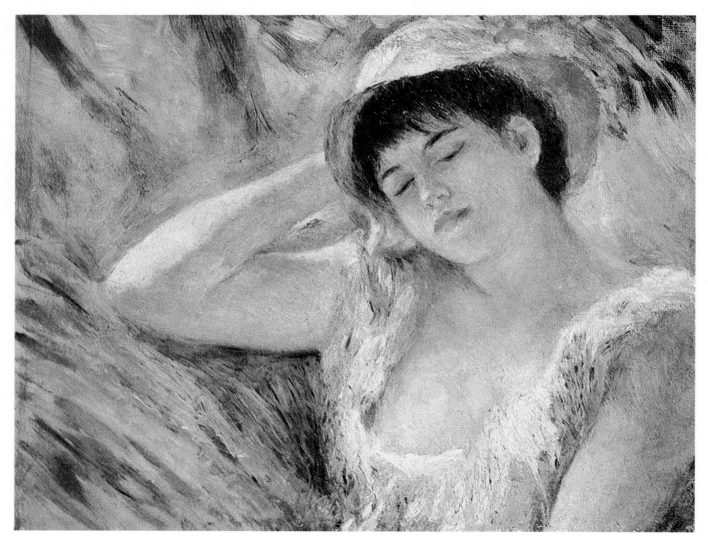

La dormeuse

*1880 - oil on canvas - 49 x 60 cm -
Private collection*

Jeune fille endormie also called
La femme au chat

1880 - oil on canvas -120 x 94 cm -
Sterling and Francine Clark Art Institute, Williamstown

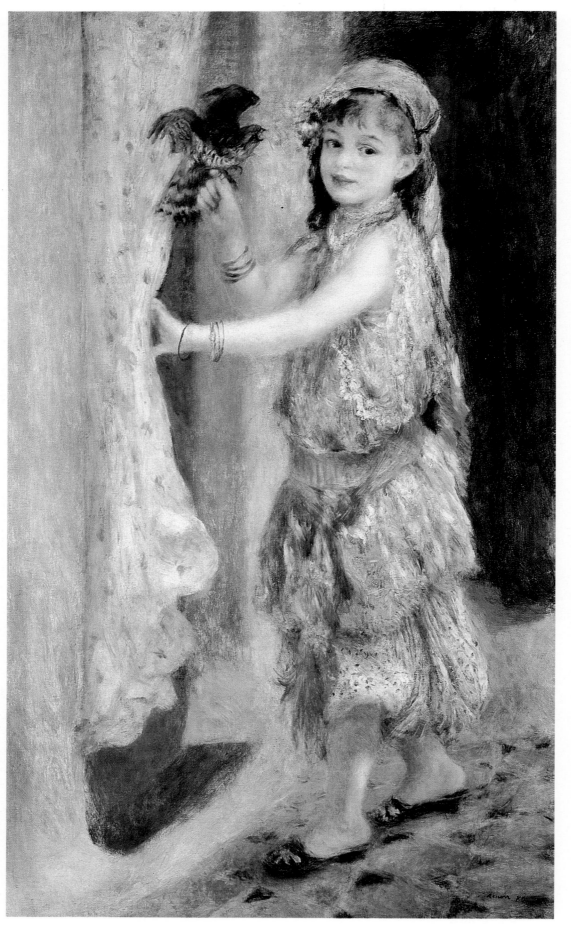

La fillette au faucon
1880 - oil on canvas - 126 x 78 cm -
Sterling and Francine Clark Art Institute, Williamstown

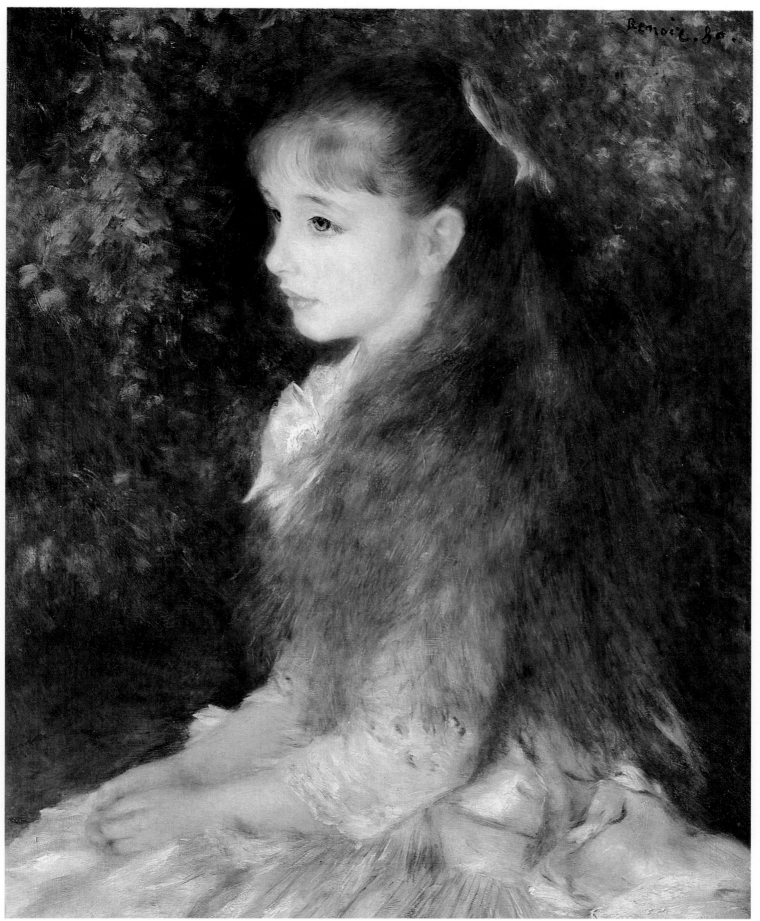

Irène Cahen d'Anvers

1880 - oil on canvas - 65 x 54 cm -
Bührle Collection, Zürich

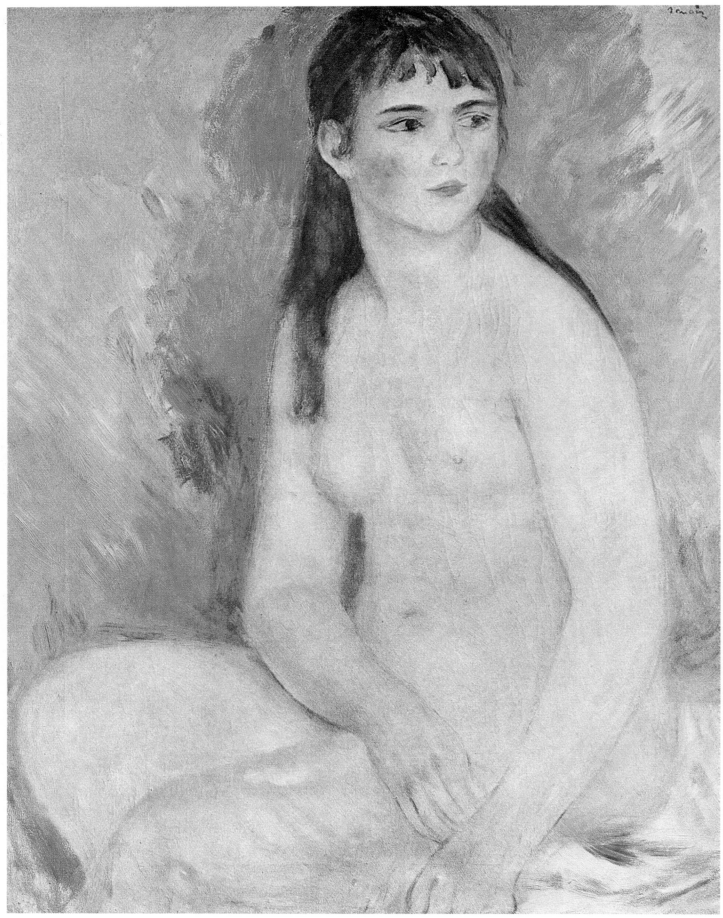

Nu
1880 - oil on canvas - 80 x 65 cm -
Musée Rodin, Paris

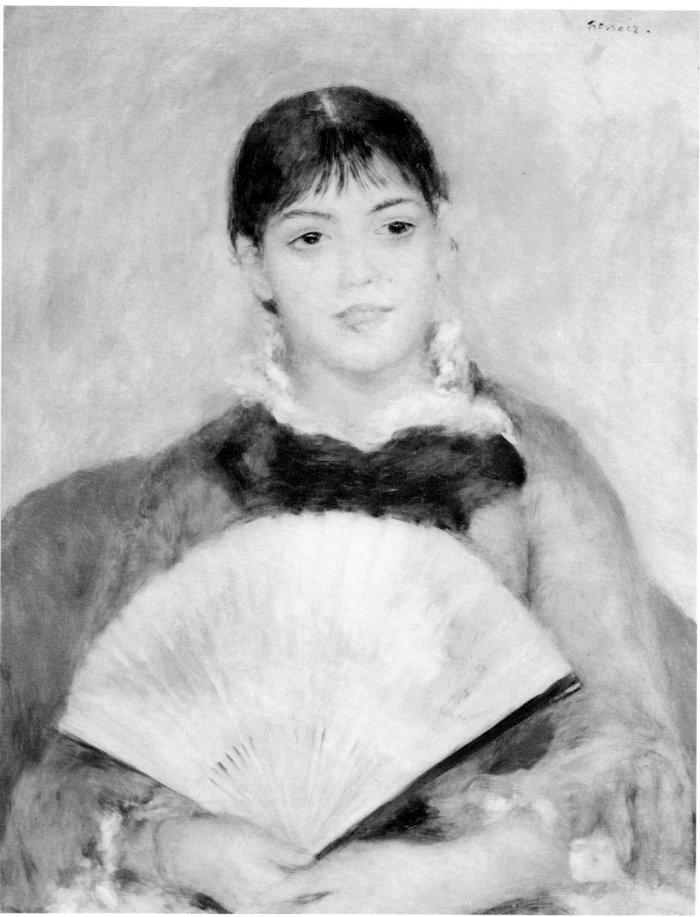

Femme à l'éventail

c.1880 - oil on canvas - 65 x 50 cm -
Hermitage, St. Petersburg

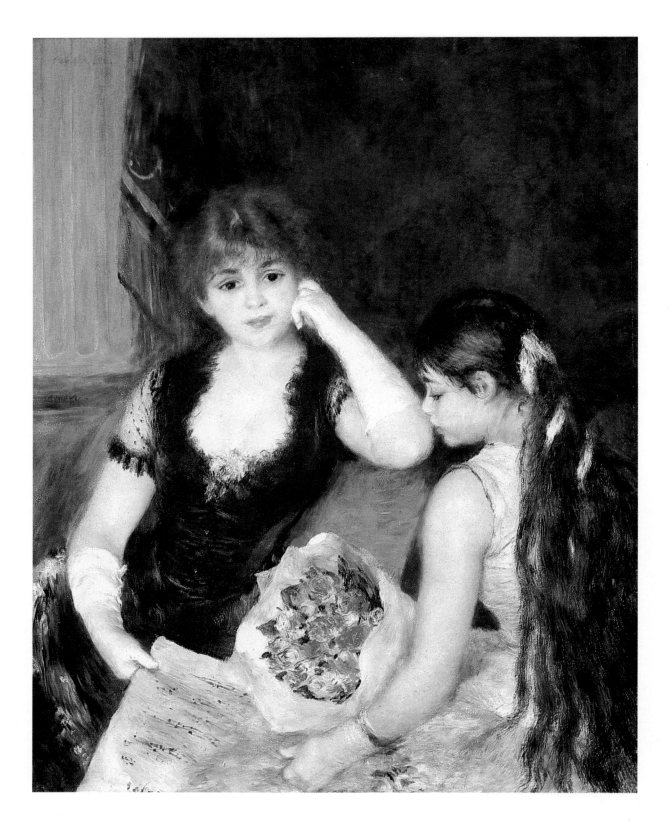

Une loge à l'Opéra also called Dans la loge
or Au concert

1880 - oil on canvas - 99 x 80 cm -
Sterling and Francine Clark Art Institute, Williamstown

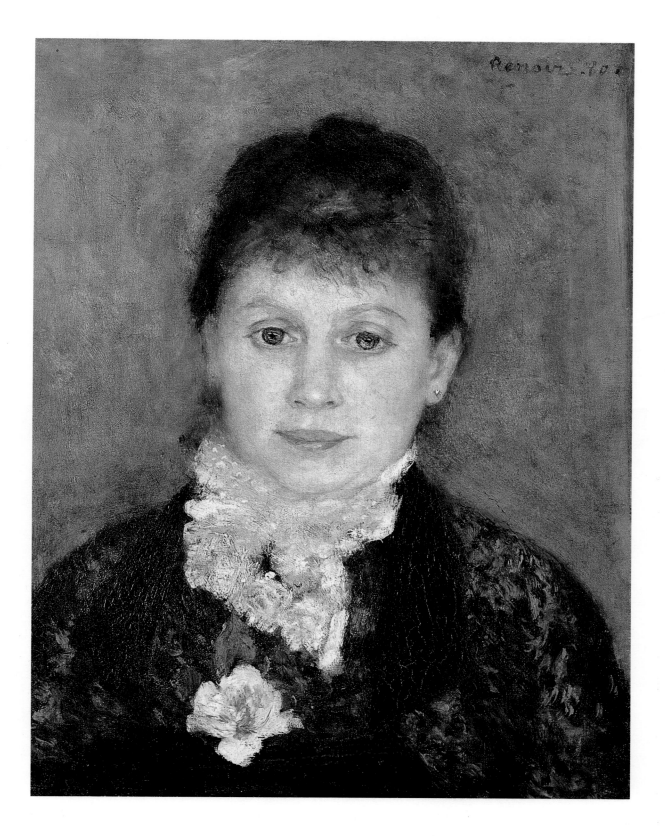

Femme au jabot blanc

1880 - oil on canvas - 46 x 37 cm -
Musée d'Orsay, Paris

Les canotiers also called
Le déjeuner au bord de la rivière

1879-80 - oil on canvas - 55 x 66 cm -
Art Institute, Chicago

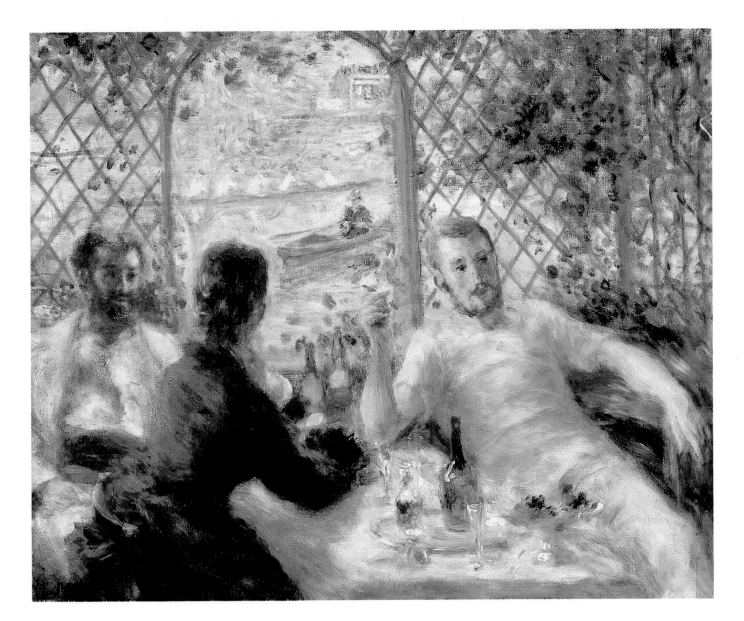

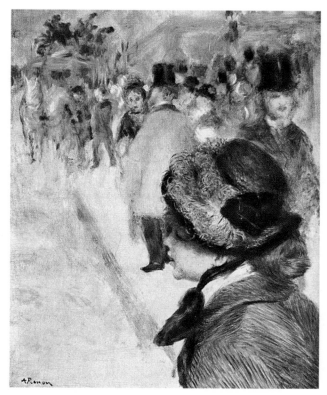

Place Clichy

c.1880 - oil on canvas - 65 x 54 cm -
Fitzwilliam Museum, Cambridge

Jeune femme lisant un journal illustré

c.1880 - oil on canvas - 46 x 56 cm -
Museum of Art, Providence

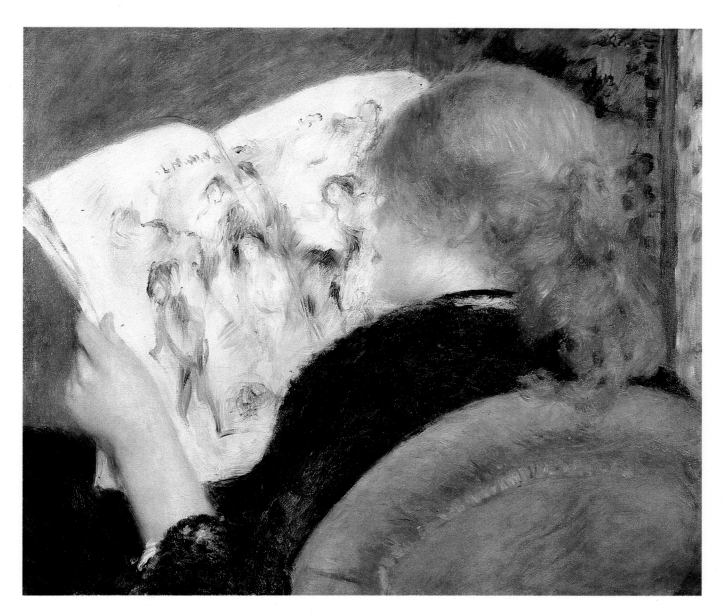

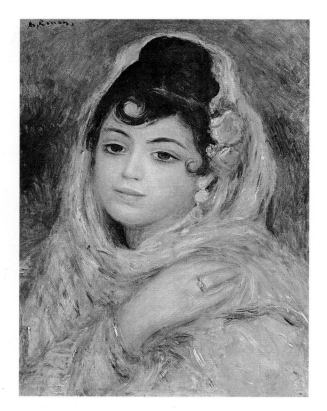

Femme algérienne

1881 - oil on canvas - 40 x 32 cm -
The Solomon R. Guggenheim Foundation
The Tannhauser Foundation, New York

Fête arabe à Alger or La Casbah

1881 - oil on canvas - 73 x 92 cm -
Musée d'Orsay, Paris

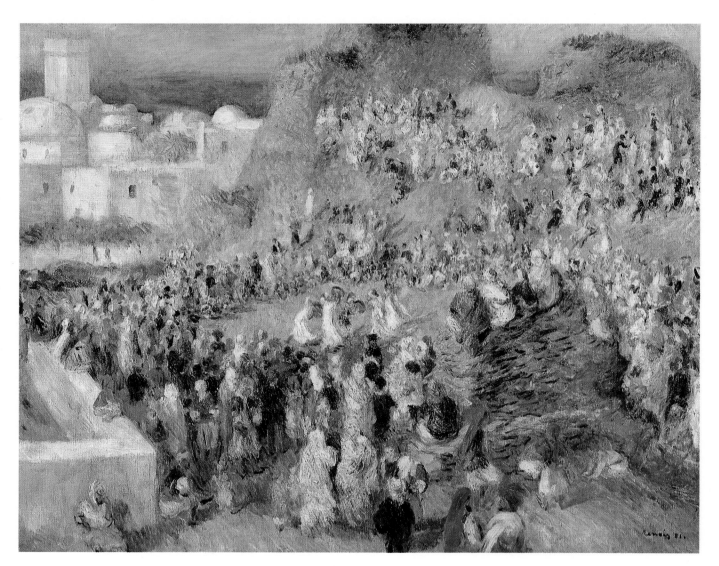

Le champ des bananiers

1881 - oil on canvas - 51.5 x 63.5 cm -
Musée d'Orsay, Paris

Paysage algérien or

Le ravin de la femme sauvage
1881 - oil on canvas - 65 x 81 cm -
Musée d'Orsay, Paris

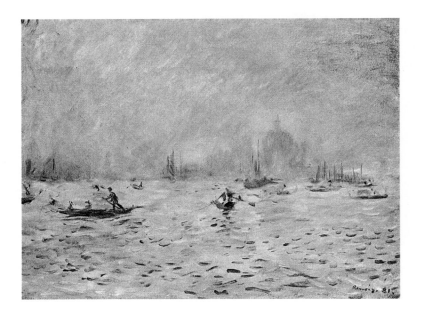

Venise, brouillard

1881 - oil on canvas - 45 x 63 cm -
Kreeger Collection, Washington, D.C.

Le Vésuve

1881 - oil on canvas - 58 x 81 cm -
Sterling and Francine Clark Art Institute, Williamstown

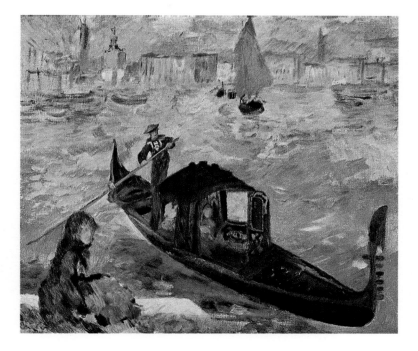

Gondole à Venise
1881 - oil on canvas - 54 x 65.5 cm -
Private collection

La place San Marco, Venise
1881 - oil on canvas - 65 x 81 cm -
Institute of Art, Minneapolis

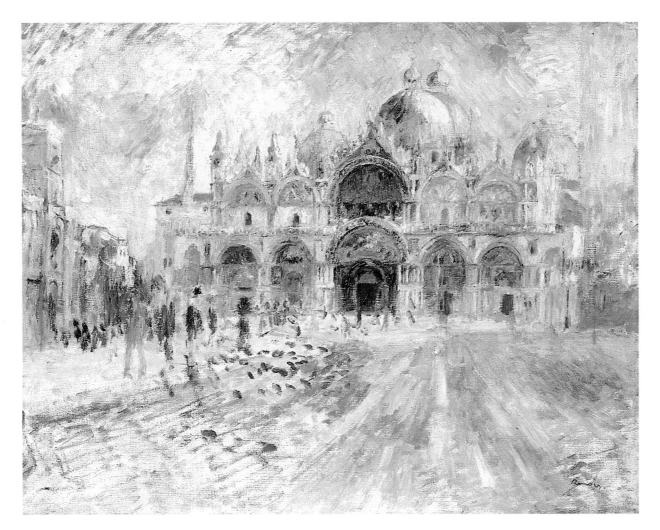

Le déjeuner des canotiers (detail)

Le déjeuner des canotiers

*1881 - oil on canvas - 130 x 173 cm -
The Phillips Collection, Washington, D.C.*

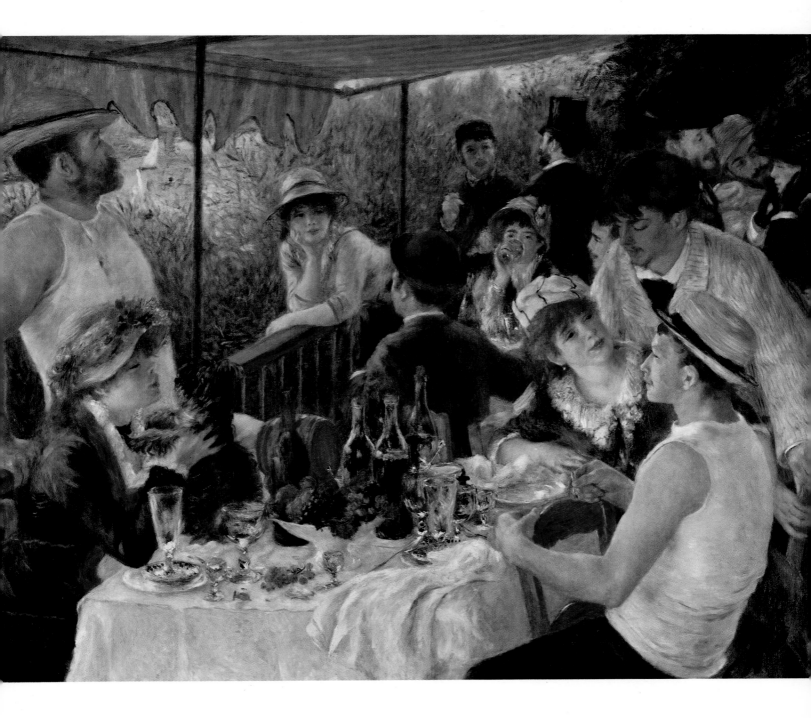

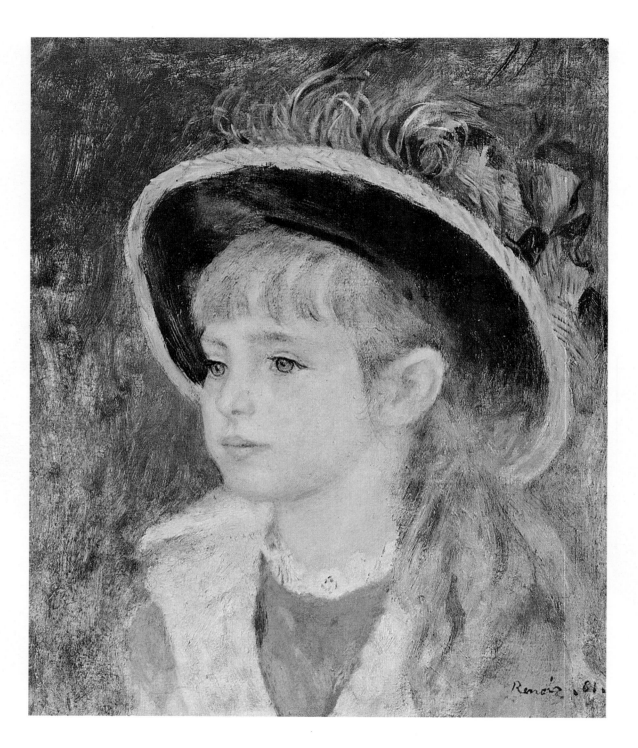

Fillette au chapeu bleu

1881 - oil on canvas - 40 x 35 cm -
Private collection

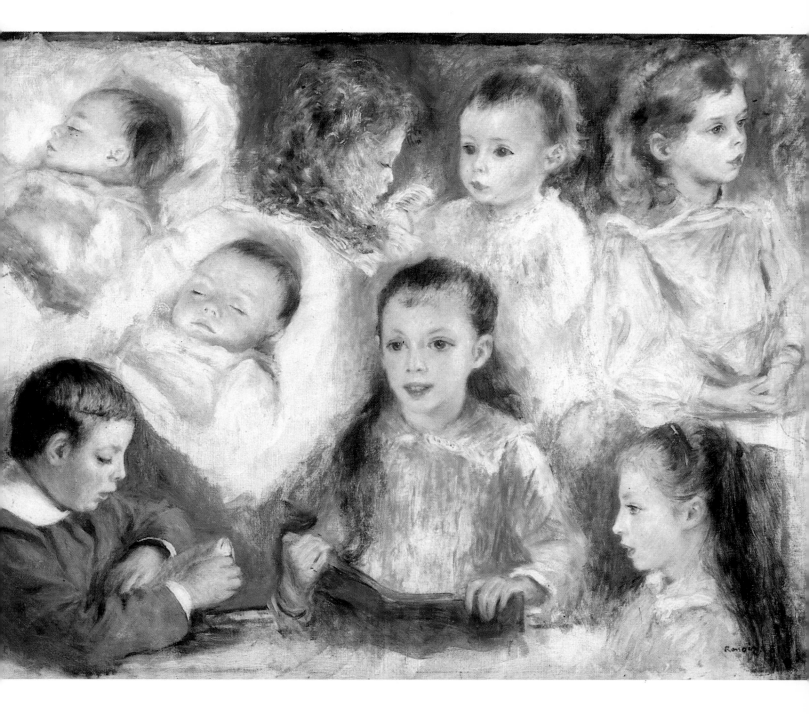

Croquis de têtes (Les enfants Bérard)

1881 · oil on canvas · 62 x 83 cm ·
Sterling and Francine Clark Art Institute, Williamstown

Oignons

1881 - oil on canvas - 39 x 60 cm -
Sterling and Francine Clark Art Institute, Williamstown

Les fruits du midi

1881 - oil on canvas - 51 x 68.5 cm -
Mr. & Mrs. Martin A. Ryerson Collection,
Art Institute, Chicago

Géraniums et chats

1881 - oil on canvas - 91 x 73 cm -
Private collection

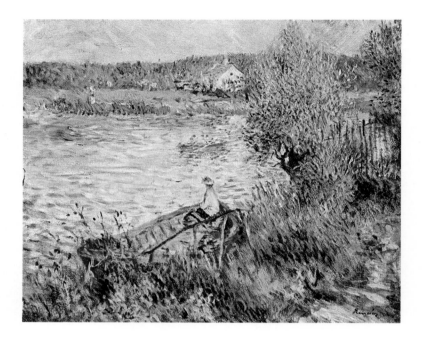

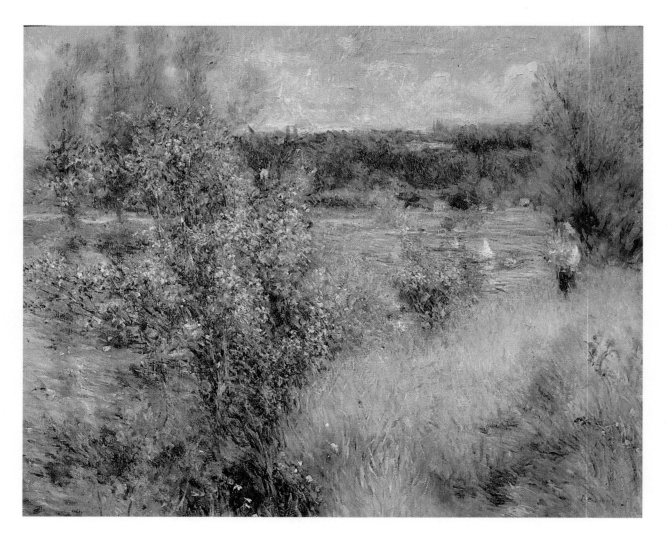

Canotiers sur la Seine à Bougival

1881 - oil on canvas - 54 x 65 cm -
Private collection

La Seine à Chatou

1881 - oil on canvas - 74 x 93 cm -
Museum of Fine Arts, Boston

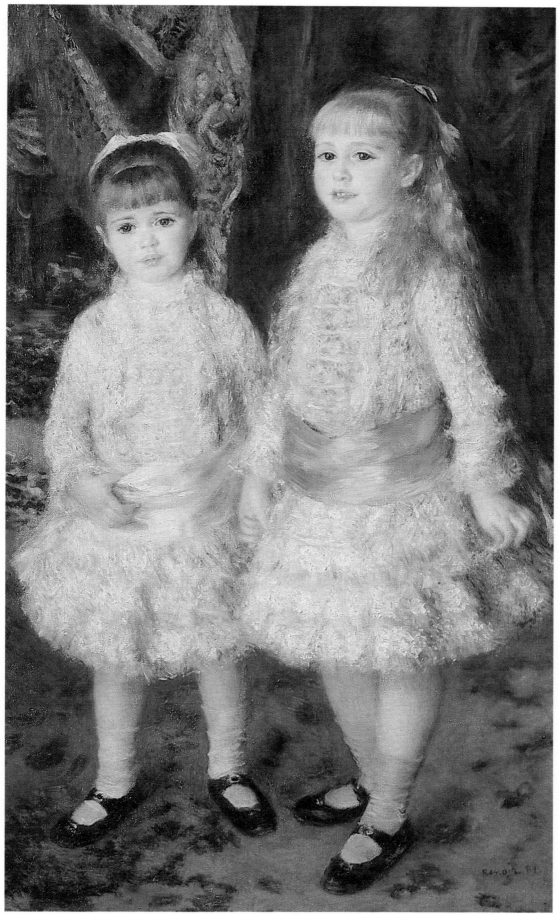

Les demoiselles Cahen d'Anvers
1881 - oil on canvas - 119 x 74 cm -
Museu de Arte, Sao Paulo

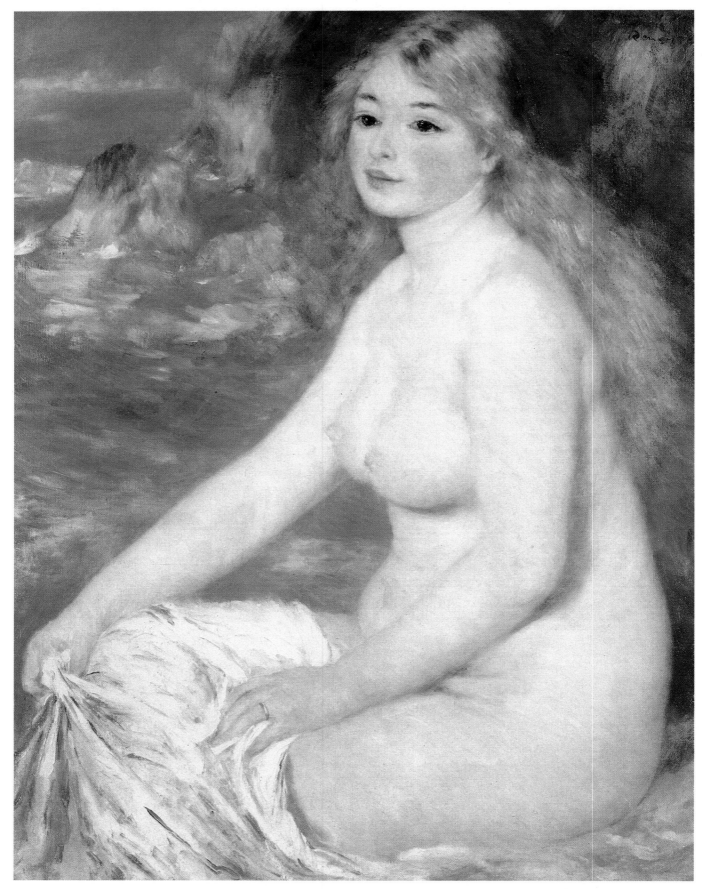

Baigneuse (so called Baigneuse blonde I)

1881 - oil on canvas - 82 x 66 cm -
Sterling and Francine Clark Art Institute, Williamstown

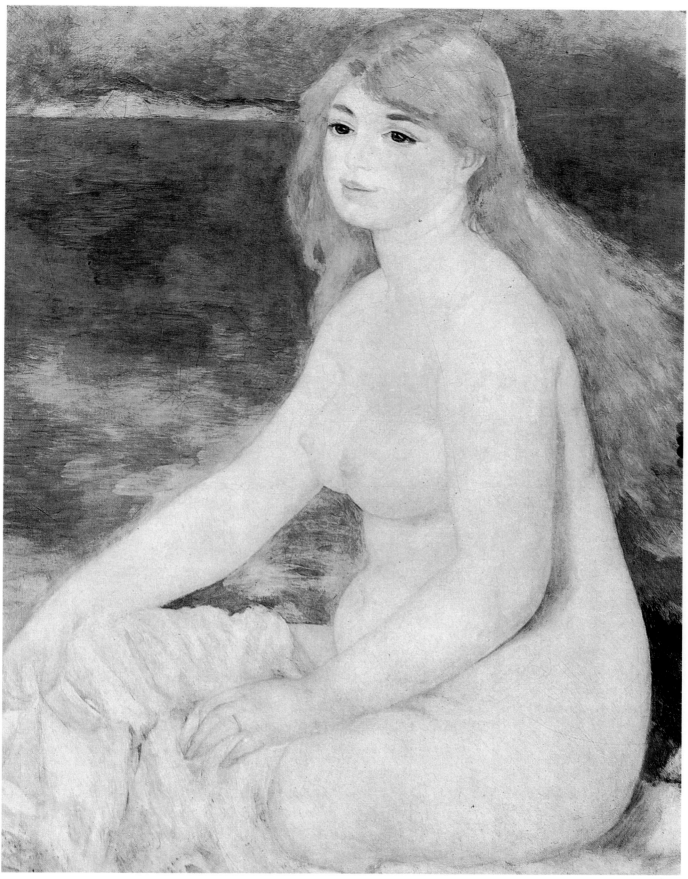

Baigneuse (so called Baigneuse blonde II)

*1881 - oil on canvas - 90 x 63 cm -
Private collection*

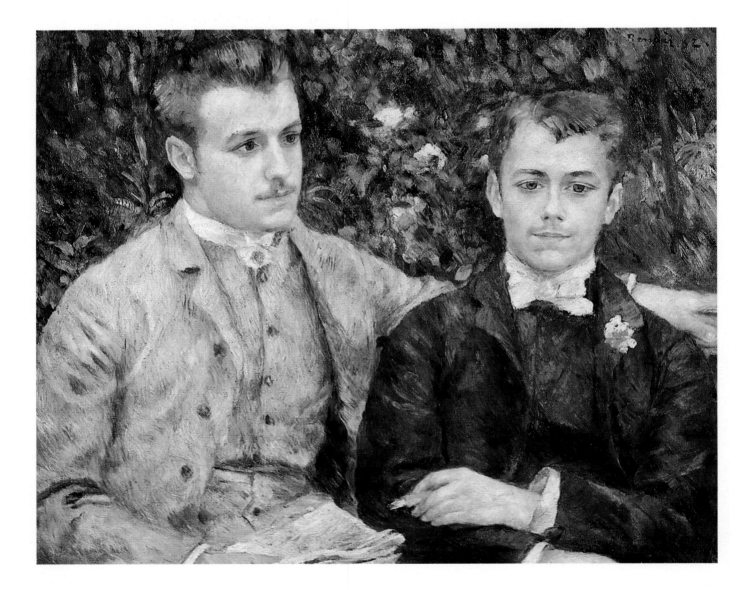

Charles et Georges Durand-Ruel

1882 - oil on canvas - 65 x 81 cm -
Durand-Ruel Collection, Paris

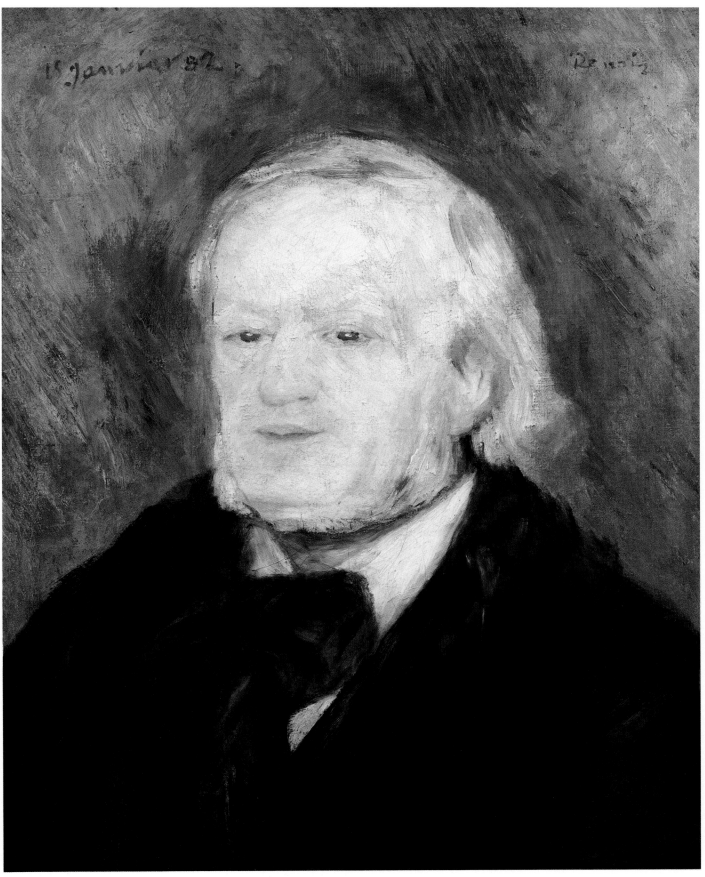

Portrait de Richard Wagner

1882 - oil on canvas - 53 x 46 cm -
Musée d'Orsay, Paris

L'Estaque

1882 - oil on canvas - 65.5 x 81.5 cm -
Museum of Fine Arts, Boston

Montagnes à L'Estaque

1882 - oil on canvas - 66 x 82 cm -
Museum of Fine Arts, Boston

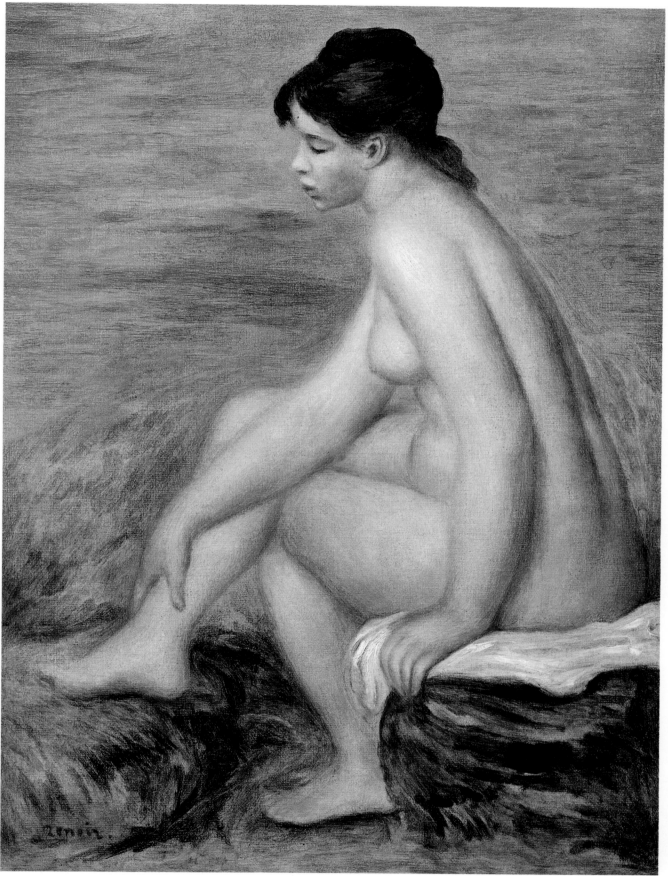

Baigneuse assise

1882 - oil on canvas - 53 x 40.5 cm -
Private collection

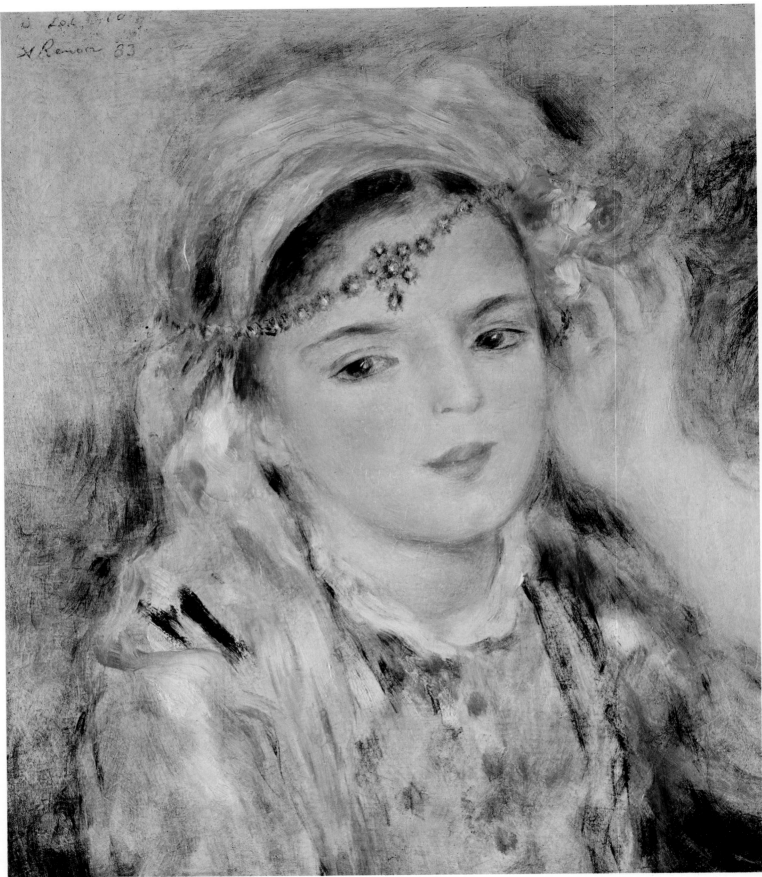

Femme algérienne

*1883 - oil on canvas - 40 x 32 cm -
Lefèvre Gallery, London*

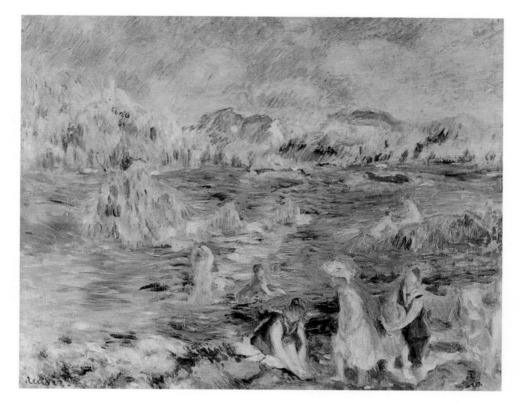

Falaise

1883 - oil on canvas - 51.5 x 63.5 cm -
Lehmann Collection, New York

Plage de Guernesey

1882-83 - oil on canvas - 32 x 41.5 cm -
Mme Hahnloser Collection, Winterthur

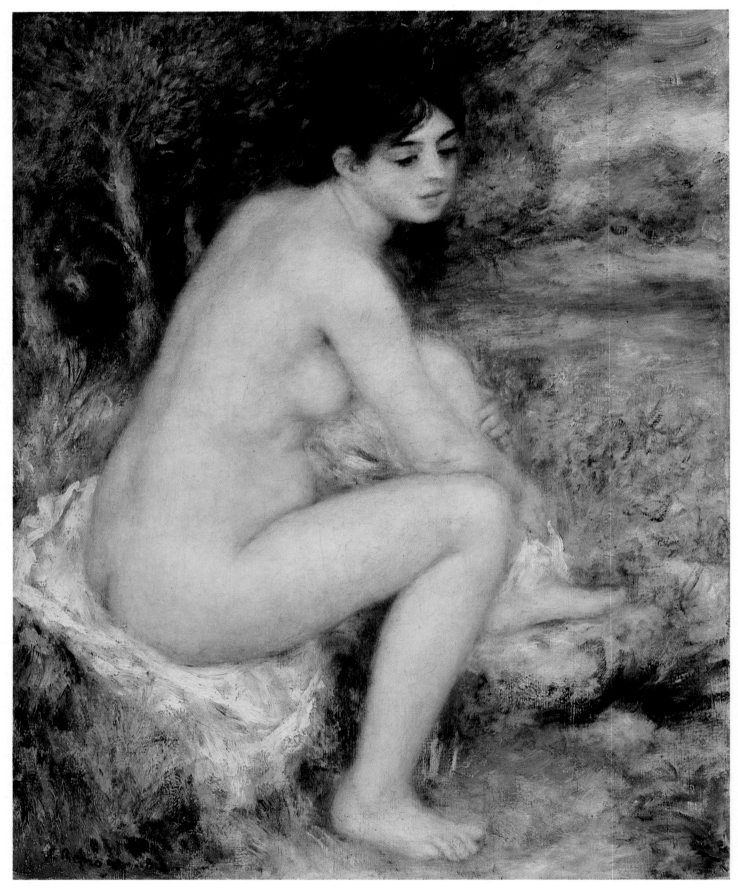

Femme nue assise dans un paysage

1883 - oil on canvas - 65 x 55 cm -
Musée d'Orsay,
Walter Guillaume Collection, Paris

Paysage près de Menton

1883 - oil on canvas - 66 x 81 cm -
Museum of Fine Arts, Boston

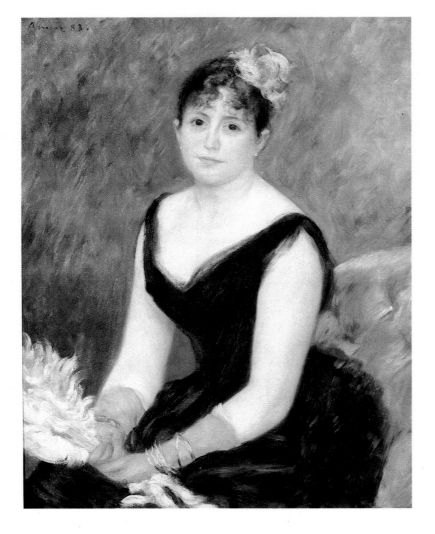

Fillette dans un parc

1883 - oil on canvas - 131 x 80 cm - Private collection

Madame Clapisson

1883 - oil on canvas - 82 x 65 cm - Art Institute, Chicago

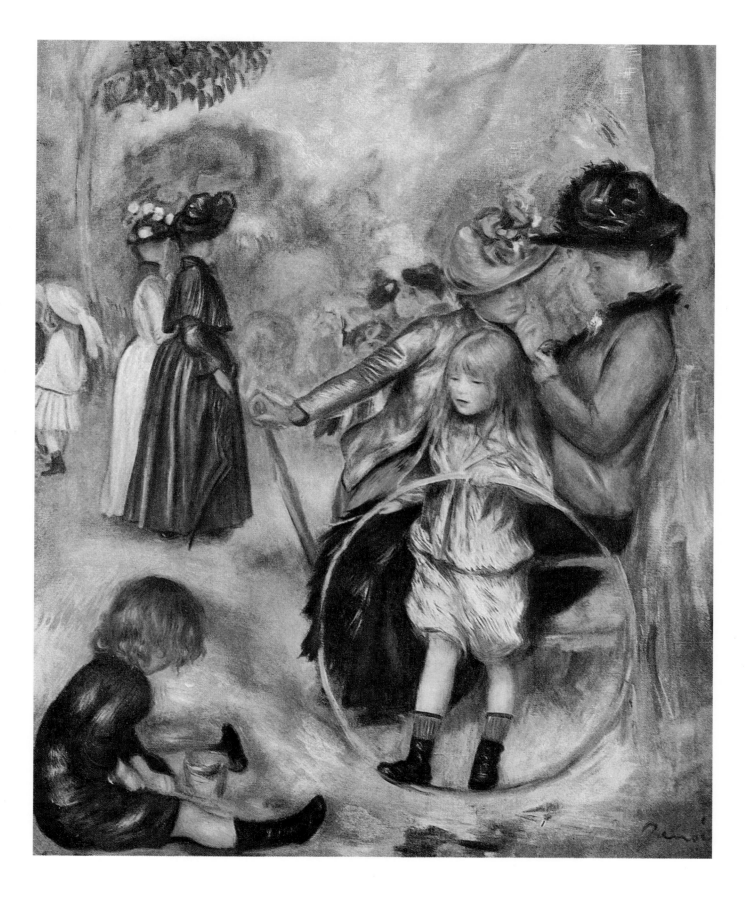

Au jardin du Luxembourg

1883 - oil on canvas - 64 x 53 cm -

Private collection

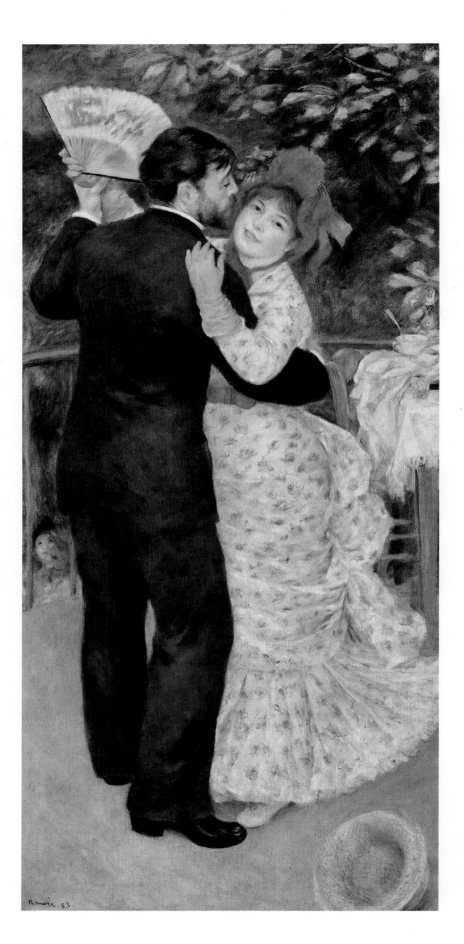

La danse à la campagne

1883 - oil on canvas - 180 x 190 cm -
Musée d'Orsay, Paris

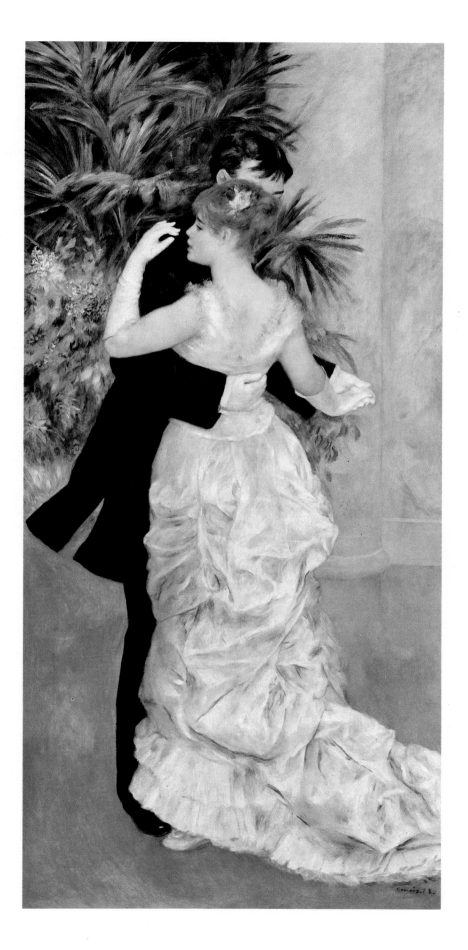

La danse à la ville

1883 - oil on canvas - 180 x 190 cm -
Musée d'Orsay, Paris

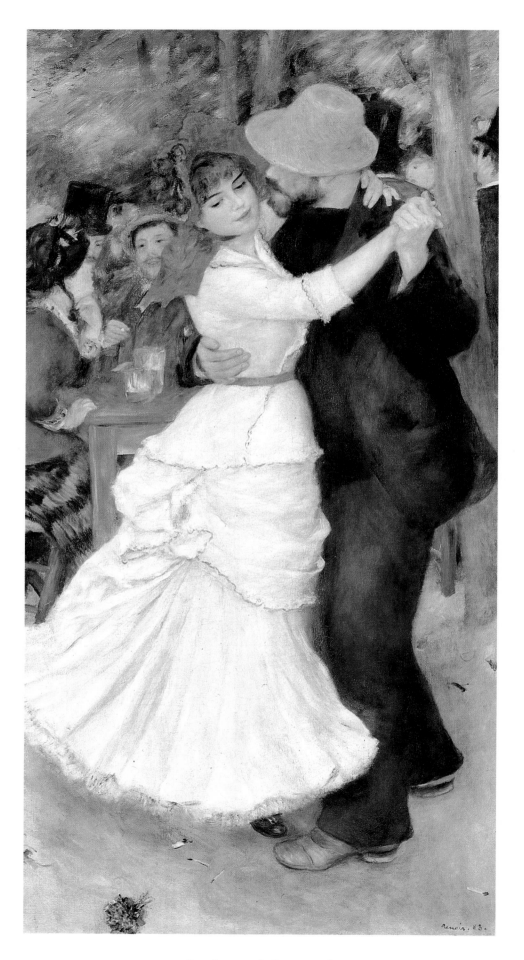

La danse à Bougival
1883 - oil on canvas - 180 x 190 cm -
Museum of Fine Arts, Boston

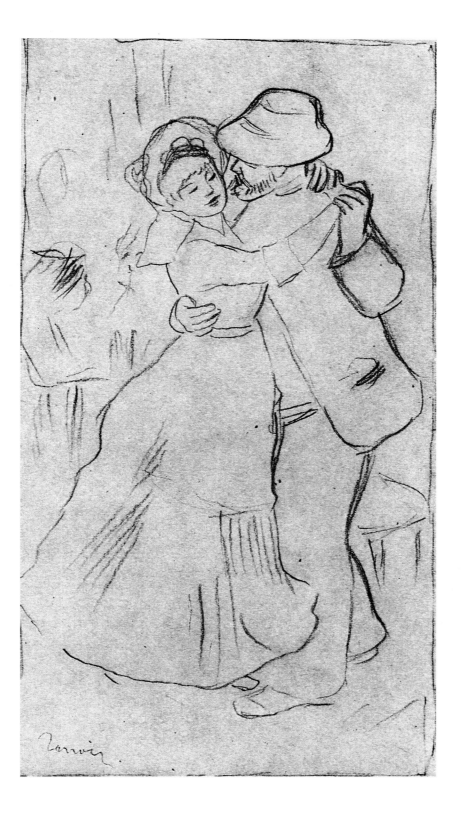

La danse
1883 - drawing - 25 x 15 cm -
Private collection

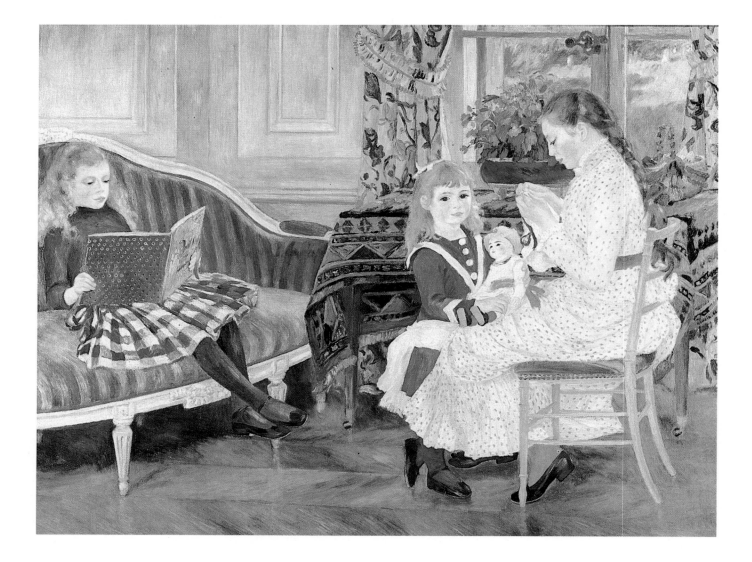

L'après-midi des enfants à Wargemont

1884 - oil on canvas - 127 x 173 cm -
Nationalgalerie, Berlin

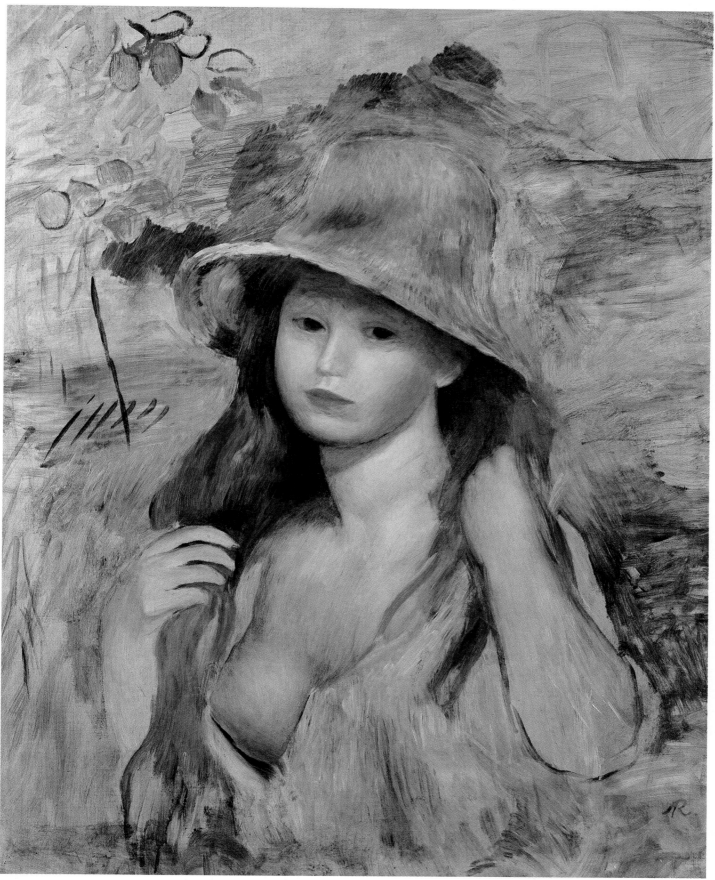

Femme au chapeau de paille
1884 - oil on canvas - 65.5 x 55.5 cm
Private collection

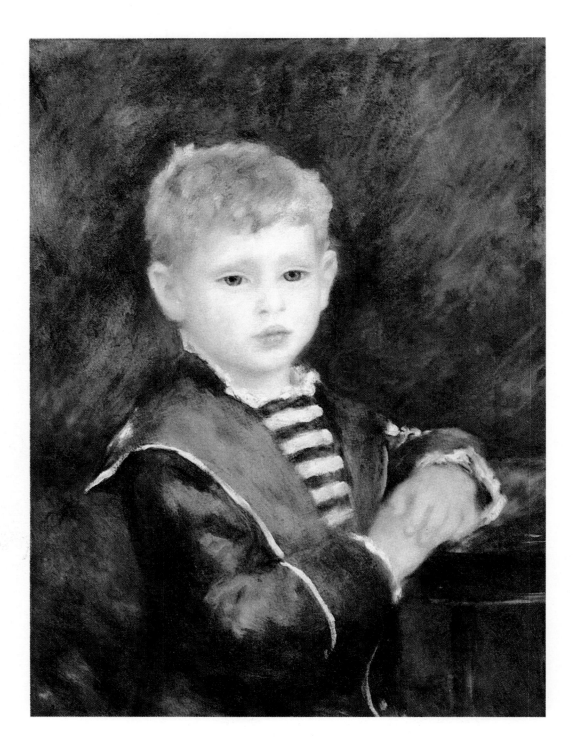

Paul Haviland

1884 - oil on canvas - 57 x 43 cm -
The Nelson-Atkins Museum of Art, Kansas City

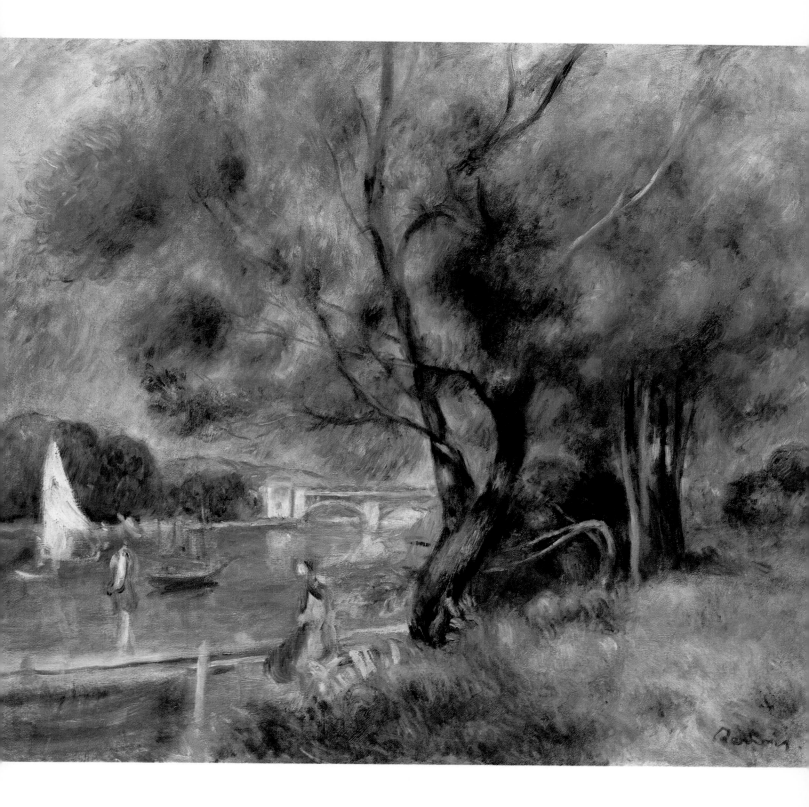

Le Pont de Chatou

1885 - oil on canvas - 55.3 x 66.7 cm -
Private collection

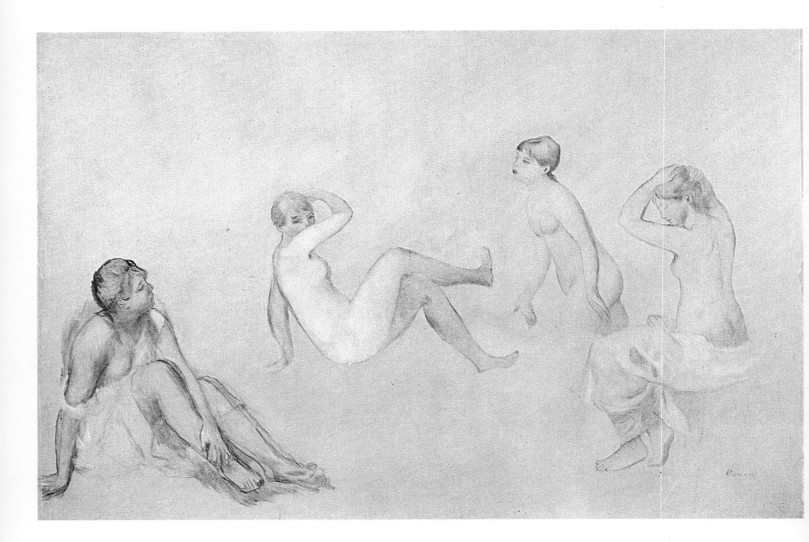

Esquisse pour les Grandes Baigneuses
1884-85 - oil on canvas - 62 x 95 cm -
Paul Pétridès Collection, Paris

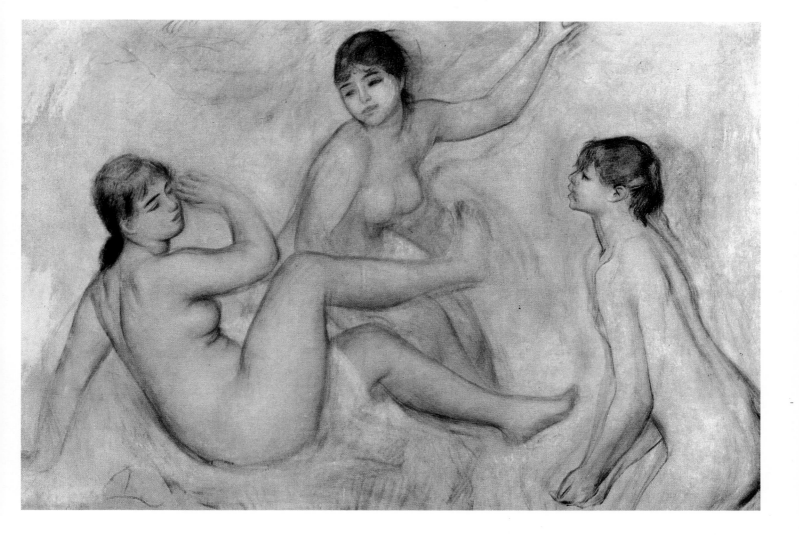

Etude pour les Grandes Baigneuses

1883-85 - Print room,
Louvre Museum, Paris

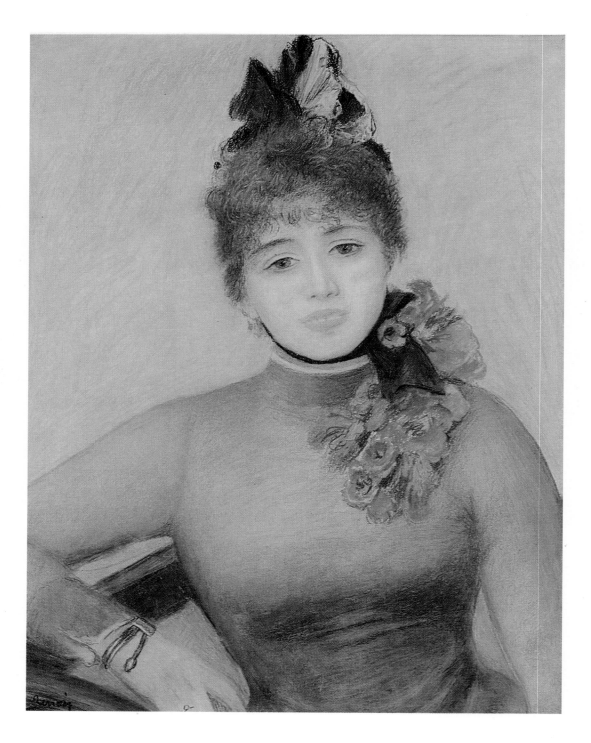

Madame Séverine

c.1885 - oil on canvas - 61 x 50 cm -
National Gallery of Art, Washington, D.C.

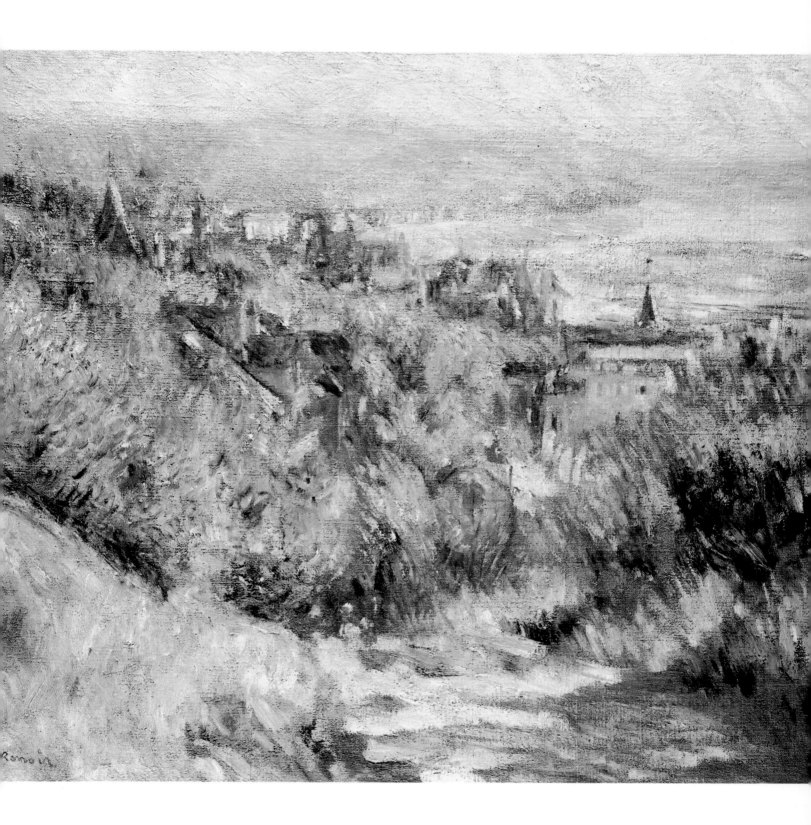

Les hauteurs de Trouville

1885 - oil on canvas - 54 x 65 cm -
Private collection

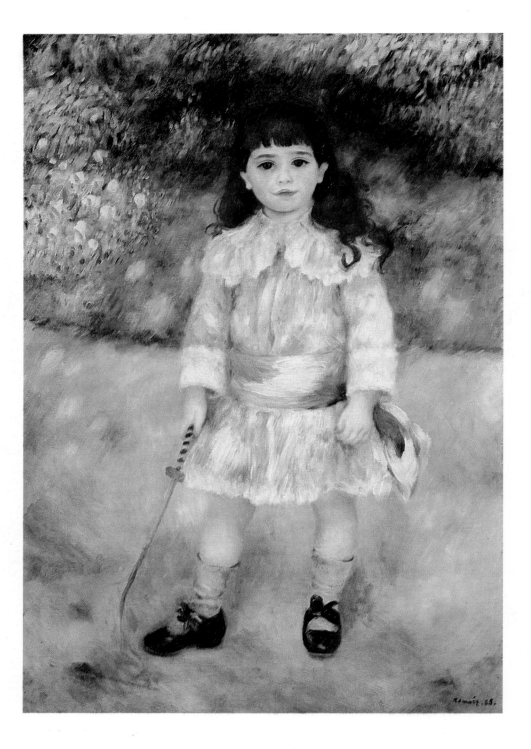

L'enfant au fouet

1885 - oil on canvas - 105 x 75 cm -
Hermitage, St. Petersburg

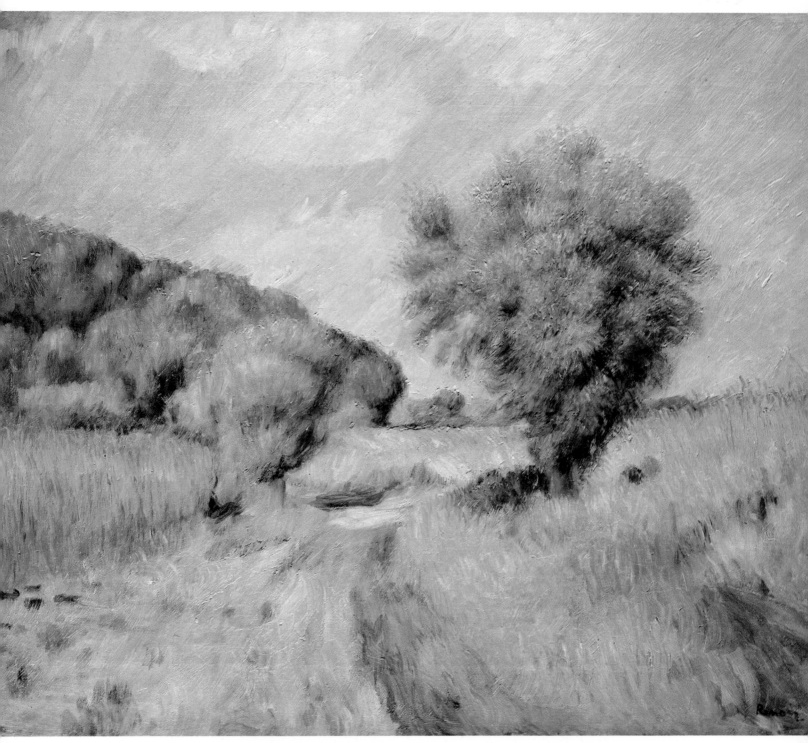

Le champ de blé

c.1885 - oil on canvas - 60 x 74 cm -
Private collection

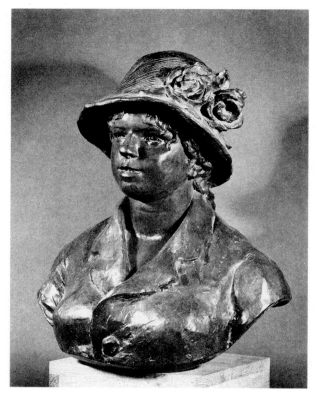

Buste de Madame Renoir

1916 - bronze
Maison de Renoir, Domaine des Collettes, Cagnes

La Roche-Guyon

c. 1885 - oil on canvas - 47 x 56 cm -
Aberdeen Art Gallery and Museums, Aberdeen

Aline Charigot (Madame Renoir)

c.1885 - oil on canvas - 65 x 54 cm -
Museum of Art, W.P. Wilstach Collection, Philadelphia

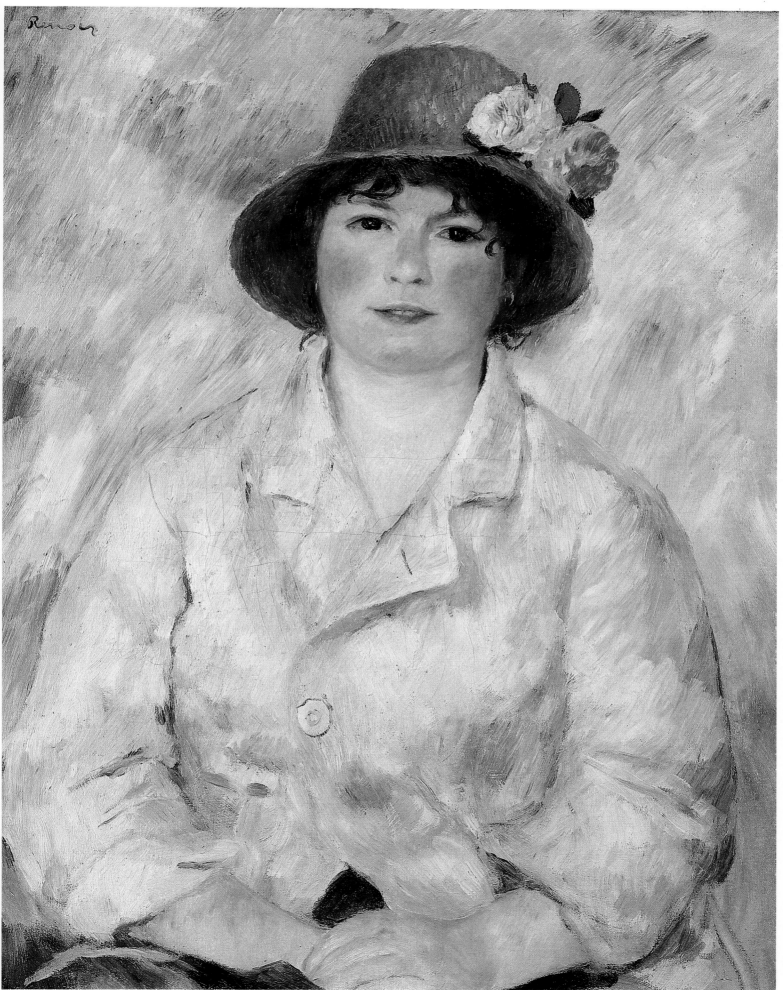

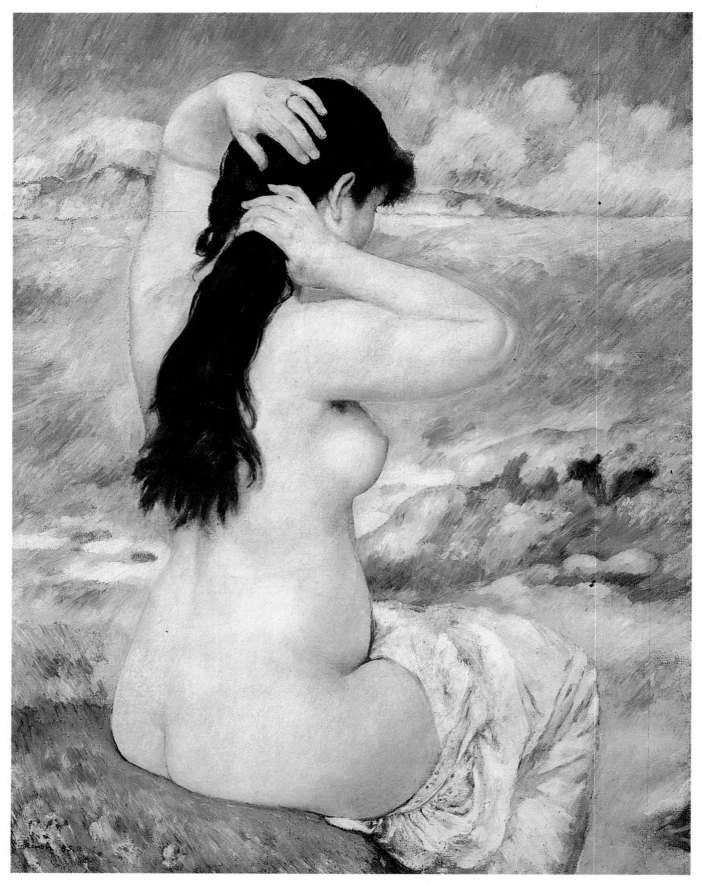

Baigneuse se coiffant

1885 - oil on canvas - 92 x 73 cm -
Sterling and Francine Clark Art Institute, Williamstown

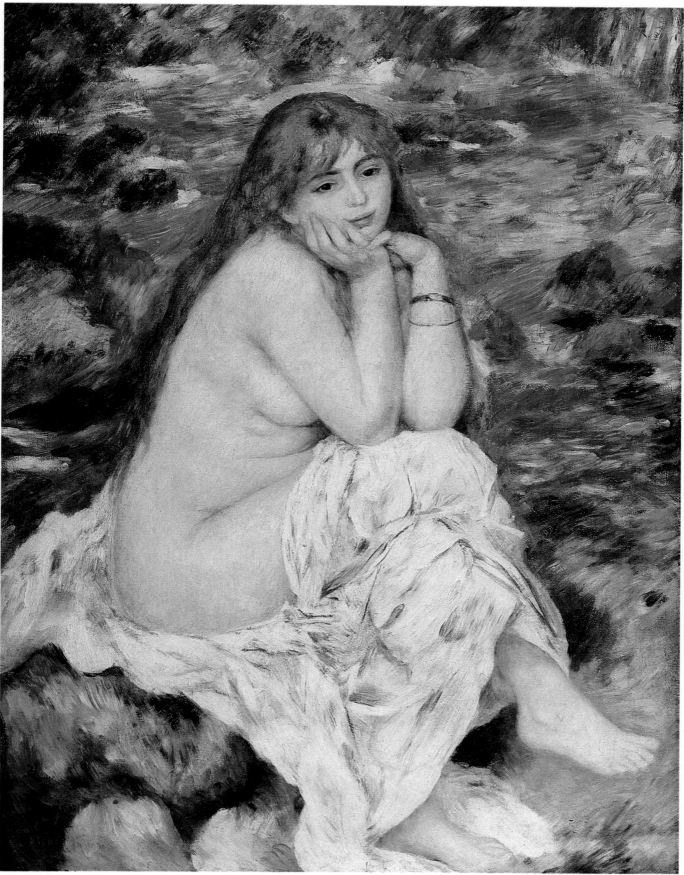

Baigneuse assise

1885 - oil on canvas - 120 x 92 cm -
Fogg Art Museum, Cambridge, Massachusetts

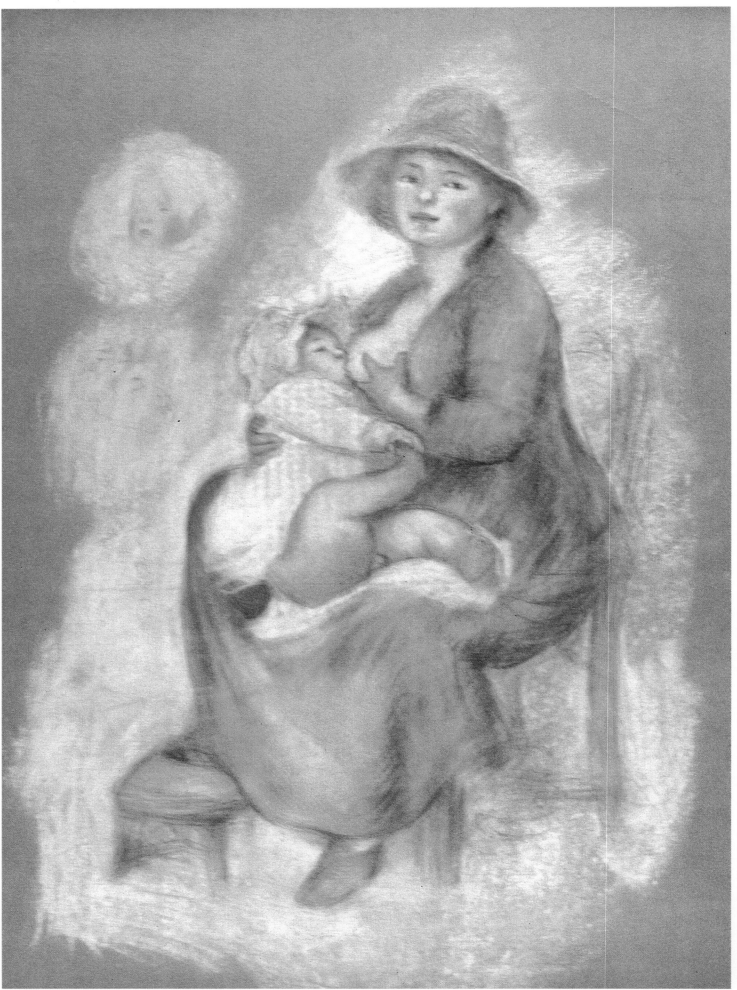

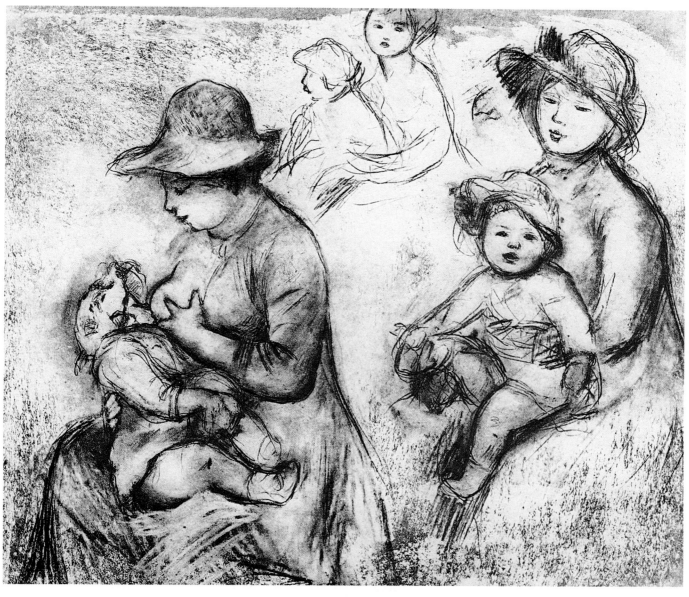

Trois esquisses de maternité
1893 - lithograph - 20.2 x 24.3 cm -
Bibliothèque Nationale, Paris

Maternité
1886 - sanguine heightened by chalk - 92 x 73 cm -
Musée des Beaux-Arts, Strasbourg

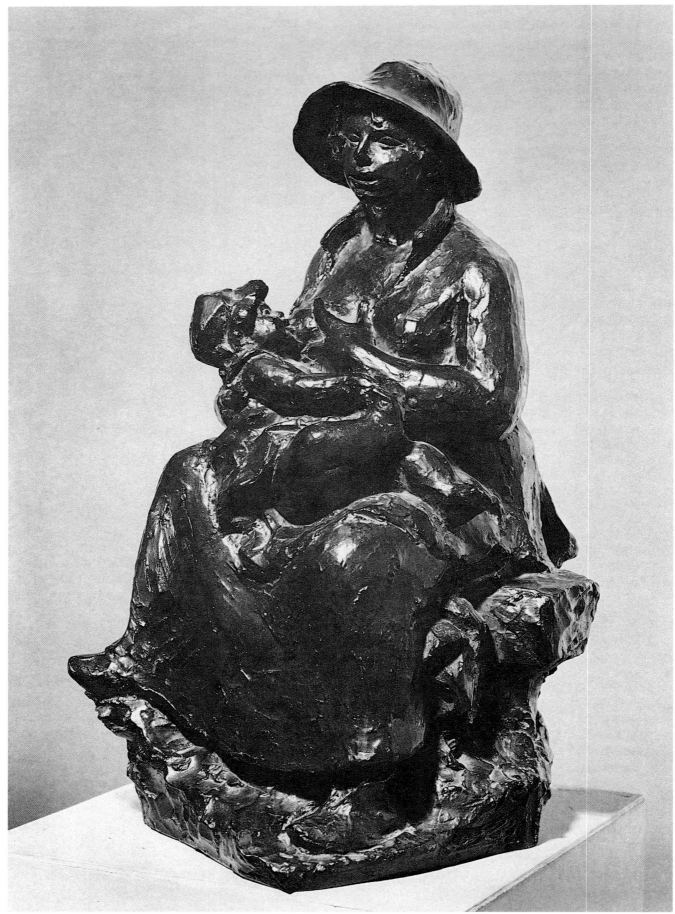

Maternité

1916 - bronze

Maison de Renoir, Domaine des Collettes, Cagnes

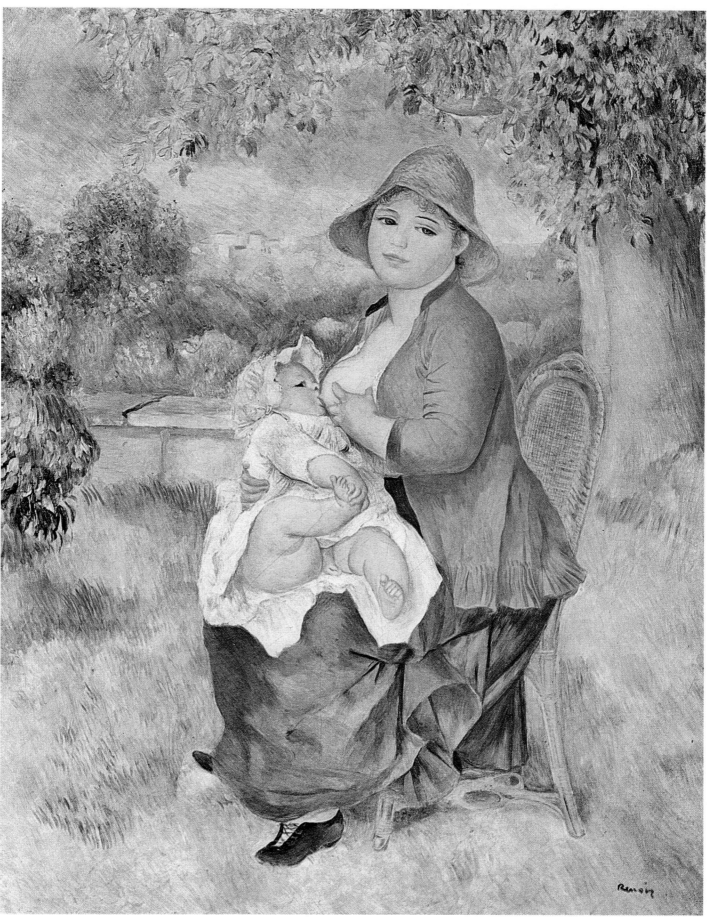

Maternité or Femme allaitant son enfant

1886 - oil on canvas - 81 x 65 cm -
Private collection

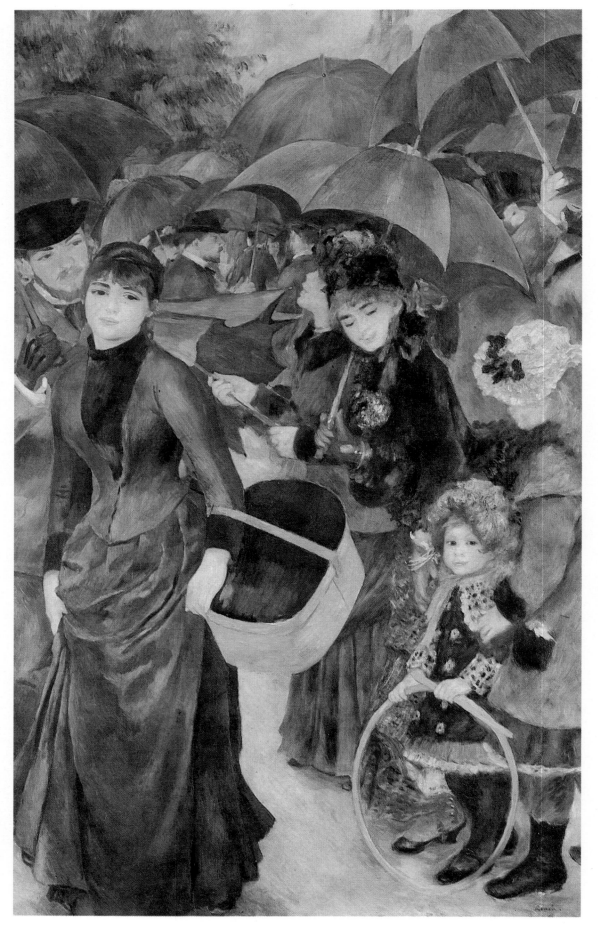

Les parapluies

c.1881-86 - oil on canvas - 180 x 115 cm -
National Gallery, London

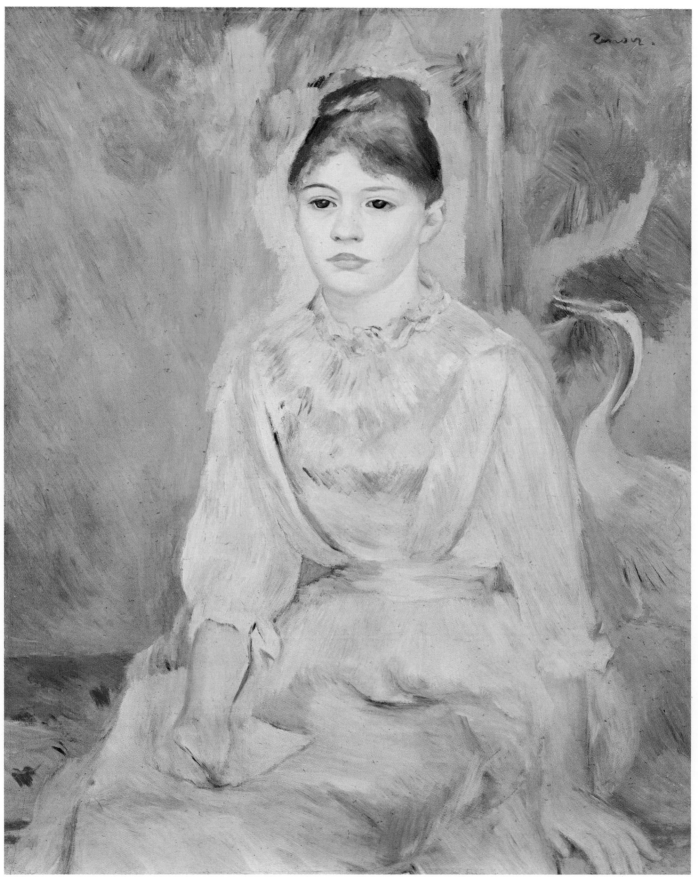

La jeune fille au cygne

1886 - oil on canvas - 76 x 62 cm -
Private collection

La bergère, la vache et la brebis

1886-87 - oil on canvas - 54 x 65 cm -
Private collection

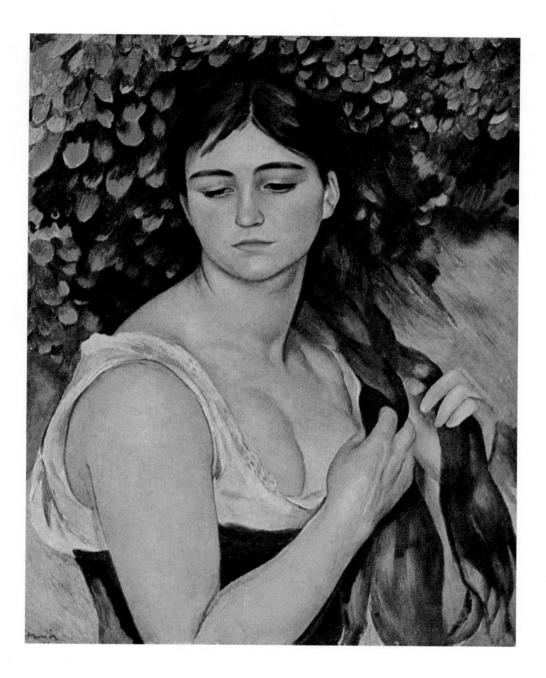

La natte, Suzanne Valadon

1886 - oil on canvas - 56 x 47 cm

Private collection

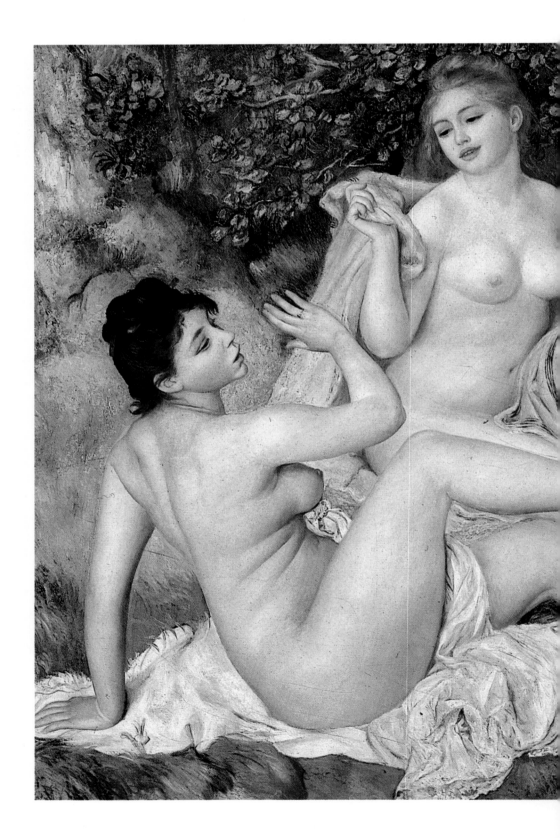

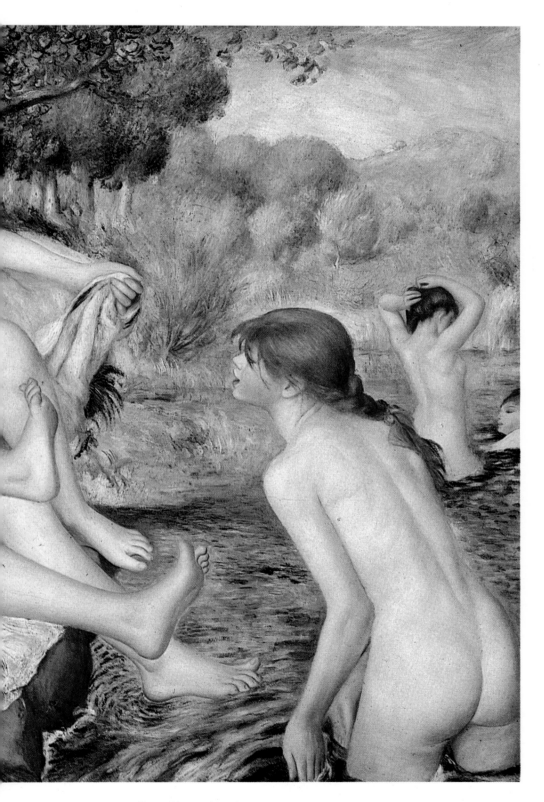

Les Grandes Baigneuses

1887 - oil on canvas - 115 x 170 cm -
Mr. and Mrs. Caroll S. Tyson Collection,
Museum of Art, Philadelphia

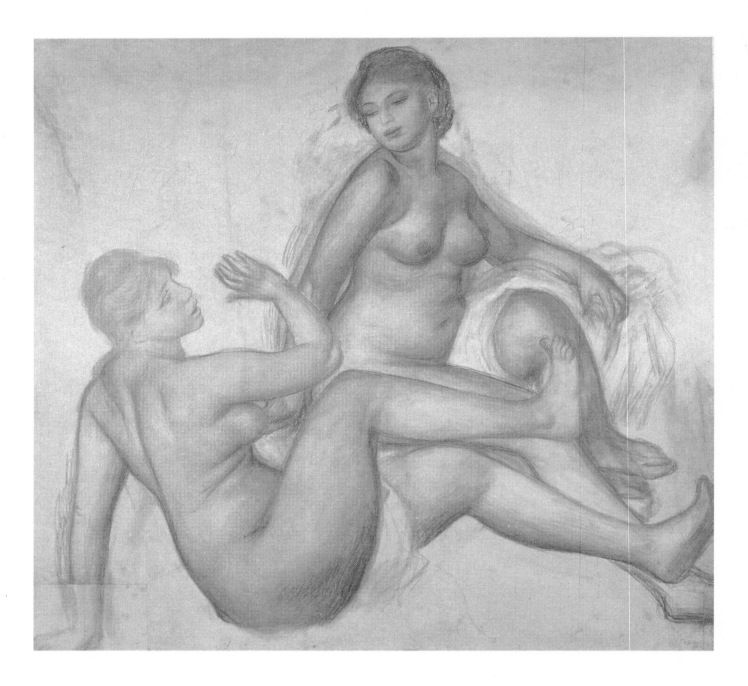

Etude pour les Grandes Baigneuses

c. 1886-87 - pastels - 125 x 140 cm -
Gift of Maurice Vertheim, Fogg Art Museum,
Cambridge, Massachusetts

Nu, étude pour les Grandes Baigneuses

1886-87 - pencil heightened by pastels - 98.5 x 64 cm -
Gift of Kate L. Brewster, Art Institute, Chicago

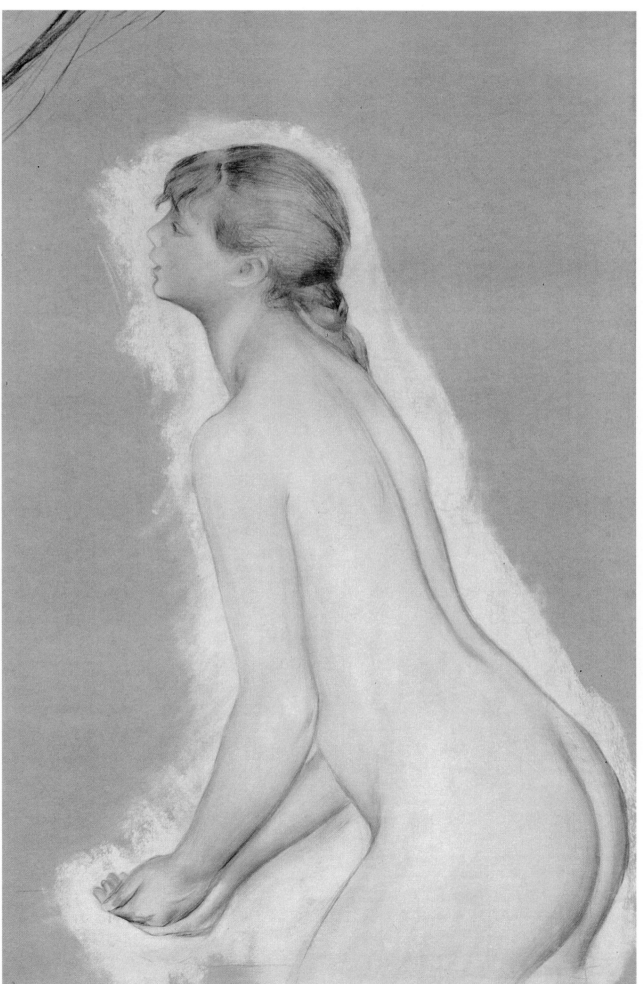

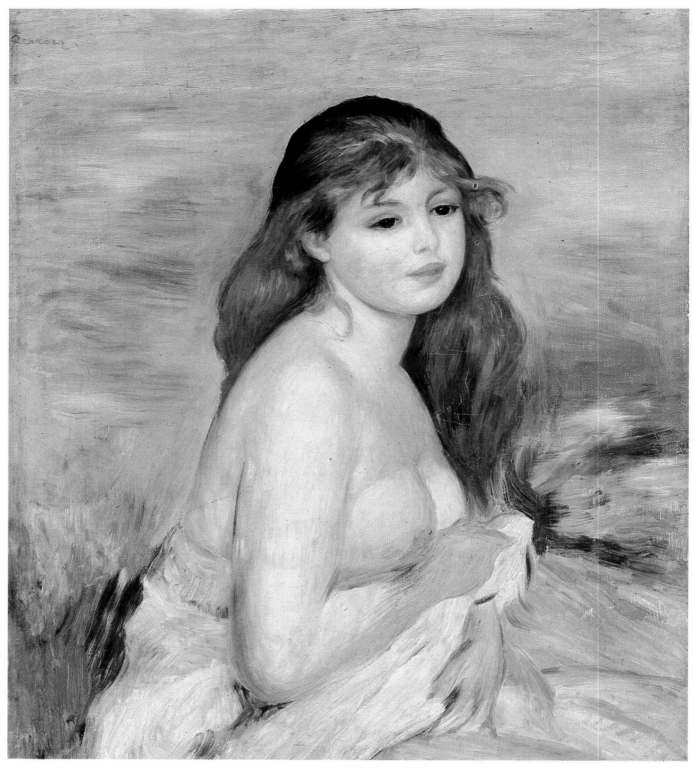

Baigneuse

1887 - oil on canvas - 60 x 54 cm -
Nasjonalgalleriet, Oslo

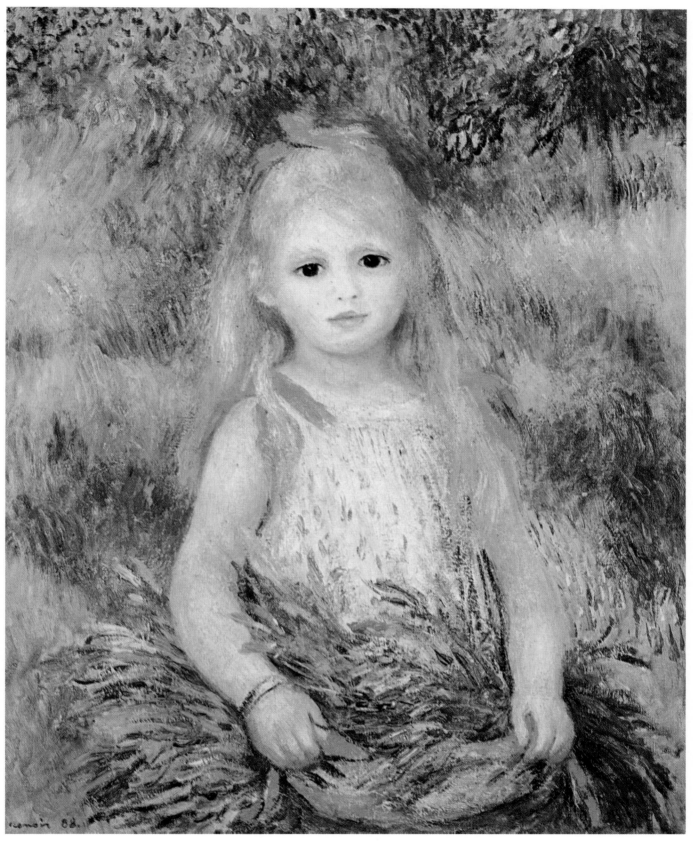

La petite fille à la gerbe

1888 - oil on canvas - 65 x 54 cm -
Museu de Arte, Sao Paulo

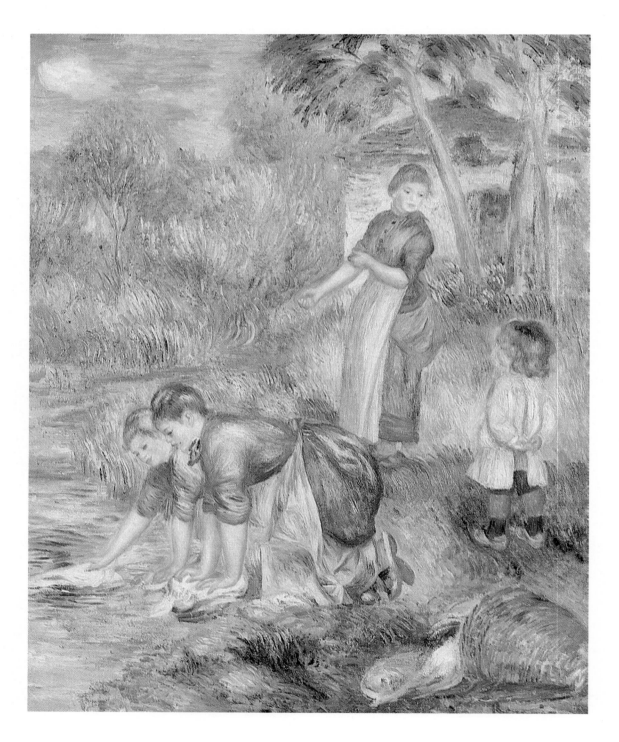

Les laveuses

c. 1888 - oil on canvas - 56 x 47 cm -
The Baltimore Museum of Art, Baltimore

Les filles de Catulle Mendès

1888 - oil on canvas - 153 x 130 cm -
The Hon. and Mrs. Walter H. Annenberg, London

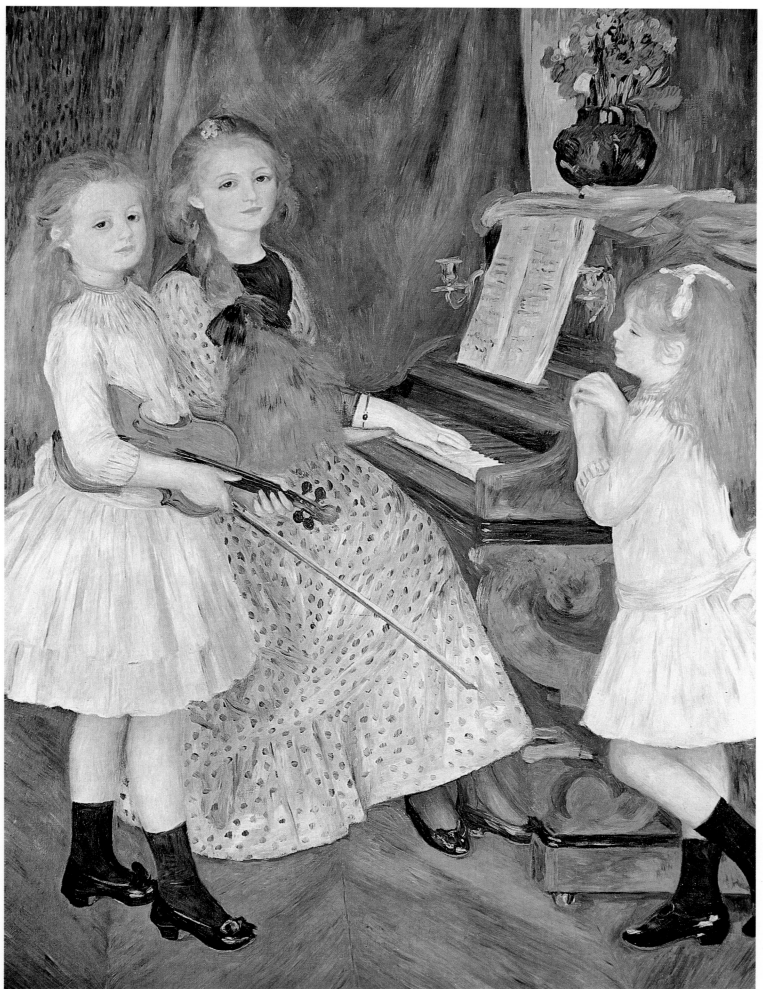

Les voiliers à Cagnes

*c. 1888 - oil on canvas - 46 x 55 cm -
Private collection*

La Montagne Sainte-Victoire

*c. 1888-89 - oil on canvas - 55 x 75 cm -
Katharine Ordway Collection
Yale University Art Gallery, New Haven*

Fleurs et fruits

1889 - oil on canvas - 65 x 53 cm -
Private collection

Vase, corbeille de fleurs et fruits

1889-90 - oil on canvas - 100 x 140 cm -
Museum of Art, Philadelphia

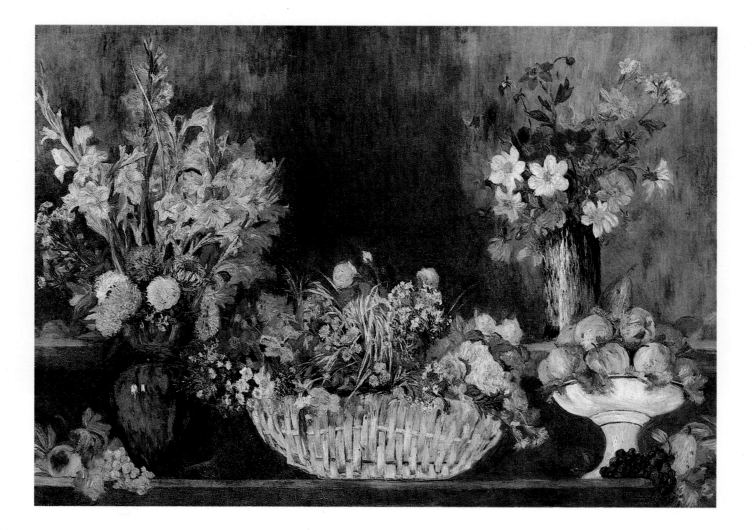

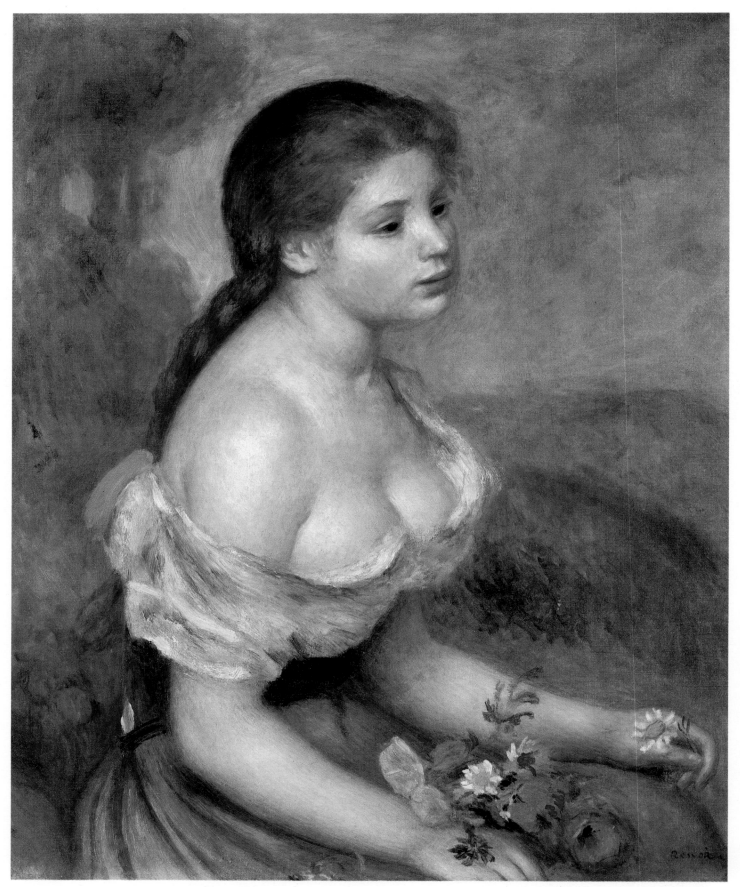

Jeune fille aux marguerites

1889 - oil on canvas - 65 x 54 cm -

Metropolitan Museum of Art, New York

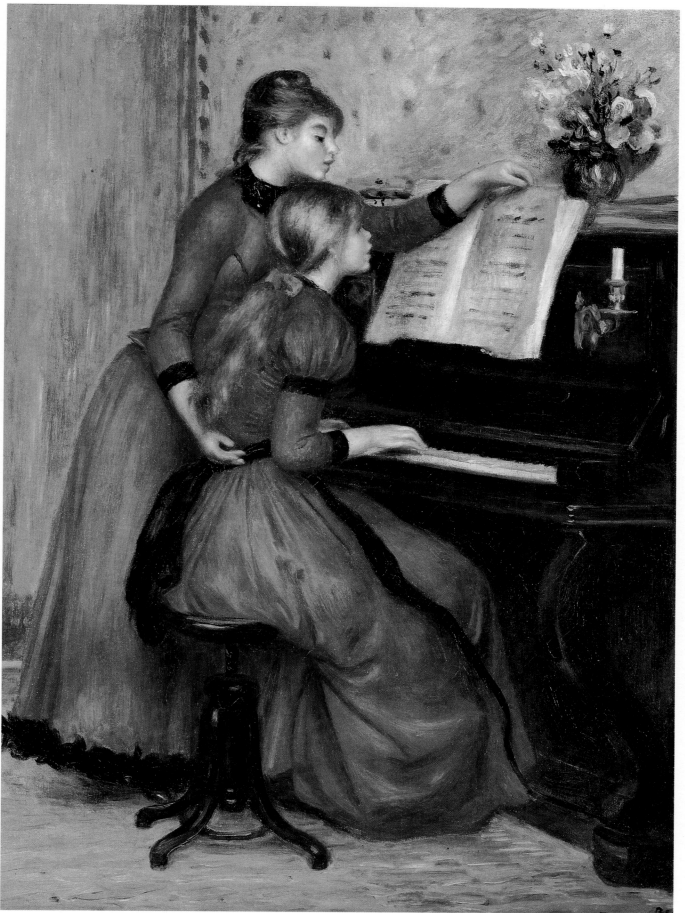

La leçon de piano

c.1889 - oil on canvas - 56 x 46 cm -
Joslyn Art Museum, Omaha, Nebraska

266

Le marchand de poissons

c.1889 - oil on canvas - 130.7 x 41.8 cm -
National Gallery of Art, Washington, D.C.

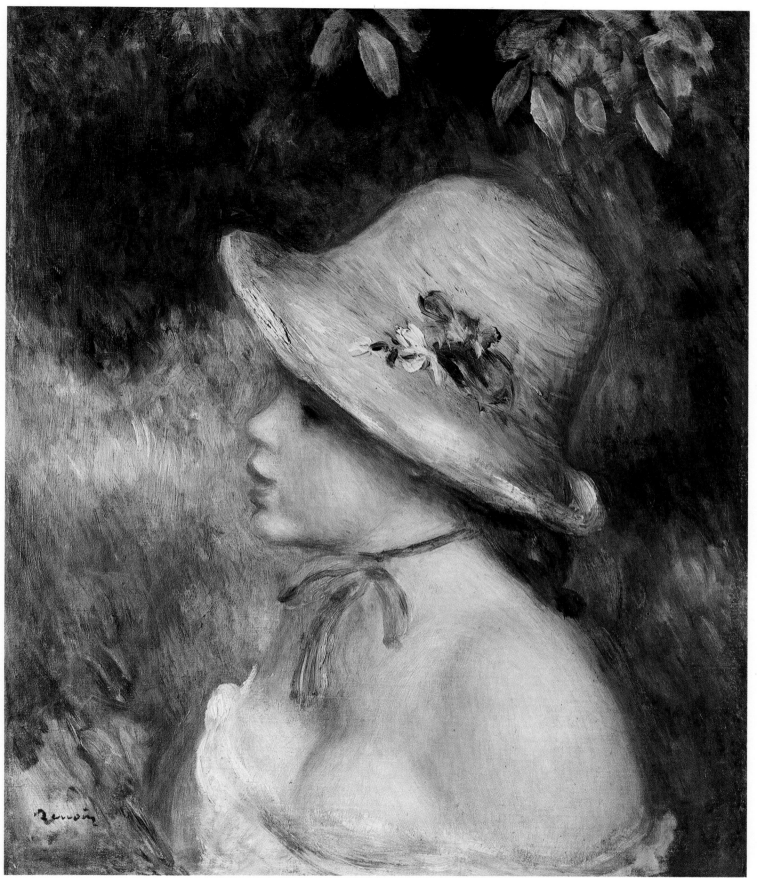

Jeune fille au chapeau de paille

1890 - oil on canvas - 46 x 38 cm -
Private collection

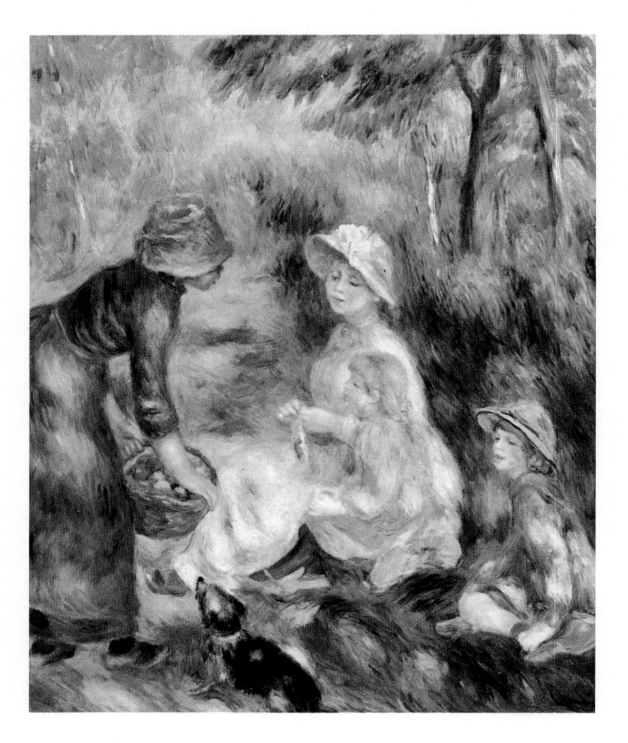

La marchande de pommes

1890 - oil on canvas - 65 x 54 cm -
The Leonard C. Hanna Jr. Collection
The Cleveland Museum of Art, Cleveland

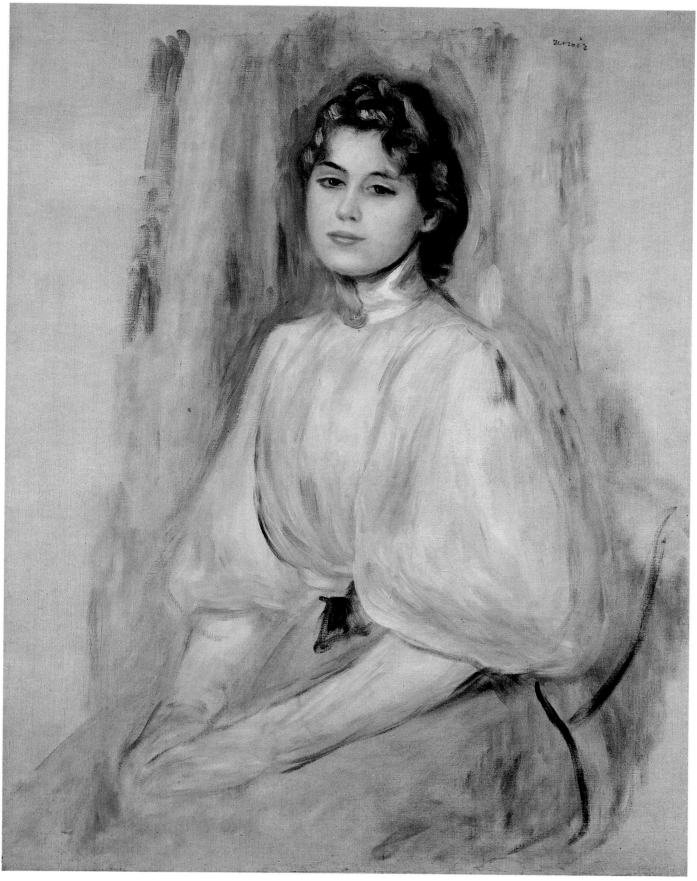

Jeune femme assise

1890 - oil on canvas - 91 x 72 cm -
Private collection

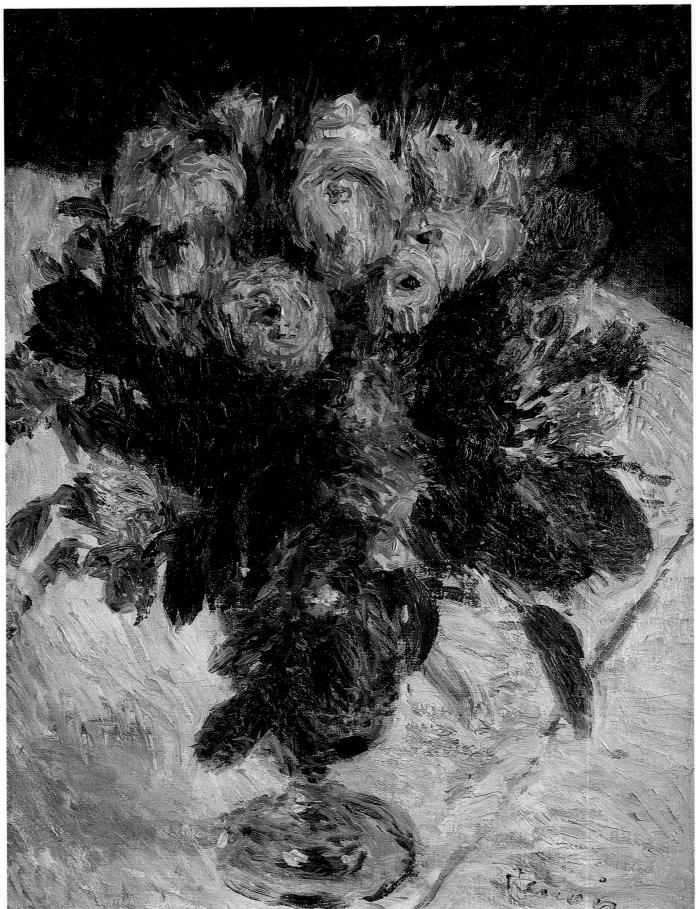

Roses mousseuses

1890 - oil on canvas - 35 x 27 cm -
Musée d'Orsay, Paris

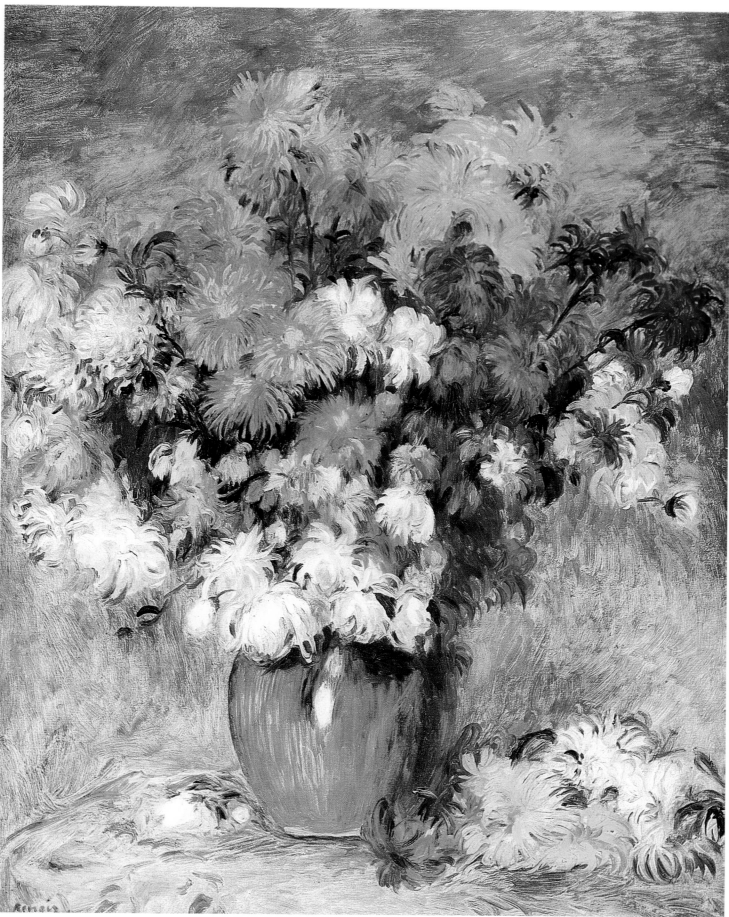

Vase de chrysanthèmes

1890 - oil on canvas -
Musée des Beaux-Arts, Rouen

Dans la prairie

1890 - oil on canvas - 65 x 81 cm -
Museum of Fine Arts, Boston

La cueillette des fleurs
(also called Dans la prairie)

c.1890 - oil on canvas - 81 x 65 cm -
Metropolitan Museum of Art, New York

La toilette

c. 1890 - sanguine and black and white chalk - 58 x 49.5 cm -
Louvre Museum, Print Room, Paris

La petite liseuse or Fillette en bleu

*c.1890 - oil on canvas - 25 x 16.5 cm -
Galerie Daniel Malingue, Paris*

276

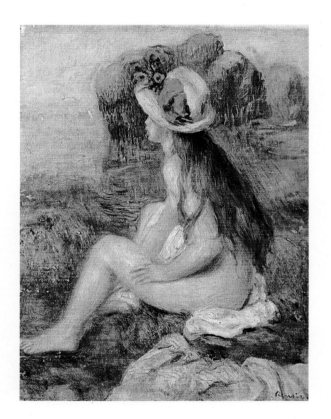

Nu au chapeau de paille
1892 - oil on canvas - 41 x 32 cm -
Private collection

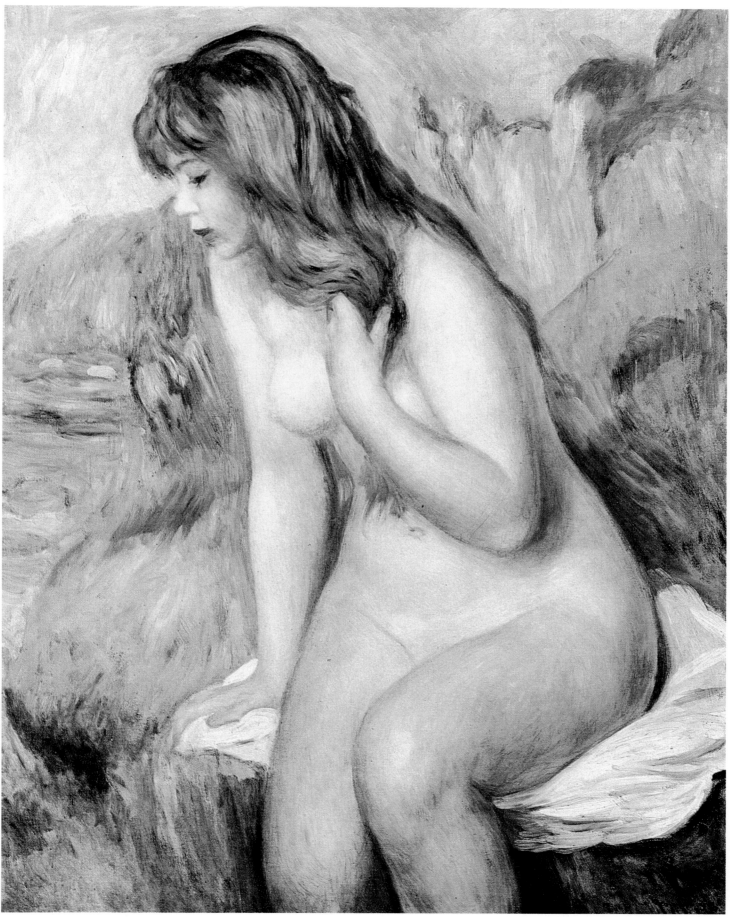

Baigneuses assise sur un rocher

1892 - oil on canvas - 80 x 64 cm -
Durand-Ruel Collection, Paris

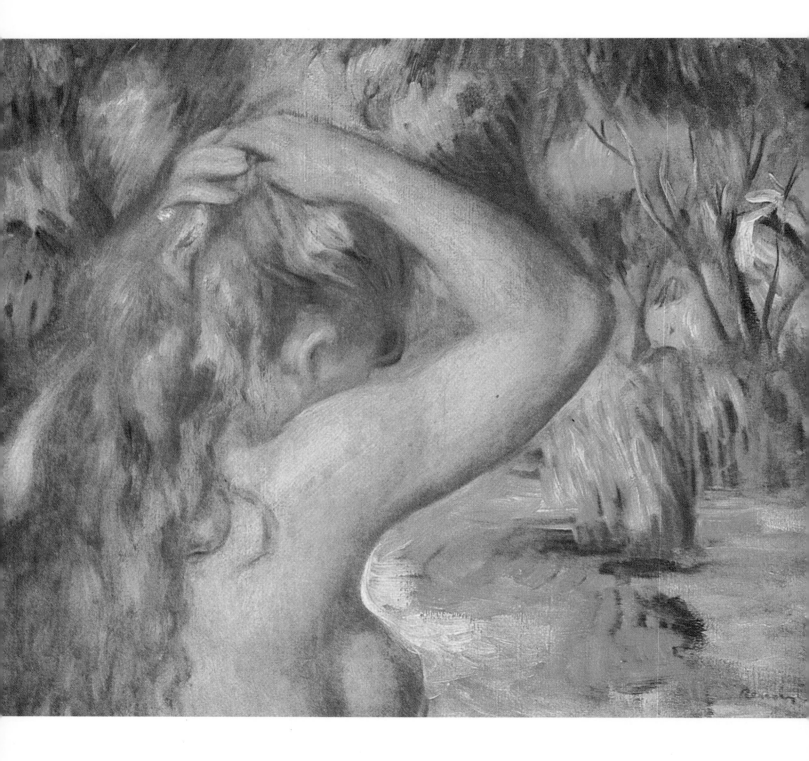

Jeune fille attachant ses cheveux

1892-95 - oil on canvas - 40 x 55 cm -
Nichido Gallery, Tokyo

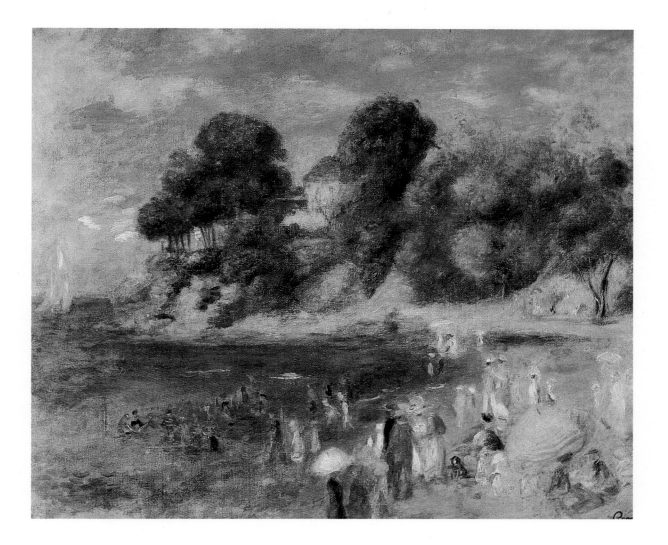

La plage de Pornic

1892 - oil on canvas - 65.5 x 81.5 cm -
Private collection

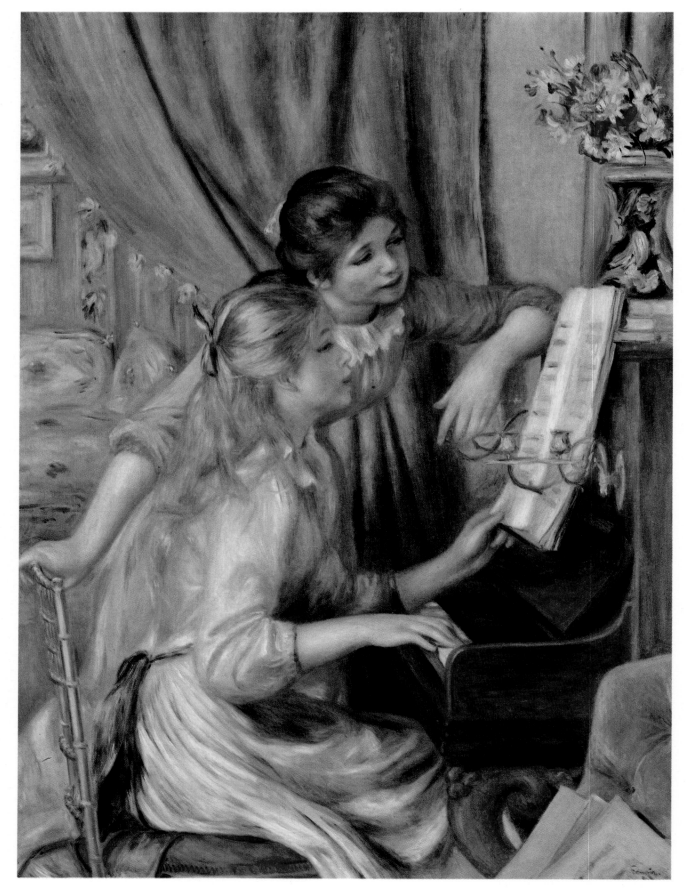

Jeunes filles au piano

1892 - oil on canvas - 116 x 90 cm -
Musée d'Orsay, Paris

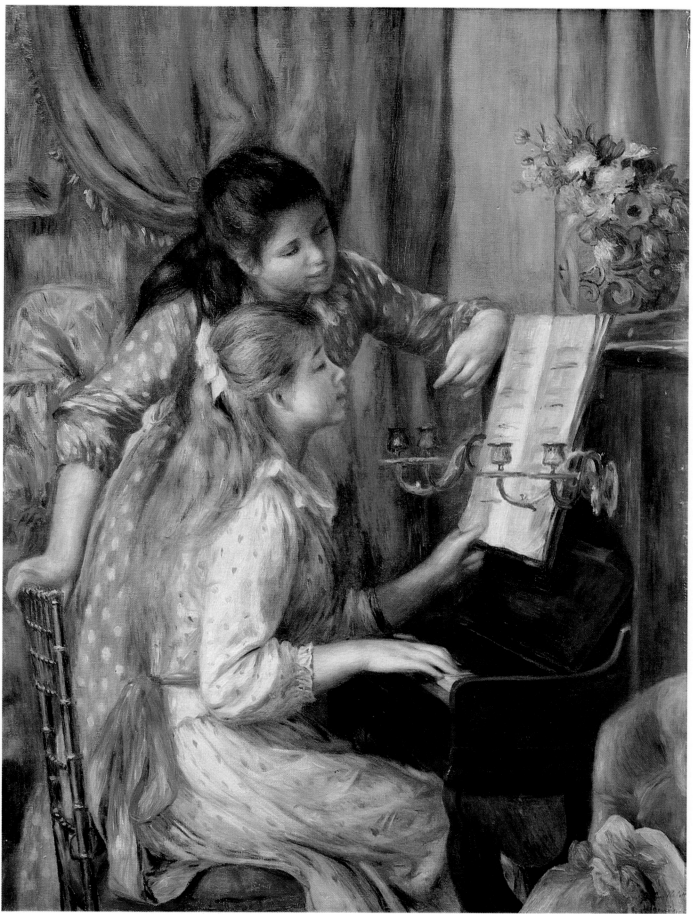

Jeunes filles au piano
1892 - oil on canvas - 117 x 90 cm - (No. 88)
Private collection

282

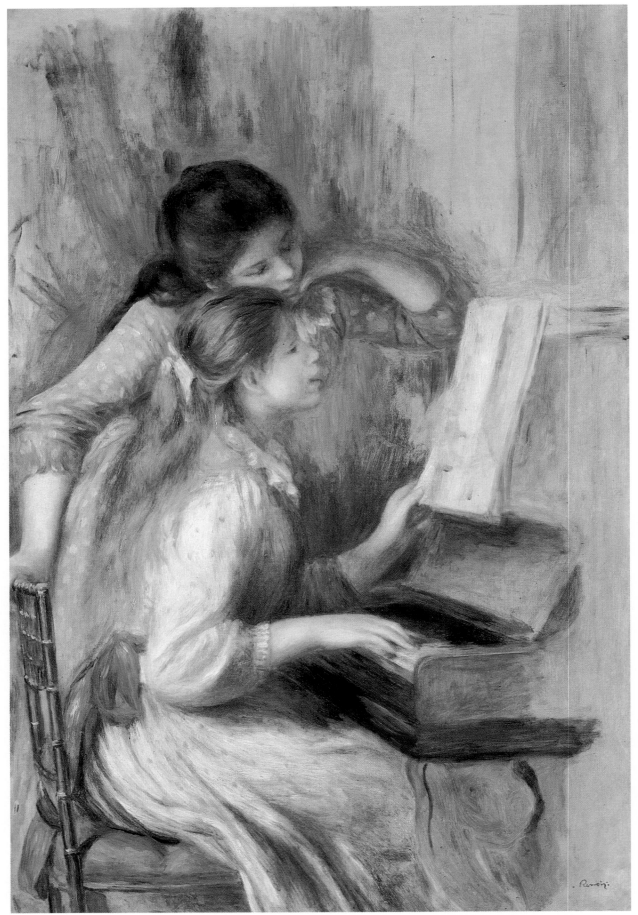

Jeunes filles au piano

1892 - oil on canvas - 116 x 81 cm -

Musée de l'Orangerie

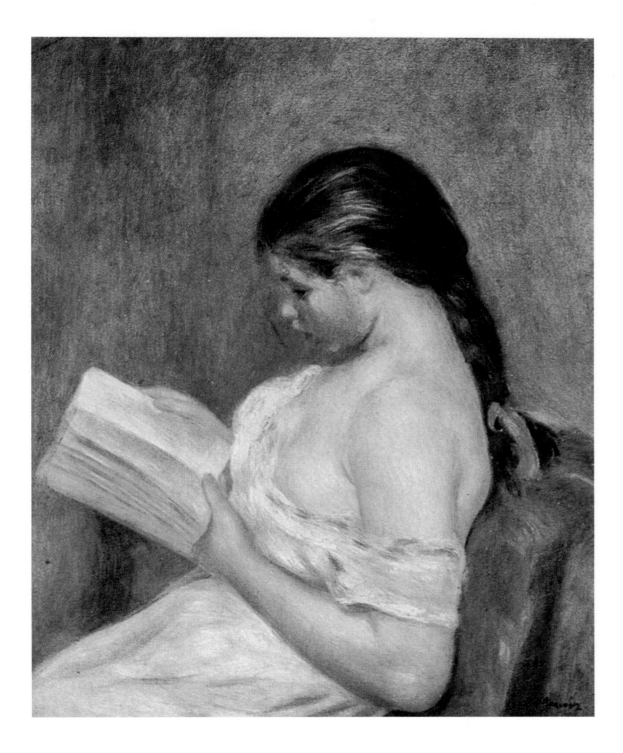

Jeune fille lisant

*1892-95 - oil on canvas - 62 x 54 cm -
Private collection*

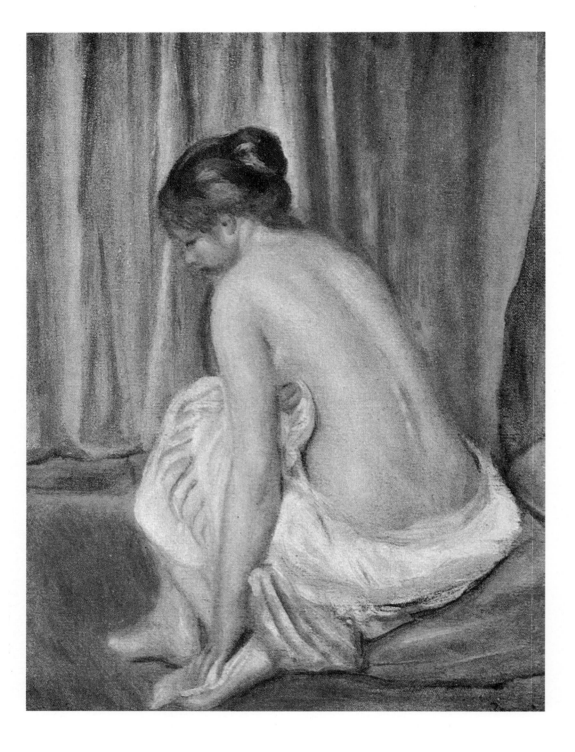

Baigneuse

*1893 - oil on canvas - 40 x 32 cm -
Private collection*

Baigneuse se coiffant

*1893 - oil on canvas - 92 x 74 cm -
National Gallery, Washington, D.c.*

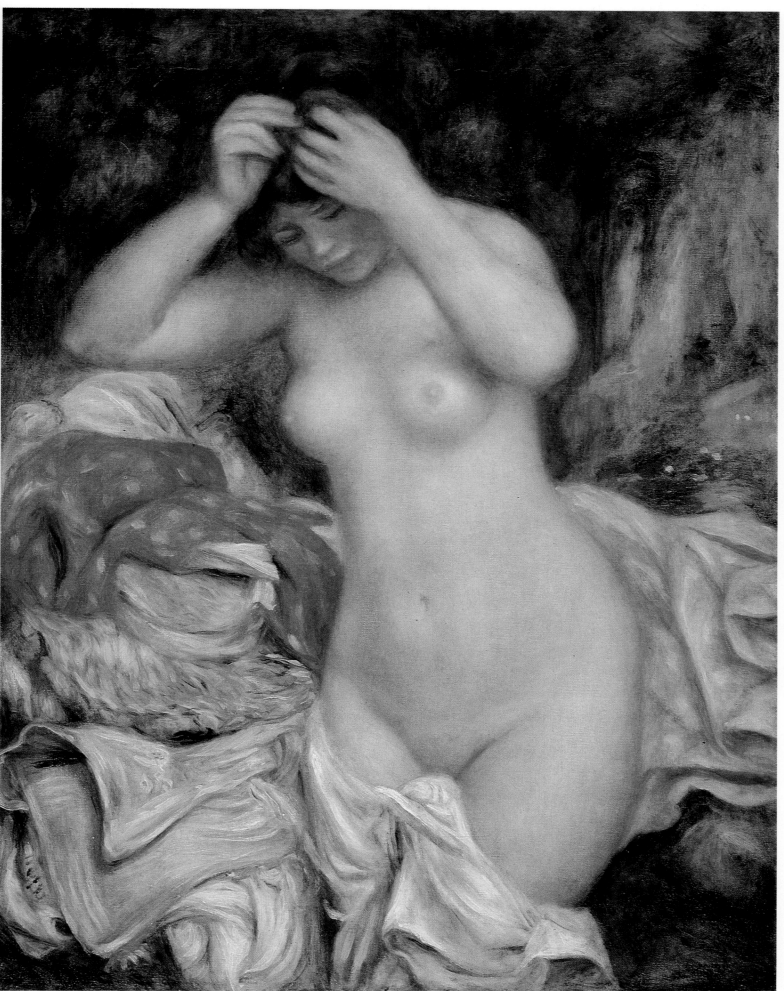

Grenades et fruits divers

c.1893 - oil on canvas - 21 x 32 cm -
Private collection

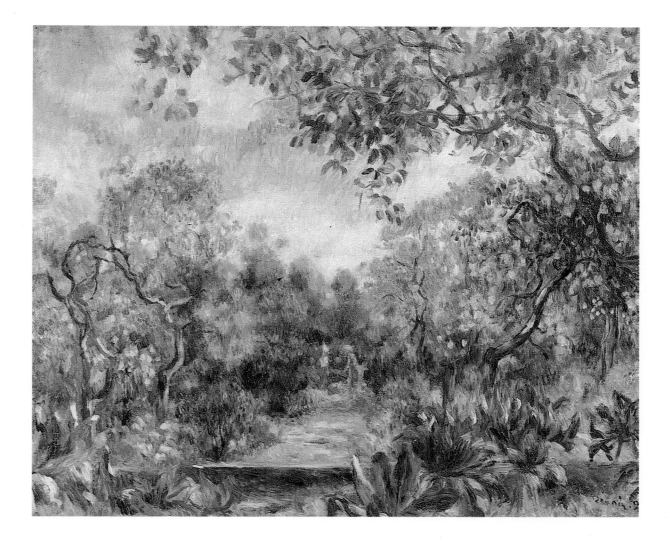

Paysage de Beaulieu

1893 - oil on canvas - 65 x 81 cm -
Fine Arts Museum of San Francisco

288

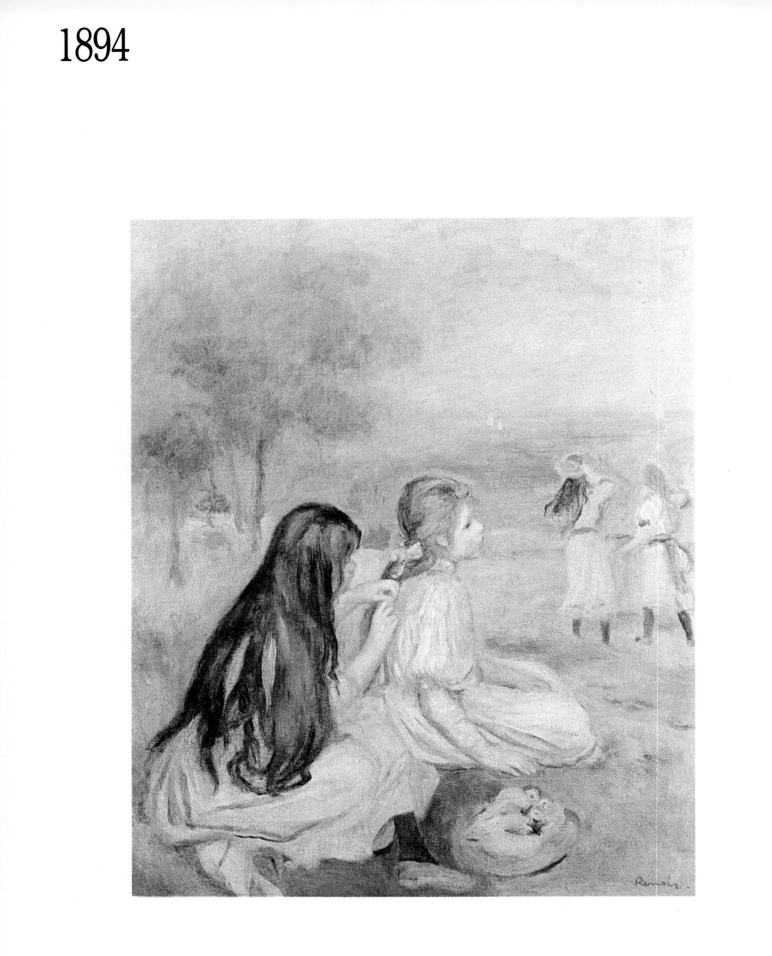

Jeunes filles au bord de la mer

1894 - oil on canvas - 55 x 46 cm -
Private collection

Jeunes filles au bord de la mer

1894 - oil on canvas - 55 x 46 cm -
Durand-Ruel Collection, Paris

La liseuse verte

c.1894 - oil on canvas - 26.5 x 21 cm -
Musée d'Orsay, Paris

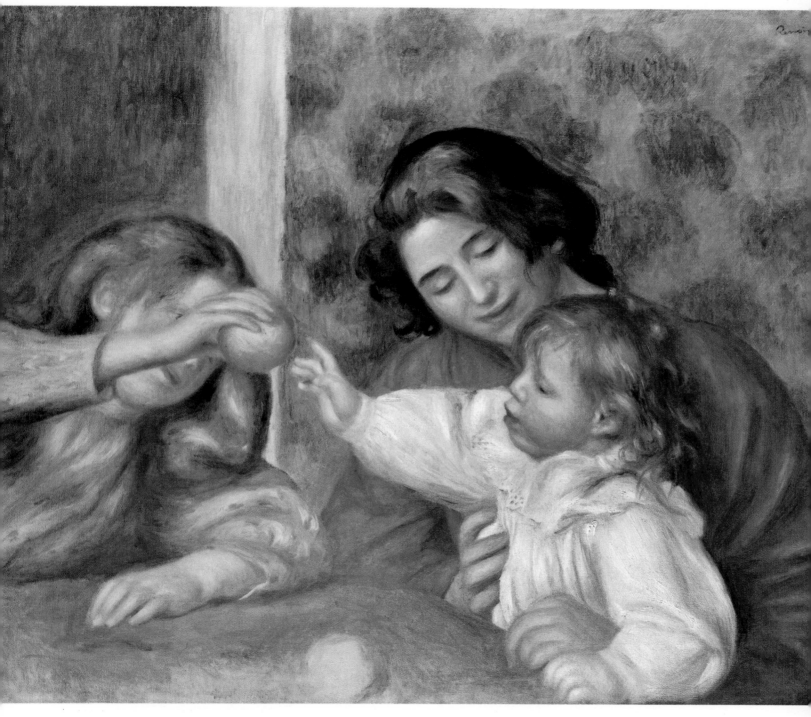

Gabrielle, Jean et une petite fille

1895 - oil on canvas - 65 x 80 cm -
Private collection

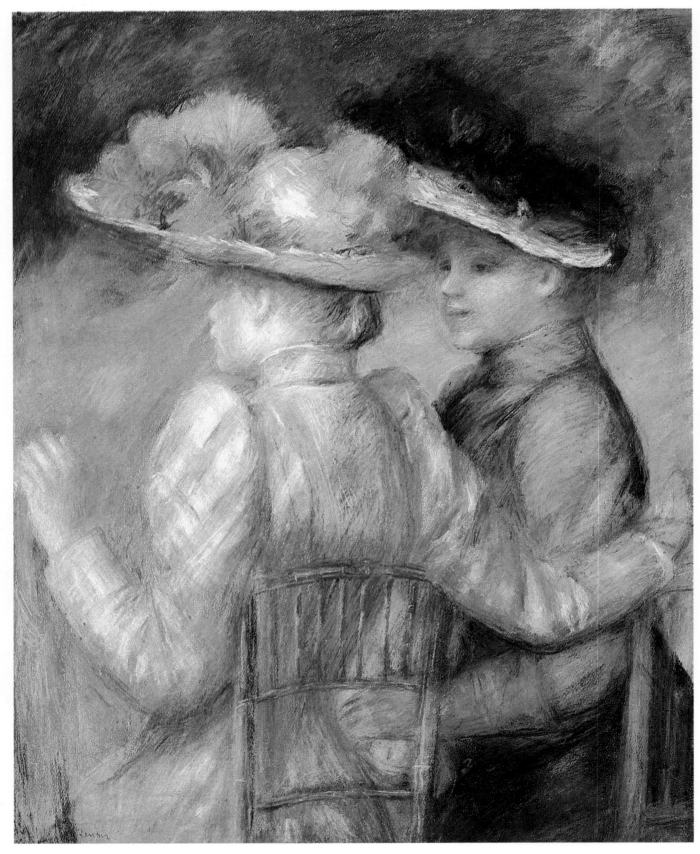

Deux femmes dans un jardin

1895 - pastels - 78 x 64 cm -
Private collection

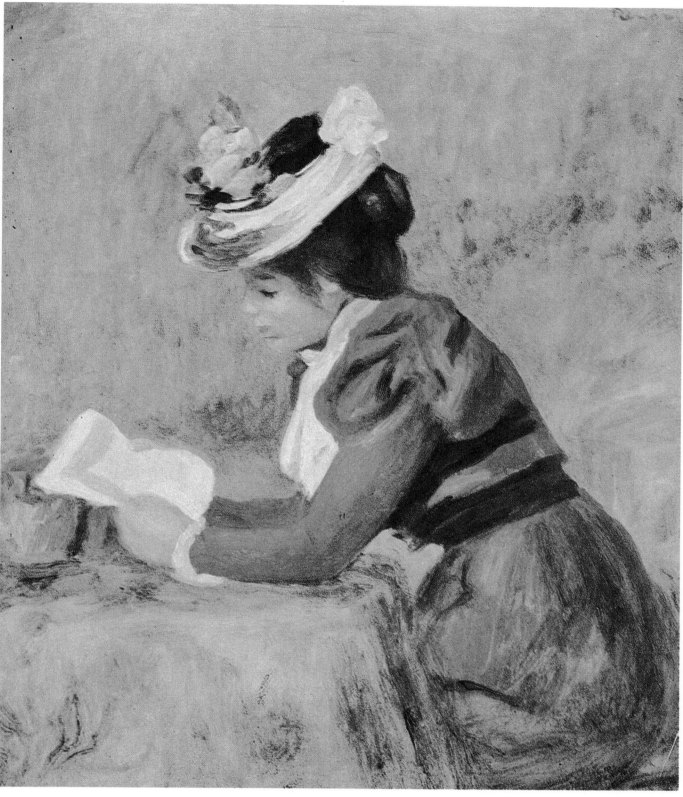

Femme lisant
c. 1895 - oil on canvas - 32 x 28 cm -
Private collection

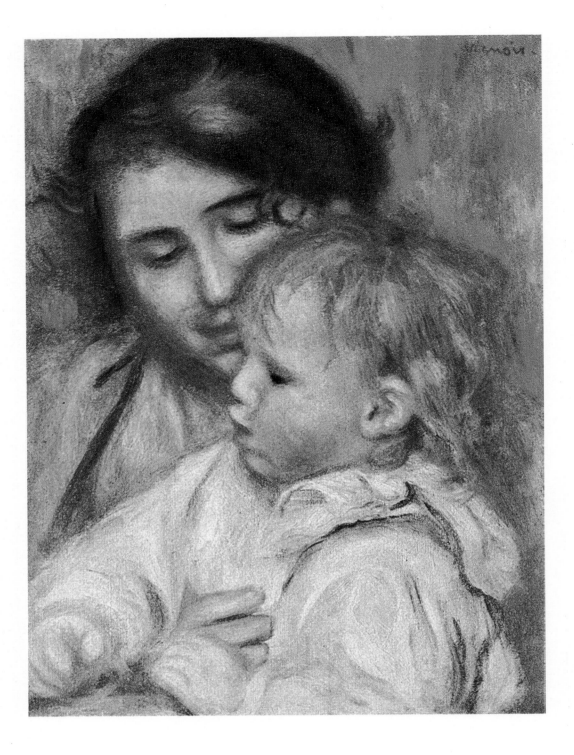

Gabrielle et Jean

*1895 - oil on canvas - 41 x 32.5 cm -
Private collection*

Gabrielle et Jean

*c.1895 - oil on canvas - 65 x 54 cm -
Private collection*

1895

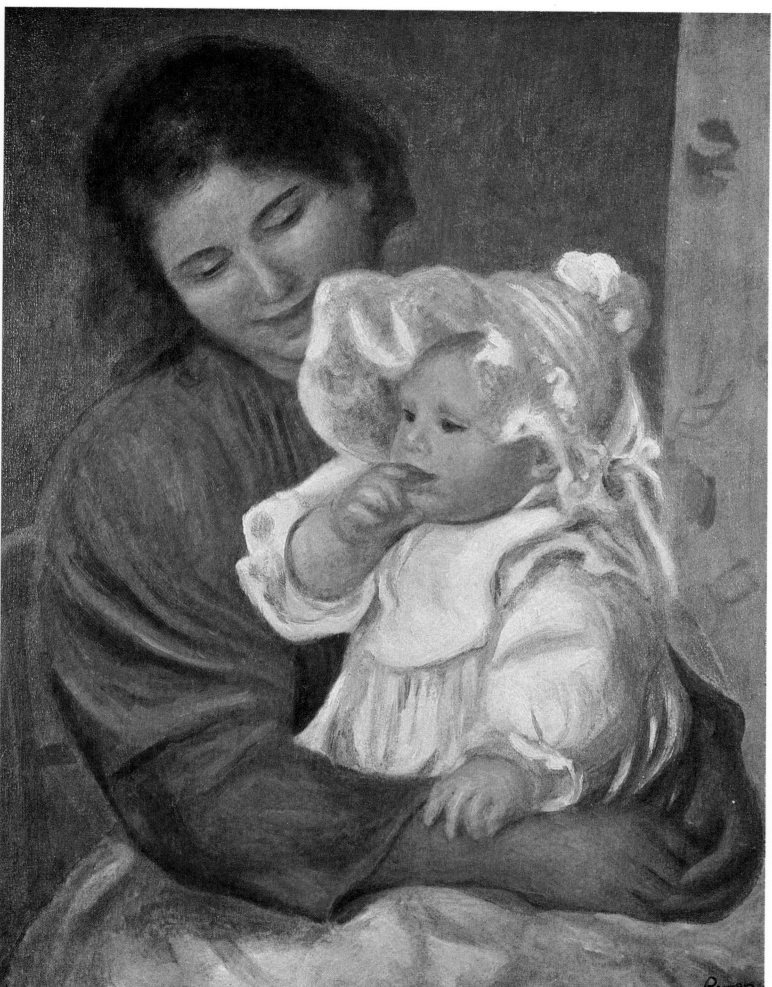

1895

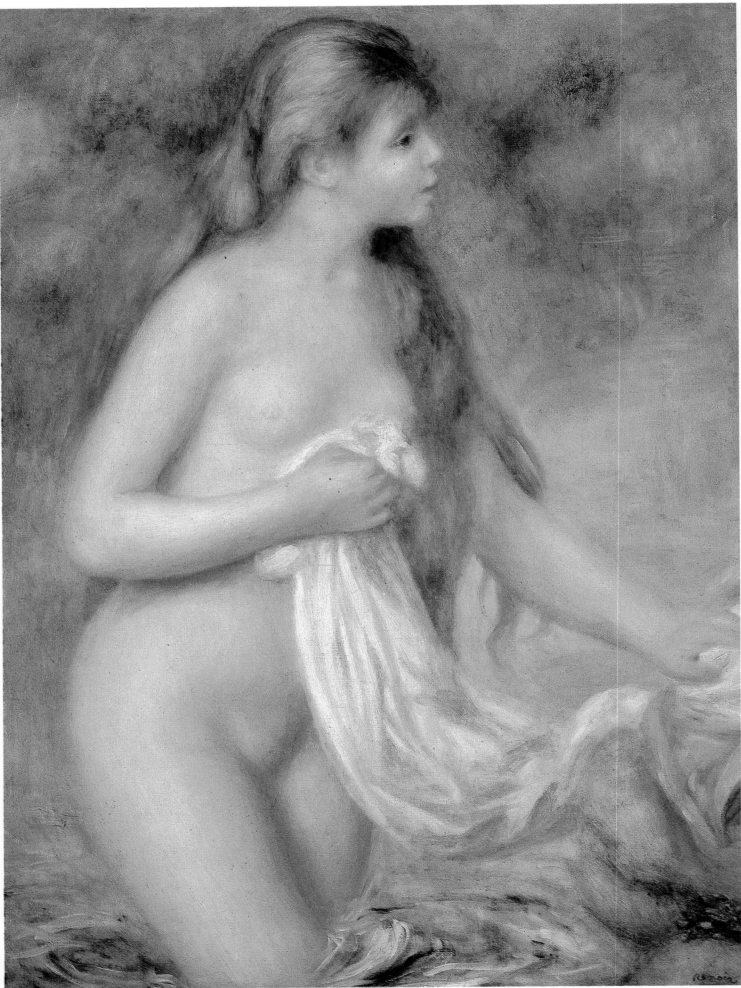

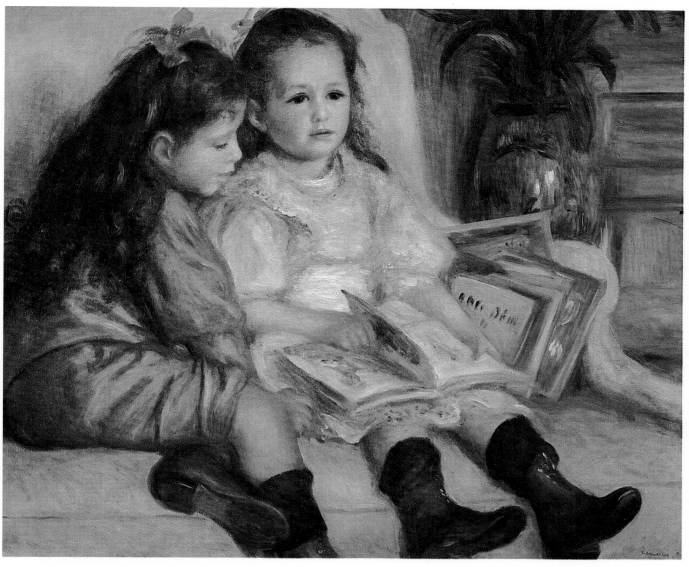

Portraits d'enfants
(Les enfants de Martial Caillebotte)

1895 - oil on canvas - 65 x 82 cm -
Private collection

Baigneuse aux cheveux longs

c.1895 - oil on canvas - 85 x 65 cm -
Musée de l'Orangerie,
Walther Guillaume Collection, Paris

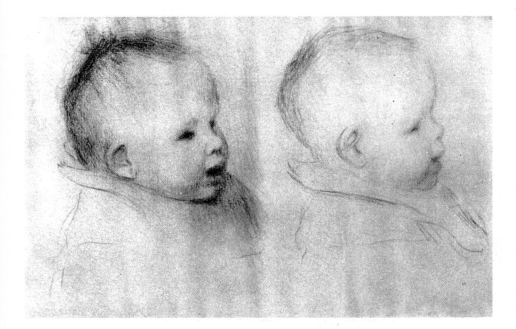

Têtes d'enfants

1890-95 - drawing - 28 x 43 cm -
Private collection

Joueuse de guitare

1896 - oil on canvas - 81 x 65 cm -
Musée des Beaux-Arts, Lyons

Baigneuse allongée et jeune fille
coiffant ses cheveux

1896 - oil on canvas - 19 x 24 cm -
Galerie Daniel Malingue, Paris

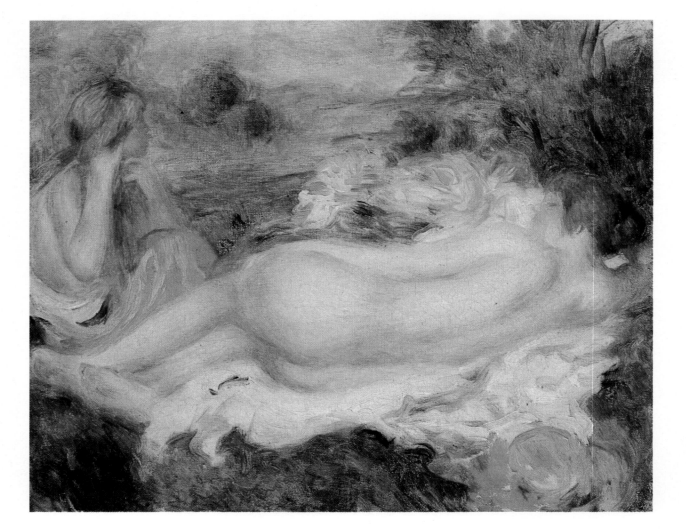

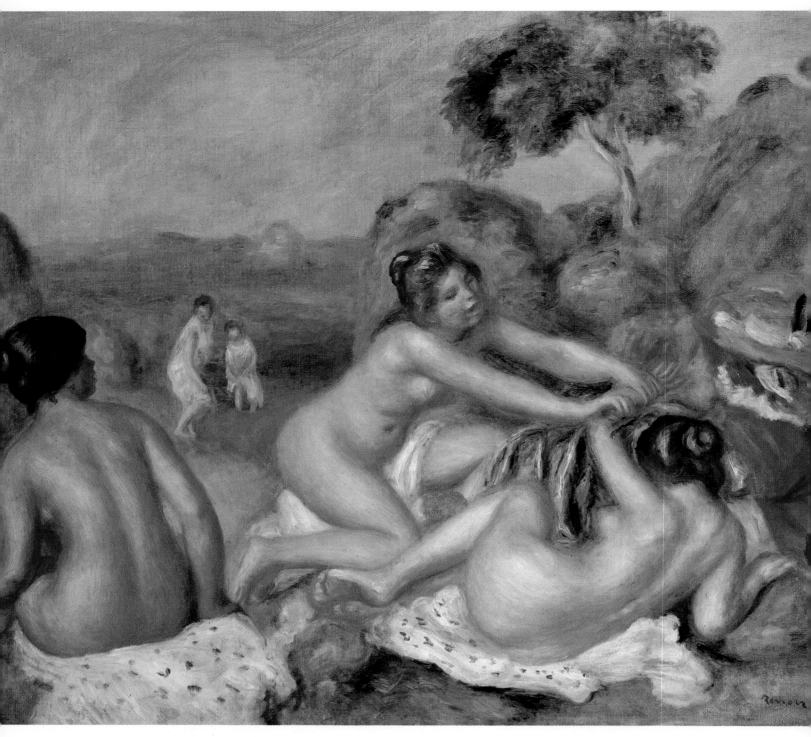

Trois baigneuses au crabe

1897 - oil on canvas - 54 x 65 cm -
Museum of Art, Cleveland

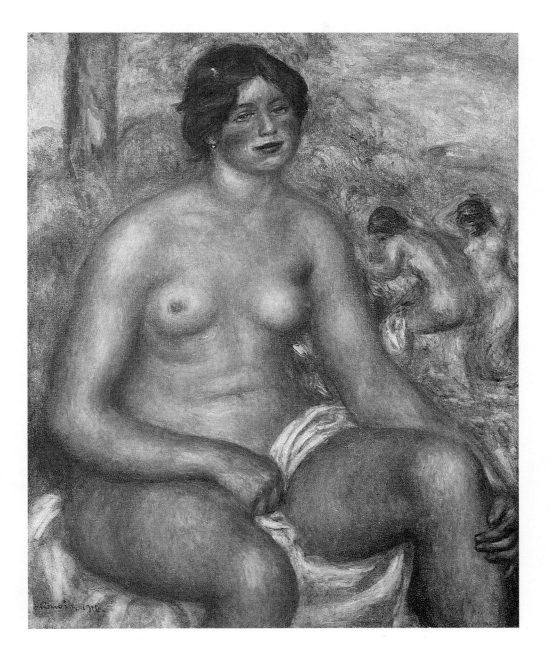

Baigneuse assise

c.1897 - engraving - 21.9 x 13.9 cm -

Private collection

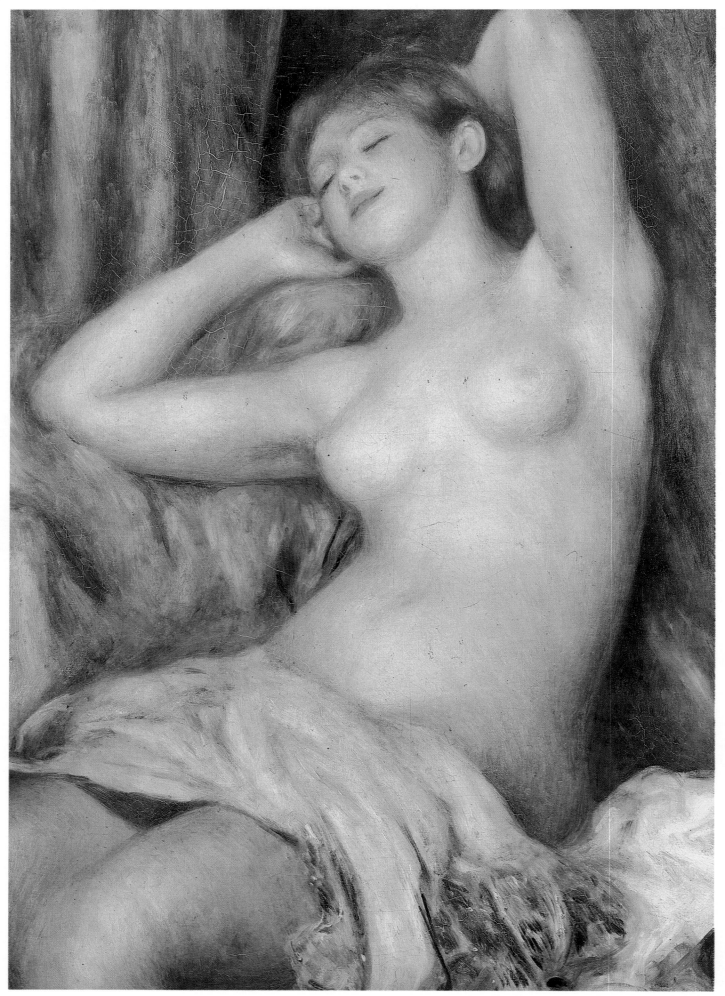

La dormeuse (La baigneuse endormie)

1897 - oil on canvas - 81 x 61 cm -
Oskar Reinhart Collection, Winterthur

Le chapeau épinglé

1897 - lithograph -
The Museum of Modern Art, New York

Yvonne et Christine Lerolle au piano

1897 - oil on canvas - 73 x 92 cm -
Musée de l'Orangerie,
Walther Guillaume Collection, Paris

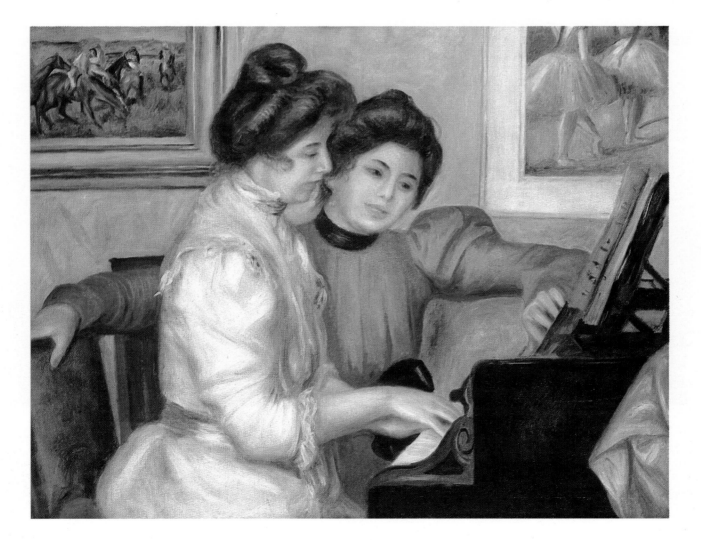

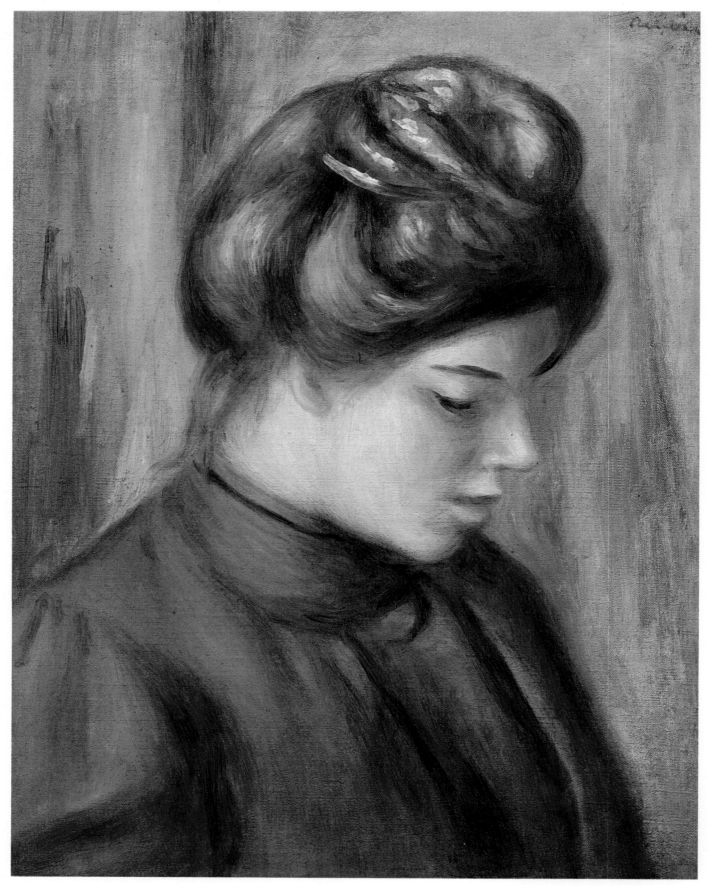

Profil de femme au corsage rouge

1897 - oil on canvas - 40 x 32 cm -
Private collection

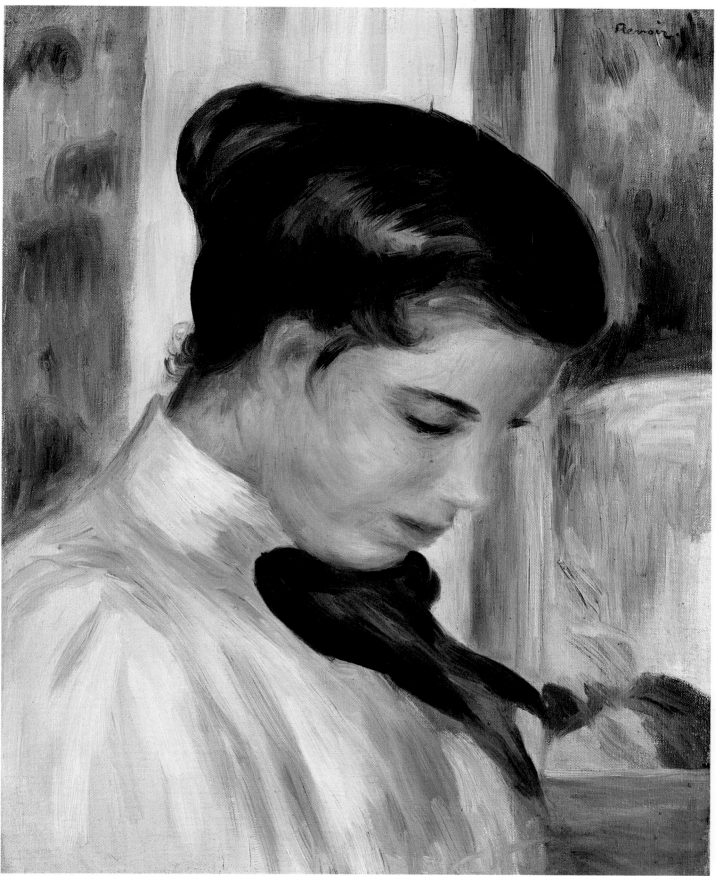

Portrait d'une jeune femme de profil
1897 - oil on canvas - 41.3 x 33 cm -
Private collection

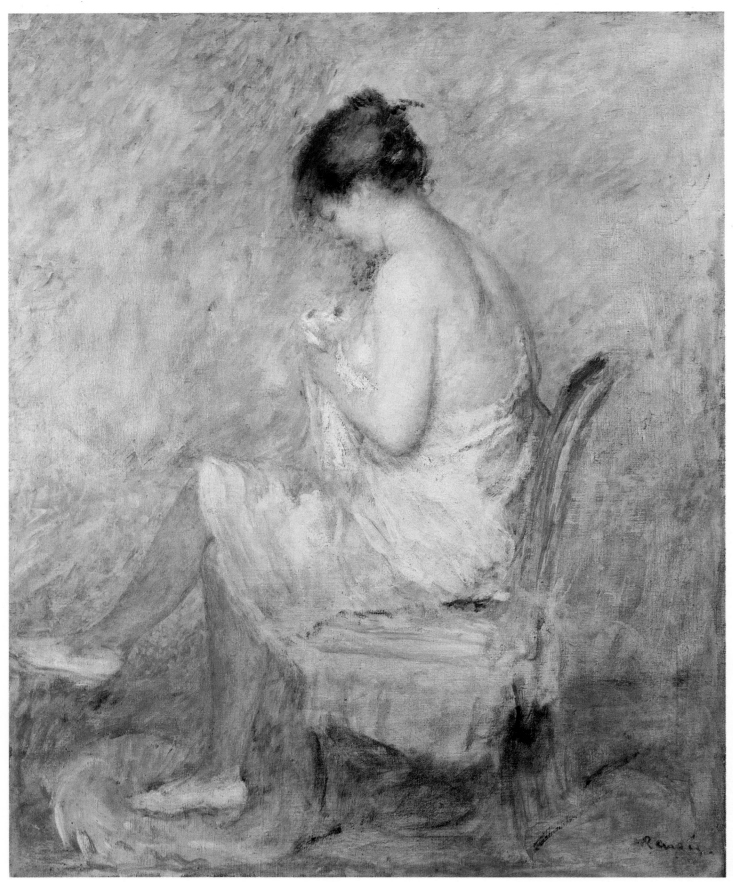

Femme à la chemise

1897-98 - oil on canvas - 65 x 53.5 cm -
Private collection

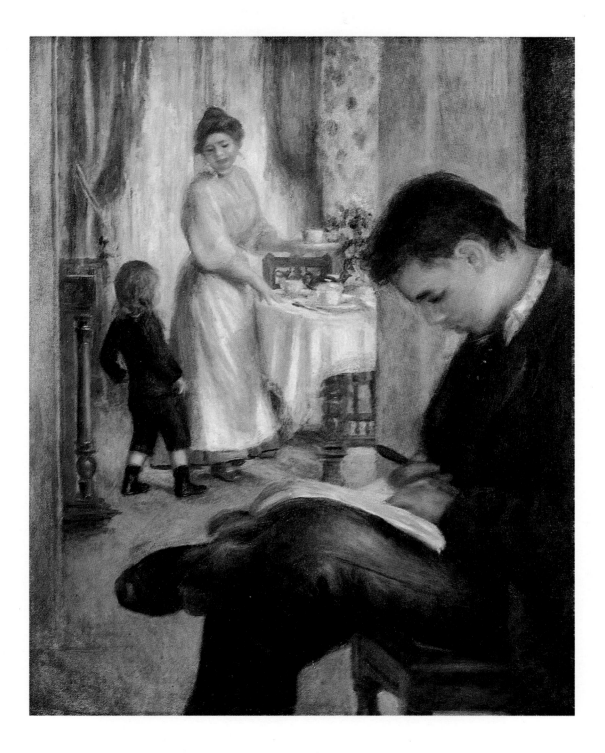

Déjeuner à Berneval

1898 - oil on canvas - 82 x 66 cm -
Private collection

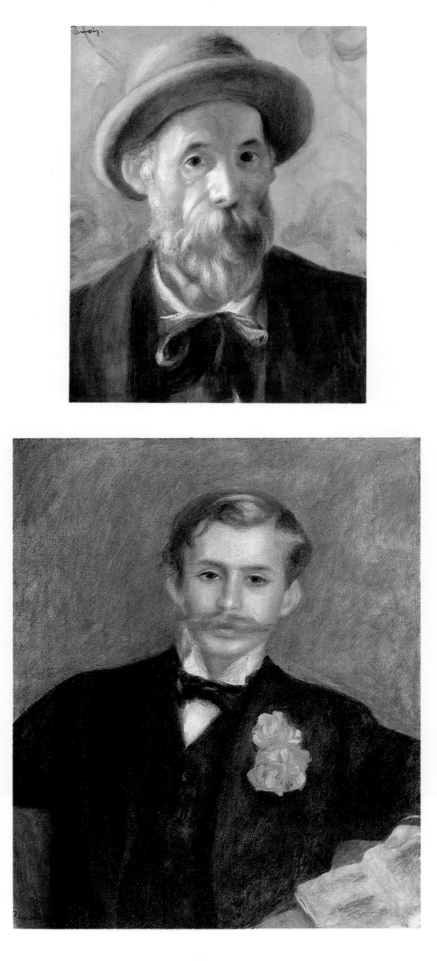

Autoportrait (Self Portrait)

1899 - oil on canvas - 41 x 33 cm -
Sterling and Francine Clark
Art Institute, Williamstown

Monsieur Germain

c. 1900 - oil on canvas - 55 x 46 cm -
Norton Gallery and School of Art,
West Palm Beach

Le chantier du Sacré-Coeur

c. 1900 - oil on canvas - 32.5 x 41.5 cm -
Bayerische Staatsgemäldesammlungen, Munich

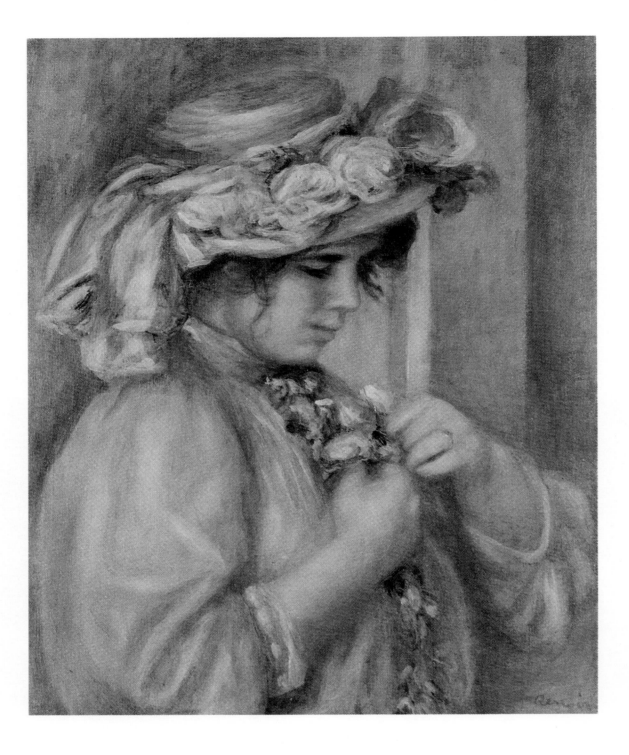

Jeune fille au chapeau

c. 1900 - oil on canvas - 55 x 65 cm -

Oskar Reinhart Collection, Winterthur

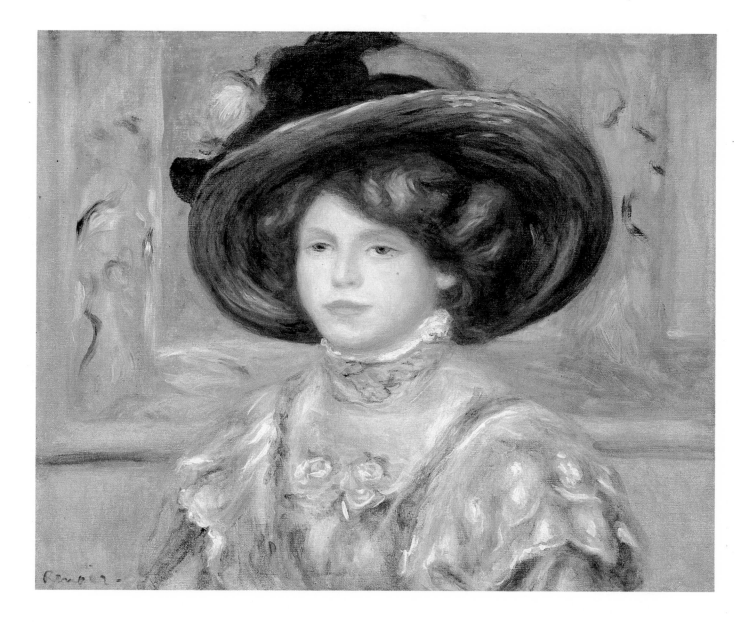

Portrait de jeune femme au chapeau bleu

c. 1900 - oil on canvas - 47 x 56 cm -
Private collection

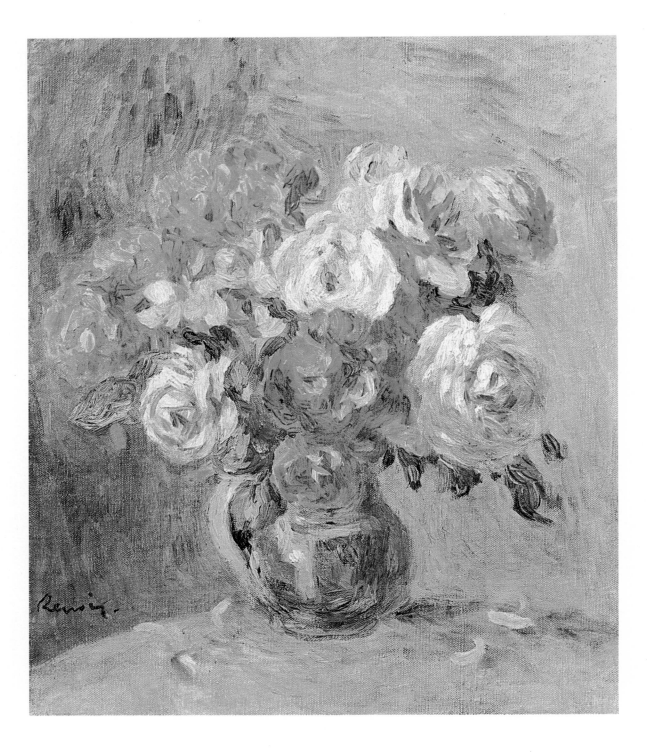

Fleurs dans un vase

c. 1901 - oil on canvas - 42 x 36 cm -
Private collection

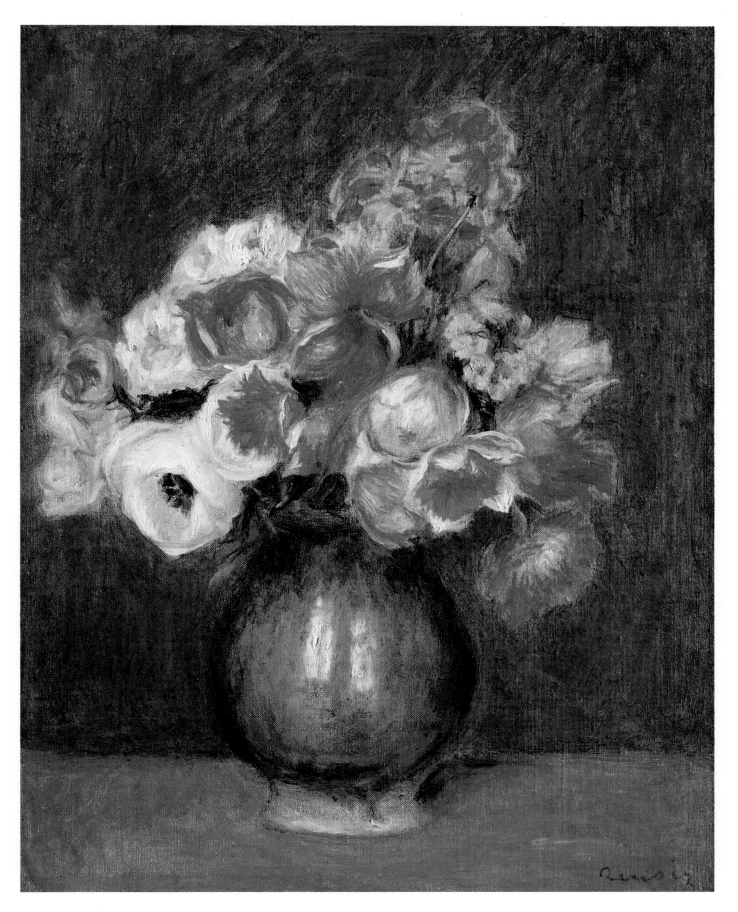

Fleurs dans un vase

1901 - oil on canvas - 41 x 33 cm -
Private collection

Femme et enfant dans un jardin

1903- oil on canvas - 19 x 18 cm -
Private collection

Villa de la Poste à Cagnes

1903 - oil on canvas - 46.2 x 55.2 cm -
Knodler and Co., New York

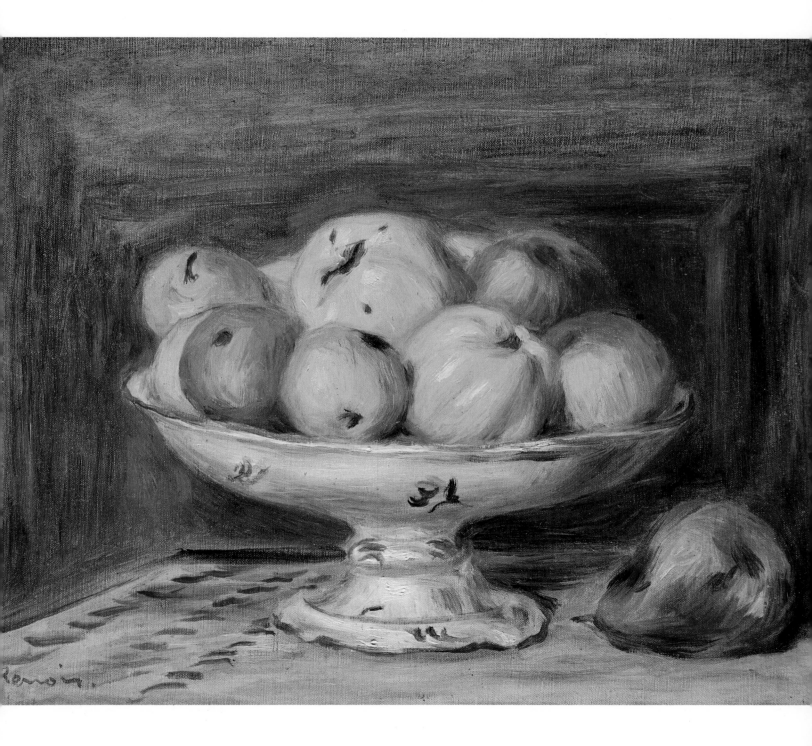

Nature morte aux pommes et à la poire

1903 - oil on canvas - 32.5 x 41.5 cm -
Private collection

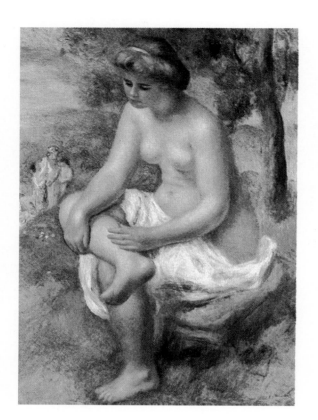

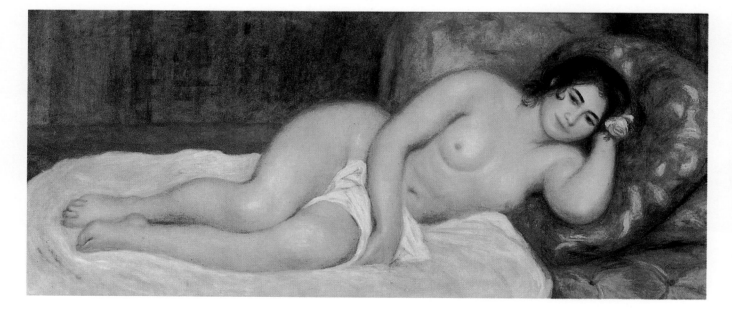

Baigneuse blonde

1903 - oil on canvas - 97 x 73 cm -
Kunsthistorisches Museum, Vienna

Femme nue couchée

1903;- oil on canvas - 65 x 156 cm -
Private collection

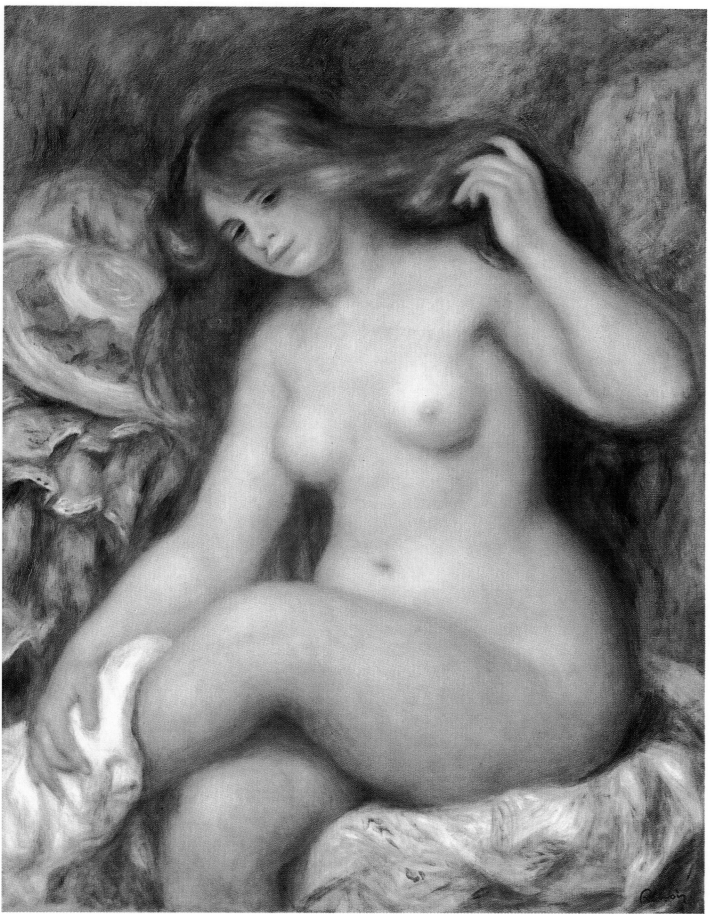

Baigneuse

c.1903 - oil on canvas - 92 x 73 cm -
Kunsthistorisches Museum, Vienna

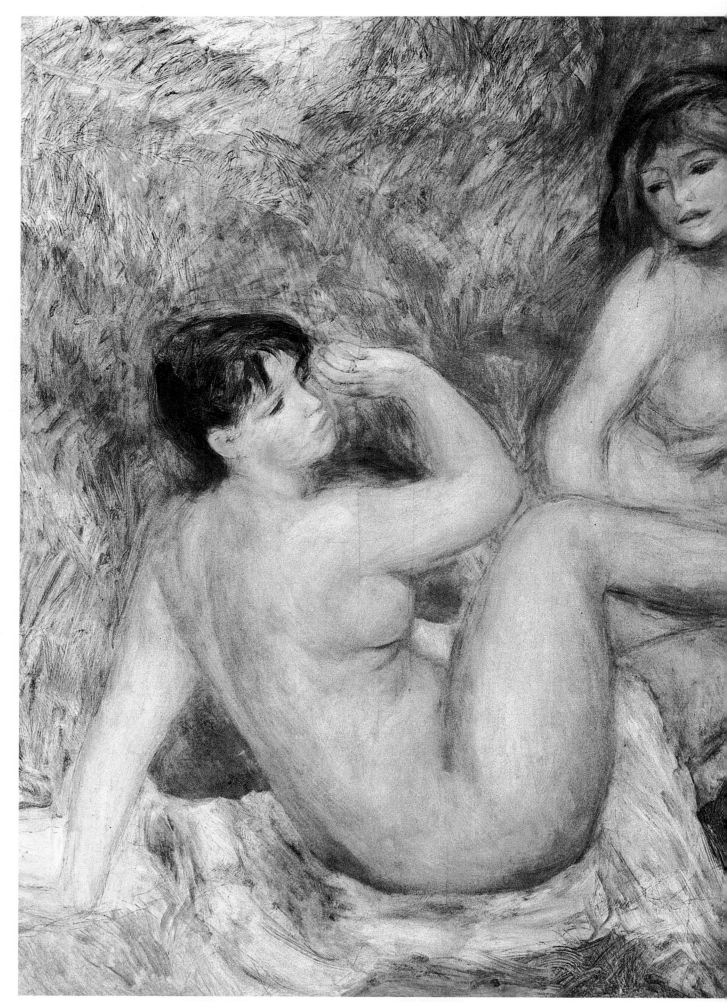

variation on Les Grandes Baigneuses

1903 - pencil - 111.7 x 166.3 cm -

Musée des Beaux-Arts Jules Cheret, Nice

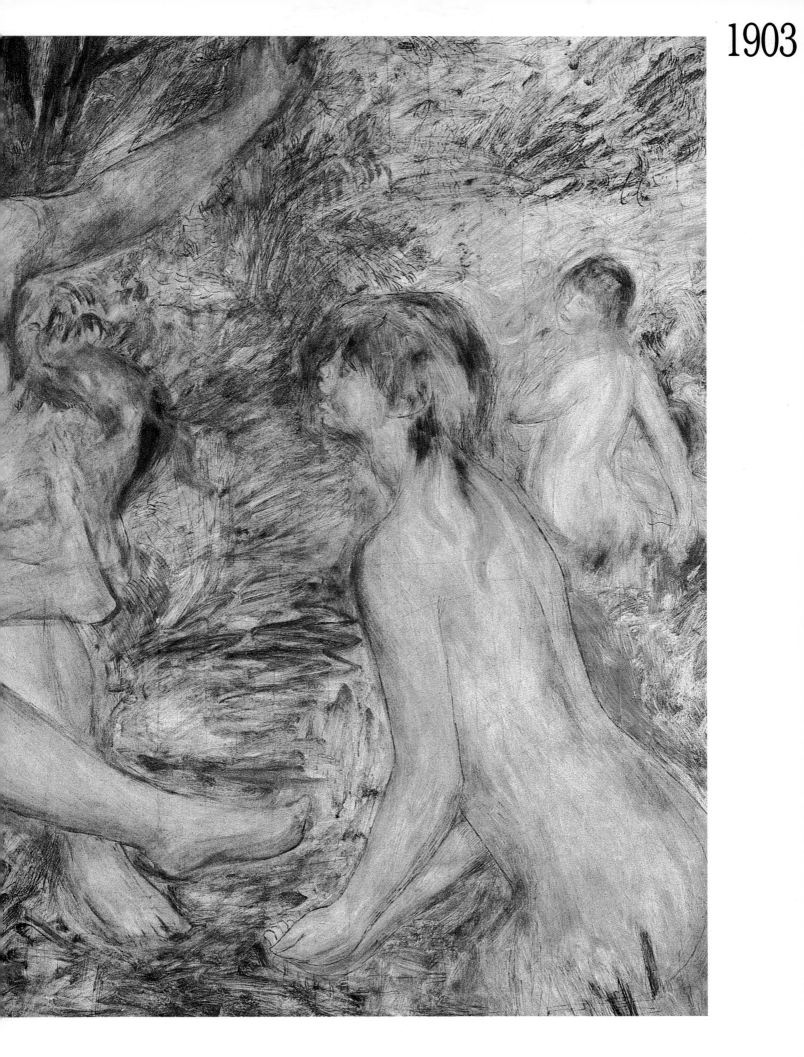

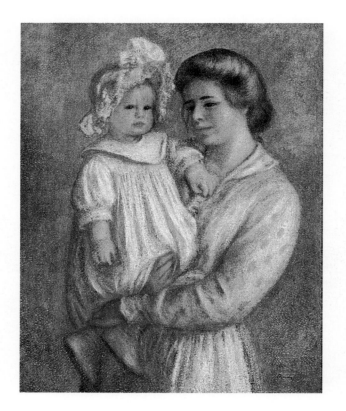

Claude et Renée

1903 - 04 - pencil -61 x 47.7 cm -
National Gallery of Canada, Ottawa

Deux têtes de Coco

c.1903 - oil on canvas - 19 x 19 cm -
Private collection

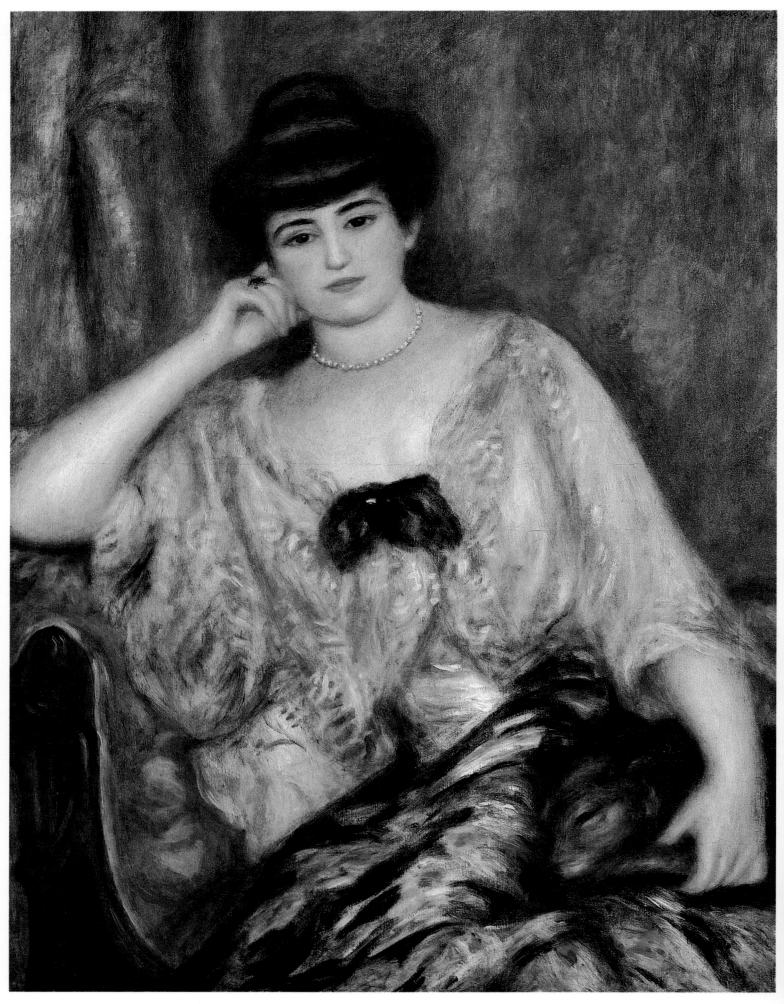

Nature morte à la tasse et au sucrier

1904 - oil on canvas - 21 x 32 cm -
Private collection

Portrait de Misia

1904 - oil on canvas - 92 x 72 cm -
National Gallery, London

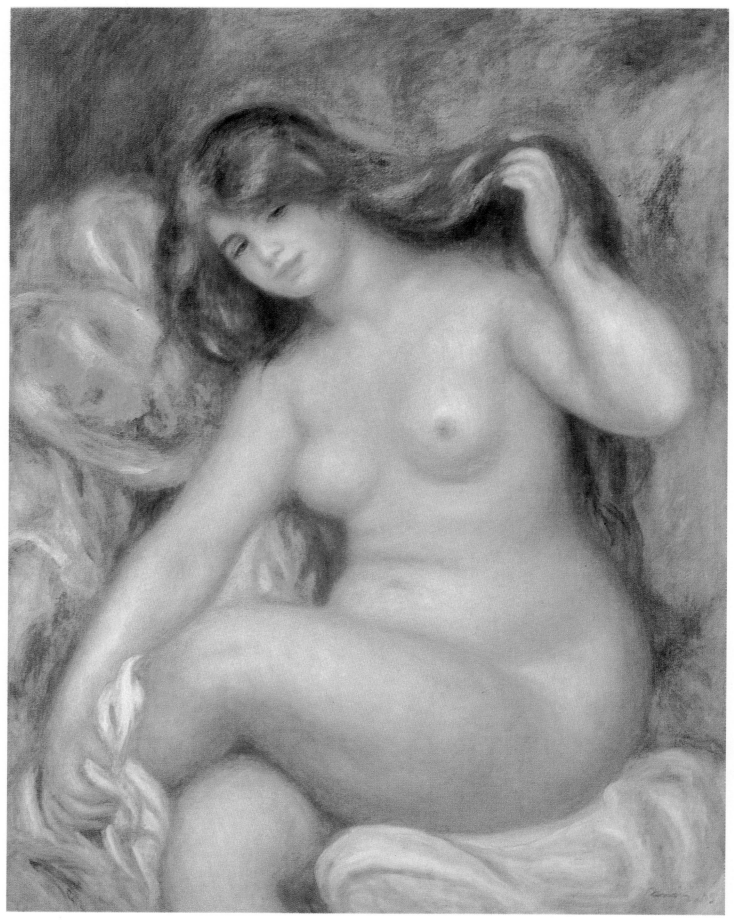

Baigneuse

1905 - oil on canvas - 97 x 73 cm -
Philadelphia Museum of Art

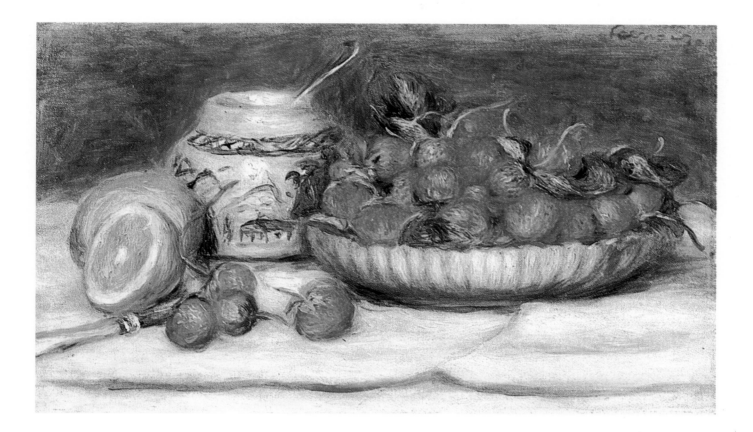

Fraises

c. 1905 - oil on canvas - 28 x 46 cm -
Musée de l'Orangerie,
Walther Guillaume Collection, Paris

Cros-de-Cagnes

1905 - oil on canvas - 26 x 29 cm -

Private collection

Maisons à Cagnes

1905 - oil on canvas - 42 x 33 cm -
Private collection

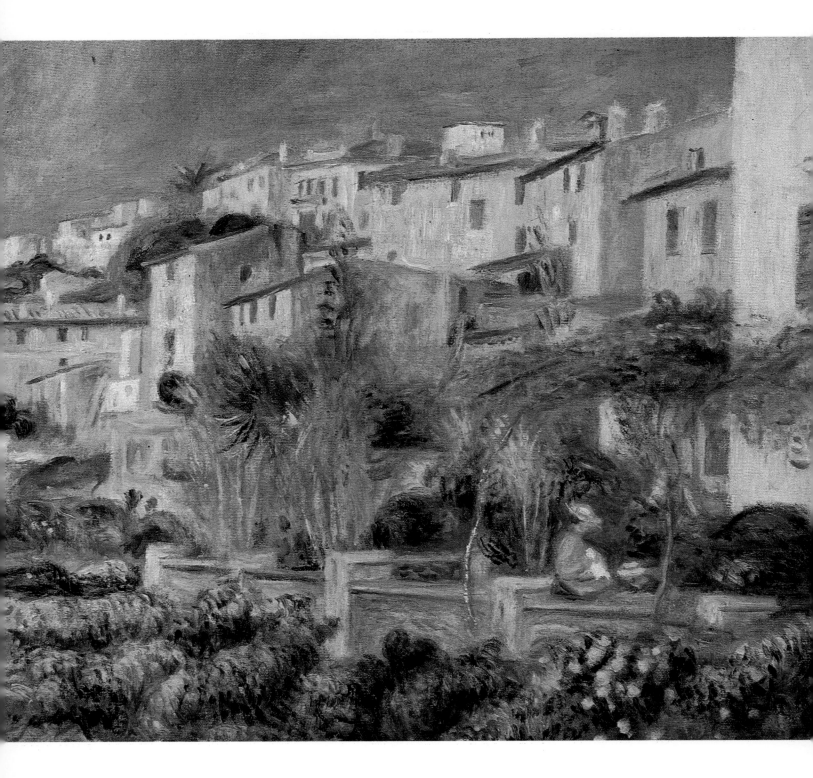

Terrasse à Cagnes

1905 - oil on canvas - 46 x 55 cm -
Ishibashi Collection, Tokyo

Claude

1905 - sanguine heightened with white - 60 x 46 cm -
Private collection

Claude

1905 - drawing
Private collection

Claude Renoir jouant

c. 1906 - oil on canvas - 46 x 55 cm -
Musée de l'Orangerie,
Madame Jean Walther Collection, Paris

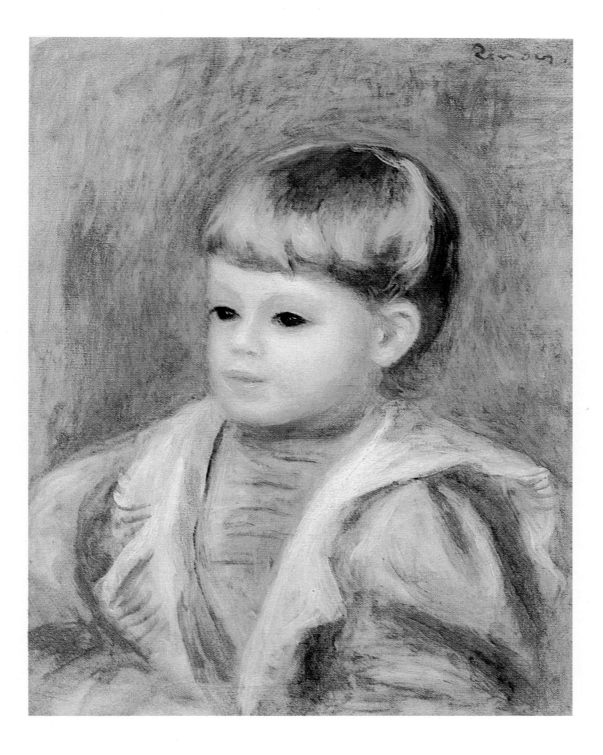

Portrait d'enfant (Philippe Gangnat)

c. 1906 - oil on canvas - 41 x 33 cm -
Private collection

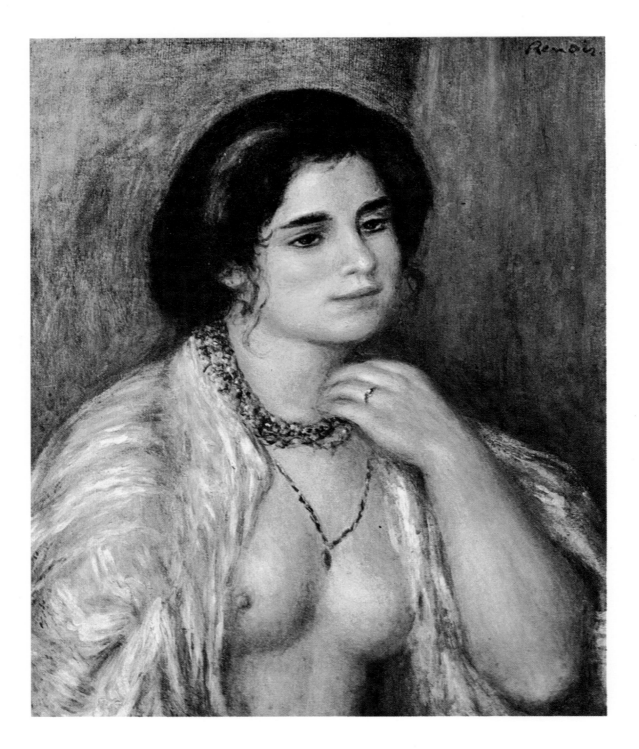

Gabrielle aux seins nus

1907 - oil on canvas - 56 x 46 cm -
Mme Lucile Martinais-Manguin, Paris

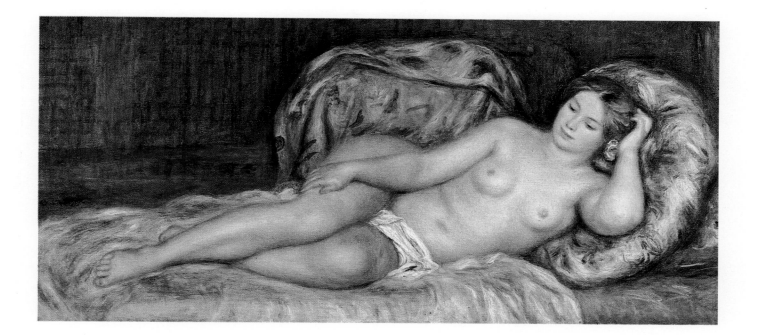

Nu sur les coussins

1907 - oil on canvas - 70 x 155 cm -
Musée d'Orsay, Paris

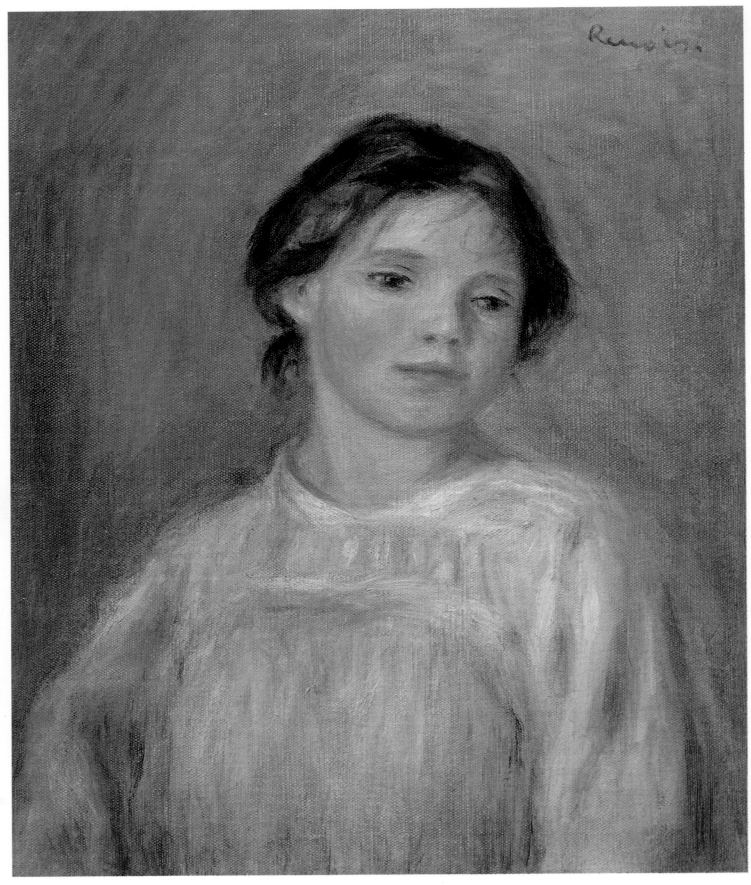

Portrait d'Hélène Bellow

1908 - oil on canvas - 33.5 x 28.5 cm -
Private collection

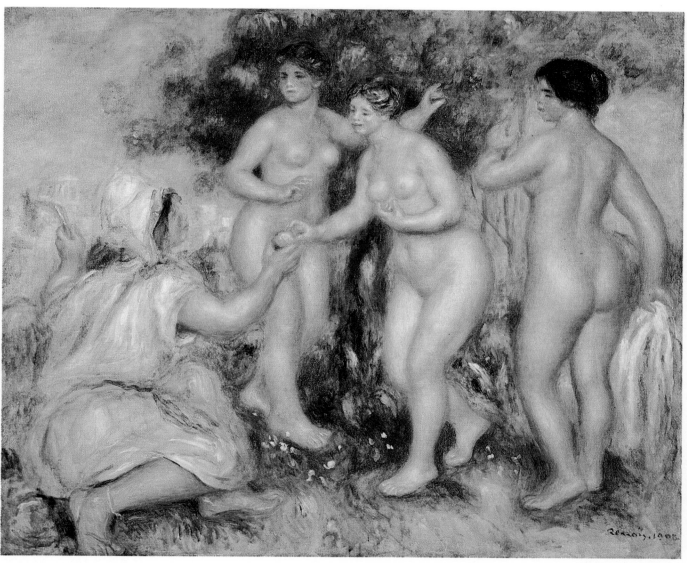

Le jugement de Pâris

1908 - oil on canvas - 81 x 101 cm -
Private collection

La toilette : femme se peignant

1907-08 - oil on canvas - 55 x 46 cm -

Musée d'Orsay

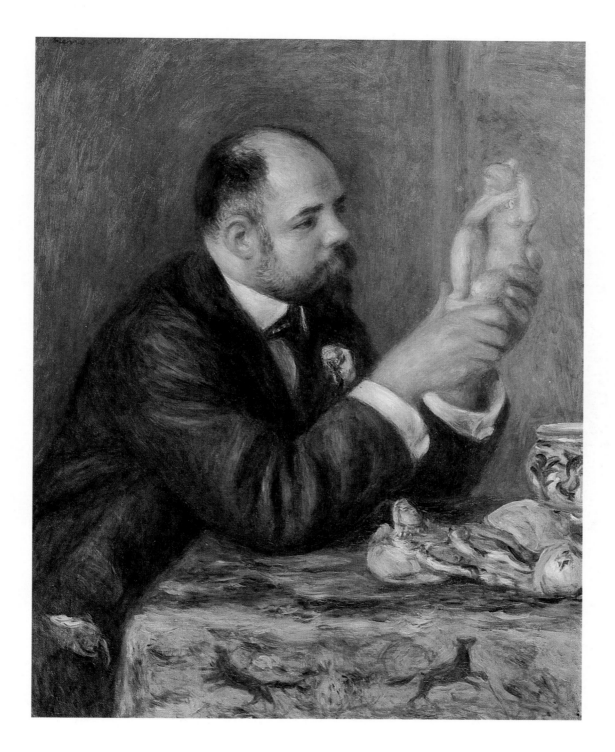

Ambroise Vollard

1908 - oil on canvas - 82 x 65 cm -
Courtauld Institute Galleries, London

Les vignes à Cagnes

c.1908 - oil on canvas - 46 x 55 cm -
Brooklyn Museum, New York

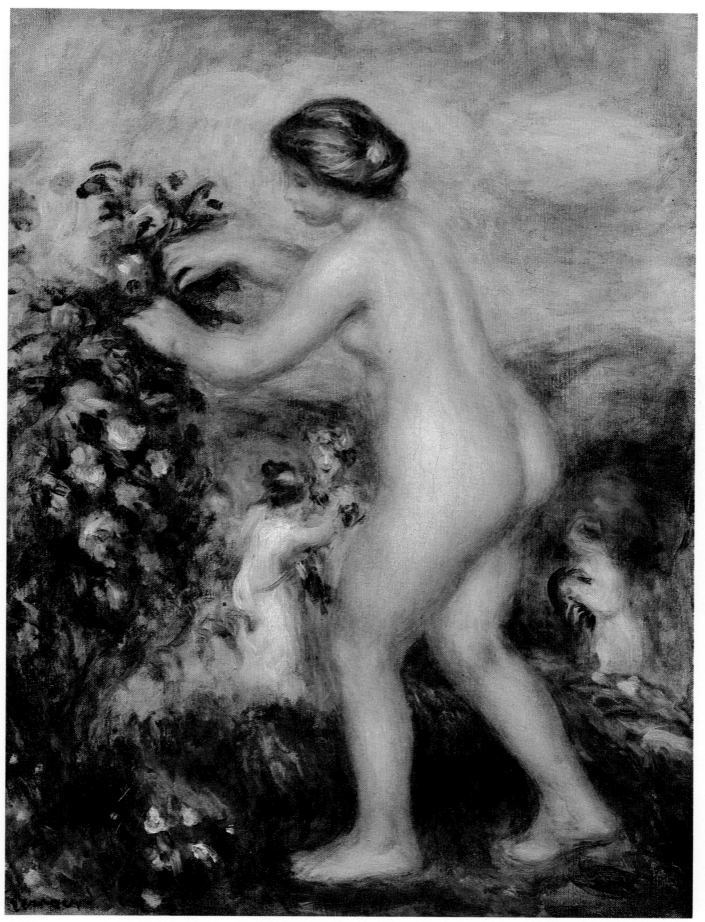

Ode aux fleurs (after Anacréon)

1903-09 - oil on canvas - 46 x 36 cm -
Musée d'Orsay, Paris

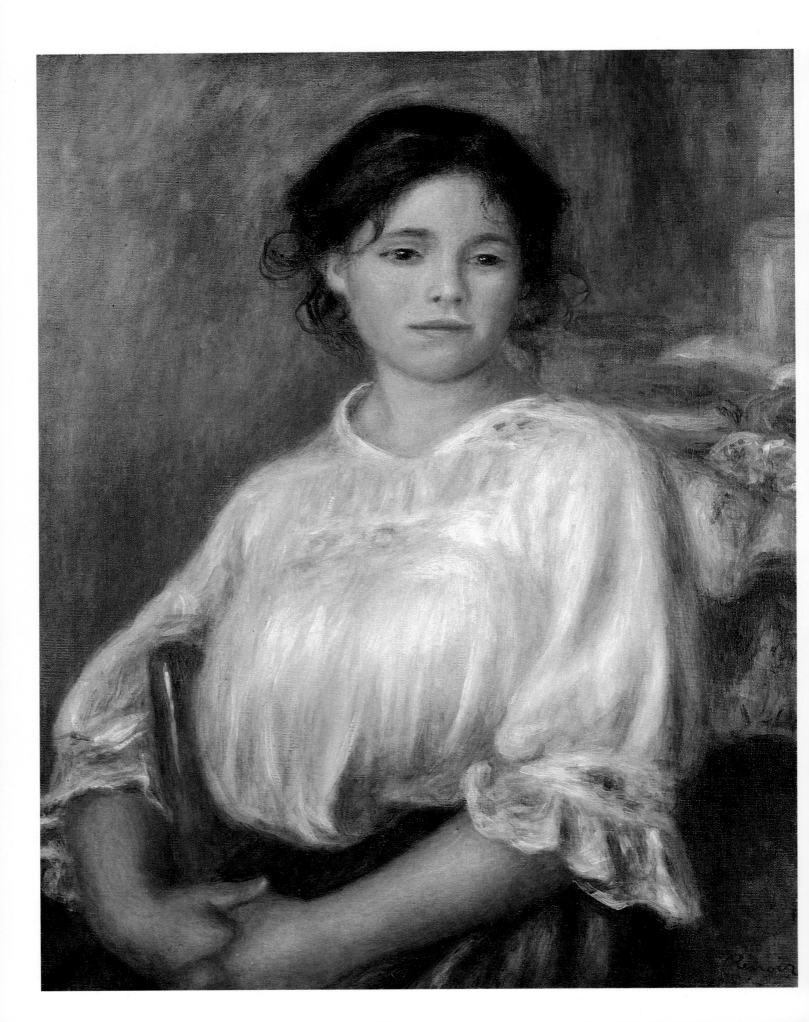

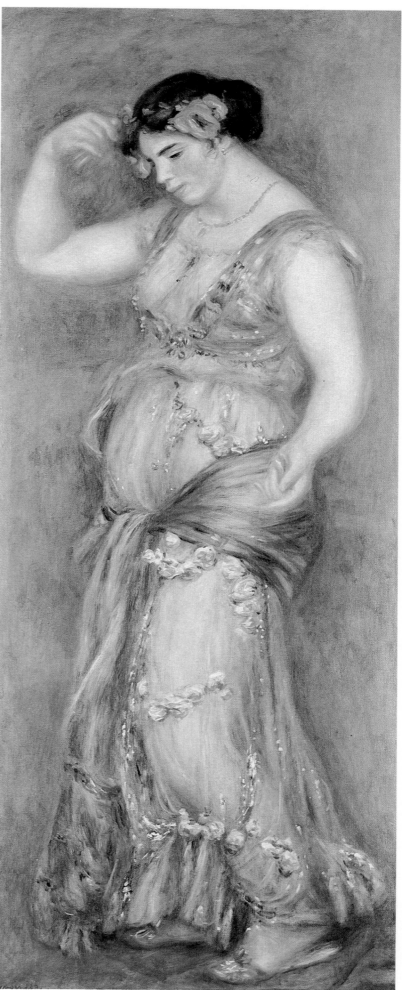

Jeune fille assise
1909 - oil on canvas - 65 x 54 cm -
Musée d'Orsay, Paris

Danseuse aux castagnettes
1909 - oil on canvas - 155 x 65 cm -
National Gallery, London

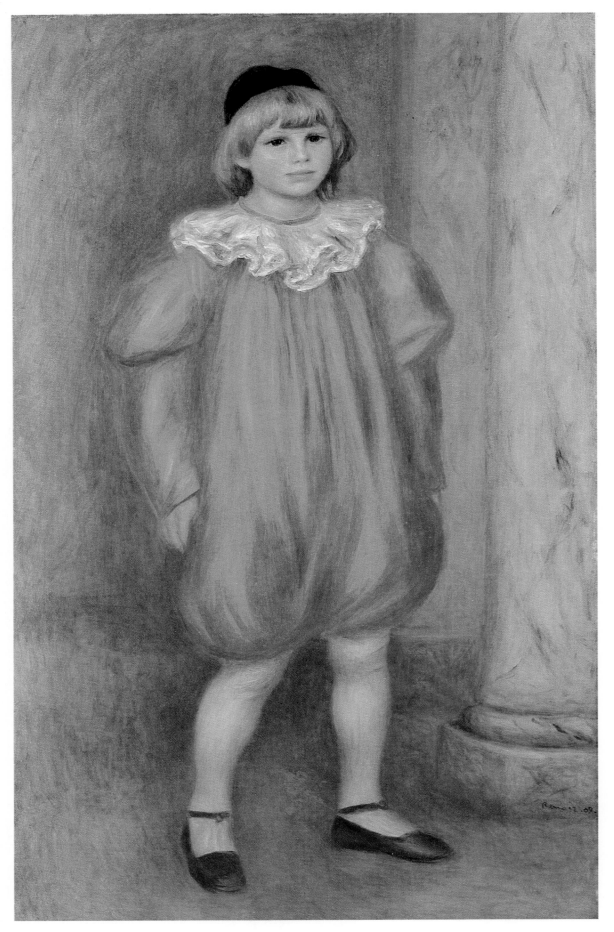

Le clown *ou* Claude en robe rouge

*1909 - oil on canvas - 120 x 77 cm -
Musée de l'Orangerie, Paris*

Le jardin des Collettes

1909 - oil on canvas - 26 x 28 cm -
Private collection

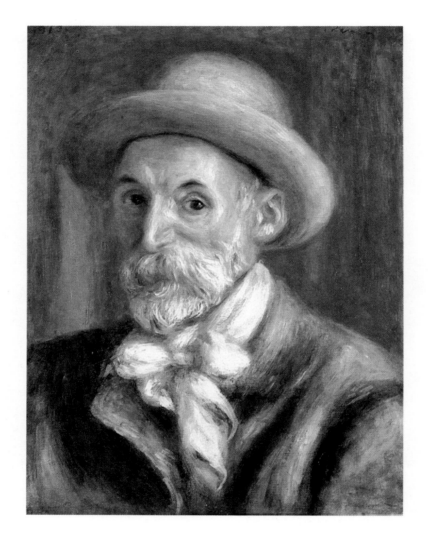

Autoportrait (Self-portrait)

1910 - oil on canvas - 47 x 36 cm -

Private collection

Autoportrait au chapeau blanc

1910 - oil on canvas - 42 x 33 cm -
Durand-Ruel Collection, Paris

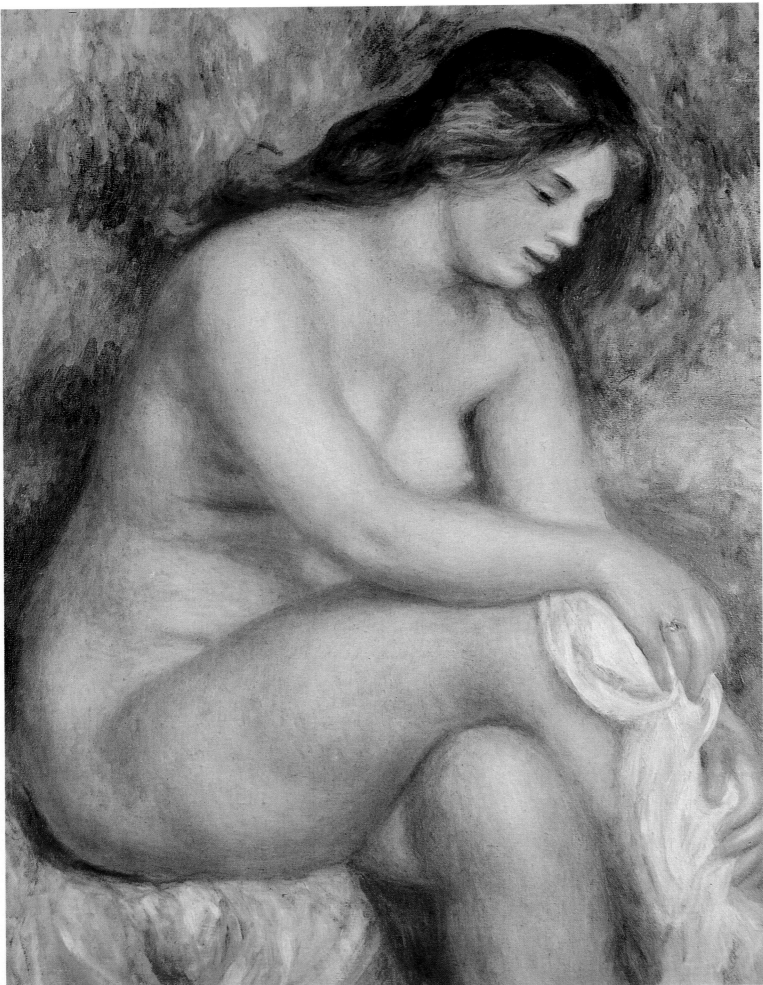

Baigneuse s'essuyant la jambe
(Baigneuse assise)
c.1910 - oil on canvas - 84 x 65 cm -
Museu de Arte, Sao Paulo

Femmes nues dans un paysage
or Femmes au bain
c.1910 (or c.1915) - oil on canvas - 47 x 36 cm -
Nationalmuseum, Stockholm

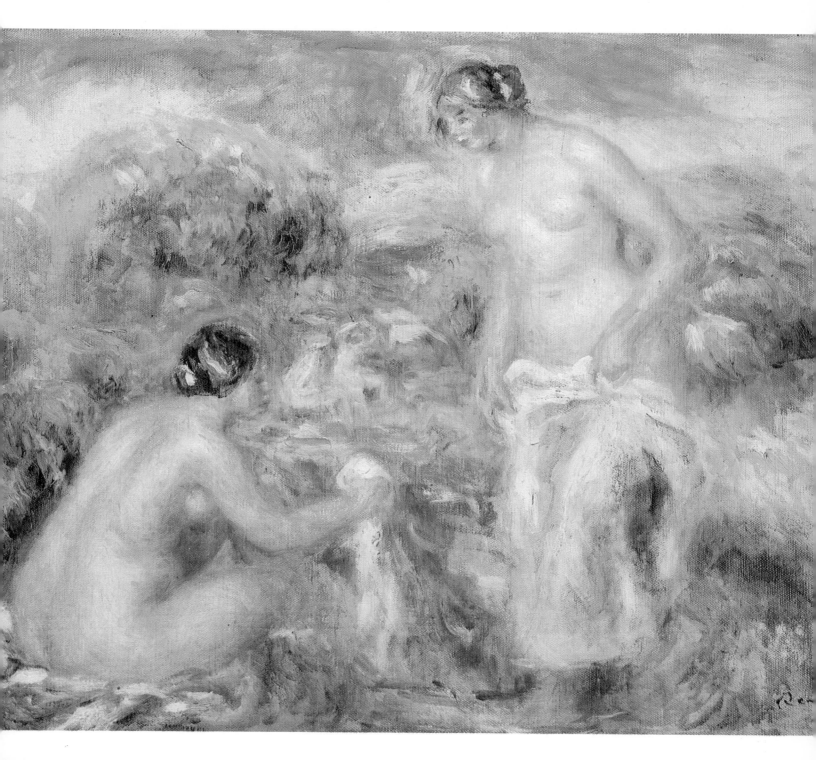

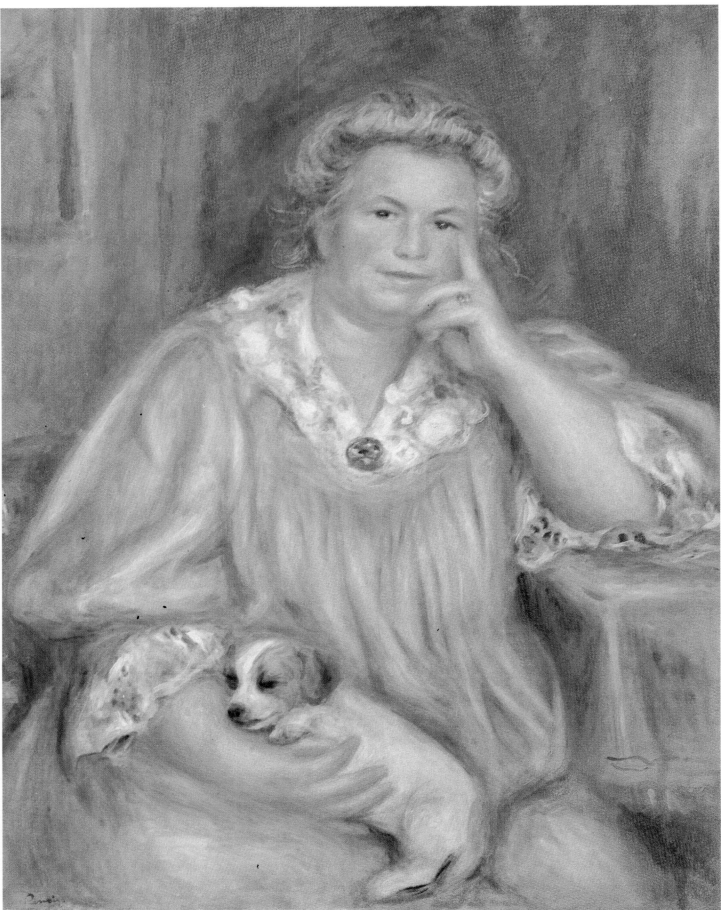

Madame Renoir avec Bob

1910 - oil on canvas - 81 x 65 cm -
Ella Gallup & Mary Catlin Summer
Collection, Wadsworth Atheneum, Hartford

Coco et les deux servantes

1910 - oil on canvas - 65 x 54 cm -
Galerie Daniel Malingue, Paris

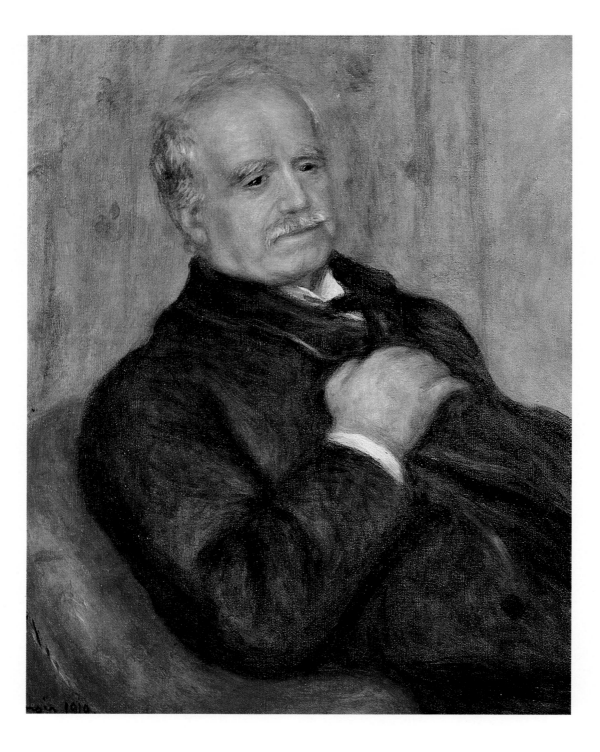

Paul Durand-Ruel

1910 - oil on canvas - 65 x 54 cm -
Durand-Ruel Collection, Paris

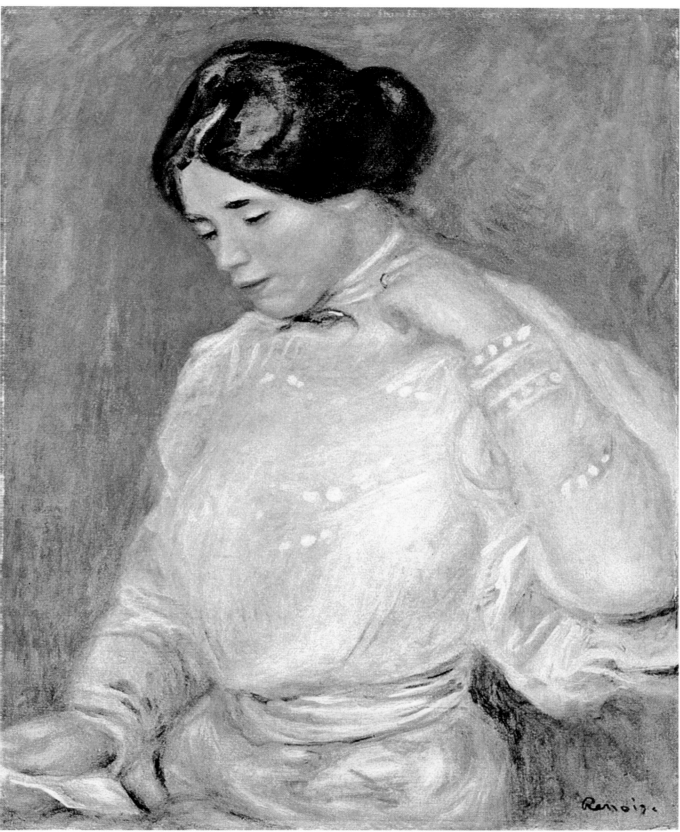

Graziella

1910 - oil on canvas - 65.5 x 54 cm -
Detroit Institute of Arts, Detroit

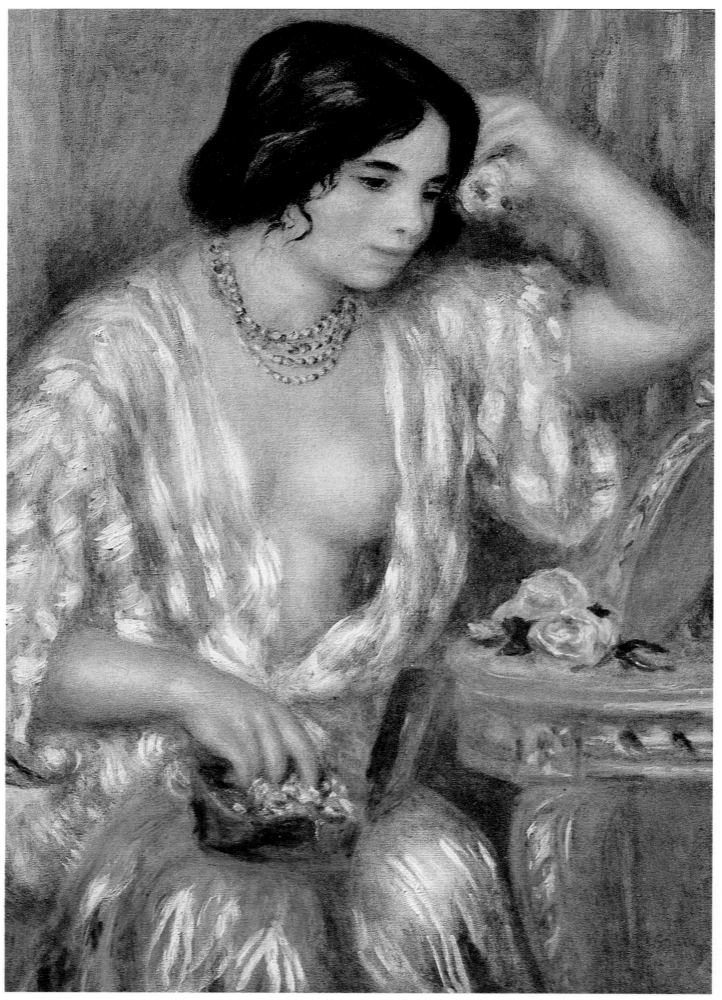

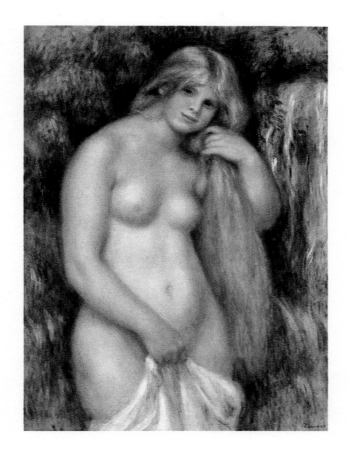

Baigneuse dans la forêt

1910-15 - oil on canvas - 92 x 73 cm -
Bührle Foundation, Zürich

Gabrielle aux bijoux

1910 - oil on canvas - 81 x 65 cm -
Private collection

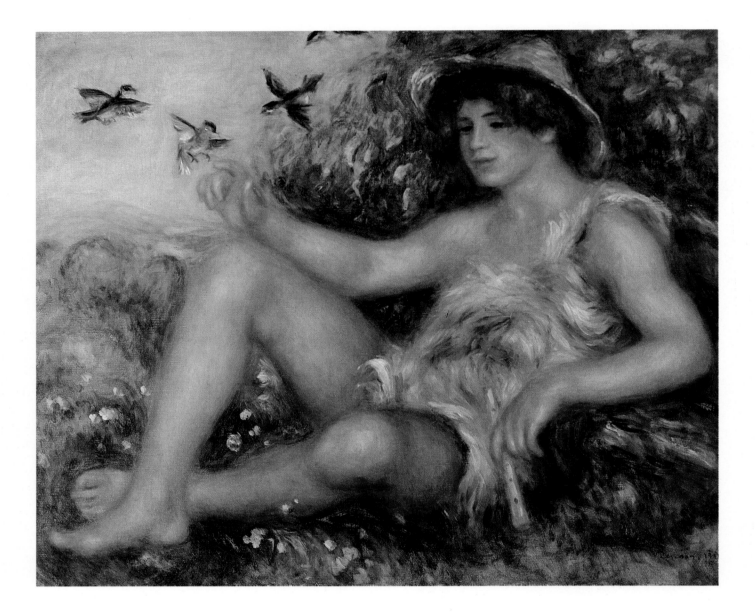

Alexandre Thurneyssen en jeune pâtre

1911 - oil on canvas - 75 x 93 cm -
Museum of Art, Providence

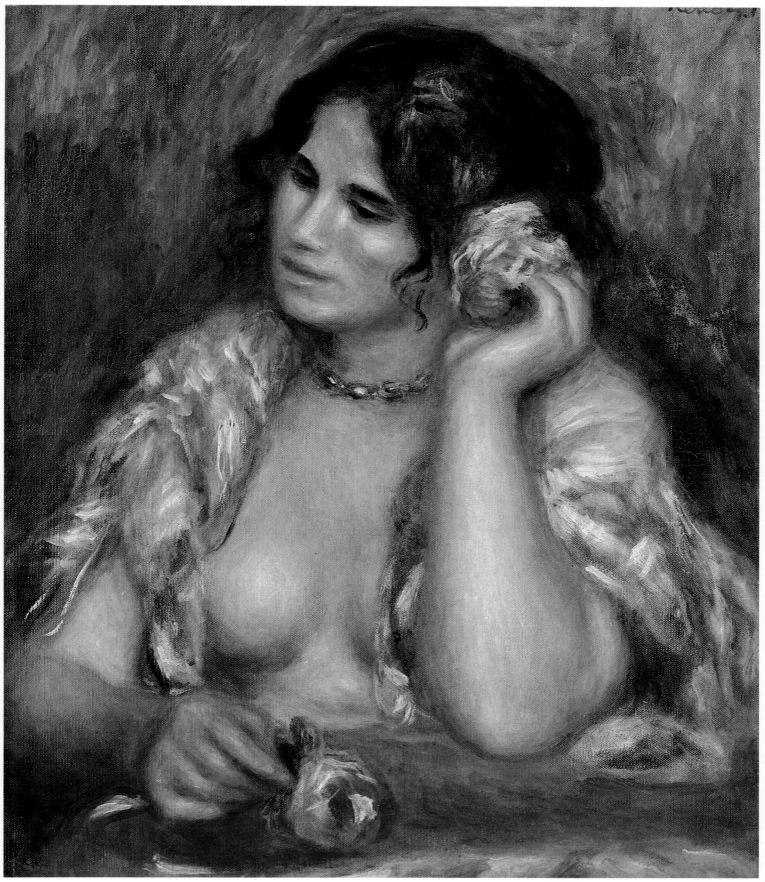

Gabrielle à la rose

1911 - oil on canvas - 55.5 x 47 cm -
Musée d'Orsay, Paris

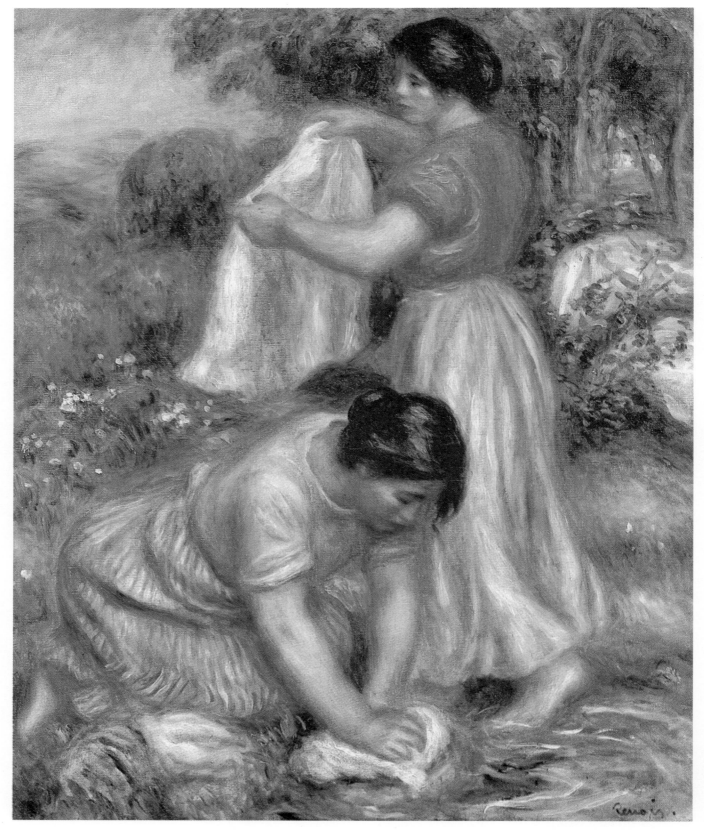

Les laveuses

c. 1912 - oil on canvas - 65 x 55 cm -
Gift of Raymonde Paul
Metropolitan Museum of Art, New York

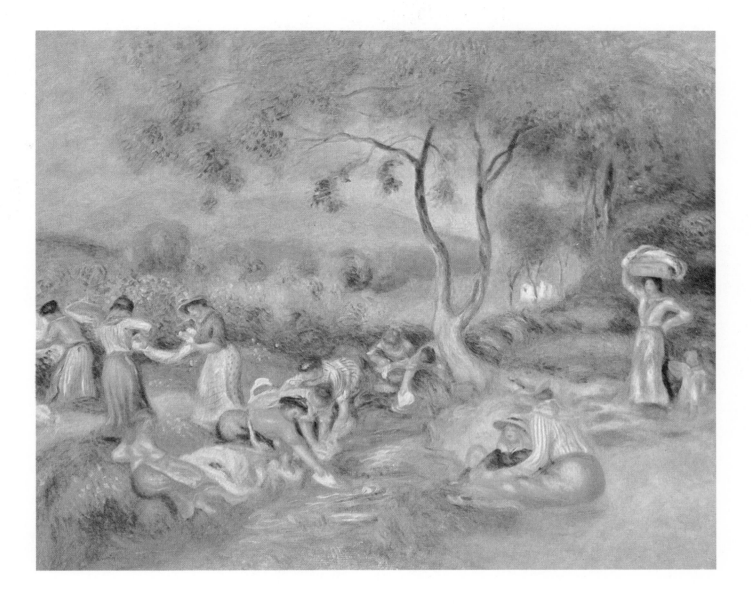

Les laveuses à Cagnes (Les lavandières)

c. 1912 - oil on canvas - 73 x 92 cm -
Private collection

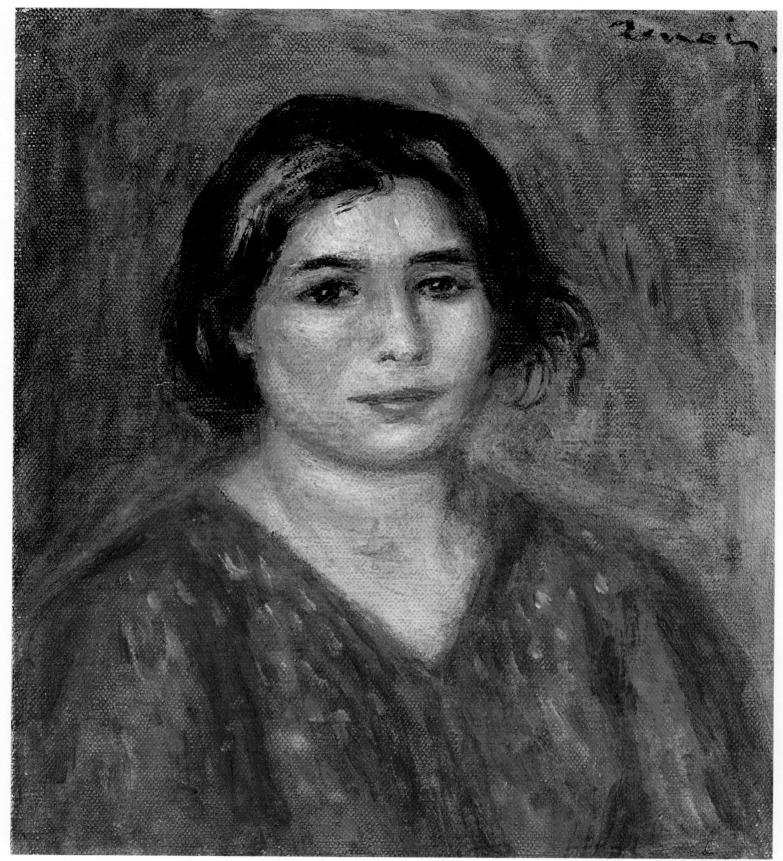

Gabrielle en blouse rouge

1913 - oil on canvas - 23.5 x 20 cm -
Private collection

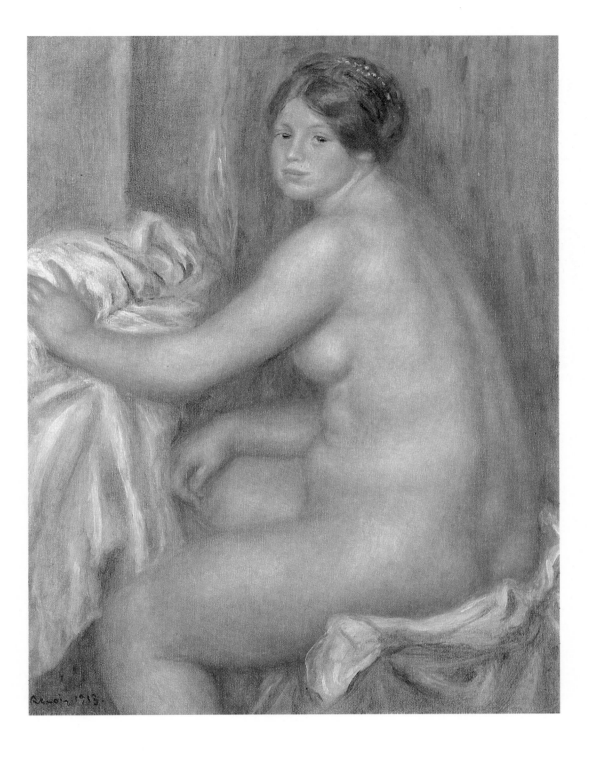

Baigneuse

1913 - oil on canvas - 81 x 65 cm -
M. et Mme. Alexandre Lewyt Collection

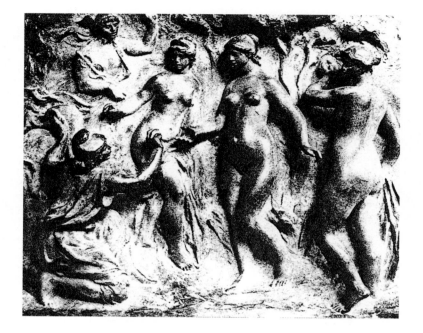

Tilla Durieux

1914 - oil on canvas - 92 x 74 cm -
Gift of Stephen C. Clark
Metropolitan Museum of Art, New York

Le jugement de Pâris

1914 - bronze - 75 x 93 x 15 cm-
Stedelijk Museum, Amsterdam

Le jugement de Pâris

c. 1913-14 - oil on cloth - 73 x 91 cm -
The Hiroshima Museum of Art, Japan

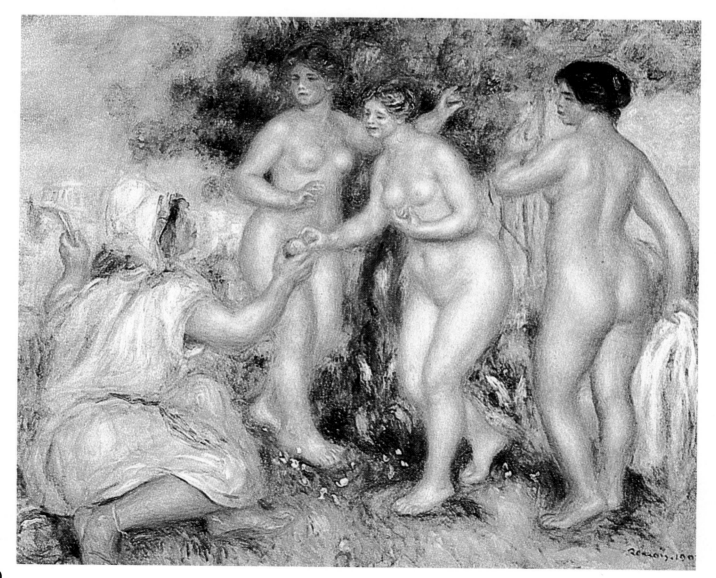

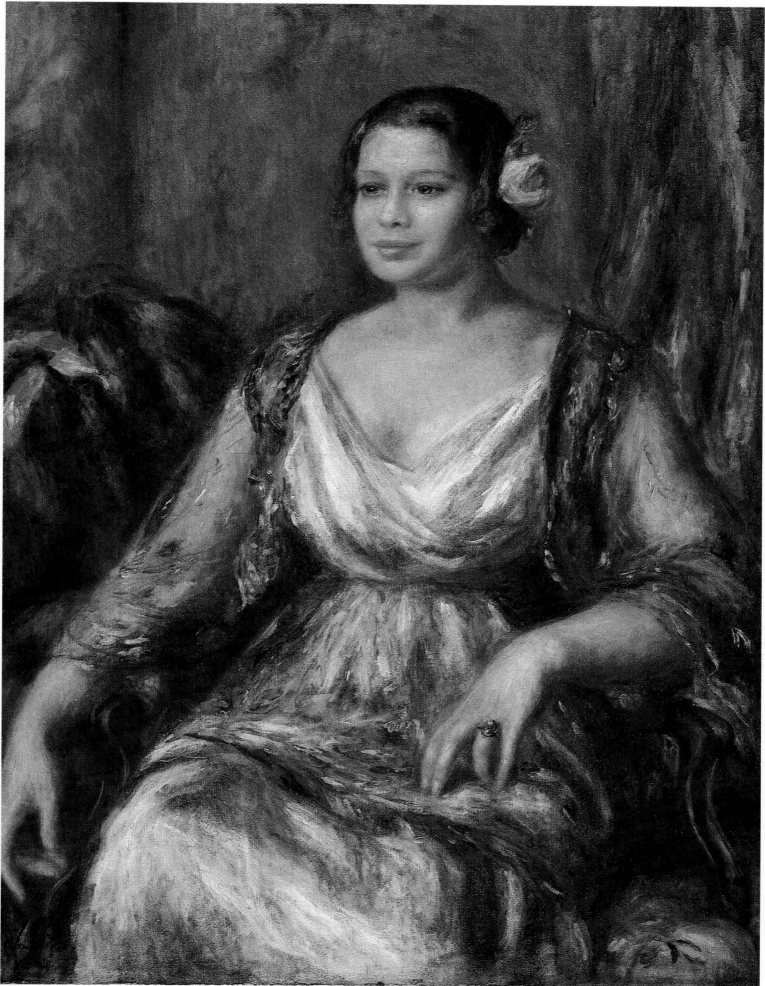

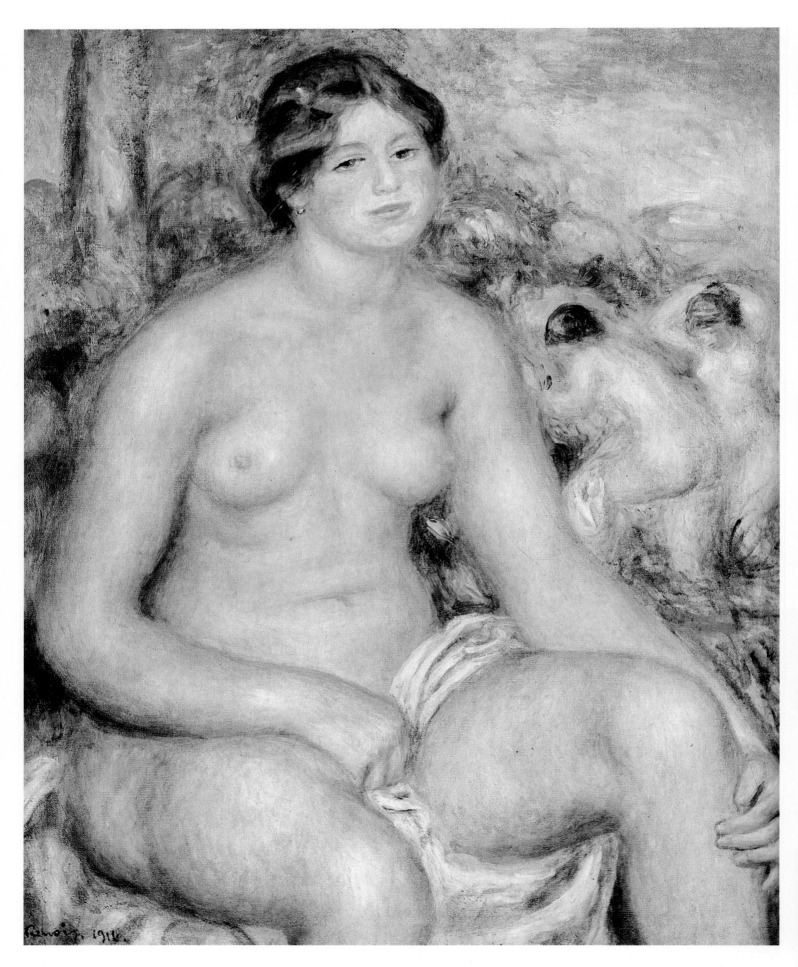

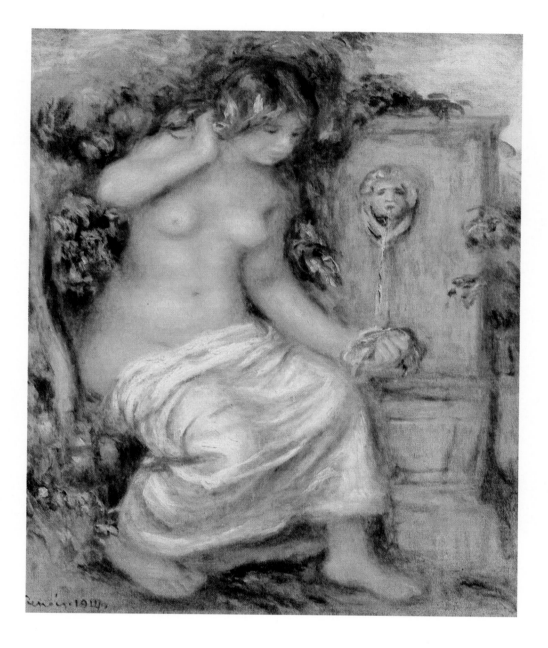

Baigneuse assise

1914 - oil on canvas - 81 x 67 cm -
Art Institute, Chicago

Baigneuse à la fontaine

1914 - oil on canvas - 55.5 x 47 cm -
Galerie Daniel Malingue, Paris

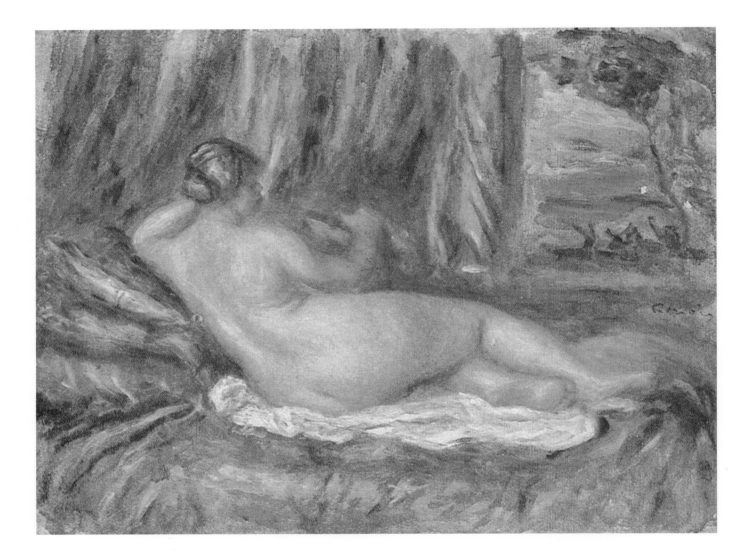

Nu couché

1914 - oil on canvas - 35.5 x 49 cm -
Private collection

Fraises

*1914 - oil on canvas - 21 x 28.6 cm -
Philippe Gangnat Collection, Paris*

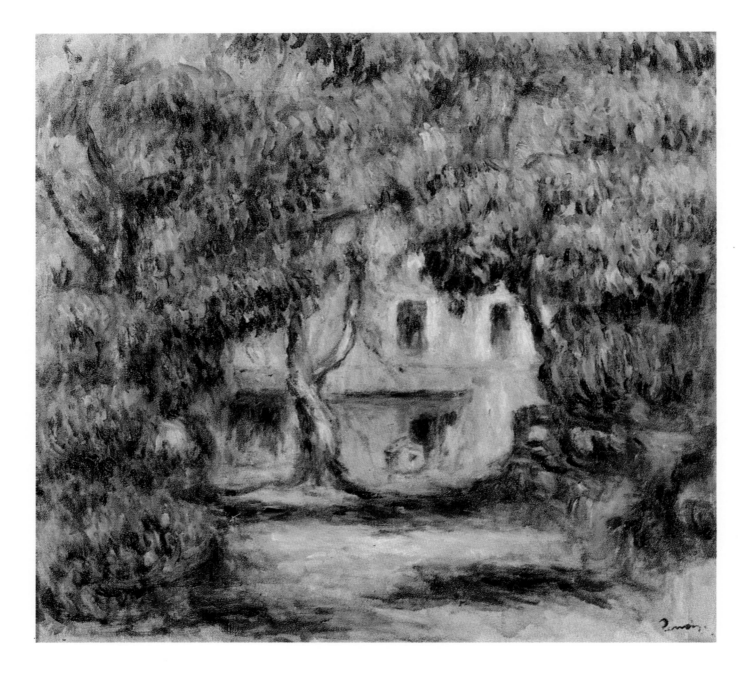

La ferme des Collettes

1915 - oil on canvas - 46 x 51 cm -
Musée des Collettes, Cagnes-sur-Mer

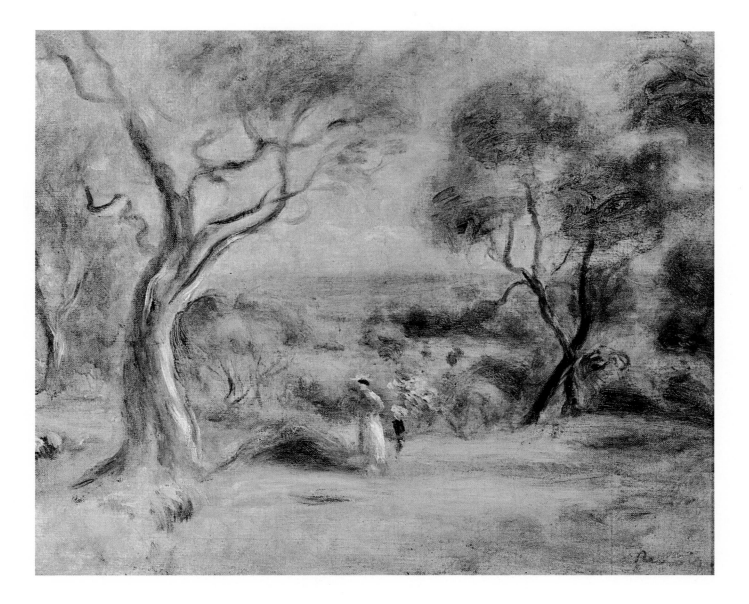

Promenade au bord de la mer

c. 1914 - oil on canvas
Civica Galleria d'Arte Moderna,
Grassi Collection, Milan

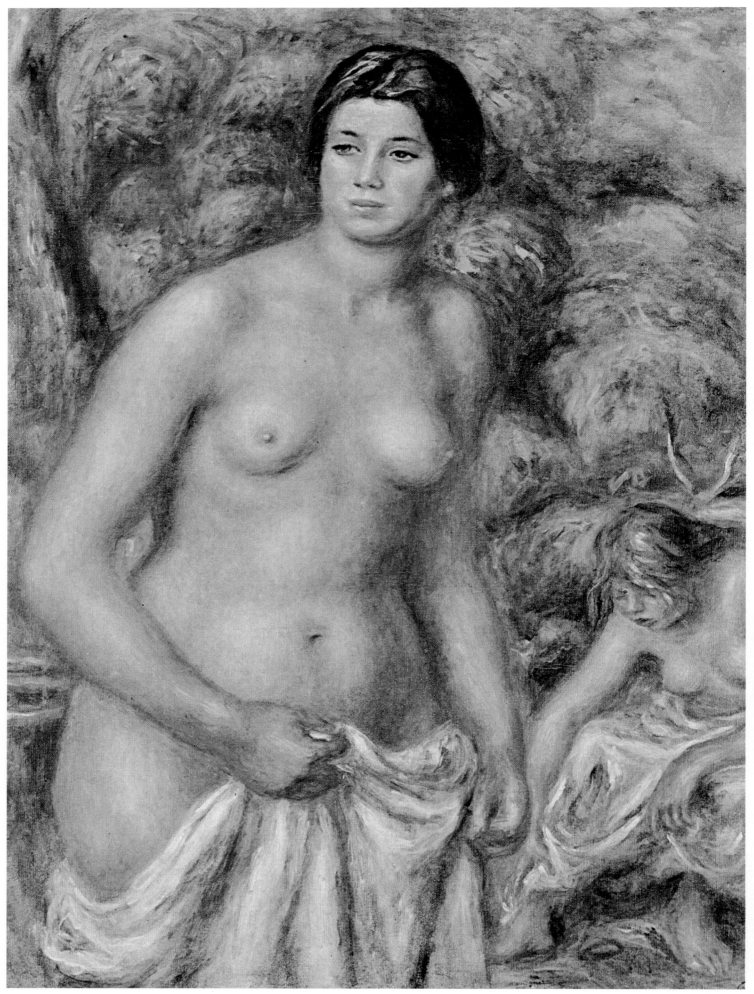

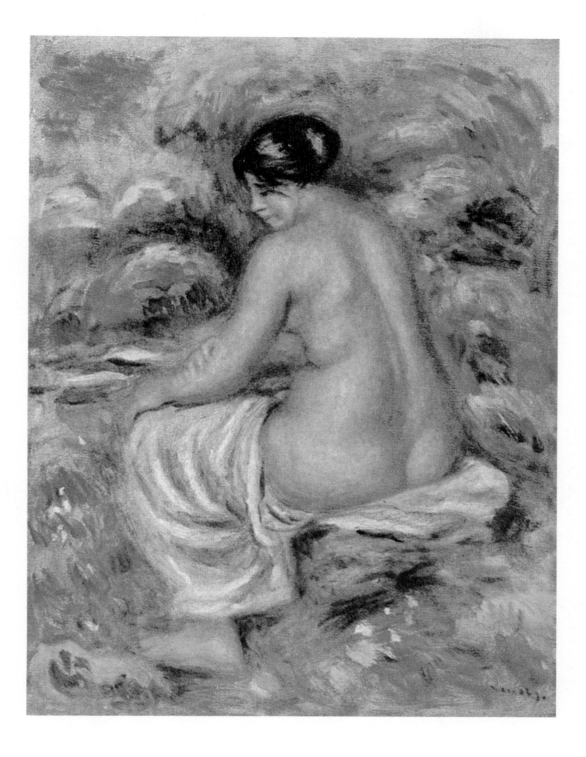

Nu

1916-17 - oil on canvas - 38 x 31 cm -
Private collection

Madeleine Bruno (Les deux baigneuses)

1916 - oil on canvas - 93 x 72 cm -
Private collection

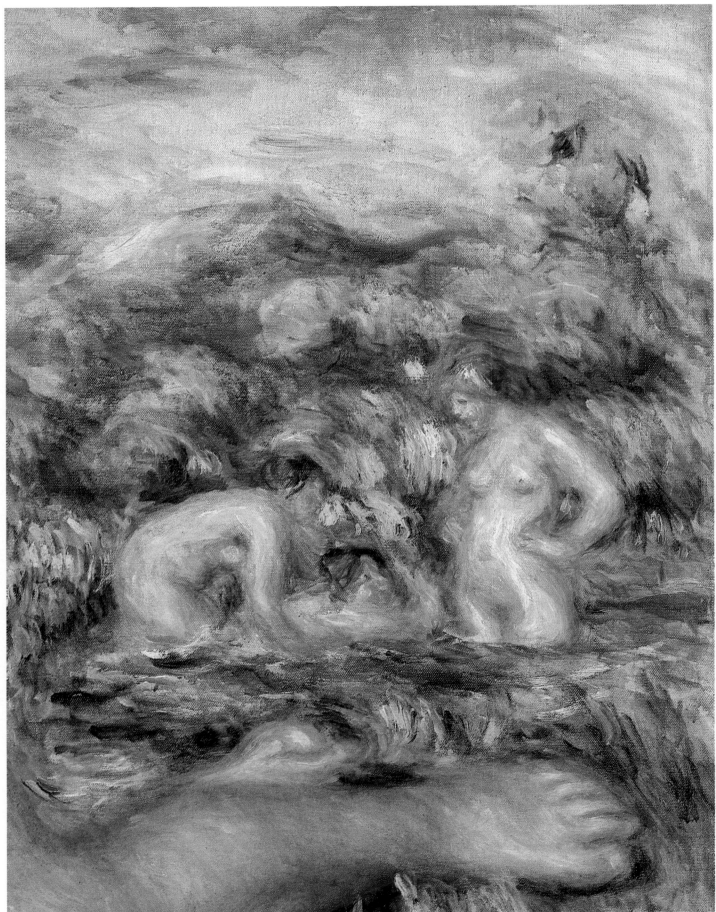

Les Baigneuses

detail

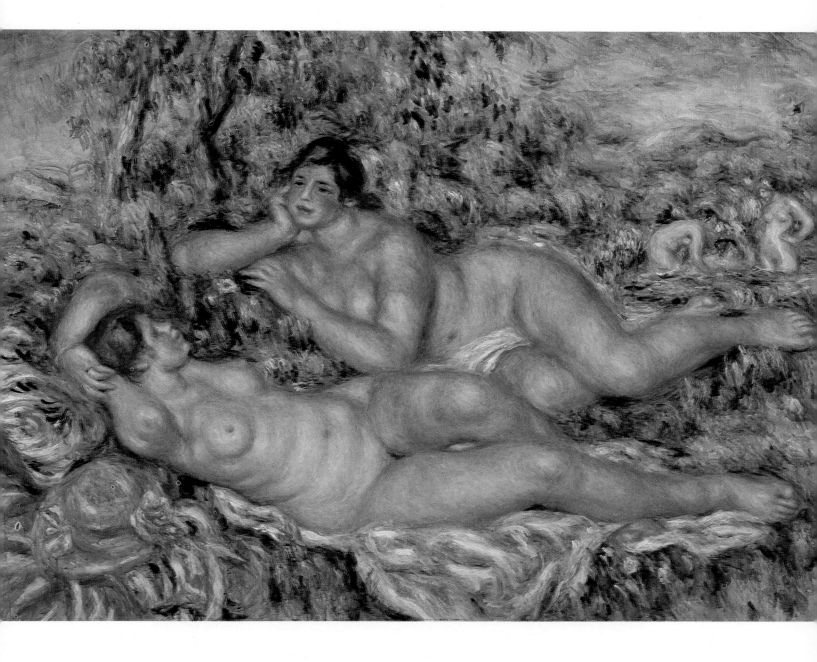

Les Baigneuses

*c. 1918-19 - oil on canvas - 110 x 160 cm -
Musée d'Orsay, Paris*

372

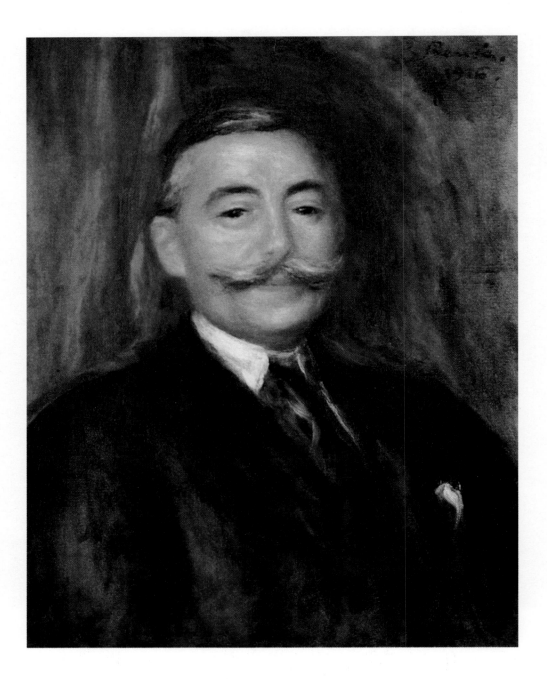

Maurice Gangnat

1916 - oil on canvas - 47 x 38 cm -

Private collection

Le concert

c.1919 - oil on canvas - 75 x 93 cm -
Art Gallery of Ontario, Toronto

Composition: AAA Concept, Vernon
Printing and Binding: PPO - 93500 Pantin - France